Too Beautiful
to Picture

ZEUXIS, MYTH, AND MIMESIS

ELIZABETH C. MANSFIELD

University of Minnesota Press
Minneapolis • London

Published by the University of Minnesota Press
111 Third Avenue South, Suite 290
Minneapolis, MN 55401-2520
http://www.upress.umn.edu

Library of Congress Cataloging-in-Publication Data

Mansfield, Elizabeth, 1965–
 Too beautiful to picture : Zeuxis, myth, and mimesis / Elizabeth C. Mansfield.
 p. cm.
 Includes bibliographical references and index.
 ISBN-13: 978-0-8166-4748-4 (hc : alk. paper)
 ISBN-10: 0-8166-4748-8 (hc : alk. paper)
 ISBN-13: 978-0-8166-4749-1 (pb : alk. paper)
 ISBN-10: 0-8166-4749-6 (pb : alk. paper)
 1. Art and mythology. 2. Mimesis in art. 3. Narrative art. 4. Zeuxis, 5th cent. B.C.
I. Title.
N7760.M26 2007
701—dc22

 2006027681

Printed in the United States of America on acid-free paper

The University of Minnesota is an equal-opportunity educator and employer.

12 11 10 09 08 07 10 9 8 7 6 5 4 3 2 1

THIS BOOK IS DEDICATED TO HENRI ZERNER

Contents

Acknowledgments

MANY COLLEAGUES AND FRIENDS helped bring this project to completion. I am grateful for the patience and generosity of those who read and commented on early drafts: Jülide Aker, Laura Barlament, Scott Bates, David Carrier, Marjorie B. Cohn, Susan Dackerman, John Grammer, Nicolas Moschovakis, and Jim Peterman. Richard Wendorf, who led the graduate seminar from which this book grew, provided crucial early direction. More recently, suggestions and criticisms given by Mary Sheriff, Jill Casid, and David Carrier helped strengthen and clarify the arguments presented on the following pages. Whatever lapses in precision or persuasion that may remain are the fault solely of the author.

Support for research and writing came from an Appalachian College Association Postdoctoral Fellowship and a Millicent C. McIntosh Fellowship awarded by the Woodrow Wilson Foundation and generously funded by the Gladys Krieble Delmas Foundation. My thanks go to Dean Thomas A. Kazee and Dean Rita Kipp and to faculty grants coordinator Sherri Bergman for helping me find the time and funding necessary to write this book.

I have had the pleasure of working with two wonderful editors at the University of Minnesota Press, Andrea Kleinhuber and Richard Morrison. I am grateful for their unflagging support and guidance.

For his constancy and encouragement I thank my husband, Joe.

Introduction

Where is she in the flesh? That matchless Venus of the ancients,
so often sought and never found except in scattered elements,
some fragmentary beauties here, some there!

⇀ HONORÉ DE BALZAC, *THE UNKNOWN MASTERPIECE*

Fatal beauty!

⇀ HONORÉ DE BALZAC, *SARRASINE*

WHEN NICOLAS POUSSIN FIRST MEETS the fictional painter Frenhofer in Honoré de Balzac's *Unknown Masterpiece,* he is awed no less by the old man's perfectionism than by his skill. Frenhofer tells his young admirer that he has devoted several years to painting an image of "a flawless woman, a body whose contours are perfectly beautiful."[1] The canvas will be realized, he explains, once he finds the right model to pose for the finishing touches. Poussin begs to see the work even in its incomplete state, if just to catch a glimpse of the ideal form he, too, aspires to create. Frenhofer refuses. Only when Poussin offers his lover, Gillette, as a model does Frenhofer finally relent. But the perfect woman Frenhofer claims to have painted is nowhere visible. All Poussin sees is a canvas smeared illegibly with layers of paint, a single foot the only recognizable form emerging from the chaotic veils of pigment. Yet Frenhofer exclaims:

Aha! You weren't expecting such perfection, were you?
You're in the presence of a woman, and you're still looking
for a picture. . . . Where's the art? Gone, vanished! Here's
true form—the very form of a girl. . . . But I do believe she's
breathing. . . . You see that breast? Ah! Who could fail to

worship her on his knees? The flesh throbs, she's about to stand
up, wait a moment.[2]

Poussin's bafflement—and Frenhofer's madness—spring from the same
source: a desire to make visible the ideal, to paint what is too beautiful to
picture. Balzac even personifies the impasse by staging an encounter be-
tween the historical artist Poussin and the imaginary Frenhofer. What can
come of a dialogue between the real and the ideal? At best, a comic series of
misunderstandings; at worst, the extinction of the ideal. Hans Belting char-
acterizes this predicament as "the modern artist's struggle." Postromantic
artists, Belting observes in his book *The Invisible Masterpiece*, found them-
selves "in the hell of art" where "perfect art was a shadow, a mere ghost of
classical times."[3] Romanticism acknowledged the gulf between concept and
practice, making it increasingly difficult to realize in painting or sculpture
the ideal of perfection. "The contradiction between idea and work could
not be resolved, because only the idea could be absolute: the moment it
became a work it was lost."[4] Taking Balzac's story as his point of departure,
Belting presents a persuasive history of modern art as a series of vexed at-
tempts at and retreats from the "masterpiece," that is, a fully realized, ma-
terial expression of an aesthetic ideal. Without disagreeing with Belting's
account of modernism, I find in Balzac's *Unknown Masterpiece* traces of
another history of art, one that began in antiquity and—like Frenhofer's
painting—remains unresolved.

Frenhofer's longing for "that matchless Venus of the ancients, so often
sought and never found except in scattered elements, some fragmentary
beauties here, some there,"[5] is not, I argue in the following chapters, a mod-
ern one. It echoes a struggle first given narrative form in antiquity. The
classical tale of Zeuxis Selecting Models is one of the West's most enduring
myths of artistic creation, having served as a lesson in visual representation
for more than two millennia. Yet it has received almost no serious atten-
tion from art historians or aestheticians.[6] According to tradition, the Greek
artist Zeuxis was commissioned to paint an image of the legendary beau-
ty Helen of Troy. He began by summoning all the young women he could
muster, but he was unable to find a suitable model: none of the women pos-
sessed the physical perfection attributed to the mythical Helen. Zeuxis re-
solved his dilemma by choosing five models whose best features he then
combined in a composite image.

Did Zeuxis succeed where Frenhofer failed, assembling the "scattered ele-
ments, some fragmentary beauties" into a satisfying representation of ideal
form? I do not believe so. The aesthetic anxiety that left Frenhofer incapable

of differentiating between the real woman Gillette and the formless riot he created also animates the legend of Zeuxis Selecting Models. It, like Balzac's *Unknown Masterpiece*, bears witness to the impossibility of rendering visible the ideal. This is not simply an aesthetic predicament; it is an ontological one. Balzac makes this clear in another novella, *Sarrasine*, which evokes even more plainly the trauma embedded within the myth of Zeuxis.

The title character of Balzac's *Sarrasine* is an acutely sensitive sculptor of the ancien régime whose story is told at an elegant Paris soirée held during the Bourbon Restoration. Circulating among the guests is a very old man whose presence provokes unease in all who encounter him. Apparently a member of the noble family giving the party, the old man is attended nervously by the hostess and her children. Speculation about his identity—and its connection to the family's renowned fortune—focuses on strange and sinister possibilities: a murderer, a con man, a ghost, even an alchemist. Those who stand near the spectral figure complain of a sudden chill. "He smells like a graveyard," reports one frightened guest to the narrator. To mollify her fear, the narrator agrees to tell her the old man's history, which is bound with that of the sculptor Sarrasine.

Upon winning the Prix de Rome Sarrasine leaves Paris for Rome in 1758, eager to continue his study of sculpture with classical and Renaissance works as his guides. Shortly after arriving in Rome he treats himself to an evening at the opera. There, he is enthralled by the prima donna La Zambinella. Her appearance transports him:

> At that instant he marveled at the ideal beauty he had hitherto sought in life, seeking in one often unworthy model the roundness of a perfect leg; in another, the curve of a breast; in another, white shoulders; finally taking some girl's neck, some woman's hands, and some child's smooth knees. . . . This was more than a woman, this was a masterpiece![7]

Like all academically trained artists of the eighteenth century, Sarrasine has been taught to emulate Zeuxis's strategy of combining parts of various models into a composite ideal. Now, in the seeming presence of this ideal, Sarrasine finds himself in a strange state of rapture commingled with despair, of fever alternating with chill. Even at this first encounter, his ideal-made-real exerts an uncanny influence. Regardless, he resolves "to be loved by her, or die!"[8] Eventually, Sarrasine discovers that his feminine ideal is as incomplete, as fragmentary as Zeuxis's famous Helen. La Zambinella is a castrato. The shock of this realization leads Sarrasine first to die metaphorically: "A

horrid truth crept into his soul. . . . No more love. I am dead to all pleasure, to every human emotion."[9] His literal death follows just moments later at the hands of assassins sent by La Zambinella's patron.

The narrator brings his tale to a close, explaining that the figure haunting the party is the aged La Zambinella. Though long stripped of his beauty, the old castrato still triggers an uncanny effect in those who see him. The narrator's companion summarizes the awful truth of Sarrasine's realization: "Excepting for monsters, don't all human feelings come down to the same thing, to horrible disappointments? . . . If the Christian's future is also an illusion, at least it is not destroyed until after death."[10] Balzac here invites the reader to contemplate the fact that art is like faith in that both seek to disguise the impossibility of confirming the existence of the ideal.

In *Sarrasine*, Balzac brings to life the Helen of Zeuxis. Far from reassuring, this false and fragmentary ideal provokes anxiety. Balzac makes plain her association with castration and death, a point that Roland Barthes emphasizes in his well-known analysis of the story, *S/Z*:

> Fragmented Woman is the object offered to Sarrasine's love. Divided, anatomized, she is merely a kind of dictionary of fetish objects. This sundered, dissected body is reassembled by the artist into a whole body, the body of love descended from the heaven of art, in which fetishism is abolished and by which Sarrasine is cured.

Barthes is also careful to note the ultimate failure of this gesture.

> However . . . this redeeming body remains a fictive one. . . . the sculptor will continue to whittle the woman (just as he whittled his pew in church as a child), thereby returning to its (fragmented) fetish condition a body whose unity he supposed he had discovered in such amazement.[11]

Barthes's reference to an earlier part of the story, where Sarrasine's natural urge to create leads him to whittle the pews during mass, points to the inherent fetishism of artistic representation, especially the depiction of women. Eliding the difference between sculpting statues and carving women, Barthes's description of art making foreshadows the Zeuxian performances of the contemporary French body artist, Orlan.

Balzac's literary illustrations of Zeuxis Selecting Models find a living counterpart in the "carnal art" of Orlan. From 1990 to 1993 Orlan underwent

nine surgical procedures to modify her appearance. Specifically, she altered her facial features to resemble those of five women depicted in famous paintings (see chapter 7). Orlan's enactment of Zeuxis Selecting Models graphically manifests the episode's underlying trauma. Staging her surgeries as performances, she invites viewers to experience the Zeuxian process via closed-circuit television or videotape. In this way, Orlan asks her audience to witness the fragmentation and reassemblage necessary to achieve ideal beauty as it is theorized in the legend. Orlan's project, however, is only one of many responses to Zeuxis Selecting Models to evoke the legend's fetishistic strategy. I believe that Shelley's *Frankenstein* is another, as is Picasso's watershed painting *Les Demoiselles d'Avignon* (Figure 36).

By bringing these works as well as several Renaissance and early modern depictions of the Zeuxis theme into conversation with one another, I seek to show that Zeuxis Selecting Models holds special significance for the history of Western art. Specifically, I argue in the following chapters that Zeuxis Selecting Models functions as a myth about mimetic representation itself. By mimetic, I mean more than simply imitative. In its full, classical sense "mimesis" refers to a twofold approach to representation: first copying forms observed in nature, then generalizing or perfecting those forms to achieve a kind of ideal.

This book turns on the following premise: The legend of Zeuxis Selecting Models records and perpetuates a persistent cultural anxiety about the use of mimesis in visual representation. At certain moments throughout the history of Western art, this anxiety has become so acute as to result in periods of iconoclasm. Typically, scholars have examined iconoclasm strictly as a consequence of social forces.[12] But an additional source for this anxiety bears scrutiny: the colliding aesthetic and psychic interests inherent to a particular type of mimesis. This type of mimesis, which I refer to as Zeuxian, or classical, mimesis, has been alternately embraced and rejected in the West since antiquity. Evident in ancient aesthetics as recorded by Xenophon, Plato, and Aristotle, classical mimesis lost its currency in the West throughout much of the Middle Ages. Renaissance artists and authors reclaimed classical mimesis, and it has remained a prevalent theory of representation to this day.

My argument hinges on two main assertions. First, Zeuxis Selecting Models functions mythically in that it transmits ideology. In other words, the legend retains traces of a cultural unconscious that makes its presence felt by triggering an uncanny sensation. Second, the uncanny experience elicited by Zeuxis Selecting Models is a symptom of the ontological impasse posed by classical mimesis itself. The myth, I argue, encodes a disguised history of

Western art, an unconscious record of the West's reliance on mimetic representation as a vehicle for social and metaphysical solace.

Following the shape of my argument, the chapters in this book are grouped into two parts. The first part presents an analysis of the Zeuxis narrative. I begin by explaining the relevance of myths and legends about artistic creation for the study of visual culture. While long-lived legends such as those of Veronica's Veil, St. Luke Painting the Virgin, Pygmalion and Galatea, the Corinthian Maid, and Apelles Painting Campaspe contribute to our understanding of the history of Western art, the legend of Zeuxis Selecting Models stands apart. Zeuxis Selecting Models taps into the unconscious history of art. In chapter 1 I also present an account of classical mimesis. As acknowledged by the writings of Plato, Xenophon, and Aristotle, classical mimesis became a privileged mode of representation in antiquity. Prohibitions codified in Hebrew law in addition to concerns raised in the writings of Plato fueled late antique—especially Christian—suspicion of mimetic representation, a wariness that persisted well into the Middle Ages. Both mimesis and the Zeuxis myth, then, are understood in this chapter to be historically constituted.

The special status of Zeuxis Selecting Models is delineated in chapter 2. Here I examine the narrative structure of Zeuxis Selecting Models, arguing on behalf of its status as a myth, by which I mean a form of representation that transmits ideology as well as ideas. That is to say, Zeuxis Selecting Models tells a story about an artist as it encodes and promulgates certain cultural beliefs or assumptions. The mythic quality of Zeuxis Selecting Models becomes evident in this chapter through an analysis of its narrative structure. I begin this analysis by documenting the sources of the legend of Zeuxis Selecting Models. Cicero and Pliny the Elder offer the earliest extant records. Their accounts differ on a few particulars, but the basic elements of the legend remain consistent in all versions, ancient as well as modern. The main features of the story, I argue, should be read as traces of an uncanny narrative. By placing the story in dialogue with texts by Homer, Stesichorus, Johann Wolfgang von Goethe, E. T. A. Hoffmann, and Sigmund Freud, I show that Zeuxis Selecting Models is redolent of the uncanny. And, like Freud, I assert that uncanny experiences function like buoys, chained to a submerged event. My aim is to find the cultural event marked by Zeuxis Selecting Models.

My use of Freudian terminology and strategies requires some explanation at this point. Though their therapeutic value has been contested, Freud's psychoanalytic theories remain fruitful as tools for cultural analysis.[13] Freud's insightful "readings" of patients demonstrate the capacity of images and stories simultaneously to disguise and transmit the subtlest of

meanings. Freud proceeded from the assumption that self-representation is at once transparent and opaque. This axiom holds true for all forms of discourse, personal as well as cultural. I find in psychoanalysis a useful model for cultural analysis, that is, the study of ideology as it is conveyed via representation. Clinical psychoanalysis seeks to understand a personality by bringing unconscious motivations to the surface, with the goal of providing self-knowledge and, hence, psychological well-being. Cultural analysis dispenses with any therapeutic goal, seeking rather to understand the effect of occult social forces on a culture. In other words, I cast culture as the personality of a society, ideology as its unconscious.[14]

Among the psychoanalytic concepts I adopt—and adapt—is the notion of a primal scene.[15] The Freudian primal scene refers to a young child's observation of sexual intercourse, most often involving his parents. Freud hypothesizes these circumstances: "It is perfectly possible for a child, while he is not yet credited with possessing an understanding or memory, to be a witness of the sexual act between his parents or other grown-ups."[16] Although the child does not fully understand what he is watching, he sees enough to detect that the woman does not possess a penis.[17] This unexpected and shocking realization provokes the boy's experience of castration anxiety, or the fear that his penis is vulnerable to the loss or "lack" experienced by women.[18] Of course, subsequent psychoanalytic theorists have pointed out that Freud's notion of castration anxiety metonymically masks the fear of ultimate loss or lack: death.[19] Whether the sight of adult sexuality is associated with potential castration or with death, the whole encounter is repressed. In a neurotic, these repressed memories will emerge as symptoms such as attachment to a fetish. Even healthy adults experience uncanny sensations in response to repressed memories or fears. Interestingly, Freud explains that a child's repressed memory of the primal scene may, in fact, be simply a "primal phantasy." Seeking an outlet for sexual curiosity or a means to disguise autoerotic thoughts or behavior, the child may fantasize about adults copulating without having witnessed the act previously. Either way, Freud concludes that the memory—real or imagined—remains linked to castration anxiety and will, therefore, undergo repression only to manifest itself via illness in the case of neurotics.

My application of Freudian ideas is inflected by the work of literary critic Ned Lukacher, who has recast Freud's notion of the primal scene for use in cultural studies. Lukacher proposes deploying the primal scene as "trope for reading and understanding." Developed in an effort to achieve a critical strategy that might mediate between antithetic positivist and poststructuralist approaches, Lukacher's primal scene is an "interpretive dilemma"

posed by "a constellation of forgotten intertextual events offered in lieu of a demonstrable, unquestionable origin."[20] A kind of interpretative certainty might be gained, Lukacher suggests, by understanding texts as symptoms of an obscured (or sublimated) cultural experience:

> Rather than signifying the child's observation of sexual intercourse, the primal scene comes to signify an ontologically undecidable intertextual event that is situated in the differential space between historical memory and imaginative construction, between archival verification and interpretive free play. . . . I use the expression "primal scene" to describe the interpretive impasse that arises when a reader has good reason to believe that the meaning of one text is historically dependent upon the meaning of another text or on a previously unnoticed set of criteria, even though there is no conclusive evidential or archival means of establishing the case beyond a reasonable doubt. The primal scene is thus the figure of an always divided interpretive strategy that points toward the Real in the very act of establishing its inaccessibility; it becomes the name for the dispossessive function of language that constitutes the undisclosed essence of language.[21]

Lukacher's sensitivity to the capacity of language—which I take to mean representation, whether literary or visual—makes his theory of the primal scene especially relevant to visual studies. His assertion that language can simultaneously evoke both presence and absence points to compelling interpretive possibilities. The interplay of cultural desires, fears, and memories takes place at the level of myth, which manages these experiences. In other words, myth performs difficult cultural memories, expressing them as images or narratives. It is my contention that representations of Zeuxis Selecting Models function as traces of cultural memory, as echoes of a primal scene. This book is a record of my soundings of the narrative and psychic depths of the Zeuxis myth. Beneath its surface is hidden a cultural primal scene that explains the West's ambivalence toward mimesis.

While Lukacher's account of a cultural primal scene contributed to my own pursuit of such a concept, my use of psychoanalytic theory in this study has been shaped fundamentally by feminist historians of art and culture. The relevance of gender and sexuality for the Zeuxis myth makes itself felt at every turn. Neither the fetishistic drama embedded within the myth, for instance, nor the story's rehearsal of the man-as-creator/woman-as-

created formula can be addressed without attention to the role of gender. Because the psychoanalytic strategies developed by scholars such as Lynda Nead, Griselda Pollock, Kaja Silverman, and Ewa Lajer-Burcharth underlie much of my thinking about Zeuxis Selecting Models, their influence will no doubt be detected often in the following chapters.

The second part of the book proceeds from the question that initially sparked my interest in Zeuxis Selecting Models: Why are there so few post-Renaissance visual depictions of this subject? With the rise of artists' academies throughout Europe during the seventeenth and eighteenth centuries, antique themes about artists grew enormously popular. There are hundreds of paintings of Pygmalion and Galatea, Apelles Painting Campaspe, and the Corinthian Maid. What makes the Zeuxis narrative so different? The episode seems to present a suitable, even ideal, subject for ambitious artists of the seventeenth through nineteenth centuries. It possesses all the requisite ingredients: an antique subject taken from important classical sources, a chance to be identified with a legendary artist, an opportunity to depict idealized nude figures, and, above all, a story about representation itself. Was this theme problematic for post-Renaissance artists? If so, why?

To begin to address these questions, in chapter 4 I examine the academic reception of Zeuxis. Not surprisingly, the legend of his decisive strategy was enthusiastically disseminated by academicians. A close reading of these academic accounts, however, reveals some rhetorical peculiarities. In particular, a link between Zeuxian creativity and masculine procreativity became increasingly prevalent in eighteenth-century discourse. This, perhaps, is not remarkable given the popular assumptions of the time regarding women's creative and intellectual capacities. But I believe that there is more to this rhetoric than simply an expression of social norms. That women artists are subject to different social conditions than are their male counterparts is no longer contested, thanks to the important foundational work of scholars like Linda Nochlin, Norma Broude, Pat Mathews, Thalia Gouma-Peterson, Griselda Pollock, and Mary Garrard. What remains a crucial and comparatively unexplored component of early modern resistance to feminine creative agency is the theoretical discourse that both generates and responds to this condition.[22]

Aesthetic theory serves as a vehicle for the ideologies that manifest themselves in institutional and other social practices. Thus, in order to understand the practice and experience of women artists, the theoretical bases for their real or constructed difference must be analyzed. This is the point of departure for chapter 5, in which I explore early modern negotiations of Zeuxis Selecting Models by women. Specifically, I examine Angelica Kauffman's

late eighteenth-century painting of the subject and Mary Shelley's novel *Frankenstein.* Interestingly, both women offer a critique of the theme's characterization of creative relationships in terms of man-as-creator/woman-as-created.

Ultimately, what Kauffman's and Shelley's interventions reveal is that the misogyny promulgated by academic references to Zeuxis is a symptom of a larger issue. If the Zeuxis myth were merely a convenient means for expressing the superiority of masculine creative activity, more male artists would have depicted the episode of Zeuxis Selecting Models. But very few examples were produced in the eighteenth century, a period distinguished by a vogue for visual interpretations of themes taken from Roman sources such as Cicero and Pliny. I have found only four paintings of the subject by male artists working in the mid-eighteenth to mid-nineteenth centuries, the period of Neoclassicism's florescence.[23] Given the theme's enormous popularity in contemporary literature and aesthetic discourse, this paucity is quite striking. Indeed, it was precisely this visual reticence on the part of male academicians that initially led me to look at the theme more closely. These four paintings—when studied against the formal structure and narrative history of Zeuxis Selecting Models—visually play out the anxiety embedded in the episode.

Chapter 6 focuses on these as well as other visual depictions of Zeuxis Selecting Models by male artists. All the works addressed in this chapter endow Zeuxian creativity with sexual potency and promiscuity. This erotic impulse grows stronger through time, so that the incongruous evocation of a brothel in the earliest of the paintings, François-André Vincent's canvas of 1789 (Figure 24), becomes an unapologetically bawdy pictorial joke in Jacques-Albert Senave's work of the early 1800s (Figure 31). It is in this chapter that I draw Pablo Picasso's *Les Demoiselles d'Avignon* into my study of Zeuxis Selecting Models. This painting, I argue, visits the same primal scene managed by the Zeuxis myth. I take as my point of departure the nickname given to the painting in 1907 by Picasso's friends. They called it "The Philosophical Brothel" in reference to the marquis de Sade's *Philosophie dans le boudoir.* Sade's text serves as a linchpin for my analysis of Picasso's painting, which I discuss in relation to eighteenth-century depictions of the Zeuxis myth. It is my contention that Picasso's *Demoiselles* portrays Zeuxis Selecting Models from the vantage point of Zeuxis himself. With the *Demoiselles,* Picasso shows *how to paint like Zeuxis.* Thus, the primal scene of Zeuxian mimesis is finally confronted. The consequence is both the destruction of painting and its rebirth.

Orlan's Zeuxian remaking of her own body through her surgery-

performances is the subject of chapter 7. Not surprisingly, Orlan's project has been received largely with shock, outrage, or puzzlement. A few critics and art historians have attempted to admit Orlan into the history of Western art by exploring her work in relation to conceptual art practices, feminism, or protest art. While these accounts help explain the social or political goals of Orlan's approach to body art, they fail to account for its significance as *art*. One of the aims of this book is to redress this shortcoming by considering Orlan's project in relation to the story it retells, that of Zeuxis Selecting Models. This reevaluation will help show the thematic and theoretical importance of the Zeuxis myth for the history of Western art.

Taken together, these diverse responses to the theme of Zeuxis Selecting Models trace a hidden history of art, a history that has remained in Western art's unconscious. Bringing this history to light is the final purpose of this book. It is my hope that the observations and arguments presented in following chapters ultimately reveal some of the cultural and psychic impulses that have motivated the role of mimesis for Western visual art.

Myth and Mimesis
in Western Art History

Art History as Myth

THE HISTORY OF WESTERN ART comprises many narratives. Artists' biographies, catalogues raisonnés, and interpretive treatises have been used for centuries to render aesthetic and historic significance. But another, even more enduring, genre exists. Myths and legends about artists and their accomplishments have constituted a form of art history since antiquity. These narratives have not enjoyed a prominent place in modern scholarship, no doubt because of their dubious correspondence to verifiable facts. For art history, a discipline largely codified during the heyday of positivism, myths and legends hold little serious interest. But it is precisely their presence beneath the surface of authorized art history that makes these narratives especially compelling sources. The history of a culture is found not only in its archives but also in its stories, rituals, and games. Without an account of Western art's dreams and desires, its historiography remains incomplete.[1]

A handful of legends purporting to explain the meaning and function of art have persisted since antiquity. Because these legends connect artistic practice to specific cultural needs or expectations, they function as a form of art history. Art historians, however, tend to dismiss these stories as quaint fables. The only time we turn our scholarly attention in their direction is when they function as subjects for works of art. But stories about Pygmalion, the Corinthian Maid, Apelles, and Zeuxis are the narrative precursors of our own carefully reasoned and scrupulously documented accounts of visual culture. Treating these legends as the irrelevant juvenilia of

an immature discipline falsifies as it impoverishes the history of art history. For embedded in these stories are the concerns that have motivated the study of visual culture in the West since antiquity.

Of course, the same could be said of popular Christian legends that deal with visual representation. The stories of St. Luke Painting the Virgin and of Veronica's Veil, for instance, have served to exemplify aesthetic decorum in Western art since the early Middle Ages.[2] Unlike the antique themes mentioned above, however, the later Christian legends focus on the miraculous production of ritual objects. One of the earliest recorded versions of the legend of Veronica, the apocryphal *Acts of Pilate,* says that Veronica "desired to have a picture of [Jesus] always by her, and went to carry a linen cloth to a painter for that purpose. Jesus met her, and on hearing what she wished, took the cloth from her and imprinted the features of his face upon it."[3] Veronica's part in the story is incidental. Later versions of the legend, in which the saint is reported to have secured Jesus's image on her veil by wiping his face as he struggled on the road to Calvary, maintain Veronica's ancillary role. The story of St. Luke painting the first portrait of the Virgin Mary likewise traces its origin to the early Middle Ages.[4] And it too focuses on the miraculous power of a religious artifact. Aesthetic agency is divorced entirely from human endeavor, so that artistic creation plays little or no role in these stories.[5]

The stories of Pygmalion, the Corinthian Maid, and Apelles Painting Campaspe, on the other hand, engage issues directly related to art making. Each of these classical tales addresses artists' motives and techniques as well as the cultural significance of the visual arts. In this way, these stories function, like the Zeuxis myth, not only as models for various modes of representation but also as illustrations of a shared aesthetic goal, namely, the ability of art to deliver a profound—and profoundly emotional—aesthetic experience. And it is to these themes that post-Renaissance artists, critics, and theorists have most persistently turned when seeking to establish the lineage of Western art history. By providing précis of the legends of Pygmalion, the Corinthian Maid, and Apelles Painting Campaspe, I aim to show how the Zeuxis myth differs importantly from them.

The most popular antique legend of artistic creation remains that of the sculptor Pygmalion.[6] Since its appearance in Ovid's *Metamorphoses* (CE 8), the tale has been told and retold in texts ranging from Jean de Meun's *Romance of the Rose* and William Shakespeare's *Winter's Tale* to numerous operas, poems, and even contemporary movies, such as *Weird Science.*[7] Ovid's seminal version appears in book 10 of the *Metamorphoses* amid verses about love extinguished by death or perversity. A description

of the blasphemous practices of the Propoetides of Cyprus, who defiled a temple of Venus by prostituting themselves within its precinct, segues into Pygmalion's story. Pygmalion witnessed the profanation of the temple, and his disgust at the behavior of the Propoetides led him to pursue a solitary, celibate life. With only his sculpting skill to distract him, Pygmalion carved "a figure out of snowy ivory, giving it a beauty more perfect than that of any woman ever born. And with his own work he falls in love."[8]

Pygmalion caressed the sculpture, spoke to it, dressed and adorned it, brought it gifts, and even placed it on his bed as the "consort of his couch." With the arrival of midsummer, Pygmalion visited Venus's temple to make his customary offering, asking the goddess to grant him a favor. But he couldn't bring himself to ask Venus to animate his statue so he prayed "to have as wife . . . one like my ivory maid." Venus understood the true nature of his request, so that

> When he returned [home] he sought the image of his maid, and bending over the couch he kissed her. She seemed warm to his touch. Again he kissed her, and with his hands he also touched her breast. The ivory grew soft to his touch and, its hardness vanishing, gave and yielded beneath his fingers, as Hymettian wax grows soft under the sun and, moulded by the thumb, is easily shaped to many forms and becomes usable through use itself. The lover stands amazed, rejoices still in doubt, fears he is mistaken, and tries his hopes again and yet again with his hand. Yes, it was real flesh![9]

While Pygmalion and Galatea may enjoy pride of place as the most frequently represented Western myth of artistic creation, the legend of the Corinthian Maid has frequently served as a point of theoretical departure for critics and art historians, especially during the eighteenth and nineteenth centuries.[10] The theme's alternate title, the Invention of Painting, denotes its role as an etiological myth of Western art. But the story did not always account for the origins of painting. The earliest extant reference to the story appears in Pliny's *Natural History*:

> Modelling portraits from clay was first invented by Butades, a potter of Sicyon, at Corinth. He did this owing to his daughter, who was in love with a young man; and she, when he was going abroad, drew in outline on the wall the shadow of his face thrown by a lamp. Her father pressed clay on this and made

a relief, which he hardened by exposure to fire with the rest of his pottery; and it is said that this likeness was preserved in the Shrine of the Nymphs until the destruction of Corinth by Mummius.[11]

Although Pliny's account focuses on Butades's fabrication of a sculpted likeness, later versions of the story tend to highlight the role played by the potter's unnamed daughter.[12] Quintilian, writing in the late first century, refers to the legend in book 10 of his *Institutio oratoria*, albeit obliquely as well as pejoratively. He wonders,

> Shall we follow the example of those painters whose sole aim is to be able to copy pictures by using the ruler and the measuring rod? It is a positive disgrace to be content to owe all our achievement to imitation. For what, I ask again, would have been the result if no one had done more than his predecessors? . . . We should still be sailing on rafts, and the art of painting would be restricted to tracing a line round a shadow thrown in the sunlight.[13]

Less a retelling of the legend than an allusion made for didactic purposes, Quintilian's reference nevertheless confirms that by the end of the first century the story of the Corinthian Maid had assumed greater importance vis-à-vis painting than sculpting. This has remained the case ever since. What is more, for Quintilian it was clearly a negative example, a perception that persisted in Renaissance and post-Renaissance aesthetic theory.

Like the legends already discussed, Apelles Painting Campaspe links artistic activity with erotic love.[14] A long-standing theme in the history of Western art, the tale of a (male) artist falling in love—almost out of creative necessity—with his (female) model appears in the biographies of Raphael, Titian, Rembrandt, Francisco José de Goya, Dante Gabriel Rossetti, James McNeill Whistler, Auguste Rodin, and Pablo Picasso, to cite only a few of the most prominent examples.[15] This convention resembles its equally prevalent literary analog, exemplified by Dante and Beatrice or Petrarch and Laura. No doubt the frequency with which the conceit appears in artists' biographies results in part from the influence of Dante and Petrarch on the early practitioners of modern art history.[16]

Apelles Painting Campaspe is the antique forebear of these legends. According to Pliny, Alexander the Great commissioned Apelles to paint a portrait of the ruler's favorite mistress, Campaspe. During the course of

Campaspe's sittings, Apelles fell in love with her. Alexander soon realized what had happened, and, in a gesture of devotion to the artist, he gave his mistress to him. Pliny adds, "Some persons believe that she was the model from which the Aphrodite Anadyomene was painted."[17] Apelles Painting Campaspe, like the story of Pygmalion and his statue, found enthusiastic interpreters among post-Renaissance artists as well as playwrights and composers.[18] A tale of restraint and honor as well as seduction, its function as an *exemplum virtutis* presumably mitigated its strictly erotic appeal.[19] Not surprisingly, many artists nonetheless emphasized the latter.

Each of the classical themes discussed so far ascribes an erotic or romantic impetus to art making. Less theoretical than anecdotal, the stories of Pygmalion, the Corinthian Maid, and Apelles Painting Campaspe characterize creativity as a consequence of emotional or corporeal stimuli. Supremely reassuring, they link art making to love, sexual fulfillment, and psychic and physical wholeness. Furthermore, each of these narratives endows artistic activity with the power to transcend human shortcomings. The legend of Zeuxis Selecting Models offers something quite different. A commentary on aesthetic theory, the Zeuxis myth valorizes an intellectual rather than emotional approach to art making. What is more, it differs from other ancient legends of artistic production in its resistance to being represented. Unlike the other stories, Zeuxis Selecting Models is rarely given visual form. This fact alone raises the question of what makes the Zeuxis narrative so different.

No legend tells us more about what is at stake in early modern art and art history than Zeuxis Selecting Models. This legend dates to the fourth century BCE and recounts the famed artist's strategy for painting an image of Helen of Troy. Zeuxis began by summoning several young women in order to choose a suitable model. Unable to find the perfect features he was seeking in a single model, Zeuxis selected the best features of five women to create an image of ideal beauty. For ancient artists and authors, Zeuxis's strategy exemplified classical mimesis. An approach that involves copying as well as manipulating forms found in nature, classical mimesis has long been a favored mode of representation in the West. The twinned pursuit of realism and idealism demanded by classical mimesis in fact illustrates the West's abiding ambivalence about the function of the visual arts. Should art provide a reassuring affirmation of our daily existence? Or should it offer a means to transcend reality, providing access to ideal experience? Because classical mimesis seeks to accommodate both these cultural needs, it inevitably exposes their irreconcilability. In other words, classical mimesis wants to confirm the existence of the ideal but falters because it relies on

the real as its model. In this way, classical mimesis professes an unsatisfying cultural faith in materialism as it confesses doubt about the possibility of aesthetic—or spiritual—transcendence.

A METAPHOR FOR MIMESIS

In current English usage, "mimesis" generally denotes imitation through words, actions, sounds, or imagery. But in antiquity, the term referred to a more complex mode of representation. Not simply the imitation of something or someone, mimetic representation involved generalizing, modifying, or idealizing observed reality. Göran Sörbom argues that the term is probably a cognate of *mimos,* meaning actors who perform as mimes. Because mimes acted by means of "simplification, choice of characteristic detail, overstatement, overemphasis, or caricature," their performances relied on discernment as well as mimicry.[20] Mimes did not seek to reproduce exactly the gestures or deportment of a particular individual. Instead, they worked to portray a type: greedy old man, brave warrior, and so on. As an aesthetic designation, Sörbom finds that mimesis implied a multiplex process. Based on an accurate depiction of something seen in nature, mimesis depended further upon the artist's memory, biases, habits, and imagination. In this way, mimesis differed importantly from straightforward copying or imitation.

Among the Greek texts in which Sörbom finds frequent references to mimesis is Xenophon's *Memorabilia.* In book 3, Xenophon records a purported exchange between Socrates and the painter Parrhasius in which the philosopher asks, "Does the art of painting consist in making likenesses of what is seen?" After Parrhasius responds affirmatively, Socrates continues: "Moreover, in making as likenesses the beautiful forms, you bring together from many what is most beautiful in each, and in this way you make whole bodies appear beautiful, since it is not easy to chance upon a single human being all of whose parts are blameless."[21] Again, Parrhasius acknowledges the accuracy of Socrates's observation. This characterization of the artist's creative process is, Sörbom argues, indicative of a theory of "artistic mimesis" generally understood by most educated Greeks.[22] Sörbom summarizes the theory of artistic mimesis delineated in Xenophon's writings as a manifold creative process. First, artistic mimesis documents "things we see with our eyes." But artistic mimesis is not simply copying, since all the "things [the artist] remembers to have seen, or sketches he has done for practice" are also brought to bear in the final image. Finally, such observed, remembered, or recorded images are arranged according to a "mental image" held

by the artist, an image that "is not of some particular and existing phenomenon at a given moment but is of a more general although concrete sort."[23] Direct observation combines with memory and practice to bring forth the artist's conception.[24]

Plato's well-known discussion of mimesis in book 10 of the *Republic* offers a comparatively narrow definition of the term. An elaboration of his theory of forms, the dialogue presented here gets under way with a discussion of furniture. A couch, Plato explains, exists first as an ideal form conceived of by God. If a carpenter builds a couch, it is an imperfect copy or shadow of the ideal form. Painters can produce couches as well, Plato explains, but the couch executed by the painter is even further degraded. Because the painter bases his image on the carpenter's couch, the resulting depiction imitates the couch's ideal form in only the meanest sense. For Plato, the painter is akin to a person holding up a mirror to nature. Mimesis, then, refers here to imitation without artistic intervention or conceptualization. "What is the object of painting?" Plato asks his interlocutor Glaucon. "Does it aim to imitate what is, as it is? Or imitate what appears, as it appears? Is it imitation[25] of appearance or of truth?" "Of appearance," Glaucon answers. This response provides the springboard for Plato's condemnation of the imitative arts:

> Then the mimetic art[26] is far removed from truth, and the
> reason for its being able to produce everything is that it lays
> hold of a small part of each thing, and that an image. As, for
> example, a painter, we say, will paint us a cobbler, a carpenter,
> and other craftsmen, though he himself has no understanding
> of any of their crafts; but nevertheless he might deceive chil-
> dren and foolish people, if he were a good painter, by painting
> a carpenter and exhibiting at a distance, so that they thought
> it was truly a carpenter."[27]

Mimesis threatens to distort or undermine truth, and hence the exclusion of poets and painters from Plato's ideal city. That artistic mimesis might aspire to a conceptual truth beyond documenting the physical characteristics of a particular model is not admitted.

Sörbom finds Plato's narrow characterization of artistic mimesis idiosyncratic among classical sources. The cause of this deviation from standard antique usage probably comes from Plato's need to bring the term into the service of his larger philosophical project.[28] Specifically, representational arts serve a mainly didactic role in Plato's writings, especially in the

Republic.[29] Since painters cannot possibly know everything about all the subjects they paint, the risk of conveying misinformation runs dangerously high. Pliny's familiar anecdote of Apelles and the Cobbler illustrates this concern. In this story, Apelles displays one of his paintings outside his studio and then hides from view in order to eavesdrop on passersby. A shoemaker is among those to stop and admire the piece. The cobbler observes to his companions that the sandals worn by the figure in the painting have too many eyelets to accommodate their laces. Apelles hears this comment and, once the observers depart, corrects the sandals. The following day, Apelles once more displays his painting and hides. The cobbler again passes by and notices that the painting had been modified in accord with his observation. Emboldened, he now voices a misplaced criticism of the figure's legs. Apelles then reveals himself, admonishing the shoemaker to "stick to his last."[30] Plato's concerns about mimesis were, it seems, enduring enough to inspire this popular joke.

With Aristotle comes a return to a more conventional—and sympathetic—treatment of artistic mimesis. By entirely disengaging art from Plato's theory of forms, Aristotle releases mimetic representation from its role as a false model. And in so doing, he absolutely distinguishes artistic mimesis from truth. Aristotle achieves this distinction, as Terryl L. Givens points out, through recourse to "aesthetic distance."[31] Only the presumption of aesthetic distance allows Aristotle to observe, "Objects which in themselves we view with pain, we delight to contemplate when reproduced with minute fidelity."[32] The experience of mimetic representation bears no relation to the experience of reality because aesthetic distance affords the viewer a comfortable—and unmistakable—remove from the real. Consequently, artistic mimesis must be judged according to criteria wholly apart from those used to analyze truth or lived experience.

According to Aristotle, there are "three distinctions underlying artistic mimesis."[33] These are "media, objects, and mode."[34] In other words, artistic mimesis cannot be considered apart from the stuff from which an artwork is made, the subject matter it addresses, and the manner in which it is produced. The last implicates *style* in artistic mimesis, thereby distinguishing it from mere copying. Aristotle explains further what he means when he invites poets to learn from visual artists: "Poets should emulate good portrait painters, who render personal appearance and produce likenesses, yet enhance people's beauty."[35] Clearly, Aristotle neither expects nor desires artistic mimesis to conform to observed reality. An artist's (or poet's) ability to idealize, improve, or universalize his or her subject underlies the success or failure of mimesis. Aristotle illustrates this point with his declaration: "Not

to know that a hind has no horns is a less serious matter than to paint it inartistically."[36] In other words, aesthetic success (or style) supersedes truth to nature in the evaluation of the mimetic arts. Aristotle's characterization of mimesis testifies to its general meaning for ancient artistic practices.[37]

Classical mimesis remained the privileged model for the visual arts for much of Greek and Roman antiquity. The plethora of stories relating to artistic mimesis, including Zeuxis Selecting Models, speaks to its popularity and prominence in everyday life as well as in the Greek and Roman imagination.[38] By late antiquity, however, the influence of classical mimesis upon artistic practice had waned. Antimimetic philosophical traditions, including Plato's theory of forms and the Jewish commandment prohibiting "graven images," had persisted. The rise of Christianity gave both of these antimimetic traditions greater currency. With its faith in a transcendent, unknowable God who could also assume material form, Christianity found mimetic and antimimetic aesthetic traditions equally resonant.[39] Consequently, a variety of representational as well as abstract forms of devotional imagery flourished during the early Christian period. This coexistence collapsed for a time during the Iconoclastic controversy of the eighth century. The Eastern church banned religious imagery for nearly a century. Even with the restoration of representational religious arts by the Empress Theodora and her son Michael, abstraction powerfully inflected the visual arts. And though the Western church persisted in representing Jesus, Mary, and the saints, such depictions grew increasingly divorced from naturalism. Thus, classical mimesis had little direct influence on visual arts practice during the Middle Ages.[40]

Not surprisingly, themes or legends suggestive of classical mimesis fell from popular consciousness, although among the particularly learned, the legend of Zeuxis Selecting Models may have been known via manuscript copies of Valerius Maximus's *Memorable Deeds and Sayings*. Written in the first half of the first century CE as a manual for rhetoric and oratory, the text enjoyed some currency in the Middle Ages as a source for examples of virtuous or moral behavior. The first three books of *Memorable Deeds and Sayings* explain religious rites, civil law, and military institutions; the remaining six books illustrate morals and virtues. Some medieval copies of the text date back as far as the tenth century, though most extant versions were produced in the fourteenth.[41] Marjorie A. Berlincourt's research reveals that many western European libraries held copies of Valerius during the Middle Ages. Her review of medieval sources and references to Valerius leads her to conclude that "the name of Valerius was merely listed among [the medieval] author's ancient sources, quotations from his work were

used in support of the author's point of view, or excerpts or versifications were made."[42]

Valerius mentions Zeuxis in book 3, chapter 7, which carries the heading "Of Self-Confidence." Among the Roman instances of self-confidence, Valerius includes Scipio Africanus's refusal to pay a debt imposed by the Senate and the poet Accius's haughty refusal to rise before Julius Caesar. The story of Zeuxis Selecting Models numbers among the non-Roman examples. Zeuxis demonstrates his confidence, according to Valerius, by commending his own painting without regard for public opinion:

> When Zeuxis had painted Helen, he did not think he should wait to see what the public would think . . . but then and there added these verses:
>
> > No blame that Trojans and well-greaved Achaeans
> > Should suffer pains so long for such a woman.
>
> Did the painter claim so much for his hand as to believe that it captured all the beauty that Leda could bring forth by divine delivery or Homer express by godlike genius?[43]

With this gesture, Zeuxis joins Euripides, Hannibal, the Thracian king Cotys, and a pair of Spartan warriors in Valerius's annals of self-confidence. The significance of the Zeuxis legend shifted from serving as a metaphor for mimesis to serving as a lesson in boldness. And without its strong connection to mimesis in this period, Zeuxis Selecting Models ceases to function as a myth of representation. The existence of copies of Valerius in medieval libraries suggests clerics and scholars had some familiarity with the legend of Zeuxis, but its inclusion in a chapter on self-confidence makes it an unlikely candidate for special commentary or popular dissemination. I have found no evidence that Valerius's discussion of Zeuxis appealed to either a lay or clerical audience before the sixteenth century.

Manuscript copies of Pliny and Cicero also helped perpetuate the story of Zeuxis Selecting Models among the literate during the Middle Ages.[44] Some manuscripts even included visual representations of the scene. An interesting example of this appears in a thirteenth-century illuminated Crusader manuscript of Cicero's *Rhetoric* produced in Acre and now in the Musée Condé in Chantilly.[45] The main features of the classical tale—the painting of Helen, the Juno temple, the nude maidens—are suppressed in this curious representation of Zeuxis (Figure 1). Here, at left a pair of elegant columns supporting trefoil arches hints vaguely at an antique setting

and serves to divide the miniature into halves. On the right, five young men are shown exercising. One pair wrestles, two others throw javelins, and a lone figure prepares to hurl the sphere in a shot put. These must be the men who were, according to Cicero, displayed to Zeuxis as evidence of the beauty of all the youth of Croton. The scene deviates from Cicero's account, however, by depicting the men fully clothed. Decorousness presumably prevented the illuminator from painting nudes.

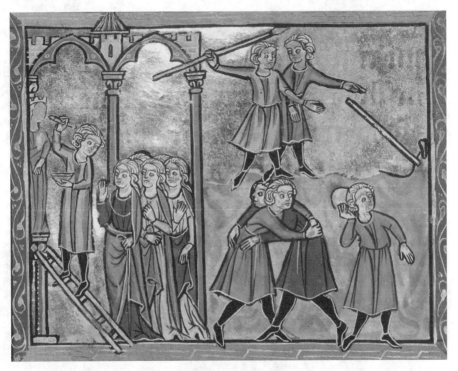

Figure 1. The Hospitaller Master, *Zeuxis Prepares an Image of Helen for the Crotonian Temple of Juno,* from an illustrated *Rhetoric of Cicero,* MS Chantilly 433, fol. 45v (vellum, later thirteenth century, Musée Condé, Chantilly). Photograph courtesy of Réunion des Musées Nationaux / Art Resource, New York.

In the left half of the composition, Zeuxis stands on a ladder as he adds color to a statue of a crowned woman. Polychrome sculpture—popular throughout western Europe by the thirteenth century—here replaces Zeuxis's customary métier. Looking over his shoulder, the artist regards a knot of five women, no doubt his famous models. Only three are fully visible, though, as two of the models are simply suggested by a pair of extra pates barely discernable between the others' heads. The maidens, like their male counterparts seen exercising in the gymnasium, are clothed. In fact, the

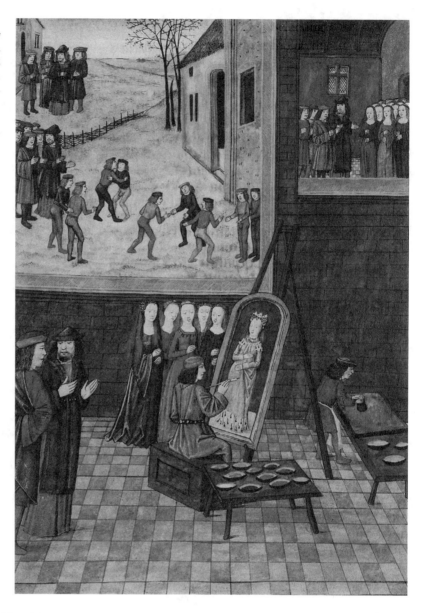

Figure 2. *Zeuxis Selecting Models,* from Cicero's *Rhetoric,* Ghent MS 10 (vellum, fifteenth century, Universiteits-bibliotheek Gent, Ghent, Belgium). Photograph courtesy of Universiteits-bibliotheek Gent.

excessive folds of drapery surrounding the women make their nonnudity all the more striking.

A similar treatment of the subject appears later in a fifteenth-century codex of Cicero's *Rhetoric* (Figure 2).[46] Again, discrete episodes are separated, in this case through the device of a series of window frames. Through one frame, two moments are captured: Zeuxis discussing his project with his patrons, then standing with them to watch the young men wrestling in brightly colored costumes. Through another framed aperture, an interior

scene reveals itself with Zeuxis and his patrons confronting a large group of (clothed) women. The bottom, and largest, register shows the five maidens standing next to a nearly completed panel painting of a woman wearing a yellow silk dress trimmed in ermine. Zeuxis sits before his painting as his patrons observe his work. Meanwhile, an assistant prepares colors nearby. This illustration of Cicero's text clearly belongs in the medieval tradition exemplified by the Chantilly manuscript insofar as it illustrates the story of Zeuxis without appealing to classical mimesis as an exemplary means of visual representation. The episodic composition, the discarding of nude models, and the elision of Zeuxis's engagement in selection or discrimination (the models are presented as a largely undifferentiated cluster of women) all point to the illuminator's interest in the story as a simple narrative as opposed to a metaphor for mimesis.

The story of Zeuxis Selecting Models may or may not have resonated with a popular medieval audience, but the artist's name was in circulation in educated courtly circles in Europe. For instance, Jean de Meun's courtly allegory *Romance of the Rose* refers to the artist. Citing Cicero as his source, Jean uses the story to prove the inability of art to represent Nature faithfully. Jean introduces Zeuxis by having his narrator, the Dreamer/Lover, bemoan his inability to describe Nature, whom he has observed weeping and lamenting:

> I would willingly describe her to you, but my sense is not equal
> to it. . . . No human sense would show here, either vocally or
> in writing. . . . Even Zeuxis could not achieve such a form with
> his beautiful painting; it was he who, in order to make an
> image in the temple, used as models five of the most beautiful
> girls that one could seek and find in the whole land. They re-
> mained standing quite naked before him so that he could use
> each one as a model if he found any defect in another, either in
> body or in limb. Tully recalls the story to us in this way in the
> book of his *Rhetoric,* a very authentic body of knowledge. But
> Nature is of such great beauty that Zeuxis could do nothing
> in this connection, no matter how well he could represent or
> color his likeness.[47]

Here, it is the insufficiency of classical mimesis that is noted. Far from being heroic or worthy of emulation, Zeuxis's effort testifies to humanity's hubris (the very thing causing Nature's distress in the *Romance*). Illustrated copies of the *Romance* occasionally depict the scene. A particularly fine

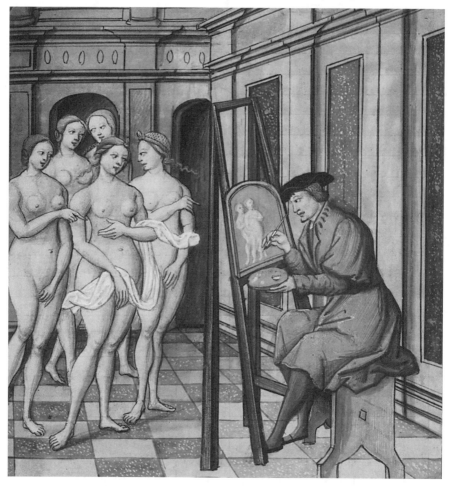

Figure 3. *Zeuxis Painting Five Nudes,* from Guillaume de Lorris and Jean de Meun, *Romance of the Rose,* MS M.948, f.159 (vellum, ca. 1520, the Morgan Library, New York). Photograph courtesy of the Morgan Library.

miniature showing Zeuxis and his models appears in a manuscript prepared for the French king Francis I (Figure 3). In a curious variation, another illuminator shows a befuddled Zeuxis carving a small sculpture of five women, all of whom pale (literally) in comparison with the personification of Nature as a comely young woman (Figure 4).⁴⁸ Clearly, Zeuxis's ability to discern among or improve upon the figures he observes is either unknown or irrelevant to the illuminator.

Perhaps in emulation of Jean de Meun, Geoffrey Chaucer likewise mentions Zeuxis in a passage on the incapacity of art to render beauty as it is seen in nature. The reference appears early in "The Physician's Tale":

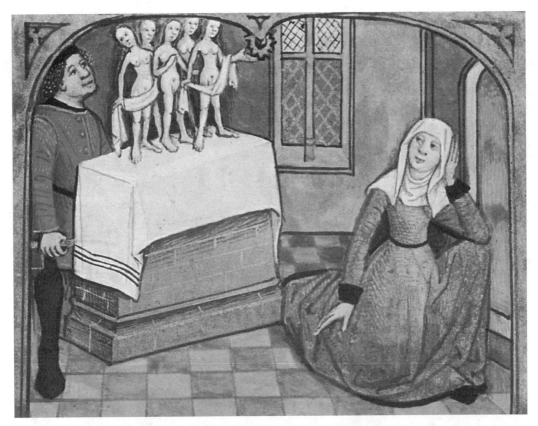

Figure 4. *Nature Better Than Zeuxis's Five Model Virgins,* from Guillaume de Lorris and Jean de Meun, *Romance of the Rose,* MS Douce 195, fol. 116v (vellum, late fifteenth century, Bodleian Library, Oxford). Photograph courtesy of the Bodleian Library.

Ther was, as telleth Titus Liuvius,
A knyght that called was Virginius . . .
 This knyght a doghter hadde by his wif:
No children hadde he mo in al his lif.
Fair was this mayde in excellent beautee
Abouen euery wight that man may see,
For nature hath with souereyn diligence
Yformed hir in so greet excellence
As thogh she wolde seyn: "Lo, I, nature,
Thus kan I forme and peynte a creature
Whan that me list. Who kan me countrefete?
Pigmalion noght, thogh he ay forge and bete
Or graue or peynte. For I dar wel seyn
Apelles, Zanzis sholde werche in veyn."⁴⁹

With the *Canterbury Tales* and the *Romance of the Rose* we find that medieval literature sustained Zeuxis's (that is, Zanzis's) legacy, at least among the educated of the fourteenth century.[50] The artist's association with the creation of physical beauty had not been forgotten even if the story's relationship to classical mimesis had lost its relevance. Only with the Renaissance, however, would both classical mimesis and, hence, the story of Zeuxis Selecting Models regain cultural prominence.

2 The Zeuxis Myth

Note that Zeuxis of Heraclea painted Helen. The painter Nicomachus was amazed at the picture and obviously admired it. Someone approached to ask him why he so admired the artistic quality. He replied: "You wouldn't have asked me if you had my eyes."

<div align="right">

☞ AELIAN, *HISTORICAL MISCELLANY*

</div>

And we should hardly call it uncanny when Pygmalion's beautiful statue comes to life.

<div align="right">

☞ SIGMUND FREUD, "THE UNCANNY"

</div>

CICERO'S *RHETORIC* AND PLINY'S *NATURAL HISTORY* preserve the earliest known versions of the legend of Zeuxis Selecting Models.[1] Their renditions differ slightly but interestingly. Cicero, writing in 84 BCE, dates the episode to "once upon a time"[2] but offers a precise locale: the town of Croton. A prosperous Greek settlement on the southeastern coast of Italy, Croton maintained a major sanctuary dedicated to Hera. Cicero explains that Zeuxis came from Heraclea to decorate the temple. During his stay in Croton, the artist asked whether he might include a portrait *(simulacrum)* of Helen of Troy among his paintings. The townspeople readily agreed to compensate the renowned artist for an additional painting. Zeuxis set to work, requesting "maidens of surpassing beauty" from whom he might choose a model. Curiously, the Crotoniats responded by taking the painter to the gymnasium, where a group of young men were exercising. "There are in our city the sisters of these men; you may get an idea of their beauty from these youths."[3] Zeuxis asked to see the reported beauties. A public decree was then issued, calling the maidens to a place where the painter

could examine them. "He chose five because he did not think all the qualities which he sought to combine in a portrayal of beauty could be found in one person, because in no single case has Nature made anything perfect and finished in every part."[4] Upon concluding the tale, Cicero explains that Zeuxis Selecting Models illustrates his own approach to teaching rhetoric, the proper subject of his text.[5]

Pliny, writing in the middle of the first century CE, delivers a more succinct narrative. He also asserts greater chronological precision: Zeuxis was born, Pliny writes, in 397 BCE. The painter's career, according to this account, would therefore have flourished in the early to middle fourth century BCE.[6] Pliny also sets the scene elsewhere. The Sicilian town of Agrigentum, rather than Croton, is the site of Zeuxis's aesthetic triumph. Pliny states that the painting was commissioned at "the public cost" for "the Temple of Lacinian Hera."[7] This statement does not jibe with Pliny's chronology, however, since Agrigentum was sacked in 406 BCE by the Carthaginians. Not until 338 was the city refounded by Timoleon. It seems unlikely that the inhabitants of Agrigentum would have had the wherewithal to sponsor such a project by a famous—and, as Pliny claims, famously expensive—painter during the first half of the fourth century.[8] Perhaps Agrigentum's prominence during Pliny's own lifetime led him to bestow upon it this cultural distinction.[9] Pliny's version is further distinguished from Cicero's in its reticence about the subject of the painting, described only as "a picture" *(tabulum)*.[10] But Pliny makes it clear that the painting depicted a nude woman when he explains that Zeuxis "held an inspection of maidens of the place paraded naked and chose five, for the purpose of reproducing in the picture the most admirable points in the form of each."[11]

The differences between Cicero's and Pliny's narratives derive from any number of causes: the authors' relative remove from the era in which Zeuxis purportedly lived; the inconsistency of their sources; the dissimilar purposes of their texts; even the vagaries of their own inclinations. I am not interested in determining which author offers the most accurate version. Instead, I aim to uncover the significance of the Zeuxis myth for the history of Western art. An analysis of the myth's structure and function is an essential step toward this understanding.

Zeuxis Selecting Models cannot be understood fully without taking into account its status as a myth. Never haphazard or accidental, mythic narratives are structured so as to convey—usually imperceptibly—social codes as well as shared experiences and perceptions. Because of the multifold character of myth as a creative as well as a psychological, philosophical, and political manifestation, mythography has been taken up by scholars from a

range of disciplines. Anthropologists, literary critics, historians, theologians, philologists, sociologists, and psychoanalysts have at one time or another attempted to codify the practice of mythography.[12]

Rather than aver allegiance to any one mythographic approach, my study of Zeuxis Selecting Models is that of an unapologetic methodological magpie. Myths, like all forms of representation, offer oblique or metaphorical access to cultural truths. What is more, the message of a myth is inseparable from its medium. For this reason, myths require internal as well as external analyses. Internal (hermeneutic or structural) analysis attempts to reveal the discrete workings of a particular myth. This involves synchronic study: What forms does the myth take? How does it cohere? How does it impart meaning? On the other hand, external (social or psychological) analysis explores the function and significance of myth for culture and the individual: How does the myth change through time? How is it transmitted across cultures?

This chapter engages in an internal analysis of Zeuxis Selecting Models. By outlining its form as well as its classical sources, I hope to show that this myth operates as an uncanny narrative. Subsequent chapters engage the myth's external life as it changes through time and across Western cultures.

THE LANGUE OF ZEUXIS

The similarities and differences inherent in Cicero's and Pliny's accounts invite a preliminary analysis at the level of narrative structure. Structuralism offers a means of organizing and comparing these moments of narrative harmony and discord. "Structuralism" refers here specifically to methods derived from the work of anthropologist Claude Lévi-Strauss. Borrowing from the linguistic theories of Emile Benveniste and Ferdinand de Saussure, Lévi-Strauss applied to myth the approach used by structuralists to study language. Saussure and Benveniste held that language consists of two tiers, langue and parole. "Langue" refers to the grammar of a language, its internal rules and logic. "Parole" refers to speech utterances, that is to say, to language as it is used for social exchange.[13] Parole is more flexible than langue, changing in response to the needs of individuals and cultures. Lévi-Strauss argued that myth is, fundamentally, the language of a culture. As such, myth invites study at the level of both langue and parole.

The study of myth was not, of course, introduced to cultural anthropology by Lévi-Strauss. Mythography had long been part of anthropological research. But by refusing to divorce the social expression of a myth from its deep structure, Lévi-Strauss's method added a new dimension to

mythography. Like the linguists whose theories he adapted, Lévi-Strauss sought to isolate the langue, that is, the internal, perhaps even universal, workings of myth. This pursuit led Lévi-Strauss to engage in broad cross-cultural comparisons, too often resulting in generalizations about the needs and significance of all human cultures. Despite the shortcomings of Lévi-Strauss's method for anthropology, it does, I think, offer a useful means for organizing the formal and social operation of Zeuxis Selecting Models. Because it derives from linguistics, his approach is attentive to the meaning and function of signs. Semiotics acknowledges that all social experience (as opposed to somatic experience) is filtered through representation. Such a theoretical presumption is particularly beneficial in the case of the Zeuxis myth because it is a *representation about representation.* A theory that responds to the special properties of signs is essential for any study of myths about artists or the history of art. Structuralism has the capacity to expose the mechanics of the story of Zeuxis Selecting Models, revealing its status and behavior as representation. Formal analysis is, then, a necessary first step toward discerning the mythic character of Zeuxis Selecting Models.[14]

The two earliest sources for the legend have enough in common to provide a glimpse of the story's deep structure. Likewise, the differences between Cicero's and Pliny's versions offer insight into the possible mythic significance of the story. In both versions, the identity of the artist remains stable.[15] In both, he has traveled to a foreign town to paint an image of ideal female beauty for a Hera (Juno) temple. What is more, both towns are provincial, meaning that they enjoy a liminal status in relation to the center as well as to the frontiers of (Greek) civilization. Neither entirely Greek nor completely foreign, Croton and Agrigentum provide the story with a setting at once familiar and strange. The towns in which the authors place the scene also have in common renown for their prosperity: Croton in Greek times, Agrigentum during the Roman Republic and the early Roman Empire. Finally, the stories have in common the resolution of Zeuxis's aesthetic dilemma: The artist views a group of nude figures before selecting and combining the best features of five different women.

The differences between the two versions include the precise locale (Cicero's Croton versus Pliny's Agrigentum) and the specific identity of the woman Zeuxis seeks to portray in the painting. Cicero's explicit mention of Helen of Troy is, I think, as significant a detail as Pliny's failure to specify the subject of the painting. Another telling difference between their versions involves Cicero's assertion that Zeuxis, at the start of his creative process, examines *male* nudes as opposed to nude maidens.

AN UNCANNY NARRATIVE

The basic narrative components of this story—the strangeness of the locale, the persistent deferral of female nudity (supplanted either by nude men or by selected fragments of female bodies), the oblation to Hera (a goddess associated with childbearing and betrothal), and the eventual aesthetic triumph achieved through the subdivision and assemblage of women's bodies—are suggestive of the uncanny. In structure and theme, Zeuxis Selecting Models accords provocatively with Freud's account of this phenomenon. Seeking to explain a prevalent class of neurotic symptoms, Freud published "Das Unheimliche" ("The Uncanny") in 1919.[16] The essay describes and attempts to explicate a common sensation of psychic disorientation. Freud's discussion begins with a linguistic analysis of the term *"unheimlich,"* which he shows oscillates between two referents: the familiar and the unfamiliar, or, more literally, the home-like and the not-home-like. The tension inherent in the German usage of the word *"unheimlich"* distinguishes it from its counterparts in other languages, such as its nearest English equivalent, "uncanny."[17]

Freud goes on to illustrate what is meant by uncanny. He first cites E. T. A. Hoffmann's story "The Sandman" as delivering a particularly good evocation of the uncanny. In this story, the young protagonist, Nathanael, falls passionately in love with a woman he spies in a neighboring apartment. The story turns on Nathanael's failure to recognize that the woman he loves is actually a mannequin. Freud supplements this fictional instance of the uncanny with examples of uncanny encounters in real life, including his own experience during a visit to an unfamiliar town:

> As I was walking, one hot summer afternoon, through the deserted streets of a provincial town in Italy which was unknown to me, I found myself in a quarter of whose character I could not long remain in doubt. Nothing but painted women were to be seen at the windows of the small houses, and I hastened to leave the narrow street at the next turning. But after having wandered about for a time without enquiring my way, I suddenly found myself back in the same street. . . . I hurried away once more, only to arrive by another detour at the same place yet a third time. Now, however, a feeling overcame me which I can only describe as uncanny.[18]

Freud's own uneasiness at finding himself in the red-light district combines the disorientation of being in a strange town with the excess of female

sexuality visible through the brothel windows. And rather than referring to the prostitutes directly, he chooses an oblique or metaphorical—indeed, fragmented—means of conveying their identity: painted women.[19] This euphemism suggests the visibility as well as the invisibility of the women: They are highlighted by their makeup, which also serves to veil or defer the body. Interestingly, Freud makes a point of identifying the place as a "provincial town in Italy."[20] Just as in the Zeuxis myth, the provincial locale allows the scene to unfold in a place that signifies concomitantly civilization and wilderness. In this way, a provincial setting seems to enhance the uncanny sensation.

But what sort of repression manifests itself through the uncanny? Freud argues that there are two classes of repressed material that can produce the uncanny. The first class includes "infantile complexes which have been repressed and are once more revived by some impression." Among these is the castration complex. Freud associates the uncanny sensation reported when individuals confront "dismembered limbs, a severed head, a hand cut off at the wrist" as a response to repressed castration anxiety. Most often, though, an experience of the uncanny coincides with a reminder of one's own mortality via the sight of dead bodies or some encounter with death. For this reason, Freud finds it compelling that "it often happens that neurotic men declare that they feel there is something uncanny about the female genital organs." Freud links this phenomenon to castration anxiety as well as to fears of death. Not only does the vagina signify the absence of a penis, but it also "is the entrance to the former *Heim* [home] of all human beings."[21] With the evocation of birth comes the reminder of death.

The second class of repressed memories consists of "primitive beliefs . . . that . . . seem once more to be confirmed." By "primitive beliefs," Freud is referring to superstitions based on "animism" or the "omnipotence of thoughts."[22] To illustrate these, Freud cites the tendency of one neurotic patient, "Rat Man," to ascribe to himself the capacity to make real his secret desires. Rat Man found evidence of his abilities when, for instance, a man whose death he had wished for in a moment of anger actually died two weeks after the secret wish was made. Another example offered by Freud involves repeated encounters of a certain number or name during a brief span.

> If we come across the number sixty-two several times in a
> single day, or if we begin to note that everything which has
> a number—addresses, hotel rooms, compartments in railway
> trains—invariably has the same one . . . we do feel this to be

uncanny. And unless a man is utterly hardened and proof
against the lure of superstition, he will attempt to ascribe
a secret meaning to this . . . number.[23]

No matter what repressed memories may underlie the uncanny, this
sensation occurs in response to some predictable triggers. As already men-
tioned, these incitements include encounters with death, dead bodies, or
parts of bodies; repetitive occurrences of names, numbers, or other symbols;
and evidence of supernatural phenomena or the omnipotence of thoughts.[24]
Finally, there is another class of triggers briefly discussed by Freud. These
involve eyes or vision. Faulty vision as well as lost, injured, or threatened
sight may be experienced as uncanny. Hoffmann's "The Sandman" repeated-
ly invokes this vehicle of the uncanny. As a child, the protagonist, Nathanael,
fears losing his vision to the Sandman, whose offspring "have crooked beaks
like owls with which they pick up the eyes of human children." Later, using a
small telescope, he peers into a neighbor's house and sees a mannequin that
he mistakes for a beautiful woman. While observing the enchanting automa-
ton through his glass, Nathanael witnesses what he believes to be a horrible
attack on the woman as her eyes are torn out by his oculist. Nathanael finally
leaps from a tower to his death crying, "Ah, nice-a eyes, nice-a eyes!"[25]
 Freud associates the preoccupation with sight in "The Sandman" with
the castration complex. "A study of dreams, phantasies and myths has
taught us that anxiety about one's eyes, the fear of going blind, is often
enough a substitute for the dread of being castrated."[26] But what Freud fails
to address directly is the necessary link between vision and all his instances
of the uncanny. Freud's essay is shot through with references to vision and
metaphors of sight.[27] His personal accounts of uncanny experiences, for in-
stance, describe his disorientation at mistaking his reflection in a mirror
for another man or his disorientation at seeing prostitutes during his un-
canny walk through an unfamiliar Italian town. Freud also describes the act
of seeing one's double (doppelgänger) as another uncanny experience. Even
his examples of repetitive events involve seeing a number, name, or symbol
repeatedly. Freud's discussion of the evil eye as a manifestation of "omnipo-
tence of thoughts" fails to give special notice to the fact that the uncanny is
being controlled or transmitted here through vision.[28] It is an emphatically
visual phenomenon. The line he draws (perhaps unconsciously) connect-
ing vision, the uncanny, and castration (or death) holds promise as a means
to understanding the uncanny purpose of the Zeuxis myth. If the uncanny
is propelled through visual experiences, perhaps some forms of visual rep-
resentation can produce uncanny sensations. Mimesis clearly seems to be

implicated in Freud's analysis. Nathanael's uncanny experience hinges upon seeing a representation that appears to be not only real but ideal. Because classical mimesis fosters intense naturalism as well as the perfection of nature's flaws, its implication in the uncanny would seem indubitable.

Indeed, Freud points to a causal relationship between mimetic representation and the uncanny. Nearing the end of his paper, he adds,

> There is one more point of general application which I should like to add. . . . This is that an uncanny effect is often and easily produced when the distinction between imagination and reality is effaced, as when something that we have hitherto regarded as imaginary appears before us in reality, or when a symbol takes over the full functions of the thing it symbolizes, and so on.[29]

The possibility of mistaking a mannequin or doll for a human (as Nathanael does in Hoffman's "The Sandman") or of confusing one's own reflected image with that of a stranger are among the examples Freud uses to illustrate this momentary confusion. The uncanny sensation occurs at the moment the error is recognized. In this split second, the familiar commingles with the unfamiliar and the imagined threatens to displace the real. Interestingly, this is precisely the phenomenon that occurs in another legend about Zeuxis.

ZEUXIS'S GRAPES

Recorded by Pliny, this story explains how the rival painters Zeuxis and Parrhasius sought to determine once and for all whose skills were superior.[30] The pair agreed to a competition in which each artist would execute a wall painting and then share the task of judging their entries. Zeuxis showed his painting first. The bunch of grapes that Zeuxis had depicted was so lifelike that birds attempted to dine on the luscious-seeming fruit. Assuming that he had triumphed, Zeuxis asked Parrhasius to remove the drape and show his painting. Parrhasius explained that the drape was, in fact, his painting. Zeuxis immediately acknowledged his defeat: "Whereas he had deceived birds Parrhasius had deceived him, an artist."[31]

This amusing tale of an artist's deflated hubris revolves around mistaking representation for reality, first on the part of the birds and then on the part of Zeuxis himself. Interestingly, the uncanny phenomenon of birds pecking at imaginary grapes is given little emphasis. Pliny's account instead stresses Zeuxis's misapprehension, but even then the confounding of reality

and representation receives only passing notice. Instead, it is Zeuxis's em-
barrassment and concession of defeat that propels the narrative. Why does
the narrative elide these uncanny moments? A similar deferral takes place
in Pliny's record of Zeuxis's disappointment in his painting, *Child Carrying
Grapes*. Again, this story makes mention of birds pecking at the realistic
but illusory grapes. And Zeuxis is once more disheartened: "I have painted
the grapes better than I have painted the child, and if I had made a success
of that as well, the birds would inevitably have been afraid of it."[32] Pliny's
prose once more gives narrative precedence to Zeuxis's embarrassment
rather than to the astonishing behavior of the birds.

Perhaps Freud's account of the uncanny can help explain Pliny's non-
chalance. The history of the West's uncomfortable relationship with mi-
metic art can be traced to the fifth century BCE. Plato asserted a clear and
unyielding distinction between form and image *(eikon)*. Before Plato's time,
Western culture exhibited no fear of confusing divine or ideal form with
degraded matter. Alain Besançon, in his unparalleled study of iconoclasm,
The Forbidden Image, observes that "the truth is that the [archaic and clas-
sical] Greek god was represented, was the most represented of all the gods,
so much so that he was not really distinguishable from his representation."[33]
Plato, however, emphasizes the necessary divergence of image and model.
Representation, Plato insists, can never equal the thing it represents. To
claim otherwise would be idiotic, spiritually base, and even dangerous.
Plato illustrates his meaning in *Cratylus* by conjuring two men: "One of
them shall be Cratylus, and the other the image of Cratylus."[34] No matter
how exact or lifelike the copy, it maintains its status as an image *(eikon)*. To
clarify this, Socrates states that "a number 10 is exactly the number 10: if
one adds to it or takes something away from it, it immediately becomes a
different number."[35] But images, Socrates explains, require a different stan-
dard. Manipulating, enhancing, or modifying an image does not change its
status as an image.

The story of Zeuxis's grapes reinforces this lesson. Representation—no
matter how closely it approximates reality—remains a falsehood. To mis-
take the image for true form results in disappointment for the bird and hu-
miliation for Zeuxis. What Pliny's story and Plato's examples show is the
postclassical need for the absolute separation of image from ideal (Plato's
forms). To refuse this distinction would be to refute the existence of the
ideal, that is, the divine. Toward what sort of good or truth could human
civilization aspire, Plato asks, without universal ideals? Images are neces-
sarily subject to human intervention. Thus images, as opposed to Platonic

ideals, can be manipulated for sinister or selfish purposes by "imposters." Besançon writes that

> Plato comes to the definition of the imposter, who imitates the wise man without having his knowledge, who fabricates fraudulent "marvels." This is the Sophist. In that progression, the artist is only one degree away from the Sophist and the tyrant: his works have a false beauty; one cannot even say whether they are or are not; they are objects, not of knowledge, but of opinion.[36]

With Plato, the West enters its wary—and still-unfolding—negotiation between iconophilic and iconoclastic impulses. Classical mimesis, of course, instigated this process. And mimesis continues to propel concerns over the always-imminent usurpation of the ideal as well as the real by representation.[37]

Hellenistic Greek and Roman society would increasingly guard the distinction between images and reality (particularly in relation to the divine), and the rise of Christianity only widened this divide. Of course, Christian insistence upon the division between divine essence and material existence reflects Jewish theology as much as late antique philosophy on this point. At any rate, by the time Pliny recorded the story of Zeuxis's contest with Parrhasius, the capacity of representation to defraud, if not endanger, the exalted status of divine or perfect form had become a pressing philosophical concern, and even a cultural and political one. Pliny's narrative quickly passes over—represses, really—these concerns, which, like all uncanny triggers, serve as reminders of human fragility and inevitable mortality. The strict division between the divine and material presence cannot help but highlight the latter's eventual degradation.

The legend of Zeuxis Selecting Models also encodes a lesson about the uncanny nature of classical mimesis. Called to a provincial town, the painter proposes to realize ideal female form within a Hera temple. The artist's decision to make manifest the ideal woman's body is significant, of course, because of the association between the female body and the uncanny. Its placement within a Hera temple only underscores this point: It "is the entrance to the former *Heim* of all human beings." The proposed image, like the provincial temple it will occupy, vacillates between the familiar and the unfamiliar. Furthermore, Zeuxis cannot work without a model. In other words, he requires a stable referent to perceived reality. But he realizes that a real model cannot serve as a bridge to the ideal. This is the crux of the

narrative; it is the moment Zeuxis finds himself *en abyme*. The painter cannot *conceive* of ideal form. If he could, no model would be necessary. At the same time, he searches but cannot confirm the existence of the ideal in the world he perceives. This leads to a crisis: How can the ideal exist if it can neither be seen nor imagined? And, as Plato explains, the nonexistence of the ideal would eliminate the possibility of transcendent experience. Without transcendence—spiritual, aesthetic, or moral—there would be only the abyss. This is the realization that Zeuxis Selecting Models sublimates. At the moment of Zeuxis's crisis, the narrative offers a series of fetishistic distractions: nude male gymnasts, fragments of women's bodies, and the assurance of a resolution that restores the body to an ideal whole. Mimetic art, in this narrative, promises mastery but sows doubt.

HELEN'S UNCANNY BEAUTY

Uncanny narratives are structured accounts that employ one or more of the tokens described by Freud as indicative of a repressed complex or superstition. These tokens include the simultaneous sensation of familiarity and unfamiliarity; an encounter with dead bodies, severed heads or limbs, female genitalia, damaged or threatened vision, or a doppelgänger; and the inability to distinguish representation from reality. The legend of Zeuxis Selecting Models engages a number of these uncanny traits, but there is a final feature of the myth that requires attention: the subject of the painting in Cicero's account (lost or repressed in Pliny's).

Cicero asserts that Zeuxis's painting depicted Helen of Troy. His specificity on this point deserves, I think, some consideration. Why Helen? She was, of course, renowned for her beauty. What is more, Helen's involvement in the story of Troy was triggered by an act of aesthetic discernment. Paris, like Zeuxis, engaged in a process of selection. Furthermore, the task of painting Helen would pose a remarkable challenge: How, exactly, would an artist signify ideal beauty? These are, unquestionably, the aesthetic impulses that propel the Zeuxis narrative. But Helen's beauty does not entirely explain her role in this story. The challenge of giving physical definition to ideal beauty could have been just as (perhaps even more) convincingly illustrated by making Aphrodite or another divine being the subject of Zeuxis's painting.

Helen's significance for the Zeuxis legend is not, of course, limited to her striking physical appearance. In fact, her beauty is of an ambiguous nature. "The face that launch'd a thousand ships"[38] is an epithet that speaks of inspiration as well as destruction. Helen personifies an uncanny duplicity. In his typological study of Aphrodite, Paul Friedrich argues that Helen is a

mythic cognate of the goddess.[39] One of Aphrodite's favorites, Helen embodies the attributes associated with her divine patroness: beauty, love, and sexuality. Of course, Helen is also linked to Aphrodite via the ill-fated judgment of Paris. But Friedrich also points out that Helen signifies other qualities not usually connected with Aphrodite: war and pollution or defilement. "In Greek culture, sexuality in violation of the code of honor was as polluting as filth or death; and . . . much of the epics involves a system of exchange between sex and death."[40] In Homeric legend, the adulterers Helen and Clytemnestra, as well as the disloyal servants of Odysseus, are all compared with dogs. And dogs, Friedrich argues, are "a master symbol of pollution."[41] Helen is repeatedly referred to as a dog.[42] An animal that eats the dead as well as its own vomit, the dog signals the abject (and hence provokes an uncanny experience) in mythic discourse.

Helen's connection to organized as well as wanton violence is not limited to the Trojan War. Undoubtedly, Helen's identity as a Spartan queen would also have carried associations with violence and destruction for Zeuxis's contemporaries and later biographers. As head of the Peloponnesian League, Sparta symbolized the humiliating defeat of Athens. Thus, Helen's Spartan origin gives an additionally threatening layer of meaning to her already-complex status as an uncanny sign.[43] That late fifth-century Athenians were aware of having a symbolic kinship with Homer's Trojans as common victims of Spartan aggression emerges in the war plays of Euripides. *Andromache, Hecuba*, and *The Women of Troy* all document the suffering of sympathetic Trojan heroines, giving Greek audiences a model for their grief while pointing to Sparta as a common enemy.

Two Euripidean plays give particular attention to the uncanniness of Helen. She is an important character in *The Women of Troy* (415 BCE) and, of course, in the eponymous drama, *Helen* (412 BCE). Both plays feature passages detailing how her irresistible beauty and sexuality lead to war, mutilation, and death. This link becomes especially clear in *The Women of Troy* when Euripides has Priam's widow, Hecuba, warn the victorious Menelaus not to trust his errant wife:

> HECUBA: If you mean to kill your wife, Menelaus,
> You'll have my support. But don't see her,
> Don't risk becoming a slave
> Of your lust again. With one look
> She makes men's eyes her prisoners, she sacks
> Whole cities, burns houses to the ground
> With that bewitching smile![44]

Hecuba's plea not only confirms Helen's dual significance as exemplar of beauty and harbinger of death but also implicates sight as the means through which both roles are enacted. Euripides pursues both themes further in *Helen*. Propelled by irony and dark humor, *Helen* offers an alternative account of the heroine's role in the Trojan War. According to this version, Helen never went to Troy with Paris. Instead, the war is fought over a doppelgänger: a phantom of Helen produced by Hera, furious over Paris-Alexander's judgment in favor of Aphrodite. The envious Hera resolves to destroy Paris and his fellow Trojans while at the same time depriving him of the prize promised by Aphrodite. Helen spends the entire decade in Egypt. The exiled beauty explicates at the start of the play:

> HELEN: Hera, of course, was furious that she hadn't won
> And put the other goddesses in their place,
> So she turned Alexander's relish at having me
> In his bed, into thin air—literally.
> Because it wasn't in fact me that she gave to him at all,
> But a walking talking living doll,
> A non-existent image made in my likeness.[45]

Helen later complains:

> It's Hera's fault,
> At least half of it. The other main cause,
> Is, I'm afraid, my ravishing beauty.
> I sometimes wish I could simply have been
> Rubbed out, like a drawing, and sketched again
> From scratch, in a much uglier version
> Instead of this masterpiece.[46]

Helen compares herself to a work of art. Indeed, her double is pure artifice, evoking in Menelaus an uncanny sensation based on successive visual encounters with both Helens:

> MENELAUS: I don't think I'm mad. I must be seeing things!
> HELEN: Now look at me. Don't you feel I'm your wife?
> MENELAUS: Physically, you're her double. It's uncanny.[47]

This explanation of Helen's guiltless connection to the Trojan War is traced by Plato to the *Palinode* written by the sixth-century poet Stesichorus.

In *Phaedrus,* Plato has Socrates explain that Stesichorus had been rendered blind by Helen (deified along with her brothers, the Dioscuri, according to some myths). The divine Helen took offense at Stesichorus's uncomplimentary and presumably untruthful songs about her dishonorable behavior. In recompense to the goddess, Stesichorus composed a panegyric intended to set the record straight. This recantation of his earlier slander (called descriptively his *Palinode,* or "song re-sung") identifies an *eidolon* (ghost, shadow, image) of Helen, rather than Helen herself, as the cause of so much Trojan and Spartan suffering. According to Plato's Socrates, the *Palinode* pleases Helen enough that she restores Stesichorus's sight.

Norman Austin has traced the textual history and significance of the tradition positing two Helens. It is, Austin explains, a consequence of Helen's uncanny behavior in all versions of the Trojan myth. "The confusion that arises when Helen's honor or shame is the issue has left uncanny traces of itself in several manuscripts . . . that allude to the *Palinode.*" This uncanniness is, Austin argues, a consequence of Helen's position as being and not-being. He writes that "Helen is strangely both a goddess and a human at the same time and therefore occupies both circles, of Meaning and Being." In other words, Helen is simultaneously Platonic form and matter, divine and degraded, life and death. But—and this is crucial—she cannot be perceived as both in the same instance. Her significance therefore shifts continuously, producing a disorienting rather than stabilizing mythic sign. "The *eidolon,* whether taken as a revision or as an intriguing interpretation of the traditional myth, is an uncanny expression of the ambivalences continuously at work in the construction of the Helen myth."[48]

The sensation of encountering one's double is discussed by Freud as a prevalent manifestation of the uncanny. In his account Freud defers to Otto Rank's analysis of the doppelgänger:[49]

> [Rank] has gone into the connections which the "double" has with reflections in mirrors, with shadows, with guardian spirits, with the belief in the soul and with the fear of death. . . . This invention of doubling as a preservation against extinction has its counterpart in the language of dreams, which is fond of representing castration by a doubling or multiplication of a genital symbol. The same desire led the Ancient Egyptians to develop the art of making images of the dead in lasting materials. Such ideas, however, have sprung from the soil of unbounded self-love, from the primary narcissism which dominates the mind of the child and of primitive

man. But when this stage has been surmounted, the "double" reverses its aspect. From having been an assurance of immortality, it becomes the uncanny harbinger of death.[50]

In this way, Stesichorus's attempt to recast Helen as an innocent fails insofar as he is unable to divest Helen of her uncanny significance. By invoking a doppelgänger, the poet reveals (precisely through his attempt to disguise) Helen's embodiment of threat. The device of a doppelgänger produces a symptom or trace of the cultural memory that Stesichorus's *Palinode* attempts to repress.

The *Ecomium of Helen,* written by the rhetorician Gorgias as an exercise in persuasive speech in the late fifth or early fourth century BCE, marks another attempt to restore her reputation.[51] The long-standing characterization of Helen as a deceitful wife and the cause of the Trojan War is here challenged by Gorgias via four arguments justifying her actions. The fourth argument puts forth the possibility that Helen succumbed helplessly to love. Love, Gorgias explains, is a kind of instinct: It supersedes rational thought. Consequently, those under the thrall of love cannot be held accountable for their decisions or behavior. Gorgias explains this phenomenon by comparing it to the influence of sight:

> Things that we see do not have the nature which we wish them
> to have but the nature which each of them actually has; and
> by seeing them the mind is moulded in its character too. For
> instance, when the sight surveys hostile persons and a hostile
> array of bronze and iron for hostile armament . . . it is alarmed,
> and it alarms the mind, so that often people flee in panic when
> some danger is imminent as if it were present. So strong is the
> disregard of law which is implanted in them because of the
> fear caused by the sight; when it befalls, it makes them dis-
> regard both the honour which is awarded for obeying the law
> and the benefit which accrues for doing right. . . . And many
> have fallen into groundless distress and terrible illness and
> incurable madness; so deeply does sight engrave on the mind
> images of actions that are seen.[52]

Sight is more persuasive, more immediately felt than other senses. It shapes thoughts and perceptions, beliefs and behavior. Just as Helen seduces through her beauty, she too is vulnerable to corruption via the visual.

Among modern portrayals of Helen, Goethe's account in part 2 of his

Faust refers briefly to the tradition of the *eidolon* before reaffirming her un-
canny significance. In part 2 of the drama, Faust insists that Mephistopheles
enable him to conjure the shades of Helen and Paris as entertainment for
the emperor. Mephistopheles is at first reluctant. Retrieval of the legendary
lovers requires a visit to the goddesses in Hades. "To talk about them makes
me feel uneasy," Mephistopheles says, noting, "They're called the Mothers!"
Faust replies, "The Mothers! Why, it sounds so queer, the word."[53] Later,
Faust adds, "Mothers! That word's like a blow!"[54] Goethe links the frighten-
ing name with the uncanny a few lines later, when Faust discourses upon
his anxiety over "Mothers" before the puzzled Mephistopheles:

> MEPHISTOPHELES: Are you so narrow, hide-bound that you fear
> A new thing? Only want to hear
> Things heard before? Really, there's no need,
> Whatever comes, for you to feel dismayed,
> Who are so used to what's strange and queer.
> FAUST: That's not for me: a soul that's frozen, shut;
> Awe and wonderment are a man's best part.
> They cost one, in the world, those sentiments,
> Yes seized by them, man feels what's great,
> immense.[55]

Goethe's repetition of the word—and its provocation of dread—links the
uncanny with the name "Mother." Like Freud with his notion of the un-
canny, Goethe imparts this sensation to female triggers.

Regardless of his initial anxiety, Faust resolves to go and retrieve Helen
and Paris. His journey is successful and a vaporous apparition appears
briefly before Faust, Mephistopheles, and the assembled court. Upon see-
ing Helen, Faust is enraptured:

> Is what I see a thing seen with the eyes,
> Or beauty's very fount and origin
> Outpouring from the depths of mind within?[56]

He is consumed with her and insists that Mephistopheles help him find
her. But before showing how Faust achieves his desire, Goethe inserts act 2,
which tells of the generation of a Homunculus. Paracelsus's legendary lab
experiment is here enacted, and the resulting creation becomes part of an
unnatural trinity. Faust's attainment of Helen in act 3 also comes through a
process of deviant generation. Through one of the devil's spells, Faust claims

Helen by stepping back into history disguised as her rescuer. Helen has returned to Sparta after the Trojan War. Unsure of Menelaus's plans for her, Helen returns to their palace to await his judgment. There, an old servant, Phorkyas (actually the disguised Mephistopheles), taunts and teases her.

> But what they say is, two of you were seen,
> One in Ilium, also one in Egypt.[57]

Helen seems not to understand this comment, but the allusion grounds Goethe's account in the classical tradition while hinting at her uncanny doppelgänger.

Phorkyas then goes on to convince Helen that Menelaus is preparing to sacrifice her as a final gesture of recompense for the war fought in her name. Desperate, Helen agrees to go with Phorkyas to another castle, where she can take refuge with another king. The castle is an illusion, and the nobleman who awaits her is Faust. Mephistopheles arranges for Helen and Faust to live in Arcadia, where they enjoy an enchanted life and raise a son, Euphorion. Once fully grown, though, Euphorion declares that he is made for adventure and conquest and must leave Arcadia. He attempts to fly away on wings of fabric in order to join the action outside their paradisiacal home. But, like Icarus, he plunges to his death. Unable to bear the loss, Helen disappears to join him in Hades. Thus Helen, like the Homunculus, propels an illusion that reveals itself to be uncanny insofar as it is found ultimately to signify death. And her association with a dangerous doppelgänger only furthers this uncanny potential.

WHITE-ARMED HERA

A final question must be asked with regard to Helen's role in the Zeuxis narrative: Why would an image of Helen be placed in a temple dedicated to Hera? What relationship does Helen have to Olympus's chief goddess? These questions cannot be addressed without first considering more generally the function of painted portraits, or *simulacra,* inside temples. Numerous references to narrative scenes—or what art historians today would call "history paintings"—exist in antique sources. Strabo, for instance, locates a *Sack of Troy* as well as a *Birth of Athena* in the Artemis temple in Alpheionia near Olympus. In the same temple, Athenaeus claims, there is a scene showing Poseidon offering tuna to Zeus. Homeric scenes painted by Polygnotos adorned part of the sanctuary of Apollo at Delphi, according to Pausanias, who also describes a *Marriage of the Daughters of Leukippos*

by the same painter as well as a representation of the *Argonauts* by Mikos at the precinct of the Dioscuri at Athens. Pausanias further describes paintings on the Athenian Acropolis: In one of the rooms of the Propylaia are more Homeric subjects.[58] But what of *simulacra*?

Pliny mentions the existence of individual likenesses in temples during Zeuxis's purported lifetime (about the mid-fourth century BCE), but he limits his discussion to their aesthetic significance and does not address any social or religious purpose. He similarly describes how Lucius Mummius, in the second century BCE, took as booty from the defeated Corinthians a painting of "Father Liber or Dionysus by Aristides" and then placed the image in the shrine of Ceres. Moving to Cicero's time, Pliny states that "it was the Dictator Caesar who gave outstanding public importance to pictures by dedicating paintings of Ajax and Medea in front of the temple of Venus Genetrix."[59] This confirms that paintings suggestive of likenesses could be seen in temples during Cicero's lifetime. But the exact function of these portrait-like images is suggested elsewhere in Pliny's text:

> The existence of a strong passion for portraits in former days is evidenced by Atticus the friend of Cicero in the volume he published on the subject and by the most benevolent invention of Marcus Varro, who actually by some means inserted in a prolific output of volumes portraits of seven hundred famous people, not allowing their likenesses to disappear or the lapse of ages to prevail against immortality in men. Herein Varro was the inventor of a benefit that even the gods might envy, since he not only bestowed immortality but despatched it all over the world, enabling his subjects to be ubiquitous, like the gods. This was a service Varro rendered to strangers.[60]

The use of portraiture—or *simulacra*—to overcome mortality links the *simulacrum* (or *eikon*) of Helen with the doppelgänger (or *eidolon*) of Freud's uncanny in that both serve to defer a confrontation with death. But still the question persists: Why place an image of Helen in Hera's sanctuary? Hera's main duties in the Greek and Roman pantheon involved protecting women during marriage and childbirth. Helen had been married (from one to three times, depending on the source) and had given birth to a daughter, Hermione. But this hardly seems to justify her appearance in a Hera temple. The connection between these figures must be sought elsewhere, perhaps in other narratives.

Helen and Hera are importantly linked in the Homeric epics. Hera's

indignant fury following the judgment of Paris leads her to undermine Aphrodite's plan to reward Paris with Helen. The jealous goddess accomplishes this by supporting the Greeks in their war to reclaim Helen. As already mentioned, Stesichorus and some later writers show Hera achieving her ends by creating an *eidolon* of Helen. Either way, Hera facilitates the bloodletting conducted in Helen's name. The women are, in fact, mirror reflections of each other. As goddess of matrimony and domestic arts, Hera stands in opposition to the broken marital vows and wanton sexuality of Helen (or her double). Just as the *eidolon* of Helen serves as a shadow of the real Helen, Helen serves as an inverted reflection of Hera.

Even their Homeric epithets emphasize this mirror relationship: "Helen of the white arms" and "the goddess of the white arms, Hera." [61] This, of course, is not the only instance of shared epithets in the Homeric cycles. But like all shared epithets, this repetition serves subtly to highlight connections between characters. As a sign of beauty, white arms link confinement to feminine beauty.[62] The white arms of a privileged and dutifully house-bound wife contrast with the tanned arms of a woman who must labor outside the home. In fact, when the epithet is used to describe Aphrodite, it is in the context of her maternal protection of Aeneas: "And now Aeneas, king of men, would have perished then and there, had not his mother . . . thrown her two white arms about the body of her dear son."[63] Likewise, its appearance in connection with Andromache—the last of the four women to whom the epithet is attached—underscores the association between "white-armed" and domestic virtue.[64] In this way, Helen is linked rhetorically to signs of feminine domesticity and maternity. This serves to heighten both her similarity to and her difference from this feminine ideal. Once again, this doubling reveals the uncanny significance of Helen, who at once conveys domestic security and shattering violence.

Taken together, the mythemes, or discrete units of meaning, embedded within the legend of Zeuxis Selecting Models articulate an uncanny narrative. Because Freud links uncanny sensations to an *individual's* brief—and subconscious—psychic awareness of horror, his theory cannot adequately account for the uncanny purpose of the Zeuxis myth. Instead, the notion of a cultural uncanny must be enlisted. As discussed in the introduction, Ned Lukacher has developed such a concept. His theory of a cultural primal scene recommends that textual critique take seriously moments of narrative repression, contradiction, transference, and masquerade. Such instances, Lukacher argues, can provide important—and otherwise invisible—interpretive insights. I would like to build upon Lukacher's theory by positing that uncanny narratives can serve as symptoms of cultural primal

scenes. The nature of the cultural primal scene encoded by Zeuxis Selecting Models cannot be determined, however, without considering how the myth presents itself through time and across cultures.

THE ZEUXIS MYTH AS PAROLE

The preceding discussion explores the formal structure, or langue, of Zeuxis Selecting Models. What, then, of its parole? The parole of a myth encompasses its social or cultural manifestations. In the following chapters, I address the postclassical parole of the Zeuxis myth. Of course, the earliest extant texts in which the story appears—Cicero's *Rhetoric* and Pliny's *Natural History*—deploy the story for different reasons and for distinct rhetorical benefits. For Cicero, the story serves as a metaphor for his own method of teaching rhetoric. Like Zeuxis, he started by "collecting all the works on the subject" and then "excerpted what seemed the most suitable precepts from each, and so culled the flower of many minds."[65] Pliny's mention of Zeuxis comes as part of a compendium of artists and techniques in his *Natural History*. This chronicle of the history of art is a digression from the author's catalog of minerals and their uses, the main topic of the book in which the story appears.[66] In Pliny, then, the legend of Zeuxis serves as an anchor to history, securing the text's claim to truth. Pliny's matter-of-fact version of the tale, along with his inclusion of details not recorded in Cicero, endow the later text with a rhetorical authenticity. The ancient parole of the Zeuxis legend, insofar as it can be reconstructed, functioned mainly as a metaphor for classical mimesis. Medieval references to the story, as seen in chapter 1, serve largely the same function, though the relevance of classical mimesis had diminished considerably. Indeed, the *Romance of the Rose* cites Zeuxis's attempt to paint ideal beauty as evidence of the insufficiency of classical mimesis. With the Renaissance, however, both classical mimesis and the Zeuxis myth would regain cultural prominence.

3
Myth and Mimesis
in the Renaissance

Zeuxis, the most excellent and most skilled painter of all,
did not rely rashly on his own skills as every painter does today.

<p style="text-align:right">↜ LEON BATTISTA ALBERTI, ON PAINTING</p>

Hyperion's curls, the front of Jove himself,
An eye like Mars, to threaten and command,
A station like the herald Mercury
New lighted on a heaven-kissing hill,
A combination and a form indeed,
Where every god did seem to set his seal.

<p style="text-align:right">↜ SHAKESPEARE, HAMLET</p>

WITH THE REAWAKENING OF INTEREST in antique literature, philosophy, history, and arts during the fourteenth and fifteenth centuries, classical mimesis regained its currency—especially in southern Europe.[1] By the dawn of the sixteenth century, this revival had already become doctrine. As Martin Kemp observes, "Renaissance writings on art are . . . dominated by the ideal of *mimesis.*"[2] In his definitive analysis of fifteenth-century Italian aesthetic discourse, Kemp discerns that the Renaissance notion of mimesis coincides largely with the concept of invention *(invenzione)*. Linked to processes of empirical discovery as well as to artistic originality, invention requires both knowledge and creativity. This dual character is illustrated by Leonardo da Vinci's writings on art. As Kemp observes, the artist privileges nature and human invention alternately. This seeming contradictoriness underlies the operation of mimesis. Without a complete understanding of nature,

representation will be faulty. But it is invention that transforms nature into art. As Leonardo explains, "Nature is concerned only with the production [*produtione*] of elementary things [*semplici*] but man from these elementary things produces an infinite number of compounds, though he has no power to create [*creare*] any elementary thing except another like himself, that is his children."[3] In this way, the twin concerns of classical mimesis—copying after nature and then improving upon nature's forms—can be seen to inflect not only Leonardo's thinking specifically but Renaissance art theory generally. Since the purpose of this chapter is not to provide an exhaustive account of Renaissance discussions of mimesis, I will focus only on two of the more widely circulated and influential texts, by Leon Battista Alberti and Giorgio Vasari.[4] These authors not only negotiate prevailing aesthetic concerns, but they also appeal to the Zeuxis myth in order to illustrate mimetic representation.[5]

Not surprisingly, the resurgence of mimetic strategies in the fourteenth and fifteenth centuries generated a renewed interest in the story of Zeuxis Selecting Models. The earliest use of the legend to exemplify artistic mimesis occurs in Alberti's *On Painting* (*Della pittura*, 1436). Written mainly for artists, Alberti's treatise describes methods for achieving perspective, shading, and correct proportion. He commends narrative scenes *(istoria)* as the highest genre of painting because they require the artist to paint the human body. And the successful rendering of human bodies depends, as does all painting, upon the close observation of nature. Indeed, Alberti insists that painters depict those things seen in nature as opposed to concepts when he writes, "No one would deny that the painter has nothing to do with things that are not visible."[6] But adherence to nature does not mean that artists should simply copy what they see. Beauty remains the painter's ultimate goal, which means that nature sometimes requires enhancement:

> It will please [the painter] not only to make all the parts true
> to his model but also to add beauty there; because in painting,
> loveliness is not less pleasing than richness. . . . For this reason
> it is useful to take from every beautiful body each one of the
> praised parts and always strive by your diligence and study to
> understand and express much loveliness. This is very difficult,
> because complete beauties are never found in a single body,
> but are rare and dispersed in many bodies.[7]

These recommendations lead Alberti to introduce the example of Zeuxis, "the most excellent and most skilled painter of all."[8] Alberti goes on to

recount the legend of Zeuxis Selecting Models, evidently using Cicero as his main source.[9] After giving the details of Zeuxis's method, Alberti concludes, "He was a wise painter."[10] In this way Alberti commends Zeuxis Selecting Models to Renaissance art and theory.

Among the few Renaissance artists to depict the scene is the Italian Domenico Beccafumi (1484–1551).[11] His rendering of *Zeuxis Selecting Models* remains where it was painted on the ceiling of the Palazzo Bindi-Sergardi in Siena (Figure 5). The scene forms part of a cycle of frescoes illustrating subjects from Valerius's *Memorable Deeds and Sayings* commissioned by Jacopo Venturi in celebration of his son's wedding in 1519. *Zeuxis Selecting Models* adjoins *The Continence of Scipio* (Figure 6) at the center of the ceiling. The pairing of these scenes at first seems puzzling.[12] Thematically, the subjects illustrate different laudable traits. As discussed in chapter 1, the legend of Zeuxis appears in a chapter titled "Of Self-Confidence." The story of Scipio's refusal of the offer of a beautiful maiden by the defeated Carthaginians, preferring instead to restore her to her family, illustrates the chapter "Of Abstinence and Continence" in book 4. Though the lessons

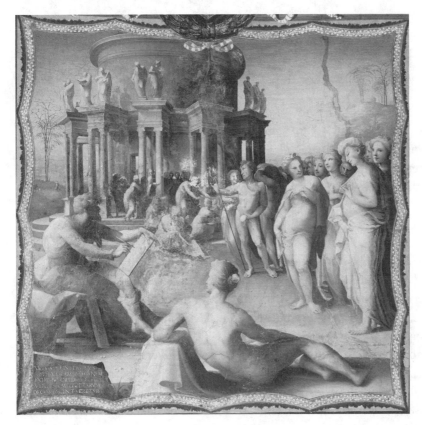

Figure 5. Domenico Beccafumi, *Zeuxis Selecting Models* (fresco, ca. 1519, Palazzo Bindi-Sergardi, Siena). Photograph courtesy of Scala / Art Resource, New York.

Figure 6.
Domenico Beccafumi,
The Continence of Scipio
(fresco, ca. 1519,
Palazzo Bindi-Sergardi,
Siena). Photograph
courtesy of Scala / Art
Resource, New York.

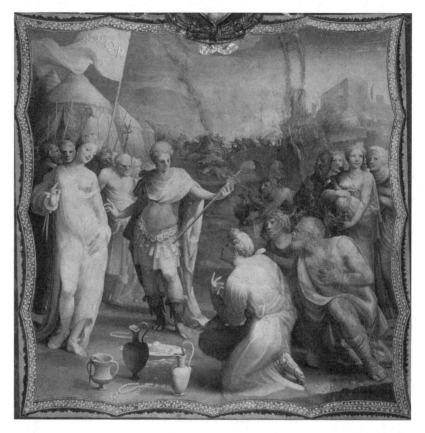

conveyed by the stories differ, both concern female beauty. Zeuxis creates an image of the perfect beauty Helen; Scipio overcomes the desire to possess a beautiful virgin. Indeed, both legends involve the management of feminine beauty by seemingly high-minded men. Probably this association explains Beccafumi's pairing of the scenes in a project commissioned to celebrate a nobleman's marriage.

Beccafumi in fact emphasizes the importance of physical beauty in both scenes and in so doing establishes strong formal connections between them. Zeuxis's models echo and reecho the graceful pose of the Carthaginian maiden freed by Scipio Africanus. Similarly, Scipio's elegantly nonchalant *contrapposto* stance mirrors that of the nude man near the center of the Zeuxis scene, with the general's baton replaced by a lance. Ultimately, Beccafumi appears to have selected those scenes from Valerius that could best accommodate nudes, though his eagerness in this vein resulted in some unusual passages in the cycle. His predilection manifests itself perhaps most clearly in his depiction of *The Beheading of Spurius Maelius* (Figure 7), taken from Valerius's chapter "Of Ingrates." The incongruous presence of a diapha-

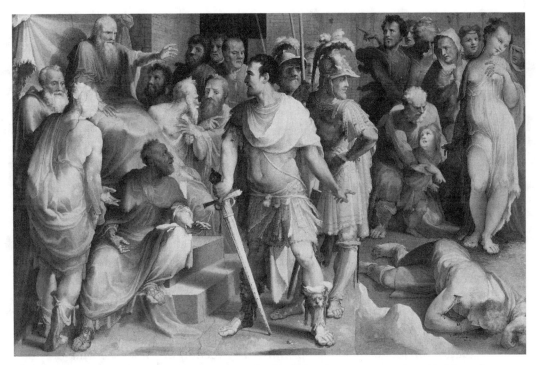

Figure 7. Domenico Beccafumi, *The Beheading of Spurius Maelius* (fresco, ca. 1519, Palazzo Bindi-Sergardi, Siena). Photograph courtesy of Scala / Art Resource, New York.

nously draped female figure at a grisly execution leads Pascale Dubus to add to his commentary on the fresco the understated opinion that her "nakedness and 'lovely indifference' at the macabre spectacle are, to say the least, bizarre."[13]

Beccafumi's provocative treatment of Zeuxis Selecting Models generated few imitators. Despite its obvious visual and oblique erotic appeal, the theme became increasingly allied with Renaissance aesthetic theory rather than artistic practice. Beccafumi's fresco presages this with the inscription he places in the lower left-hand corner of *Zeuxis Selecting Models:*

> ZEUXIS NON FRETUS
> ARTE VERAM IMAGINEM
> EXHIBERE CREDIDIT SI
> VIRGINUM ELECTARUM
> DECOREM INTUERETUR[14]

But it would be left to Vasari to bring the theme fully into the service of art history and theory. This campaign emerges clearly in his *Lives of the Painters,*

Sculptors, and Architects.[15] It was first published in 1550; a second edition, with expanded biographies and enhanced theoretical discussions, appeared in 1568. One of the new theoretical passages prefaces the third part of the revised edition, where the author offers five qualities essential to a successful work of art. The first two—*regola* (rule) and *ordine* (order)—in Vasari's text relate mainly to architecture. *Misura* (proportion) is the third and bears upon painting and sculpture as well as architecture. But the last two qualities—*disegno* and *maniera*—both reprise and modify the antique notion of classical mimesis, though Vasari does not use this term. He offers *disegno* as "the imitation *(imitare)* of the most beautiful in nature in all figures." With the addition of *maniera,* though, he elicits a component of classical mimesis. He describes *maniera* as "that beauty which comes from having frequently copied the most beautiful things, and from those most beautiful hands and heads and bodies and legs to join together and make a figure of as many beauties as possible, and to put it into all one's works and in each figure."[16] Thus, akin to mimesis, *maniera* involves discernment as well as copying. *Maniera,* then, is a Renaissance variation on classical mimesis.

Vasari's *maniera* includes not only the selection of the best forms of nature but also the selection, emulation, and synthesis of the *maniera* of previous artists. He commends Raphael for devoting his efforts "not to imitating the manner of [Michelangelo], but to the attainment of a catholic excellence." Vasari goes on to explain that Raphael "selected from the best work of other masters, [and] out of many manners he made one."[17] Indeed, Raphael himself confides in a letter to Baldassare Castiglione that "in order to paint a beautiful woman, it would be necessary for me to see many beautiful women."[18] As Robert Williams explains, "Raphael creates a personal style by selecting elements from others, a procedure that resembles Pico's preferred method of poetic imitation."[19] Giovanni Pico della Mirandola's method is, of course, borrowed from Cicero's insistence that rhetoricians take from other stylists their best qualities. And Cicero illustrates this point with the example of Zeuxis Selecting Models. Of course, this is not to say that mimesis and *maniera* are one and the same. The former involves an engagement with nature; the latter, strictly with art. *Maniera* is beyond the scope of classical mimetic theory and, consequently, does not elicit the concerns provoked by Zeuxian mimesis. As discussed in chapter 2, classical mimetic practice places the artist in an ontological bind as he seeks to represent the ideal through recourse to necessarily flawed real models. *Maniera* instead draws upon artifice, thus raising no ontological doubts.

Vasari's advocacy of *maniera*—which I am arguing is related to but not

identical to classical mimesis—coincides, not surprisingly, with an interest in Zeuxis. He mentions the artist several times in the second edition of the *Lives,* according him high praise among the ancients.[20] Vasari's esteem for the painter led him, in fact, to produce one of the few visual representations of the story (Figure 8).[21] The subject figures among the frescoes adorning the Sala del Camino in his house in Arezzo.[22] Vasari mentions this fresco cycle in the autobiographical chapter added to the second edition of the *Lives:* "Meanwhile [in 1548] the building of my house in Arezzo had been finished, and I returned home where I made designs for painting the hall. . . . all around are stories of ancient painters, Apelles, Zeuxis, Parrhasius, Protogenes, and others."[23] His rendering of the Zeuxis legend includes a group of ten nude women standing together on the left side of the composition. Vasari clearly took advantage of the story's reference to numerous nude models, offering a great deal of variation in the women's gestures and expressions. Their poses alternately suggest modesty, confidence, and curiosity. The right half of the fresco is given to Zeuxis's artistic endeavor. The artist sits holding a stylus to the sketchpad, his eyes fixed on the models. Behind him, an assistant busies himself preparing pigments while the face of a man can be seen peeking through the window in the upper right corner of the scene. According to Liana Cheney, this onlooker serves as a point of contrast to the artist, differentiating "between a layperson's

Figure 8. Giorgio Vasari, *Zeuxis Selecting Models* (fresco, ca. 1548, Casa Vasari, Arezzo). Photograph courtesy of Liana De Girolami Cheney.

and a professional's appreciation of nature and art."[24] Interestingly, Vasari places his depiction of Zeuxis Selecting Models adjacent to a representation of the Diana of Ephesus. Cheney accounts for this juxtaposition by explaining that the Diana of Ephesus serves as a personification of nature; the proximity of the scenes emphasizes the role of nature as the foundation of all art.[25]

More than twenty years later, Vasari executed an even more ambitious fresco program for the Sala delle Arti of his Florence house. But here, the scenes of artistic achievement concern only Apelles. Despite this focus, the legend of Zeuxis Selecting Models does recur, if obliquely. Fredrika H. Jacobs interprets the Florentine cycle as a visual manifestation of Vasari's theoretical and literary efforts to "record what the artists have done [and] also to distinguish between the good, the better, and the best, and . . . to understand the sources and origins of various styles, and the reasons for the improvement or decline of the arts at various times."[26] Jacobs divides the fresco cycle into three narrative scenes: "*The Origin of Pittura* and two illustrating Apelles at work; the double fresco showing *Models Approaching the Artist's Studio* and *Apelles Painting Diana* and, on the adjacent wall, *Apelles and the Cobbler*" surrounded by a series of personifications.[27] The cycle's emphasis on Apelles leads Jacobs to conclude that he served as a kind of alter ego for Vasari. This apparently explains Vasari's unusual concatenation of the story of Zeuxis Selecting Models with Pliny's brief record of Apelles's painting of Diana. In Vasari's hybrid scene, a painter (identified by Jacobs as Apelles) works on a nearly complete image of the goddess (Figure 9). He is accompanied by three models—one posing, two dressing or undressing. Adjacent to this group, Vasari depicted another scene showing several clothed women approaching the studio door. Perhaps, as Jacobs suggests, Vasari wished to convey simultaneously the principles of *disegno* and *maniera* as demonstrated by Zeuxis as well as the *giudizia* (judgment), *leggiadria* (prettiness), and *grazia* (grace) he associates most closely with Apelles.[28]

Jacobs notes that only the seventeenth-century Flemish painter Peter Paul Rubens similarly attempted a pictorial history of ancient art.[29] Like Vasari, Rubens adorned his house with art-historical scenes taken from Pliny. Unfortunately for modern viewers and scholars, Rubens's works decorated the exterior of his lavish Antwerp residence. What the elements did not spoil, later remodeling succeeded in destroying. Jacob Harrewijn's 1692 engraving of the facade of Rubens's house clearly shows the decorative scheme (Figure 10). The images mainly represent famous paintings known only through antique descriptions: Pausias's *Sacrifice of Oxen*, Timanthes's *Sacrifice of Iphigenia*, Aristides's *Chariot Race*, and Apelles's *Alexander with a Thunderbolt*, as well as his infamous *Calumny*. Alongside these re-

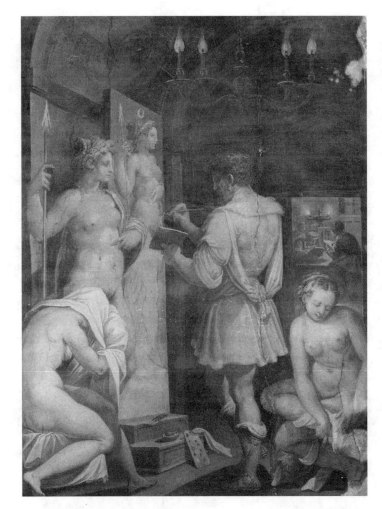

Figure 9. Giorgio Vasari, *Apelles Painting Diana* (fresco, 1569–73, Casa del Vasari, Florence). Photograph courtesy of Scala / Art Resource, New York.

creations of renowned but lost ancient paintings, Rubens adds a depiction of *Zeuxis Selecting Models.* Because this scene deviates from the cycle's preoccupation with re-presenting antique paintings, its inclusion deserves special consideration. Jacobs suggests that the episode summarizes Rubens's "advocacy of selective imitation."[30] But why did Rubens choose to depict Zeuxis at work as opposed to simply re-creating the painter's famous image of Helen of Troy? Surely this would have resulted in a more coherent program. Perhaps even Rubens was unable to summon the hubris necessary to re-create Zeuxis's legendary painting of perfect beauty. Rubens's declaration that "few among us, in attempting to reproduce in fitting terms some famous work of Apelles or Timanthes that is graphically described by Pliny or by other authors, will not produce something insipid or inconsistent with the grandeur of the ancients" hints at such humility. But his willingness to re-create paintings by both Apelles and Timanthes places this ex-

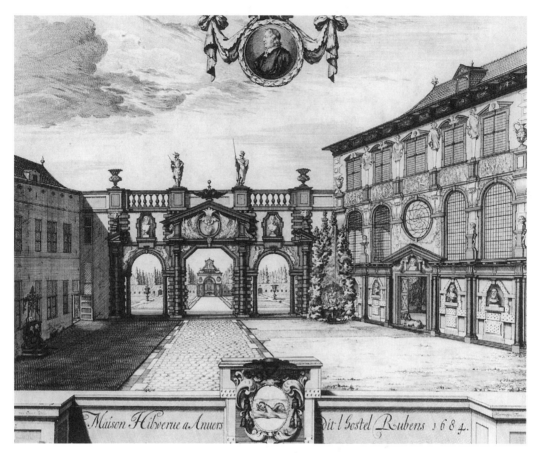

Figure 10. Jacob Harrewijn, *View of Rubens' House* (engraving, 1692, Metropolitan Museum of Art, New York). Photograph courtesy Metropolitan Museum of Art, New York.

planation in doubt. Clearly, Rubens reckoned himself one of the "few." Still, his reticence in relation to Zeuxis's painting of Helen of Troy suggests he may have decided in this case to "admire the traces [the ancients] have left" rather than "to venture to proclaim myself capable of matching them, even in thought alone."[31]

"NATURE'S BASTARDS": THE POPULAR REVIVAL OF ZEUXIAN MIMESIS

In addition to appearing in aesthetic treatises and as rarefied home decor of the sixteenth and seventeenth centuries, the legend of Zeuxis Selecting Models seems also to have enjoyed currency with a more popular audience. Perhaps the most effective vehicle for this broad awareness was Castiglione's *Il cortegiano (The Courtier)*. First published in Venice in 1528, this humanist

self-help manual quickly found readers throughout Europe. Those unable to read the text in the original Italian did not wait long for translations. A Spanish edition appeared in 1534, succeeded by versions in French in 1537, English in 1561, and Portuguese in 1584; Dutch and German translations followed in the seventeenth century.[32] Most literate Europeans would have become acquainted with the conversations recorded in *The Courtier*, and among the dialogues attributed to Castiglione's bantering nobles is a discussion about art. This exchange, not surprisingly, provides an occasion for the retelling of Zeuxis Selecting Models.

Generally agreeing that a familiarity with the visual arts should be among the perfect courtier's accomplishments, Castiglione's interlocutors enter into a debate regarding the relative superiority of painting versus sculpture.[33] Count Lodovico Canossa asserts that painting surpasses sculpture since it can be made to imitate any substance or form. He even goes on to argue that only the careful study of art, especially painting, can endow someone with the sensitivity necessary to appreciate true beauty. Cesare Gonzaga expresses some doubt, however, believing that nobody (not even an artist) can appreciate the beauty of a "certain lady" better than he. Unwilling to accept the count's suggestion that his opinion is influenced as much by affection as by discernment, Cesare argues that beauty generates affection: "When Apelles contemplated the beauty of Campaspe he must have enjoyed himself far more than did Alexander, since . . . both men's love for her was prompted solely by her beauty, and . . . this was why Alexander decided to give her to someone who, he believed, would understand it more perfectly."[34] Cesare's point is this: Affection derives from beauty, and to think otherwise would call into question the unparalleled beauty of his beloved. Cesare drives this point home by citing the legend of Zeuxis Selecting Models:

> Have you not read that those five girls of Crotone, whom the painter Zeuxis chose from among all the others of that city for the purpose of forming from all five a single figure of consummate beauty, were celebrated by many poets because their beauty had won the approbation of one who must have been the most perfect judge?[35]

Beauty alone stimulates the poet as well as the lover, Cesare suggests. Interestingly, this discussion of art and aesthetics ends just as Cesare completes his retelling of the Zeuxis myth, when new guests arrive, disrupting the conversation. The possibility of Zeuxis's sexual involvement with his models (which would seem necessary to support Cesare's point) goes unremarked.

Popular familiarity—at least among a literate public—with the Zeuxis myth probably came not only through Castiglione's work but also through vernacular versions of Valerius's *Memorable Deeds and Sayings* and Pliny's *Natural History*. Valerius could be found in French, Italian, German, and Spanish translations by the close of the fifteenth century. As for Pliny—who offers a more detailed version of the tale—Italian translations were available in the fifteenth century. German and French versions followed in the sixteenth century, and Spanish and Dutch copies could be obtained in the seventeenth century.[36] Philemon Holland's 1601 English translation of Pliny, *The Historie of the World,* found wide readership. Dubbed England's "Translator Generall,"[37] Holland is credited not only with making classical authors available to most literate English audiences but with spurring on the Elizabethan Renaissance. Holland translated into English works by Livy, Plutarch, Suetonius, and Xenophon among others in addition to Pliny. These editions functioned, as one biographer has it, as "breviaries to many generations, and they have descended to us rich treasuries of sound English and wise interpretation."[38]

Holland's *Historie of the World* claimed distinction as "the most popular of his works."[39] The influence of Holland's translation of Pliny on Elizabethan and later English literature manifests itself in works by authors including Shakespeare, John Donne, Andrew Marvell, Joseph Addison, William Wordsworth, George Gordon Byron, Percy Bysshe Shelley, and John Keats.[40] The enduring authority of his translation no doubt helped make the legend of Zeuxis Selecting Models familiar to Britain's literate classes. Whether through direct knowledge of Pliny or via literary or dramatic references to the legend, Zeuxis Selecting Models entered into the cultural vocabulary of post-Renaissance Britain. Holland's version of the legend sticks close to Pliny's description:

> When hee should make a table with a picture for the Agrigentines, to be set up in the temple of Juno Lacinia, at the charges of the citie, according to a vow that they had made, hee would needs see all the maidens of the city, naked; and from all that companie hee chose five of the fairest to take out as from severall patterns, whatsoever hee liked best in any of them; and of all the lovely parts of those five to make one bodie of incomparable beautie.[41]

This story would have been made available even to an illiterate audience by means of dramatic performances. Shakespeare's plays, for example, refer

several times to Zeuxian mimesis. The lengthiest of these discourses oc-
curs in *The Winter's Tale* when Perdita engages in an aesthetic debate with
Polixenes. This exchange takes place during act 4 near the beginning of the
fourth scene. Perdita, the now-grown royal foundling raised by shepherds,
welcomes the king of Bohemia and his entourage to a country feast. Her
gift of flowers to the noble guests sparks a discussion about the merits of
different blossoms. Perdita confesses that she does not care for the color-
ful "gillyvors," which she calls "nature's bastards," reflecting a belief (wide-
spread in the sixteenth century) that this species could cross-pollinate and
produce hybrids without human aid. Polixenes then asks why she refuses to
grow gillyvors in her garden.

> PERDITA: For I have heard it said
> There is an art which in their piedness shares
> With great creating Nature.
> POLIXENES: Say there be;
> Yet Nature is made better by no mean
> But Nature makes that mean: so, over that art
> Which you say adds to Nature, is an art
> That Nature makes. You see, sweet maid, we marry
> A gentler scion to the wildest stock,
> And make conceive a bark of baser kind
> By bud of nobler race. This is an art
> Which does mend Nature—change it rather; but
> The art itself is Nature.[42]

Polixenes here equates art—or artifice—with nature insofar as nature and
art both create hybrid or composite forms. In this way, human agency
would seem to be accorded the same power and skill as nature, an asser-
tion underlying aesthetic debates throughout the sixteenth and into the
twentieth centuries.[43] This was precisely the potential of classical mimesis
refuted by medieval authors like Jean de Meun and Geoffrey Chaucer and
reasserted by Alberti and, to a lesser extent, Vasari. Despite the advantage
Polixenes's advocacy of art over nature might give Perdita in her pursuit of
Prince Florizel, she holds in favor of nature:

> PERDITA: I'll not put
> The dibble in earth to set one slip of them;
> No more than, were I painted, I would wish
> This youth should say 'twere well, and only therefore

> Desire to breed by me. Here's flow'rs for you:
> Hot lavender, mints, savory, marjorum,
> The marigold, that goes to bed wi' th' sun,
> And with him rises, weeping . . .[44]

The irony of this declaration depends upon the audience's knowledge that Perdita is in love with Polixenes's son Florizel. The prince is a "gentler scion" than Perdita appears to be in her rustic costume. The joke turns on the flowery name of her beloved as well as on the play of art against nature, often discussed in horticultural metaphors (as were sexuality and procreation, adding a touch of ribaldry to the exchange).[45] Were aesthetic debates of this sort not familiar, the humor would seem forced. Similarly, the "resurrection" of Perdita's real mother, Hermione, in act 5 plays upon another antique legend of art making, that of Pygmalion. Believed dead by her husband, Leontes—who had ordered her execution—Hermione poses as a marble statue. Coming to life before his eyes, Hermione reenacts Galatea's vivification.

Zeuxian mimesis is again evoked in act 5 of *Winter's Tale,* in which Leontes (king of Sicily and Perdita's real father) laments his rash murder of his wife. Leontes confesses his shame to Paulina, formerly one of Hermione's ladies-in-waiting. Paulina encourages his remorse by reminding him of Hermione's peerless virtue:

> PAULINA: True, too true, my lord.
> If, one by one, you wedded all the world,
> Or, from the all that are, took something good
> To make a perfect woman, she you kill'd
> Would be unparallel'd.[46]

Here, Shakespeare deploys a Platonic rather than an Aristotelian brand of mimesis. Hermione assumes the role of ideal, which no manner of artifice can approximate. Echoing Perdita's earlier acclamation of nature over art, Paulina dismisses Zeuxian mimesis. But this example should not be taken as evidence of Shakespeare's Platonic sympathies. In *As You Like It,* the Aristotelian model of mimesis propels the following description of Rosalind:

> Helen's cheek, but not [her] heart,
> Cleopatra's majesty
> Atalanta's better part,
> Sad Lucretia's modesty.
> Thus Rosalinde of many parts

By heavenly synod was devis'd,
Of many faces, eyes, and hearts,
To have the touches dearest priz'd,[47]

Shakespeare's use of Zeuxian mimesis, like his evocation of the story of Pygmalion and Galatea, confirms a general awareness of these ancient legends of artistic creation, at least in England. It would be left to academicians of the seventeenth and eighteenth centuries to codify the Zeuxian method into artistic practice throughout western Europe.

Painting (Like) Zeuxis

Zeuxis in the Academy

Alberti teaches that in all things one should . . . select the most praised parts from the most beautiful bodies.

⌐ GIOVANNI BELLORI, LECTURING AT THE ACADEMY OF ST. LUKE

REFERENCES TO ZEUXIS SELECTING MODELS by Renaissance authors like Castiglione and Shakespeare confirm popular interest in the legend. But Renaissance theorists remained divided about the efficacy of Zeuxis's example. Alberti accorded highest praise to Zeuxis's method, while Vasari awarded the palm to Apelles. The ambivalence with which Renaissance authors commend the example of Zeuxis Selecting Models evaporates in seventeenth-century aesthetic discourse. During the course of the century, Zeuxis assumed a leading role in theoretical treatises and histories of painting. This heightened appreciation of Zeuxis's illustrative method coincided, perhaps not surprisingly, with the rise of the academy in western Europe. Academicians keen to confirm their professional legitimacy sought exemplary forebears. Zeuxis—famous not only for his paintings but for his methodical approach and disdain of commerce—offered a particularly apt model.

Zeuxis's renowned picture of Helen validates the pedagogical model endorsed in the academy. Early academies such as those established in Florence (1563), Bologna (1582), and Rome (1593) shared a commitment to rigorous training in drawing, anatomy, and perspective as well as in the liberal arts.[1] The program developed at the French Royal Academy of Painting and Sculpture during the second half of the seventeenth century codified this approach. Adopted with some variation by academies subsequently founded throughout western Europe, the French Royal Academy's method demonstrates the Zeuxian character of academic instruction.[2] Students began their training by copying drawings by other artists, usually accomplished academicians. Novices were admonished to discern and emulate the best habits

of the artists they copied. Lectures provided the theoretical complement to the practical studio sessions. Anatomy and geometry were taught, as were art history, aesthetic decorum, and classical history and mythology. Once students had acquired basic drawing technique, they might move on to copy after plaster casts of antique statues. Sufficiently advanced students eventually were permitted to draw after live models. Competition also served an important pedagogic purpose. Throughout their training, academy students were expected to participate in contests with their fellow pupils. Success in these competitions earned students prestigious prizes as well as permission to advance to the next level of training.

Pliny's account of Zeuxis's life highlights precisely those achievements promoted by academic training. Pliny begins with an academic pedigree of sorts, assuring the reader of the painter's illustrious lineage.[3] Like so many celebrated academic painters, "Zeuxis robbed his masters of their art and carried it off with him."[4] As expected, Zeuxis's rigorous training resulted in the production of numerous celebrated works. Each painting catalogued by Pliny exemplifies a particular aspect of the artist's genius. In addition to the illustrative *Helen,* Zeuxis's *Centaur Family* shows his originality, since no artist had ever before depicted a female centaur.[5] Other works, such as his *Penelope,* deliver a worthy moral lesson. Pliny cites Zeuxis's *Infant Hercules Throttling Two Snakes* in order to demonstrate the artist's capacity for conveying emotion. And Zeuxis's famous still life depicting a bunch of grapes reveals his facility with illusionism. Pliny adds that Zeuxis also produced some fine examples of sculpture, emphasizing the artist's complete education.

Zeuxis exemplified other academic qualities as well. His participation in painting competitions figures prominently in Pliny's biography. His often-cited contest with Parrhasius shows not only his skill but his (apparently limited) capacity for humility as well. Pliny reports that, after mistaking Parrhasius's painted drapery for a real curtain, Zeuxis quickly "realized his mistake, [and] with a modesty that did him honour he yielded up the prize." Zeuxis's disdain for commerce likewise accords with academic principles. Pliny does not say whether it was the painter's legendary hubris that led him eventually to give away his works because "it was impossible for them to be sold at any price adequate to their value."[6] Like the consummate seventeenth-century academician, Zeuxis eschewed commerce, presumably in favor of loftier aesthetic and intellectual ideals.[7] And in another gesture worthy of many famous academicians, Zeuxis announced his status through his dress, "displaying his own name embroidered in gold lettering on the checked pattern of his robes."[8]

GRAZING LIKE A BEE

That academicians should adopt Zeuxis as their lead model is not surprising since he epitomizes so many academic ideals. Giovanni Bellori—an early champion of the academies then ascendant in Italy and France—repeatedly offers the Greek painter as an exemplar for aspiring artists. For instance, in a 1664 lecture to the students of the Academy of St. Luke in Rome, later published as the introduction to his *Lives of the Modern Painters, Sculptors, and Architects* (1672), Bellori advocates a notion of beauty derived from his "Idea." Akin to Plato's ideal, Bellori's idea finds its first expression in God's acts of creation. The "unchangeable" parts of God's creation, such as the moon and stars, remain eternally beautiful and harmonious. God's impermanent or "sublunar" creations, on the other hand, do not retain the perfection of their initial form. Nature's laws operate in the realm beneath the moon and, according to Bellori, nature's fallibility accounts for the decay, deformity, and ugliness prevalent on earth. But Bellori breaks decisively from Platonic thought when he asserts that "painters and sculptors imitate that first creator, and form in their minds also an example of superior beauty and, reflecting on it, improve upon nature until it is without fault of colour or of line."[9] Far from Plato's facile and false imitators, Bellori's artists not only grasp but also reproduce ideal form.

Bellori explains that artists can transcend the faults of their visible subjects through recourse to "Exemplary Causes" or a genius that enables them to represent perfect beauty. With this, Bellori codifies in theory the rhetorical gestures with which Vasari embellished his *Lives*. Indeed, few authors have asserted so baldly the quasi-divine status afforded to artists since antiquity.[10] To support his contention, Bellori turns not to Plato but to Cicero, Alberti, and, of course, Zeuxis. The last, Bellori explains, "teaches the painter and sculptor alike to keep in mind the Idea of the best natural forms and to make a selection from different bodies, choosing what is most elegant in each."[11]

Bellori also invokes Zeuxian mimesis in order to emphasize the accomplishments of Annibale Carracci, the artist most ardently championed in his *Lives*—the vehicle he uses to celebrate the Carracci "academy" in Bologna. Annibale's "own particular style . . . was to unite [the] idea and nature, gathering together the most worthy virtues of the masters of the past."[12] Carracci's biographer Carlo Cesare Malvasia ascribes a similar quality to Annibale's cousin Ludovico Carracci, who

> entertained the bold aim of adding to the most famous styles
> of all the past masters anything further that might be desired

as the ultimate perfection of the miracles they had already achieved—that is, to add the lovely color of Correggio to the perfect measure and proportion of Raphael, and the great draftsmanship of Raphael to the lovely color of Correggio, to add the tenderness of Titian to the well-founded mastery of Michelangelo, and the deep knowledge of Michelangelo to the tenderness of Titian—in short by mixing all the particular gifts of these and every other great painter to re-create and form out of them all taken together the Helen of his deeply considered idea.[13]

Zeuxis's legendary painting of Helen here serves as a metaphor for art itself.

Malvasia attributes similar words directly to Ludovico Carracci. Supposedly observing Annibale's attainment of his mature style, Ludovico avers, "to imitate a single master is to make oneself his follower and his inferior, while to draw from all of them and also select things from other painters is to make oneself their judge and leader."[14] Anne Summerscale compares this statement to similar comments made throughout Malvasia's *Felsina Pittrice*, in which he frequently cites the bee as a model for excellent painting.[15] Malvasia's sources for this metaphor, Summerscale explains, include Horace's famous bees as well as Giambattista Marino's likening of God (and good painters) to a bee. This latter analogy appears in the section "La Pittura" ("Painting") in the poet's 1614 aesthetic treatise, *Dicerie sacre*. Marino's encomium to painting includes an elaborate metaphor in which God's creation of Jesus results from the same method used by Zeuxis:

> The famous Greek painter was permitted to choose the most noble and beautiful young woman in Agrigento as a model for his work. How unusually and secretly did God, in order to fully endow this sacred and true image of his work with every perfection, grazing like a bee the vast and uncircumscribed meadows of his immense power and infinite wisdom, accumulate the height of purity, the flower of flowers, the choice of the summit of all the beautiful of beauty in it?[16]

God—like Zeuxis, Annibale, and Ludovico—employs the best method for creation. In this way, a sustained link between Zeuxis and the progressive Bolognese academicians of the Catholic Reformation is forged in the works of Bellori and Malvasia.

ZEUXIS AND THE "GERMAN APELLES"

As academic ideals caught hold among artists and theoreticians outside Italy, Zeuxis found appreciative disciples throughout Europe. Sympathizers like Joachim von Sandrart recognized Zeuxis as a forebear whose celebrated attainments underscored the need for artists' academies north of the Alps. To compete with Italian artists, Sandrart reckoned, German painters and sculptors needed access to antique models and a liberal education. Where else but an academy could this exposure be provided? Sandrart's efforts helped give rise to academies in Augsburg and Nuremberg. But his most lasting contribution to the rise of academic training and principles in Germany remains his monumental *Teutsche Academie* (1675–79).

Fusing artists' biographies with theoretical excursuses, the *Teutsche Academie* features a long discussion of Zeuxis's career, drawn mainly from Pliny.[17] Sandrart also illustrates the story of Zeuxis Selecting Models with a half-page engraving placed at the beginning of his section on classical art (Figure 11).[18] In his print, Sandrart shows Zeuxis seated in a vaguely classical interior: Pilasters with Corinthian capitals suggest a generic antiquity. With his back to the viewer, Zeuxis raises his right hand to the unfinished painting as he turns to the left—and away from his work—to regard his models. An inscription identifies the subject of Zeuxis's painting to be Juno. This slight departure from classical sources was probably inspired by the painting's purported setting in a temple dedicated to the goddess. The proud figure of Juno, with her customary peacock, is already visible beneath the artist's brush. But her regal demeanor contrasts with the models' lack of composure. Four women slump together on a bench placed at an oblique angle to the temple's rear wall; the fifth model casts a final glance at the painting as she is led out of the room by an old woman. Appearing alternately languid and despairing, none of the five models pictured possesses the grace embodied by the fictive Juno. And this is precisely Sandrart's point: Zeuxis keeps his eyes on nature (however underwhelming) while allowing his hand to improve and perfect what he sees. The creation of ideal beauty requires the artist to attend to nature without losing sight of an imagined perfection.[19] Academic training fostered this approach. The capacity to render accurately the visible world was methodically coupled to a liberal education at the academy, whereas training in the guilds focused mainly on technical mastery.

The relationship between Sandrart's historico-theoretical treatise and the rise of academies in Germany has been commented upon previously. Viktoria Schmidt-Linsenhoff dubs *Teutsche Academie* a work of "propa-

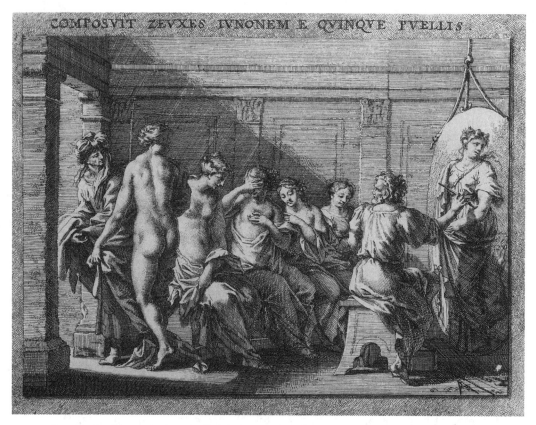

Figure 11. Joachim von Sandrart, *Zeuxis Selecting Models* (engraving from *Teutsche Academie* [Nuremberg, 1675–79], Houghton Library, Cambridge, Mass.). Reproduced by permission of the Houghton Library, Harvard University.

ganda for academic ideas in Germany."[20] And Zeuxis, she observes, serves as the movement's chief standard-bearer. She argues that Zeuxis functions as a masculine exemplar of academic methods and goals in contrast to Dibutadis (the Corinthian Maid), who personifies the manual, decorative, and reproductive arts. Schmidt-Linsenhoff is careful to note that Sandrart distinguishes himself from many of his contemporaries by acknowledging the capacity of women artists to achieve academic ideals. But rhetorically and visually, *Teutsche Academie* confirms long-standing conventions linking femininity with nature and untutored creative impulses. Sandrart's engravings of *Dibutadis Tracing Her Lover's Shadow* (Figure 12) and *Zeuxis Selecting Models*—as well as their placement within *Teutsche Academie*—reveal Sandrart's use of gender as a means of classifying the history of art. As Schmidt-Linsenhoff points out, the illustration of *Dibutadis Tracing Her Lover's Shadow* marks a transition in the text of *Teutsche Academie* from

Figure 12. Joachim von Sandrart, *Dibutadis Tracing Her Lover's Shadow* (engraving from *Teutsche Academie* [Nuremberg, 1675–79], Houghton Library, Cambridge, Mass.). Reproduced by permission of the Houghton Library, Harvard University.

Sandrart's discussion of "a mythic Ur- or natural history of art" to a "history of civilization with its male genealogies of great masters."[21] As already mentioned, the depiction of Zeuxis Selecting Models appears at the start of the section on classical artists. In this way, Schmidt-Linsenhoff shows how Sandrart's illustrations *Dibutadis Tracing Her Lover's Shadow* and *Zeuxis Selecting Models* function as pendants, each illustrating one half of Sandrart's art-historical schema. The immaturity and naïveté of Dibutadis (and of preclassical art) give way to the sophistication and deliberateness of Zeuxis and the modern canon.

Another testament to Zeuxis's significance for Germany's nascent academies appears in Johann Heiss's cycle of paintings produced in Augsburg. Probably produced in conjunction with the establishment for the city's first art academy—founded by Sandrart shortly before 1674—the cycle includes a representation of Zeuxis Selecting Models (Figure 13).[22] Heiss's version emphasizes the academic relevance of the theme. Significantly, the scene

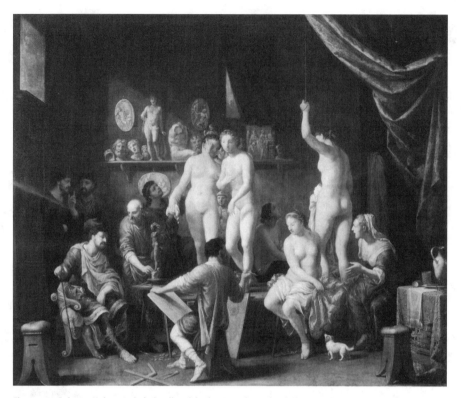

Figure 13. Johann Heiss, *Artist's Studio with Five Female Nudes* (oil on canvas, 1687, Staatsgalerie, Stuttgart). Photograph courtesy of Staatsgalerie.

takes place inside a studio, not a Juno temple. A shelf with plaster casts and antique fragments is affixed to the rear wall. Artists' tools are strewn on the floor. Students, assistants, and guests—including a visitor seated at left whose exceptional wealth (and potential as a patron) is announced by his splendid costume—underscore the bustle of the place. Zeuxis sits in the center of the composition with his back to the viewer, allowing the scene to be perceived from his vantage. Five nude or nearly nude models pose before him, three standing and two seated. The artist has discarded his calipers at his feet. Here he relies on his vision and a direct encounter with the models. This encounter, however, is guided as much by artistic precedent as it is by nature. The model standing nearest to Zeuxis assumes the conventional pose of a *Venus pudica*, while the seated model facing him recalls a classical nymph. Heiss's *Zeuxis* is a lesson in pedagogy: The proper course of study tempers invention with emulation. The painting also provides young artists with a glimpse into their futures as academicians, whose success depends as much on aplomb as on genius. What with guiding students, directing as-

sistants, and entertaining visitors, Heiss's Zeuxis exemplifies the ambitious but overworked academician.

In France, similar ideas were disseminated by the connoisseur, aesthetician, and honorary academician Roger de Piles. De Piles's Zeuxian sympathies first appear in the preface to his French translation of Charles du Fresnoy's *De arte graphica* (1668). He suggests that artists should study the work of their predecessors so that they will "learn to make a good choice of Nature, to take nothing from her that is not Beautiful, and to mend what's defective in her."[23] Although de Piles does not refer directly to Zeuxis in this passage, his valorization of the selection and manipulation of nature evokes Zeuxian mimesis. De Piles includes Zeuxis in his later *L'abrégé de la vie des peintres* (1699; translated as *The Lives of the Painters*, 1706). In his version of the legend, de Piles relies on Pliny's account while also embellishing the story:

> The Agrigentines desiring him to make a picture of Helen
> naked, to be set up in their temple, sent him, at his request,
> some of their most beautiful maids, of whom he kept five, and
> having well examined them, formed an idea of their finest
> parts, to compose the body he was to represent. He painted it
> after them; and this figure, when he had carefully finished it,
> appeared so perfect in his own eyes, *that he could not forebear
> telling the painters who came to admire it, that they might
> praise it, but could not imitate it.* [Emphasis mine.][24]

De Piles's narrative stresses the difference between invention and imitation, which he had emphasized earlier in *The Art of Painting*. Invention, according to de Piles, depends on an imaginative, intellectual engagement with nature. Imitation, in contrast, is a mechanical exercise necessary for students to learn the rudiments of composition.[25] This distinction would remain at the center of academic theory—and the reception of classical mimesis—throughout the eighteenth century.

THEORETICAL PRESENCE, PICTORIAL ABSENCE

While the preceding examples convey the accord between Zeuxis Selecting Models and academic principles, they do not explain the comparative dearth of visual representations of this theme. Thirteen paintings depicting Zeuxis Selecting Models from the seventeenth through nineteenth centuries are recorded; of these, only ten are extant.[26] Prints and drawings from this period

are similarly scarce, with most relating to the few known paintings.[27] This paucity of visual representations was discussed briefly in the introduction. I will now address this visual reticence at greater length. It is, I believe, a response indicative of the mythic (as opposed to simply thematic) character of Zeuxis Selecting Models for post-Renaissance culture. To show this, I first propose close readings of the rhetorical conjurations of Zeuxis Selecting Models in texts by Johann Joachim Winckelmann, Anton Raphael Mengs, Jonathan Richardson, and Joshua Reynolds. These influential theorists readily deploy the example of Zeuxis or Zeuxian mimesis, transmitting a lesson in aesthetics as well as ideology.

Although not a formal member of any artists' academy, Winckelmann exerted an unparalleled influence on institutional tastes and methods during the eighteenth century. His study and celebration of ancient Greek art and society contributed importantly to the rise of neoclassicism in eighteenth-century visual culture. Winckelmann's treatises on taste and beauty as well as his ambitious *History of Ancient Art* (1763–64) served as gospel for his many academic acolytes. Through this means, Winckelmann's aesthetic ideas were distilled into academic practice. The commingling of an ecstatic valorization of ancient art with academic principles sets the stage for a sustained performance by Zeuxis in Winckelmann's writing.

In his *History of Ancient Art,* Winckelmann credits Zeuxis with putting painting on a par with sculpture.[28] He also repeatedly invokes Zeuxian mimesis in order to support his definition of beauty as that in which "unity, variety, and harmony" converge. Far from epitomizing beauty, nature succumbs too often to accident or deformity. Winckelmann instead emphasizes the superiority of idealized forms over the imperfect forms found in nature. "Nature and the structure of the most beautiful bodies are rarely without fault. They have forms which can either be found more perfect in other bodies, or which may be imagined more perfect." But "the majority of artists of the present day" maintain a conception of the ideal "limited to the beautiful in a single individual."[29] This observation becomes more pointed as Winckelmann singles out Gianlorenzo Bernini for special reproof, unfavorably comparing the seventeenth-century sculptor with Zeuxis:

> Bernini expressed a very superficial opinion, when he pronounced the story of the selection of the most beautiful parts, made by Zeuxis from five beautiful women of Crotona, on being employed to paint a Juno there, an absurd invention, because he fancied that a particular part or limb would suit

no other body than that to which it belonged. Others have
been unable to think of any but individual beauties; and their
dogma is, that the antique statues are beautiful because they
resemble nature, and nature will always be beautiful whenever
she resembles those beautiful statues. The former position is
true, not singly, but collectively; the second, on the contrary,
is false; for it is difficult, indeed almost impossible to find in
nature a figure like that of the Apollo in the Vatican.[30]

By citing Bernini, Winckelmann introduces an antithesis between modern (in his own time—that is, Baroque) and classical art. The modern, for Winckelmann, relies on a misguided and "superficial" adherence to nature. Classical art, in contrast, involves the idealization and abstraction of nature. But even among "those who pretend to imitate the antique" in his own time, Winckelmann finds fault when the example of Zeuxis is not followed.[31]

THE ARTIST AS GARDENER

In addition to setting up a dichotomy based on classical versus modern practices, Winckelmann's discussion naturalizes the Zeuxis legend by suggesting that "those wise artists, the ancients, acted as a skillful gardener does, who ingrafts different shoots of excellent sorts upon the same stock."[32] This horticultural metaphor compares aesthetic production to natural generation through its dependence on potent scions. Winckelmann's recourse to a gardening metaphor is not as casual as it might at first appear. His language, I believe, presents precisely the sort of interpretive primal scene outlined by Ned Lukacher, who uses the term "'primal scene' to describe the interpretive impasse that arises when a reader has good reason to believe that the meaning of one text is historically dependent upon the meaning of another text or on a previously unnoticed set of criteria." In several eighteenth-century references to Zeuxian mimesis, images of natural creativity are evoked. Forms of creation decidedly earthy and unintellectual occur repeatedly, suggesting that Zeuxian mimesis somehow triggers these associations.

Horticultural metaphors appear frequently in eighteenth-century texts on human sexuality. For example, the French physician and naturalist Nicolas Venette, in his popular *Tableau de l'amour, considéré dans l'estat du mariage,* advises men to temper their sexual ardor, warning that "Impatient Gardiners never gather the Seeds in season."[33] An artistic variation on

Venette's warning appears in a May 1775 number of the *Middlesex Journal, or Chronicle of Liberty,* where the anonymous author warns:

> When a painter forms a design to paint a fine female figure, and gets the pallet and brush in his hand, he draws his outline under the conduct of beauty and simplicity, and is so intent and eager to perform, that fear often seizes the brush and insensibly carries him from one resolution to another, till at last he is obliged to have recourse to reason, judgment and sound theoretic principles, to carry him through; and then it will sometimes happen that irresolute touches and tameness is left behind.[34]

Artists, like gardeners, need to restrain their (pro)creative enthusiasm. Analogies between aesthetic and biological generation were in fact commonplace in eighteenth-century discourse. The observations of Charles-Augustin Vandermonde in his scientific treatise *Essai sur la manière de perfectionner l'éspece humaine* (1751) include the illustrative observation that "the beauty of men is but a reflection of the beauty that the Creator has dispersed all through the universe. The order, the arrangement, the proportions, the symmetry, are all in His works. . . . when we do not consult the portrait of Nature . . . we get lost and we become prey to very bad taste."[35] The gardener, the artist, and the lover alike must adhere to Zeuxian principles of discernment and discretion.

The comparison between artistic production and (pro)creation that characterizes eighteenth-century texts finds its origins in ancient Greece. Thomas Laqueur, in *Making Sex: Body and Gender from the Greeks to Freud,* describes the Aristotelian theory of procreation, in which "conception is for the male to have an idea, an artistic or artisanal conception, in the brain-uterus of the female.[36] Similarly, Hippocrates locates the production of semen in the brain.[37] These inextricable associations among artistic production, procreation, and masculinity survive, not surprisingly, in the texts of eighteenth-century aestheticians who championed classical models.

Winckelmann's examples shift from horticultural to apicultural as he forges a simile between artistic production and sexual procreativity. A good artist not only works like a gardener but also like "a bee (who) gathers from many flowers."[38] This metaphorical association between Zeuxian mimesis and (pro)creativity also appears in the work of Winckelmann's close friend, the artist and aesthetician Anton Raphael Mengs:

> The Bee visits that only from which it can extract the richest
> sweets; thus can also the skilful painter gather from all the
> creation the best and most beautiful parts of nature, and pro-
> duce by this Artifice the greatest expression and sweetness.[39]

The bee, as it moves from flower to flower, pollinates as it gathers the "sweets" it needs. Generation of new life is linked metaphorically to Zeuxian creativity. Mengs makes explicit the similarity between artistic production and procreation in a passage on portrait painting. In contrast to Giambattista Marino's earlier invocation of the analogy to describe divine creation, Mengs uses it to discuss less-than-perfect human efforts. The portrait painter, like Zeuxis, should take only the best features from the model and rely on invention to remedy the faulty parts:

> The Art of Painting is, to choose of all the subjects of Nature,
> the most beautiful, gathering, and placing together the materi-
> als of different places, and the beauty of various persons: to
> the contrary, for instance, Nature, to form man, is constrained
> to take the material part of the mother only, subject to all its
> accidents; from whence it is visible that a portrait might be
> more beautiful than man in nature.[40]

In this passage, Mengs associates nature (coded as feminine, as was customary in the eighteenth century) with imperfection. The negative characterization of feminine influence extended, as the following paragraphs show, to aesthetic endeavors as well.[41]

Like Winckelmann, the British artist, collector, and connoisseur Jonathan Richardson never held an academic post. But his writings, more than those of any other, guided the foundation of the British Royal Academy in 1769. Richardson repeatedly, though obliquely, evokes the story of Zeuxis Selecting Models.[42] The legend surfaces implicitly in his *Essay on The Theory of Painting* (1725), as, for example, when he observes that "in good pictures we always see nature improved, or at least the best choice of it."[43] Richardson's treatise on taste and aesthetics attempts to establish connoisseurship and artistic production as noble and even patriotic activities. For Richardson, the wealth of a nation lies not only in its material production but in its cultural production as well:

> The treasure of a nation consists in the pure productions of
> nature, or those managed, or put together, and improved by

art: now there is no artificer whatsoever that produces so
valuable a thing from such inconsiderable materials of nature's
furnishing; as the painter, putting the time (for that must also
be considered as one of those materials) into the account: it is
next to creation.[44]

Richardson repeats these Zeuxian claims in his "Discourse on the Dignity,
Certainty, Pleasure and Advantage, of the Science of a Connoisseur" (1719),
where he states,

> The great and chief ends of painting are to raise, and improve
> nature; and to communicate ideas. . . . The business of painting
> is not only to represent nature, but to make the best choice of
> it; nay to raise, and improve it from what is commonly, or even
> rarely seen, to what never was, or will be in fact, though we
> may easily conceive it might be.[45]

He concludes that only the visual arts have "this advantage, they come
not by a slow progression of words, or in a language peculiar to one nation
only; but with such a velocity, and in a manner so universally understood
that 'tis something like intuition, or inspiration; as the art by which 'tis ef-
fected resembles creation."[46] According to Richardson, the artist's ability to
"manage," "put together," or "improve" nature is analogous to creation.

Finally, Zeuxian mimesis plays a central role in the *Discourses* of Joshua
Reynolds, Richardson's most prominent eighteenth-century acolyte. From
1769 to 1790, Reynolds presented occasional lectures to members and
students of the British Royal Academy as part of his duties as the acade-
my's first president. Reynolds envisioned his *Discourses* as a theoretical
complement to the practical instruction given by academy professors.
And though his ideas reflect a variety of English and continental sources,
Richardson must be reckoned chief among them. According to Reynolds,
students must study the work of earlier artists in order to learn from their
successes and failures. Like Vasari, Reynolds emphasizes that this process
should involve the careful selection of the best aspects of many artists
rather than the slavish imitation of a single painter. Reynolds acknowl-
edges the affinity between his theoretical model and the Zeuxis myth in
his sixth *Discourse:*

> A man is as little likely to form a true idea of the perfection of
> the art, by studying a single artist, as he would be to produce a

perfectly beautiful figure, by an exact imitation of any individual living model.[47]

For Reynolds, the "art of choosing" is crucial to artistic invention. Invention, which Reynolds links to genius, depends upon the evaluation of and selection from previous works of art. Reynolds states that "it is vain for painters or poets to endeavour to invent without materials on which the mind may work, and from which invention must originate."[48]

Reynolds's allusion to the Zeuxis myth serves a variety of ideological functions. First, it establishes a link between his theories and those of the ancients. Second, the pedagogical model of the Zeuxis myth justifies the existence of an academy, where young painters can study the work of many previous artists. Thus, to maintain financial and philosophical support for the fledgling Royal Academy, Reynolds stresses its role in fostering young artists of genius. Finally, Reynolds's use of the Zeuxis myth reinforces the masculinity of artistic production, for, like Winckelmann, Reynolds metaphorically links artistic production via the Zeuxis myth to male sexuality. Reynolds repeatedly compares the mind to a womb, which remains barren and unproductive without (male) fertilization. In *Discourse VI* (1774), Reynolds claims, "When we have had continually before us the great works of art to impregnate our minds with kindred ideas, we are then, and not till then, fit to produce something of the same species."[49] Later in the same *Discourse,* Reynolds rekindles the metaphor:

> The addition of men's judgement is so far from weakening our own, as is the opinion of many, that it will fashion and consolidate those ideas of excellence which lay in embryo, feeble, ill-shaped, and confused, but which are finished and put in order by the authority and practice of those, whose works may be said to have been consecrated by having stood the test of ages.[50]

Reynolds's procreative metaphors are in keeping with contemporary theories of reproduction, in which the ovum is characterized as passive and immobile in contrast to the active, life-giving sperm.[51] Clara Pinto-Correia addresses this assumption in *The Ovary of Eve,* a study of the history of theories of preformation. Pinto-Correia explains that the notion that "the female furnishes the passive matter for generation, whereas the male acts as the prime agent, energizing the passive substance to take form," derives largely from ideas recorded in Aristotle's *Generation of Animals.* These ideas

were popularized by the pseudo-Aristotelian author of *Aristotle's Compleat Masterpiece,* which remained in continuous publication from the seventeenth through nineteenth centuries in Europe and North America. The passivity of the female contribution to conception is made clear at the beginning of the section devoted to procreation:

> Now in conception, that which is first to be regarded, and without which it cannot be, is the seed of the man, that being the active principle or efficient cause of the foetus. . . . The next thing is the passive principle of the foetus (for there must be both in order to conception) and this is an ovum, or egg, impregnated by the man's seed.[52]

Or, as the Italian physician Fabricius d'Aquapendente explains in his treatise *De formatione ovi et pulli* (1621), "the semen *perfects* the egg; it does not, however, exist within that which is generated but endows it with form and makes it a living creature by the power residing in it" (emphasis added).[53] In addition, infertility, birth defects, or "monstrous births" were generally attributed to the mother. *Aristotle's Compleat Masterpiece* includes this commentary in a section on "the signs of insufficiency in men: and barrenness in women":

> I must first premise that women are subject to many infirmities more than men, that the cause of barrenness is oftener on their side than the man's. For, if the man has the instrument of generation perfect, being in health, and keeping a regular temperate diet and exercise, I know no accidental cause of barrenness in him: whereas the cause of barrenness in a woman lies in her womb, and the infirmities incident thereunto.[54]

Though *Aristotle's Compleat Masterpiece* allows that defects may result from problems "in the seed or in the womb," any culpability on the part of the father's contribution is quickly passed over as he outlines the numerous ways the mother might have caused the defect. Her mood or thoughts at the time of conception or during pregnancy, her physical strength and health, and even her menses can cause "unnatural issue."[55] Even deformities or monstrosities believed to result from "hybridism," or interspecies copulation, were generally blamed on the indiscriminate lasciviousness of women.[56]

The currency of these ideas is made explicit even in the writings of the marquis de Sade. Like the pseudo-Aristotelian author of *Aristotle's Compleat*

Masterpiece, Sade promulgates the belief that women have little to do with procreation. In Sade's unrelentingly misogynistic *Philosophy in the Bedroom* (1795), the libertine Madame de Saint-Ange explains to her protégé Eugénie de Mistival,

> Although it is proven that the fetus owes its existence only to the man's sperm, this latter, by itself, unmixed with the woman's, would come to naught. But that which we women furnish has merely elaborative function; it does not create, it furthers creation without being its cause.[57]

Reynolds may or may not have had firsthand knowledge of contemporary theories of sexuality, but his description of artistic production reveals that both artistic and sexual discourse derive from a similar ideology. Specifically, the *Discourses* expose an ideology that counterposes masculine activity and creativity to feminine passivity and infecundity.

Implicit in academic invocations of Zeuxian mimesis is the imperfection of nature, coded as feminine, which can be corrected through artistic intervention. For example, Reynolds describes nature's relationship to the artist, who "corrects nature by herself, her imperfect state by her more perfect."[58] Although the glossing of nature as feminine was hardly an eighteenth-century novelty, the codification of artistic production as masculine reached a crescendo as the century drew to a close. In both England and France, limits on the number of women artists in the officially sponsored academies became institutionalized. In 1777, the French Royal Academy decided to limit its previously unrestricted number of women members to three. The British Royal Academy, which included two women members upon its foundation in 1769, barred the admission of additional women members and continued to do so until the twentieth century.

Eighteenth-century academic references to the Zeuxis myth reveal a sustained insistence that masculine creative endeavors—whether biological or aesthetic—could approach or even achieve perfection through Zeuxian practices of restraint and discrimination. Bellori's notion of the artist as a sort of divine creator are here brought down to earth and fitted into an organic, biological model. In this way, Reynolds, Winckelmann, and their eighteenth-century contemporaries present a post-Enlightenment Zeuxis.

The comparison between artistic production and (pro)creation, which occurs repeatedly in eighteenth-century aesthetic discourse, is at the heart of what I have been calling the Zeuxis myth. As the preceding examples show, commentators rely on the Zeuxis myth to establish a hierarchy between

nature and art, in which art emerges as superior due to its closer approximation to perfection. The metaphorical associations between Zeuxis Selecting Models and masculine sexuality posit artistic production as an exclusively male activity.[59] Zeuxian agency is not extended to women. But what, exactly, would happen if a woman tried to paint like Zeuxis?

5
Women Artists
and the Zeuxis Myth

The addition of men's judgement is so far from weakening our
own . . . that it will fashion and consolidate those ideas of excel-
lence which lay in embryo, feeble, ill-shaped, and confused.

 JOSHUA REYNOLDS, DISCOURSE VI

We have never seen a living model equal in symmetry and ele-
gance to an ancient statue, nor is it possible to be so; because, like
Helen of Zeuxis, these are composed of the *beauties* of several
of the most perfect figures that . . . could be found. *Angelica*
therefore, we believe, caught those irresistible graces that played
around her picturesque forms from the models that she studied.

 JOSEPH MOSER, ON ANGELICA KAUFFMAN

A PERSISTENT COMPARISON between artistic creativity and masculine pro-
creativity inflects academic discourse of the seventeenth through nine-
teenth centuries. Thematized by the legend of Zeuxis Selecting Models, the
comparison valorizes aesthetic "implanting," "sowing," and "impregnating."
This coincidence of aesthetic and reproductive metaphors partakes of the
then widespread presumption that *all* creation depends upon the action of
a masculine principle (see chapter 4). Academicians simply translated such
assumptions into artistic practice. The explicit and implicit sexism of aca-
demic practice has, of course, long been acknowledged. Since the 1970s,
feminist art historians have documented the causes as well as the conse-
quences of the codification of serious art making as masculine.[1] These cri-
tiques have focused mainly on the roles played by institutions and social

conventions in enforcing sexist beliefs and practices. Because of these per-
suasive studies, the assertion that women artists have been (and continue
to be) subject to different social forces than their male counterparts is no
longer contested. What remain to be explored, however, are the theoretical
impulses that sustain these conditions.

Aesthetic theory serves as a vehicle for the ideologies sustained by insti-
tutional and other social behavior. In order to understand fully the practice
of women artists, the theoretical bases for their real or perceived difference
must be analyzed. The legend of Zeuxis Selecting Models—and the theory
of mimesis it promulgates—offers a promising point of entry into such an
inquiry.[2] Its emphasis upon sexual difference and masculine creative poten-
cy makes Zeuxis Selecting Models a particularly rich theoretical example.
By exploring the ways women have negotiated Zeuxis Selecting Models in
post-Renaissance visual and literary arts, the cultural as well as psychical
significance of the myth becomes apparent.

ANGELICA KAUFFMAN AND THE POSSIBILITY OF A FEMALE ZEUXIS

Among the few eighteenth-century painters to depict the theme of Zeuxis
Selecting Models is Angelica Kauffman (1741–1807).[3] A child prodigy who
received most of her early training from her artist father, Kauffman was an
established portrait painter in her native Switzerland by her fifteenth birth-
day. Josef Kauffmann recognized his daughter's artistic as well as commer-
cial potential, and he resolved to move with her to Italy where there awaited
more lucrative commissions as well as greater opportunities for her further
training. The pair eventually settled in Rome in 1763.

Rome presented Angelica Kauffman with new commissions and, more
important for this study, new teachers and colleagues, including Anton
Raphael Mengs, Benjamin West, Nathaniel Dance, and Pompeo Batoni, all
of whom painted in an incipient neoclassical style. During this first Roman
sojourn, Kauffman increasingly experimented with antique costumes and
classical themes in her work. And her acquaintance with Johann Joachim
Winckelmann only further propelled her interest in neoclassicism. They
met in 1763 as Winckelmann was completing his influential *History of
Ancient Art* (1767). Impressed by Kauffman's artistic and musical abilities,
Winckelmann cultivated an acquaintance, even instructing her in classical
history and literature. His passion for ancient Greek and Roman culture as
well as his aesthetic principles changed the direction of Kauffman's art (I
discuss Winckelmann's engagement of the Zeuxis Myth in chapter 4). Not
content only to paint portraits, she aspired to produce scenes of ancient his-

tory and myth, though history painting normally fell beyond the purview of women painters. Social mores prevented women from studying nude models, and the nude or nearly nude god or hero was essential for most history painting. Yet Kauffman managed to circumvent the constraints placed on most European women in the eighteenth century: Instead of studying live models, she learned anatomical rendering by drawing after the antique statues made available to her by Italian collectors.[4]

Still, it was Kauffman's skill as a portrait painter that brought her early recognition. By 1765, her reputation in this genre had attracted international interest. Her particular success with English clients induced her to leave Italy for London. There she anticipated—and found—an audience appreciative of her distinctive approach to history painting. Fusing neoclassical subjects and sentiments with the rich, painterly surfaces of the Italian old masters admired by British collectors, Kauffman's style perfectly suited the tastes of her purposed patrons. And it was during her extended stay in England, from 1766 to 1781, that she embarked in earnest on her career as a history painter.

Kauffman's efforts to secure English patrons were aided by Joshua Reynolds. Introduced to him by one of her aristocratic sitters, she and Reynolds struck up an immediate and lasting friendship.[5] The relationship carried important professional consequences. Reynolds smoothed her entrée into the London art world, even naming her a founding member of the British Royal Academy.[6] Their professional and personal relationship renders certain Kauffman's familiarity with Reynolds's aesthetic theories, especially those outlined in chapter 4. Like Winckelmann, Reynolds upheld the model of Zeuxis as he rhetorically linked mimetic practice with masculine procreativity. Kauffman's painting *Zeuxis Selecting Models for His Painting of Helen of Troy* (Figure 14) shows, in fact, not only her awareness of the theme's implication in masculinist discourse but her desire to circumvent academic prejudice against women artists.

The precise circumstances surrounding the painting's production remain muddy. According to Frances Gerard, one of Kauffman's early biographers, George Bowles commissioned the work.[7] Gerard gives no evidence for this assertion nor any details about the transaction. But Bowles's status as Kauffman's most dedicated patron makes this provenance plausible. Bowles and Kauffman became acquainted during the latter's residence in Venice from October 1781 to April 1782.[8] As the birthplace of her husband, the painter Antonio Zucchi, Venice held personal as well as artistic appeal.[9] Kauffman's introduction to Bowles during this Venice sojourn is significant because it coincides with Zucchi's initiation of a running inventory of his wife's new commissions. Begun in 1781, Zucchi's "Memorandum

of Paintings" offers the only contemporary account of Kauffman's oeuvre, but it makes no mention of her *Zeuxis Selecting Models*.[10] The silence of the "Memorandum" with regard to the *Zeuxis Selecting Models* cannot, however, be accepted as conclusive evidence that Kauffman completed the painting prior to 1781 because the "Memorandum" is particularly unreliable for the years 1781–1782.[11] At any rate, the painting has a definite terminus ad quem: Kauffman's *Zeuxis Selecting Models* must have been completed by 1785, because in July of that year, William Palmer published Francesco Bartolozzi's

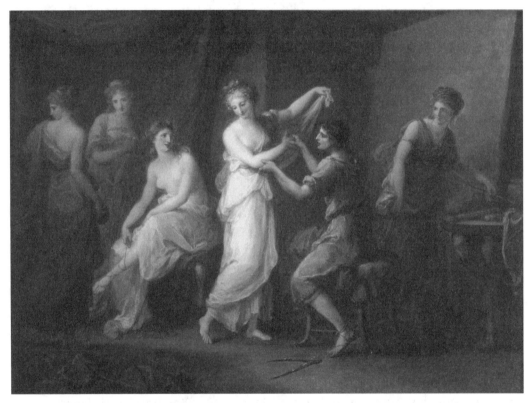

Figure 14. Angelica Kauffman, *Zeuxis Selecting Models for His Painting of Helen of Troy* (oil on canvas, ca. 1780-82, Brown University Library, Providence, R.I.). Photograph courtesy of Brown University.

engraving after the painting (Figure 15).[12] *Zeuxis Selecting Models* must have been in London and available to Bartolozzi at least a few months prior to the print's publication. These circumstances all but confirm an English patron.

Probably the painting was begun in Venice in late 1781 or early 1782. In July 1781, while still in London, Kauffman had shipped most of her belongings and unfinished works to Naples. But before heading to Naples, Kauffman, her fa-

ther, and Zucchi first visited Switzerland and then Venice. The "Memorandum" and other sources confirm that Kauffman embarked on several new projects during this trip, and *Zeuxis Selecting Models* was probably among these.[13] Formally, it is consistent with attested works dated just prior to and immediately following her departure from England.[14] Moreover, in 1781 Venice possessed one of the few extant representations of the subject.[15]

In Venice's Palazzo Albrizzi, Kauffman would have seen Ludovico David's seventeenth-century fresco *Apelles Painting the Graces* (Figure 16).[16] As was

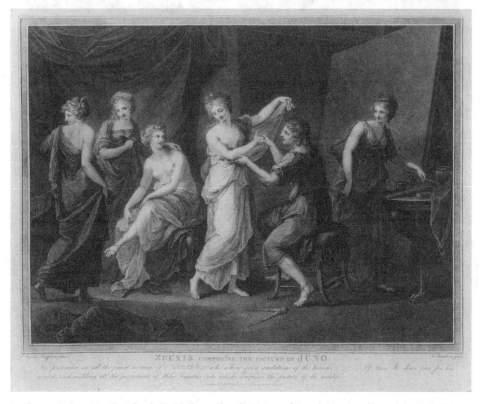

Figure 15. Francesco Bartolozzi, *Zeuxis Composing the Picture of Juno* (engraving, brown ink, 1785, Yale Center for British Art, Paul Mellon Collection). Photograph courtesy of Yale Center for British Art.

often the case during the seventeenth and eighteenth centuries, the stories of Apelles and Zeuxis are here confused and conflated. Regardless of its modern title, the scene unquestionably represents Zeuxis Selecting Models. Several nude or nearly nude women pose, dress, undress, and even cower before the intent artist. His stylus rests suspended above the canvas as he studies a model posed as a *Venus pudica*. Here design clearly takes

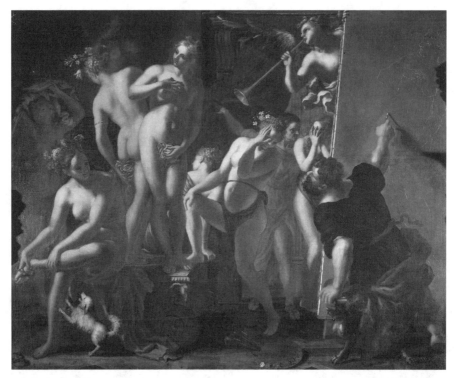

Figure 16. Ludovico David, *Apelles Painting the Graces (la Scuola del nudo)* (fresco, ca. 1667–86, Palazzo Albrizzi, Venice).

precedence over color: Zeuxis's palette sits abandoned on the floor next to the canvas.[17] The artist's active, intellectual pursuit of perfection comes through his ability to distill beauty from a variety of natural models.[18]

Not only is David's fresco the probable spark for Kauffman's pursuit of the subject, but his composition furnishes a clear model.[19] Of course, their paintings exhibit obvious differences motivated by their distinct media, styles, and decorum. But important similarities exist. Both artists employ the same general schema, grouping the female figures together on the left side of the composition and setting Zeuxis and his canvas apart on the right. In both works, Zeuxis examines a model posing as Venus (as discussed in chapter 2, Venus functions as a mythic analogue to Helen). In addition, a seated model adjusting her sandal also appears in both paintings.[20] Nude in David's version, the figure in Kauffman's has only her arms and torso exposed. Folds of drapery obscure her hips and legs. Kauffman seems also to have adopted David's disposition of the models into a variety of graceful views. The dynamic postures of David's figures are treated, however, with greater restraint and composure in her rendition.[21]

Kauffman and Zucchi left Venice in April 1782. They traveled first briefly to Rome and then on to Naples, where they retrieved their furnishings and other possessions. Kauffman probably completed the painting in her temporary Naples studio.[22] She was in frequent communication with Bowles at this time. Bowles commissioned several paintings while Kauffman lived in Naples; perhaps the *Zeuxis Selecting Models* sailed to London along with these or with the *Alexander and Apelles,* the *Cleopatra,* and the *Poetry Embracing Painting,* which she sent to him from Rome in 1782 and 1783. Certainly, the *Zeuxis Selecting Models* would have functioned as the appropriate pendant to her *Alexander and Apelles.*[23] In any event, Kauffman's *Zeuxis Selecting Models* was certainly in London by late 1784 or early 1785, in time for Bartolozzi to produce his engraving.

The original title of Kauffman's *Zeuxis Selecting Models* is, like its patron, uncertain. Modern scholars refer to the painting as *Zeuxis Selecting Models for His Painting of Helen of Troy,* though Bartolozzi's engraving bears the legend "Zeuxis Composing the Picture of Juno." Since Kauffman and Bartolozzi worked together frequently and closely, the engraver probably used the title intended by Kauffman. The reference to Juno rather than Helen in the title suggests that the literary source for the painting was Winckelmann rather than Cicero or Pliny.[24] Neither classical nor contemporary sources, however, can account entirely for the painting's unusual composition.

Kauffman's general disposition of figures conforms, appropriately, to a classically inspired frieze format. Four models—seen from different angles and assuming various poses—occupy the left side of the canvas. Their glances, too, reveal physical and emotional diversity. The model furthest left faces away from the viewer, casting her gaze over her shoulder toward the edge of the canvas. To her right another model stands holding close her garment while looking toward the viewer. The seated model next to her watches Zeuxis, who sits to inspect a fourth model. Kauffman subordinates the rest of the painting to this encounter between Zeuxis and the fourth model: This exchange occurs at the center of the canvas and is brightly illuminated. By muting the other figures in relation to this pair, Kauffman prevents her horizontal composition from becoming static or flat. The striking light cast on Zeuxis and the central model sculpts their forms as it introduces a thematic if not pictorial foreground. Additionally, the isocephalic disposition of figures common to friezes has been avoided: Zeuxis and the models alternately stand, turn, and bend.

Zeuxis sits with his back to his unfinished canvas, discarded calipers at his feet: The measure of beauty must finally be determined by the artist.[25] He gently holds the right arm of the model he regards. Supporting her hand

and elbow, Zeuxis appears to be adjusting her position, and with her arms raised and head turned, she mimics the pose of the Venus Kallipygos.[26] Kauffman's citation of the ancient sculpture here makes perfect historical sense since it is a Roman copy of a fourth-century Greek piece; the original would have been produced around the time that Zeuxis purportedly lived. Kauffman possibly had firsthand knowledge of the piece from her travels to Naples, where it formed part of the Farnese collection. Her conversations with Winckelmann are another probable source of information on the Venus Kallipygos.[27] The frequently copied sculpture would also have been available to her as a plaster cast or engraving. No matter the source, the judicious quotation distinguishes Kauffman's Winckelmannian neoclassicism from the anachronistic pastiches often produced at the time. In addition to conveying her erudition, the quotation testifies to her ability to choose prudently, like Zeuxis, from hundreds of possible models.

Completing the scene at the far right is Zeuxis's unfinished painting and another, unidentified, woman. This figure stands before the canvas, watching Zeuxis and holding one of his paintbrushes in her left hand. Her gesture suggests that she has either just taken up the brush or is about to place it on the table next to the canvas. Who is this enigmatic figure? Although she could be the fifth model mentioned by Cicero and Pliny, her station before the canvas does not recommend this role, and her dress differs from that of the models. She wears heavier drapery with no sign of the models' dishabille. A bracelet encircles her right arm, her hair is loosely taken up in a turban, and she wears slippers, in contrast to the barefoot or sandaled models. Clearly, Kauffman intends for us to understand that this woman does not serve as a model. Another clue to the woman's identity comes through her apparent invisibility to the other figures in the scene. Neither Zeuxis nor the models pay her any notice. Taken together, these clues suggest that the woman functions apart from the main narrative. Most likely, she is an allegorical figure, perhaps a representation of Inspiration or Painting.

If Kauffman intended the figure to be understood as a personification of some idea, she no doubt consulted Cesare Ripa's *Iconologia*.[28] Ripa describes the appearance and attributes of 424 allegorical figures, from "Abondanza" [sic] (Plenty) to "Zucca" (Zeal). Seventeenth- and eighteenth-century painters routinely consulted this source when depicting allegorical figures, and Kauffman was no exception.[29] She relied on it for many of her compositions.[30] A good example of her use of the *Iconologia* occurs in *Beauty Directed by Prudence Rejects with Scorn the Solicitations of Folly* (a stipple engraving of which appears in Figure 17). As Ripa recommends, Prudence "carries a looking glass in her left hand," though Kauffman foregoes the "gilded helmet

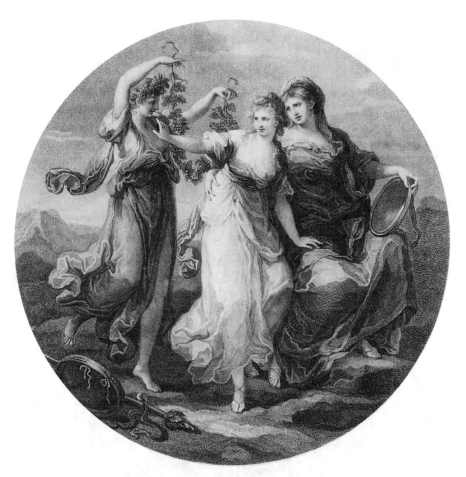

Figure 17. J.-M. Delattre, after Angelica Kauffman, *Beauty Directed by Prudence Rejects with Scorn the Solicitations of Folly* (stipple engraving, 1783, British Museum, London). Photograph courtesy of the Trustees of the British Museum.

on her head," the "stag by her," and the "arrow, and a remora fish twisting about it" held in her right hand.[31] Where one attribute will suffice, Kauffman avoids burdening her scenes with the redundant symbolism popular in Baroque imagery.

Kauffman takes a similarly selective approach to the allegorical figure in *Zeuxis Selecting Models.* Her paintbrush and costume offer the strongest clues to her identity. Paintbrushes are an attribute of two figures in Ripa: Painting and Imitation. In fact, the two are closely related: Ripa attributes to Painting a pendant with "Imitatio" inscribed upon it.[32] His description of Imitation is brief, citing not only the paintbrushes but also a mask in one hand and a monkey at her feet. Neither of these latter two attributes appears (though the emphatically zoomorphic table leg next to the figure

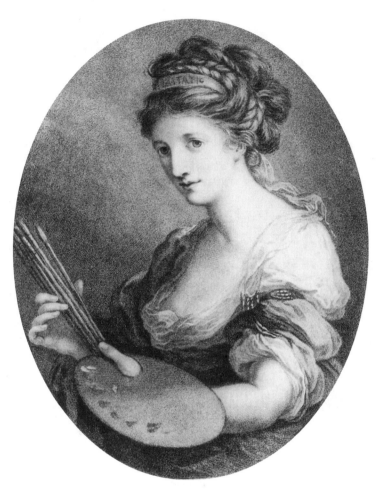

Figure 18. Thomas Burke, after Angelica Kauffman, *Self-Portrait as Painting* (stipple engraving, 1781). Photograph courtesy of Paul Mellon Centre for British Studies, London. Reproduced with permission from David Alexander.

suggests some animal's presence).[33] Of the attributes Ripa gives to Painting, the figure in Kauffman's *Zeuxis Selecting Models* bears the twisted dark hair *("capelli neri . . . ritorti in diverse maniere"),* the colorful costume *("veste di drappo cangrante"),* and the forehead illuminated by mental energy *("pensieri fantastichi").*[34] Inclusion of the palette Ripa ascribes to Painting would have secured the figure's identity but would also have lent a sharply anachronistic note to a scene supposedly taking place during the fourth century BCE.[35] Missing, too, is the gold chain with mask pendant that Ripa places around the neck of Painting. Kauffman's habit of distilling Ripa's descriptions is evident in other representations of Painting. As an example, in her *Self-Portrait as Painting* (a stipple engraving of which appears in Figure 18),

Figure 19. Angelica Kauffman, *Self-Portrait Hesitating between Music and Painting* (oil on canvas, 1791, Nostell Priory, West Yorkshire). Copyright National Trust Photographic Library.

Kauffman holds brushes and palette and wears a head scarf embroidered with "imitatio." A similar rendition of Painting appears in her *Self-Portrait Hesitating between Music and Painting* (Figure 19). She offers a closer interpretation of Ripa in her design for a fan, *The Three Fine Arts* (Figure 20).

But with her *Zeuxis Selecting Models*, I believe Kauffman goes beyond abridging Ripa's personifications. Here she offers instead a condensation of three ideas: Painting, Imitation, and Invention. The only jewelry worn by the figure is a bracelet high on her right arm. A similar ornament appears on the personifications of Painting and Invention included in the 1779 English edition of Ripa's *Iconologia* (Figures 21 and 22).[36] The bracelet also adorns a

Figure 20. Angelica Kauffman, *The Three Fine Arts* (drawing for a fan from a scrapbook, sepia and ink on paper, ca. 1780, Burghley House Collection, Stamford, U.K.). Photograph courtesy of Burghley House.

representation of Imitation executed by Kauffman circa 1780–81. Given this collection of attributes, I believe Kauffman means to personify mimesis as it involves painting, imitation, and invention. The presence of a figure symbolizing these ideas would be especially appropriate for a representation of Zeuxis Selecting Models.

The significance of the enigmatic woman standing before Zeuxis's canvas grows more complex when her resemblance to the artist is taken into account. Albert Boime first identified the woman as a self-portrait.[37] The likeness emerges clearly when compared with other contemporary self-portraits. And Kauffman frequently portrayed herself as an allegorical fig-

Figure 22. E. M., *Invention* (engraving from the 1779 English edition of Cesare Ripa's *Iconologia*). Photograph courtesy Rare Book, Manuscript, and Special Collections Library, Duke University, Durham, N.C.

ure, rendering this conceit consistent with her usual practice.[38] Kauffman's presence in the scene alters its meaning: The painting now represents two artists at work, Zeuxis and Kauffman. Indeed, Kauffman signals her usurpation of Zeuxis's artistic agency by signing her name on "his" canvas, where along the bottom edge the inscription "Angelica Kauffman Pinx." can be discerned (Figure 23). Kauffman's imposition of herself into the scene skews the narrative of Zeuxis Selecting Models and disrupts the legend's theoretical underpinnings.[39]

Angela Rosenthal attributes to Kauffman's self-portrait in *Zeuxis Selecting Models* a deliberate challenge to the masculine hold on creative agency:

Figure 23. Detail of signature on *Zeuxis Selecting Models for His Painting of Helen of Troy*. Photograph courtesy of Brown University Library.

The challenges formulated in the picture now take on a new dimension owing to Kauffman's intrusion into the piece. By placing herself as an active artist in front of a canvas, she has not only dispossessed Zeuxis of one of his models but has simultaneously also deprived him of his status as a painter by taking his painting equipment into her possession. Zeuxis appears no longer as an artist but rather as an assistant in Kauffman's studio.[40]

That Kauffman's *Zeuxis Selecting Models* offers an emancipatory gesture is evident, according to Rosenthal, not only through the artist's imposition of a self-portrait into the scene but through her suggestive references to the theme of the Judgment of Paris. According to Rosenthal, Zeuxis's pose as well as his demeanor recalls images of Paris choosing among the three goddesses vying for the golden apple. In this way, Rosenthal explains, Kauffman subtly points out the erotic impulse underlying the Zeuxis legend while providing a resolution to the problem. Kauffman shows us that the only artist who can remain intellectually engaged in the face of overwhelming physical (natural, feminine) beauty is a woman artist. Women artists—in the dominantly heterosexual culture of eighteenth-century Europe—find themselves

for once in an uncharacteristically privileged position vis-à-vis their male counterparts.

Kauffman's interpretation bears kinship not only to the Judgment of Paris but also, Rosenthal argues, to the story of Pygmalion and Galatea. Rosenthal offers a compelling reading of the painting's central drama, where Zeuxis holds the arm of the model posing as Venus Kallipygos. For Rosenthal, this vignette enacts another instance of artistic creation that results from erotic desire:

> Another legend is also evoked here owing to the fact that Kauffman's "Zeuxis" does not attempt to detect the female figure before him with his eyes, but with his sense of touch. This reminds us of the Greek sculptor Pygmalion who falls in love with an idealized female statue which he had created. It is almost as if Kauffman's portrait of a beautiful woman, bathed in bright light, with her skin and garments as white as marble has only been brought to life at this moment by Aphrodite—at Pygmalion's behest.[41]

By calling to mind Pygmalion's performance, Kauffman redoubles the scene's latent erotic charge. And, as Rosenthal points out, eighteenth-century academic discourse advocated a rational, intellectual approach to aesthetics as it warned against succumbing to the seductive power of art making. Kauffman's Zeuxis appears vulnerable to such excitation. Tremulously holding the model's arm, he has all but abandoned his canvas. By figuring herself into the scene, calmly holding the brush and standing before the easel, Kauffman claims precisely the "reason and judgment" so often denied women in this period. Rosenthal asserts that Kauffman overtly critiques the sexism of eighteenth-century academic theory and practice. What is more, Kauffman theorizes and asserts a different model of artistic agency. She offers herself—and presumably other women artists—as an exemplar of the coolheaded artist-intellectual.

What Rosenthal's compelling interpretation fails to take into account is Kauffman's decision to personify herself as an allegorical figure. As already discussed, the self-portrait inserted into her *Zeuxis Selecting Models* signifies the concept of mimesis as well as Kauffman herself. By assuming this guise, Kauffman delivers an oblique challenge to social norms and academic conventions. I do not believe she enacts here a "seizure" of artistic agency. Rather, casting herself as the traditionally female personifications of Painting, Imitation, and Invention, she forestalls any claim to artistic authority. In other words, Kauffman constructs a formulaic identity behind

which she can safely challenge exclusively masculine claims to artistic authority. By hiding her subjectivity beneath the veil of masquerade, Kauffman achieves authority while avoiding patriarchal retribution.

The use of a feminine masquerade by women was first described by Joan Riviere in her essay "Womanliness as Masquerade."[42] A Freudian psychoanalyst, Riviere observed that her female patients with successful professional careers tend to exhibit exaggerated feminine traits during moments of professional competition with men. Riviere suggests that these patients suffer from an unresolved Oedipus complex that causes them to fear retribution from their fathers or other men. By adopting traditionally masculine careers, these women challenge male authority.[43] Riviere concludes that such women put on a "mask" of "womanliness" in order "to hide the possession of masculinity and to avert the reprisals expected if [they were] found to possess it."[44]

Riviere's account of a feminine masquerade may help uncover the subversive potential of Kauffman's allegorical self-portrait. I am proposing that Kauffman hides her possession of artistic authority behind a mask of womanliness. She does this throughout her career by representing herself as various allegorical figures, which, in Western art, are preponderantly female. Ripa describes the personifications of Painting, Imitation, Invention, and Design—all of which serve as Kauffman's pictorial alter egos—as women.[45] Through this strategy, Kauffman lays claim to artistic agency without overtly challenging social norms.[46] The presence of a self-portrait in her *Zeuxis Selecting Models* certainly asserts artistic agency, and it also engages other issues generated by the Zeuxis myth. Her presence in *Zeuxis Selecting Models* disrupts the legend's libidinal circuit of exchange among the artist, the models, and art making. What is more, Kauffman's gesture promises to assuage the theme's uncanny narrative, discussed in chapter 2. Her introduction of a reassuring, whole, and active female presence into the scene suggests a transformation of the uncanny narrative. Yet her position *before* the canvas propels a twofold intervention. Ultimately, the token of reassurance becomes a harbinger of the uncanniness of mimetic representation.

Angela Rosenthal points out that Kauffman's self-portrait is framed by Zeuxis's canvas. She appears *in* as well as *before* his picture. Thus, she offers herself simultaneously as artist and as image. In this way, Kauffman ingeniously resolves the problem of the painting-within-a-painting posed by the theme. What, exactly, should this imaginary canvas reveal? Since the subject implies that Zeuxis is still working on his painting, an unfinished canvas seems logical. What is more, to represent Zeuxis's finished work would be an act of sheer hubris, given the painting's reputed perfection.[47] Renaissance

artists usually obviated the problem by showing Zeuxis sketching on a tablet.[48] Ludovico David simply pushes Zeuxis's canvas to the edge of the scene so that it is barely visible (Figure 16). Perhaps not surprisingly, academically trained artists of the seventeenth and eighteenth centuries—schooled to be as concerned with the process of painting as with its consequences—give Zeuxis's painting a prominent place in their compositions. But this option causes problems. In François-André Vincent's 1789 version, the most famous academic example, the figure outlined on the canvas seems complete (Figure 24).[49] This raises questions: Why does Zeuxis continue to seek additional models? Why does he appear so excited at finding *this* model? Vincent's studies for the painting show a blank canvas, suggesting that he had not entirely resolved the problem before embarking on the final version (Figure 28).[50] His attempt at resolution is ultimately unsatisfactory insofar as it destabilizes the meaning of Zeuxis's gestures.[51] Although Nicolas Monsiau based his 1797 version largely on Vincent's, he mitigates his predecessor's awkward handling of Zeuxis's masterpiece. Monsiau hangs a drape across part of the canvas and places a smoking brazier in front of it so that only a small part of an outline can be discerned (Figure 30).[52]

Kauffman's provocative solution to the problem of the picture-within-a-picture enables her self-portrait to oscillate between an image of artistic genius and of beauty. Kauffman is at once Zeuxis and the ideal he seeks to paint. Overlaid onto the uncanny narrative of Zeuxis Selecting Models, however, Kauffman's self-representation veers toward that of a phallic mother. Simultaneously signifying procreation via her association with Zeuxis and a threatening sexuality as Helen, Kauffman makes visible the previously untheorized female Zeuxis. But the female Zeuxis, like Lilith or Prometheus's successor Pandora, manifests destruction as well as creation. "The phallic mother represents the conflation, compaction, and concretion of all the most primitive fears and desires of hegemonic heterosexist white bourgeois patriarchy," writes Marcia Ian.[53] Her description of the phallic mother helps explain the institutional reception of Kauffman's *Zeuxis Selecting Models*.

Surprisingly, the painting was never exhibited at the Royal Academy, although Kauffman was a frequent contributor to the annual London exhibition from its inauguration in 1769.[54] Even after returning to Italy in 1781, she continued to show her work there regularly. The painting's size and subject are consistent with her other academic presentation pieces. And the degree of finish as well as the attention to anatomy and proportion distinguish the *Zeuxis Selecting Models* as an exceptional example of her work. Whether by the artist's choice or not, the painting's absence from the walls of the Royal

Academy exhibitions suggests that Britain's leading arts institution could not accommodate her version of the scene.[55]

Evidence for institutional resistance to the painting appears in Bartolozzi's engraving after the work (Figure 15). Many of the painting's potentially subversive features are eliminated. Bartolozzi modifies the composition in order to restore masculine artistic control. Bartolozzi lowers the gaze of the model who looks directly at the viewer in Kauffman's painting. This locus of potential feminine subjectivity is thus obliterated. He also closes the eyes of the woman Zeuxis physically examines, deemphasizing her agency as well. Most importantly, he removes the inscription "Angelica Kauffman Pinx." from the canvas within the painting. These subtle changes erase the subjectivity and authority of the female figures, including that of Kauffman herself. Whether deliberate or unconscious, Bartolozzi's changes to Kauffman's composition reveal the potency of her assertion of feminine authority.

Not only does Kauffman's interpretation of Zeuxis Selecting Models expose the theme's propagation of gendered stereotypes about art making, but it also reveals its uncanny purpose. Her imposition of a self-portrait into the scene challenges the sexual stereotypes of and social limitations on women, and at the same time it undermines the narrative's fetishistic efficacy. Like any conscious recollection of a primal scene, Zeuxis Selecting Models disguises an experience of horror with a comforting memory. Trauma is thus mastered by revisiting the moment of psychic shock from a position of mastery and confidence. By casting herself both as a Zeuxian creator and a feminine ideal, Kauffman evokes the trauma embedded in the legend. Her self-presentation as an artistic phallic mother threatens to realize rather than repress the uncanny. Therefore, the painting required discursive management. With its circulation minimized to private viewings and its reproduction modified to reaffirm the legend's fetishistic function, Kauffman's *Zeuxis Selecting Models* slipped into obscurity.[56]

FRANKENSTEIN, OR THE MODERN ZEUXIS

A generation later, another woman would retell the story of Zeuxis Selecting Models. In her novel *Frankenstein*, Mary Shelley, like Angelica Kauffman, critiques the link between creative practice and masculinity embedded in the Zeuxis myth. And, in so doing, she likewise exposes the theme's uncanniness. Specifically, Shelley challenges the fetishistic comfort of the Zeuxis myth by recasting it as a tale of monstrosity.[57] Zeuxis's attempt to manifest the ideal through recourse to real models finds an apt parallel in Dr. Frankenstein's creation of a living being from parts of corpses. The trauma

and fetishistic impulse contained within the Zeuxis myth expresses itself plainly in Shelley's gothic novel.

Though often rehearsed, *Frankenstein*'s genesis requires mention here. Mary Wollstonecraft Godwin Shelley began the book in June 1816 while she and Percy Shelley were living in Switzerland on the shores of Lake Geneva. Their new acquaintance Lord Byron had taken a villa nearby. The three of them—along with Byron's friend and physician John Polidori—agreed one rainy evening to amuse each other by composing ghost stories.[58] Byron and Percy Shelley started theirs almost immediately; even Polidori soon began to write. But Mary Shelley—then only nineteen—could not fix upon a tale. For several days the others would ask how her story progressed. "And each morning I was forced to reply with a mortifying negative." The reason for her mortification, she explains, was her intention to devise

> a story to rival those which had excited us to this task. One
> which would speak to the mysterious fears of our nature,
> and awaken thrilling horror—one to make the reader dread to
> look round, to curdle the blood, and quicken the beatings of
> the heart. If I did not accomplish these things, my ghost story
> would be unworthy of its name. I thought and pondered vainly.
> I felt that blank incapability of invention which is the greatest
> misery of authorship.[59]

This wish to make her literary mark was not new. She longed for intellectual community, perhaps even parity, with writers like Byron and Percy Shelley, as well as with her parents, Mary Wollstonecraft and William Godwin. Her liaison with Percy Shelley only sharpened this desire. As she later explained, "My husband was, from the first, very anxious that I should prove myself worthy of my parentage, and enrol myself on the page of fame. He was for ever inciting me to obtain literary reputation."[60] With these concerns plaguing her, it is no surprise that Mary Shelley eventually produced a story that deals as much with artistic invention as with "thrilling horror."

Invention, as understood in England at the beginning of the nineteenth century, required emulation as well as originality. Neither a product wholly of the artist's (or author's) imagination nor a slavish recapitulation of earlier works, invention accorded with the dual process of Zeuxian mimesis: copying and then improving upon what is observed. The chief British advocate of this definition of invention during the eighteenth century was, of course, Joshua Reynolds. "Invention . . . is little more than a new combination of those images which have been previously gathered and deposited in the

memory."[61] For Reynolds, originality remains under tight constraint by the academic practice of emulation. The writings of the influential British artist and aesthetician Alexander Cozens (1717–86) document a slight but important shift in British aesthetic theory of the late eighteenth century.[62] In his *New Method of Assisting the Invention in Drawing Original Compositions of Landscape* (1785), Cozens defines invention for his readers:

> Composing landscapes by invention, is not the art of imitating individual nature; it is more; it is forming artificial representations of landscape on the general principles of nature, founded in unity of character, which is true simplicity; concentrating in each individual composition the beauties, which judicious imitation would select from those which are dispersed in nature.[63]

Though Cozens's deployment of invention accords with conventional academic theory, his popularity among romantic authors and artists indicate the currency of his ideas in a wider circle (on the academic characterization of mimesis and invention, see chapter 4). Romantic artists would, by the 1830s, recalibrate invention to rely more upon individual fantasy. Concomitantly, realist theories promulgated a notion of invention based on a close record of nature. John Ruskin's declaration that "all so-called invention is in landscape nothing more than appropriate recollection—good in proportion as it is distinct" exemplifies the latter conception of invention, popular by the mid-nineteenth century.[64] But writing in 1816, Mary Shelley would have still understood invention as a delicate balance of imagination and convention.[65]

Classical, romantic, and realist definitions, however, equally presumed genius as a precondition for invention. The English artist Henry Richter, writing in the early nineteenth century, sums up the connection neatly: "This, in the Fine Arts, is Genius—the Inventive Faculty itself."[66] For this reason, Mary Shelley's pursuit of invention cannot be separated from claims to authorship and, indeed, genius.[67] But genius remained almost exclusively the purview of men. Although Mary Shelley's unusual upbringing in the household of one of England's most radical progressives instilled in her a strong (but not unwavering) belief in her intellectual and moral equality with men,[68] she nonetheless had to contend with society's prejudice and occasionally with the chauvinism of friends like Byron. After the death of Shelley, for instance, she felt patronized by the men with whom she had formerly enjoyed collegiality: "I feel myself degraded before them; knowing that in their hearts they degrade me from the rank which I deserve."[69] She

did not relish their treatment of her as what biographer Emily W. Sunstein calls "any ordinary widow."[70] And in *Frankenstein*, Shelley confronts the theoretical impulses underlying this gender bias.

ZEUXIAN MAKER, PROMETHEAN CREATOR

Shelley deploys two models of invention in *Frankenstein*. In the first half, she explores the motives and consequences of Zeuxian mimesis.[71] Mimesis is supplanted by Promethean creation in the eleventh chapter when the narrative shifts from Victor Frankenstein's voice to the Fiend's version of events.[72] Both models turn upon the assumption that artistic activity is a generative enterprise. Zeuxian mimesis was, by the latter half of the eighteenth century, closely associated with masculine procreative principles (see chapter 4). A method by which ideas or materials are isolated, reorganized, and improved, Zeuxian mimesis contrasts with Promethean creation. The legendary Prometheus transformed a base substance into a living entity. While not entirely ex nihilo, Prometheus's creativity depends upon divine as opposed to biological or intellectual effort. Renate Schlüter, in *Zeuxis und Prometheus*, argues that romantic aesthetics underwent a shift away from invention (with its insistence that originality be tempered by emulation) toward individual creativity. Assuming the generative powers of nature as their leading model, romantic authors and aestheticians adopted a Promethean aesthetic of genius. This model, with the legendary Titan as its standard-bearer, was ascendant at the beginning of the nineteenth century.[73]

The narrative structure of *Frankenstein* mirrors this shift in early nineteenth-century aesthetic practice. The first and third sections of the novel present the reader—via Captain Walton's letters to his sister—with Victor Frankenstein's account of his life. Shelley takes pains to endow Frankenstein's ostensibly firsthand account with authenticity. First, she has Walton declare that "I have resolved every night, when I am not imperatively occupied by my duties, to record, as nearly as possible in [Frankenstein's] own words, what he has related." Frankenstein apparently has no knowledge of Walton's undertaking. Later, Walton explains to his sister that "Frankenstein discovered that I made notes concerning his history: he asked to see them, and then himself corrected and augmented them in many places. But principally in giving life and spirit to the conversations with his enemy."[74] Both passages assert the authenticity of the facts recounted as well as the language used by Frankenstein. Thus, the reader is invited to accept Walton's reports as an accurate transcript of Frankenstein's testimony. This illusion of reportage distances Shelley from the views expressed

by her characters: As the (initially, anonymous) author of *Frankenstein,* Shelley takes pains to remain transparent. In this way, she is able to critique notions of genius, invention, and authorship obliquely. Shelley's strategy resembles that of Kauffman, who assumed a critical position precisely by simultaneously disguising and asserting her agency through her allegorical self-portrait. Shelley's critique takes aim at both academic and romantic theories of creativity.

A symbol of Enlightenment faith in human knowledge and science, Victor Frankenstein exemplifies eighteenth-century ideals. As he explains to Walton, "The world was to me a secret which I desired to divine. Curiosity, earnest research to learn the hidden laws of nature, gladness akin to rapture, as they were unfolded to me, are among the earliest sensations I can remember."[75] Here, Frankenstein verges on a parody of Enlightenment philosophes. But his earnestness dispels this reading. His recourse to metaphors of Zeuxian mimesis further emphasizes his embodiment of Enlightenment discourse. Frankenstein characterizes himself along the lines of an academically trained artist. Mary Shelley, in her introduction to the 1831 revised edition, also describes Frankenstein as "the artist."[76]

Studious, diligent, and above all desirous of producing a work of exceptional beauty, Frankenstein devotes himself to his labor. "After having formed this determination, and having spent some months in successfully collecting and arranging my materials, I began." Moments of anxiety nevertheless shadow him. When this happens, Frankenstein feels that he "appeared rather like one doomed by slavery to toil in the mines . . . than an artist occupied by his favourite employment." Nevertheless, he recalls his efforts as being methodical and intellectual as well as guided by aesthetic concerns. His, he explains, was a discriminating approach. He describes the figure he formed: "His limbs were in proportion, and I had selected his features as beautiful."[77] Though judicious in his selection and accomplished in his technique, Frankenstein apparently lacked understanding of the academic precepts of unity and harmony. He realizes this when he first views his living creation:

> Beautiful!—Great God! His yellow skin scarcely covered the work of muscles and arteries beneath; his hair was of a lustrous black, and flowing; his teeth of pearly whiteness; but these luxuriances only formed a more horrid contrast with his watery eyes, that seemed almost of the same colour as the dun white sockets in which they were set, his shriveled complexion and straight black lips.[78]

Here, Zeuxian mimesis produces horror rather than beauty. "Now that I had finished, the beauty of the dream vanished, and breathless horror and disgust filled my heart."[79] Tellingly, Frankenstein finds the Fiend an assault on his vision. "Begone!" Frankenstein tells his creation, "relieve me from the sight of your detested form." The Fiend assents: "Thus I relieve thee, my creator . . . thus I take from thee a sight which you abhor." With this, the Fiend passes his "hated hands" before Frankenstein's eyes.[80] As Freud reveals in his essay "Das Unheimliche," the uncanny can only be experienced visually (the necessary connection between vision and the uncanny is discussed in chapter 2). As long as the Fiend is not seen by others, he enjoys communion with nature and even with the de Lacey family. But once spied—even by himself—the Fiend provokes an uncanny sensation in the viewer and his own necessary banishment from sight.[81]

The Fiend realizes the uncanny potency of his appearance. His account of his first face-to-face encounter with the de Lacey family makes this awareness clear. "Who can describe their horror and consternation on beholding me. Agatha fainted; and Safie, unable to attend to her friend, rushed out of the cottage."[82] Of his encounter with little William Frankenstein, the Fiend reports, "As soon as he beheld my form, he placed his hands before his eyes, and uttered a shrill scream." Even the Fiend's vow upon learning that Frankenstein may provide him with a mate revolves around vision. "I swear . . . that if you grant my prayer . . . you shall never behold me again." Walton's recollection of his first view of the Fiend mimics an uncanny encounter—"I am yet dizzy with the remembrance of it"—and he goes on to attempt a description of the moment: "I entered the cabin . . . over [Frankenstein] hung a form which I cannot find words to describe. . . . Never did I behold a vision so horrible as his face, of such loathsome yet appalling hideousness. I shut my eyes involuntarily."[83] Only old Mr. de Lacey responds kindly to the Fiend, because the blind man cannot see him.

Shelley's emphasis on vision as a necessary medium for horror allies *Frankenstein* with the uncanny narratives discussed in chapter 2, such as Hoffmann's "The Sandman" or Freud's account of his walk in an Italian town. The Zeuxis myth, however, is most analogous. Victor Frankenstein's approach mimics almost exactly the method used by Zeuxis to paint Helen of Troy. Both Frankenstein and Zeuxis seek perfect form through a composite of well-chosen parts. The signal difference involves Frankenstein's collection of limbs and organs from various corpses as opposed to "the most admirable points in the form of each" of five maidens.[84] "I collected bones from charnel-houses; . . . The dissecting room and the slaughter-house furnished many of

my materials."[85] Shelley's perversion of the legend of Zeuxis Selecting Models exposes its uncanny basis.

What is more, Shelley importantly disrupts the libidinal economy of the Zeuxis myth. Zeuxis Selecting Models participates in a long-standing Western convention in which art making is understood to be a masculine activity. Posing, on the other hand, is a (highly sexualized) feminine role. When Western art history records the name of an artist's model, that model is inevitably female. Campaspe, Phryne, the Fornarina—Apelles's, Praxiteles's, and Raphael's (in)famous models—exemplify this tradition. Who were the nameless, unrecorded models who sat for Apelles's *Herakles* or Praxiteles's *Hermes* or Raphael's Plato in his *School of Athens*?

Shelley challenges the naturalized dichotomy between creator/created so often characterized by gender. She accomplishes this by denying Frankenstein the ability (or resolve) to complete a female counterpart to his creation. The Fiend's desperate plea for a companion leads Frankenstein to accede at first. "I consent to your demand, on your solemn oath to quit Europe for ever, and every other place in the neighborhood of man, as soon as I shall deliver into your hands a female who will accompany you." Frankenstein begins the task, but the project elicits disgust, then a change of heart. "I trembled, and my heart failed within me . . . and trembling [I] tore to pieces the thing on which I was engaged."[86] Interestingly, this moment of creative impotence results not only in the destruction of Frankenstein, his family, and the Fiend but also in the salvation of humanity. By abandoning his work, Frankenstein removes the possibility of "a race of devils."[87] Like Angelica Kauffman, Shelley finds a way to disrupt the gendered economy of the Zeuxis myth.

The Promethean model of artistic activity dominates the middle portion of the book. Chapters 11 through 17 recount events from the Fiend's perspective.[88] Of course, this version ostensibly comes at secondhand from Frankenstein. Walton's transcript of Frankenstein's tale is yet another layer of mediation. But, as already stated, Shelley signals to the reader to accept these words as those of the Fiend: "Frankenstein discovered that I made notes concerning his history: he asked to see them, and then himself corrected and augmented them in many places. *But principally in giving life and spirit to the conversations with his enemy*" (emphasis mine). This is, ironically, the only moment in which Frankenstein acknowledges his gift of "life and spirit" to the Fiend. While Frankenstein sees himself as an artist, the Fiend perceives him as a creator or father.

In the Fiend's version of events, the Zeuxian model disappears. Instead, Frankenstein's endeavor becomes that of a Promethean creator.[89] After the Fiend completes his story, he and Frankenstein begin a dialogue. In this

passage, the Fiend addresses Frankenstein as "creator"; Frankenstein re-fuses to assume this Promethean role, referring to himself as "maker."[90] In addition to his characterization of Frankenstein as his "creator," the Fiend evokes other Promethean moments. For instance, while living outdoors in the freezing cold, the Fiend accidentally receives the gift of fire, not from a divine Titan but from a band of "wandering beggars" who left some burn-ing embers in their abandoned camp.[91] Shelley here reverses and deflates the Promethean myth.

Indeed, Shelley promotes skepticism of both Zeuxian and Promethean modes of creativity, and ultimately nature emerges as the only praiseworthy model for creativity. Both Frankenstein and the Fiend observe nature's pro-cesses of production and destruction with awe and reverence. Unsullied by base inclinations or frailties, nature brings forth beauty without preju-dice. Compare the following passages, in which first the Fiend and then Frankenstein find aesthetic and emotional release in nature:

> Happy, happy earth! fit habitation for gods, which, so short a
> time before, was bleak, damp, and unwholesome. My spirits
> were elevated by the enchanting appearance of nature; the
> past was blotted from my memory, the present was tranquil,
> and the future gilded by bright rays of hope, and anticipations
> of joy.[92]

> These sublime and magnificent scenes afforded me the great-
> est consolation that I was capable of receiving. They elevated
> me from all littleness of feeling; and although they did not
> remove my grief, they subdued and tranquilised it. In some
> degree, also, they diverted my mind from the thoughts over
> which it had brooded for the last month.[93]

Shelley's romantic celebration of nature abets her critique of conven-tional models of authorship. Invention, she seems to suggest, remains an activity properly left to nature. Typically coded as feminine, nature offers a model of abundant generation and terrifying destruction. Some scholars have argued that Shelley's characterization of nature can be understood as a veiled advocacy for a feminine creative force. In particular, the associa-tion between nature and femininity here suggests a creative principle linked to giving birth.[94] After all, Shelley refers to Frankenstein as her "hideous progeny."[95] But Shelley's ambivalence toward motherhood complicates this model. Her correspondence and publications include as many moments of

adulation of motherhood as dread of it.[96] In this light, Shelley's embrace of a creative model based on motherhood as conventionally understood seems unlikely. Instead, she uses nature as a model through which she can manage the romantic notion of an ineffable "will to form" that drives creativity.

Shelley puts forth a metaphysics of invention in her 1831 introduction to the revised edition of *Frankenstein*. The definition of invention she offers in 1831 comes fifteen years after she first began the novel, and there is no doubt that the benefit not only of hindsight but also of the mature fruits of romantic aesthetics inflect this passage. "Invention," she writes, "does not consist in creating out of void, but out of chaos. . . . Invention consists in the capacity of seizing on the capabilities of a subject, and in the power of moulding and fashioning ideas suggested to it." Shelley distinguishes artistic invention from divine inspiration. Invention "can give form to dark, shapeless substances, but cannot bring into being the substance itself."[97] In this way, her understanding of artistic agency hovers between the Zeuxian and Promethean models she explores in *Frankenstein,* but she makes a crucial break with both models. Neither wholly active nor wholly passive, Shelley's approach eliminates the artist's individual will in favor of a will-to-form inherent in nature.[98] The will of the individual, Shelley suggests, is dangerous. It motivates Zeuxis and Prometheus as it destroys Frankenstein and nearly undoes Walton.

In 1831, Mary Shelley explains that her approach to invention while writing *Frankenstein* followed the middle course she recommends. Her concentrated efforts to devise a plot yielded only frustration. Once she adopted a passive or receptive tack, gains were made. She explains, "I placed my head on my pillow, I did not sleep, nor could I be said to think. My imagination, unbidden, possessed and guided me."[99] But Shelley's delineation of this passive mode of invention rings hollow. By 1831, Shelley had been pursuing—actively and diligently—a literary career. Whether because of the obligations carried by intellectual patrimony or the pressures of financial necessity or simply the pleasure of writing and publishing, Shelley seems anything but passive. Letters to her publisher, John Murray, reveal a purposed approach to writing and to publishing. Here, for example, she writes to Murray in 1828 in an (unsuccessful) effort to secure his imprint for her historical novel *The Fortunes of Perkin Warbeck* (1830):

> With regard to my novel I shall be much pleased if you undertake its publication—An historical subject of former times must be treated in a way that affords no scope for *opinions*, and I think you will have no reason to object to it on that score.

Mr Marshall mentioned to me that you asked whether I understood Italian & its patois, saying that you had a view in asking this—I lived nearly six years in Italy & its language is perfectly familiar to me—and I should not hesitate to undertake a work that required an intimate acquaintance with it.— I should be very glad if you would communicate your ideas to me on this subject and happy to comply with your suggestions as far as my abilities permit.[100]

In this letter, Shelley takes a wholly active stance on behalf of her career. She seeks a publisher for her new novel, which she assures Murray will not contain "opinions." In other words, the book does not promote Godwinian ideas. Further, she frankly touts her linguistic abilities. Finally, she makes clear her willingness to assume a commission on a subject not of her own choosing. Shelley leaves little doubt of her ability to summon and deploy her inventive faculties as she requires them.

Mary Poovey attributes the discord between the views expressed in the 1831 introduction and Shelley's own literary practice to contemporary social circumstances.[101] Shelly's career bridged the romantic and Victorian eras. Finding herself increasingly subject to repressive social mores, Shelley recognized the need to fashion an appropriate public persona. Her success among mid-Victorian readers depended upon her ability to soften or disguise her supposedly radical views as well as her notorious past. A female author, unlike her male colleagues, required appropriate social credentials. Rising concerns over women's shifting economic and political status resulted in a strong cultural restatement of "traditional" feminine roles. Shelley attempted to satisfy these social dictates by rewriting the history of *Frankenstein.* And she succeeded. Far from presenting an intellectually engaged woman eager to challenge her famous male friends and establish her own literary reputation, the 1831 introduction portrays an appropriately passive conduit for others' ideas. The "devout but nearly silent listener" of the 1831 introduction was Shelley's public face. Friends and associates like John Murray were acquainted with the private Mary Shelley.

Thus, Shelley's *Frankenstein* shares a fate akin to Kauffman's *Zeuxis Selecting Models.* Both works encountered institutional resistance, and both women disguised their claims to authorship through recourse to a feminine masquerade. Confronting the gendered strictures of the Zeuxis myth, both women succeeded in staking out an alternative model of female authorship. And in each case, this gesture unveiled the uncanny trauma contained within the narrative. Kauffman's and Shelley's interpretations of

Zeuxis Selecting Models implicate mimesis in a sublimated cultural primal scene.

Zeuxis Selecting Models serves Kauffman and Shelley as a powerful vehicle for women to assert artistic agency while critiquing repressive patriarchal norms. Far from finding the fetishistic drama embedded within the myth a cause for concern, it becomes instead a potentially liberating strategy.[102] But the specter of the phallic mother raised by women artists' representations of the Zeuxis myth elicits censure, revision, or outright dismissal. Male artists' attempts to render the theme likewise tap into the traumatic cultural memory that it sublimates. In these (now understandably few) examples, however, the myth's encoded psychic drama erupts. Rather than asserting a new model of creative agency, interpretations by men have served mainly as fetishistic vehicles for a return to the site of a cultural trauma: the primal scene evoked by classical mimesis.

6
Painting in the Philosophical Brothel

Everything is visible, no part of the body can remain hidden:
everything must be seen.

MARQUIS DE SADE, *PHILOSOPHY IN THE BEDROOM*

ZEUXIS SELECTING MODELS assumed new import during the eighteenth
century. In academic discourse, the theme promoted a notion of artistic
creativity akin to masculine procreativity. It would be easy—and, I believe,
mistaken—to accept this discursive link between creativity and sexuality
simply as evidence of social assumptions about the inferiority of women
artists. Of course, Zeuxis Selecting Models does support such assumptions.
But it also transmits something else.

I argued in chapter 2 that Zeuxis Selecting Models is an uncanny narra-
tive, that it gives form to a repressed cultural memory or "cultural primal
scene." Since access to the uncanny, as described by Freud, comes through
sight, visual representations of Zeuxis Selecting Models tend to compound
its uncanny effect. The experience of *seeing* Zeuxis Selecting Models dif-
fers importantly from reading or talking about the story precisely because
sight is the vehicle for the uncanny. Visual portrayals of the scene, there-
fore, have the potential to trigger an uncanny experience in the viewer. Post-
Renaissance depictions of Zeuxis Selecting Models, in particular, provide
opportunities for such an experience. As artistic conventions changed and
decorum softened in the wake of the Protestant and Catholic reformations,
representations of Zeuxis Selecting Models made the myth's uncanny char-
acter increasingly manifest. But the clearest signs of this rupture would
begin to appear in works from the late eighteenth century.

Two conditions, I believe, prepared the way for the uncanny nature of

Zeuxis Selecting Models to reveal itself in the eighteenth century. The first condition resulted from Enlightenment critiques of subjectivity. A distinctly modern notion of selfhood was emerging in western Europe during the eighteenth century. This change prepared the way for the uncanny to be recognized as a broadly experienced and distinctly modern phenomenon. As Terry Castle argues, the Enlightenment fostered precisely the cultural conditions necessary for the uncanny to emerge:

> The very psychic and cultural transformations that led to the subsequent glorification of the period as an age of reason or enlightenment . . . also produced, like a kind of toxic side effect, a new human experience of strangeness, anxiety, bafflement, and intellectual impasse. The distinctively eighteenth-century impulse to systematize and regulate, to bureaucratize the world of knowledge . . . was itself responsible . . . for that "estranging of the real"—and impinging uncanniness—which is so integral a part of modernity.[1]

Castle attributes to the modern psyche a unique susceptibility to the uncanny. The modern, or post-Enlightenment, sense of self is as much a consequence of reason as it is of tradition or faith. Uncanny experiences, then, register those moments when the modern psyche finds itself *en abyme* as it vacillates between these epistemological poles. Because Zeuxis Selecting Models attempts to mediate—via a visual demonstration—the phenomenological and the spiritual, it is uniquely capable of eliciting an uncanny response.

Castle's claims are particularly relevant to my investigation of the legend of Zeuxis Selecting Models. Throughout the fifteenth through seventeenth centuries, the legend functioned as an unproblematic metaphor for mimesis. But during the eighteenth century, evidence of the theme's uncanny significance surfaced with increasing urgency. This is in part due to the second precondition of the uncanny. By the eighteenth century, classical mimesis had resumed its preeminent status among theories of representation, a position it had not held since Greek antiquity. The final decades of the century mark the zenith of its restoration among artists and aestheticians. By the second decade of the twentieth century, classical mimesis would hold little interest for artists. Only the advent of digital technologies during the second half of the twentieth century would reignite its ascendance in the West.

What emerges in modern representations of Zeuxis Selecting Models are symptoms of the fetishistic drama embedded in the myth. While the

notion of fragmenting and reassembling women's bodies has always been central to the story, this process becomes more and more difficult to manage visually. Zeuxis's search for the perfect hip, breast, shoulders, feet, hands, or face necessitates the dislocation of each feature from the disappointing imperfection of the whole body to which it belongs. Freud associates this uncanny process with castration anxiety, with the fear generated by the sight of a woman's body (inherently imperfect because of its lack of a penis). But Freud's coupling of the uncanny to female genitalia should itself be understood as a symptom. Castration anxiety, as Julia Kristeva makes clear in *Powers of Horror,* masks a more diffuse fear of death. Thus, while Freud's theory may founder therapeutically, it nevertheless testifies to the symbolic relationship between women's bodies and the uncanny.

Kristeva invites us to understand the role of women in psychoanalytic (as well as anthropological and religious) discourse as metaphors. "The phobic person," she explains, is "a subject in want of metaphoricalness." Kristeva continues,

> Incapable of producing metaphors by means of signs alone,
> he produces them in the very material of drives—and it turns
> out that the only rhetoric of which he is capable is that of
> affect, and it is projected, as often as not, by means of *images.*
> It will then fall upon analysis to give back a memory, hence a
> language, to the unnamable and namable states of fear, while
> emphasizing the former, which make up what is most unapproachable in the unconscious.[2]

Language, then, gives shape to and transmits unconscious fears and desires. Uncanny narratives, like Zeuxis Selecting Models, conduct this work on a cultural as well as individual level. And the signs deployed in such narratives function symbolically. That is to say, the metaphorical language of the unconscious draws from a shared cultural vocabulary. Marking the feminine, women's bodies metaphorically signal "otherness." And this otherness, Kristeva explains, encompasses two categories: that of "abjection and fright" and that of the "ecstatic."[3]

The female bodies in Zeuxis Selecting Models serve as metaphors for both of the meanings Kristeva metaphorically attaches to femininity. The imagined body of Helen—ideal and irresistible—represents ecstatic femininity (for further discussion of the significance of Helen for the Zeuxis myth, see chapter 2). The necessarily alluring yet imperfect bodies of the

models signal an unstable, abject, and threatening femininity. Visual representations of the scene need to somehow manage this psychological excess.

Angelica Kauffman's painting of *Zeuxis Selecting Models for His Painting of Helen of Troy* (Figure 14) presents an exemplary attempt to govern these potentially unruly bodies.[4] Kauffman manages this in three ways. First, she asserts decorum by attiring the models in great folds of opaque drapery. This simple gesture deflects the viewer's anticipation of encountering either feminine abjection (the flawed body) or feminine ecstasy (the transcendent body). Second, Kauffman's composition interpolates a reassuring boundary between the viewer and the scene. The frieze format in which the figures are disposed never threatens to extend into the viewer's space. What is more, the classically inspired composition fixes the scene in a safely contained antique past. And like its classical forebears, the painted frieze defers undue drama or emotion. Finally, Kauffman inserts herself into the scene. The personification of Painting standing next to Zeuxis's unfinished canvas is, in fact, a self-portrait. In this way, Kauffman introduces a chaste and reassuring female presence into the scene. Thus, Kauffman attempts to suppress any hint of immediate threat. But, as discussed in chapter 5, the institutional reticence that greeted her *Zeuxis Selecting Models* suggests that she may not have been entirely successful. Bartolozzi's modifications of her composition when he translated it into an engraving for popular circulation confirms her shortfall.

In fact, most renditions of Zeuxis Selecting Models fail to subdue convincingly the story's uncanny impulses. Driving this current is the legend's dependence upon numerous appealing yet not-quite-perfect female bodies: bodies at once alluring and unsettling. In modern Western culture, this is the body typically assigned to the prostitute. Recall Freud's account of his own uncanny experience:

> As I was walking . . . through the deserted streets of a provincial town in Italy which was unknown to me, I found myself in a quarter of whose character I could not long remain in doubt. Nothing but painted women were to be seen at the windows of the small houses, and I hastened to leave the narrow street at the next turning.

The uncanniness of the prostitute, her ambiguous position in the psyche as well as in society, is explored by Shannon Bell in *Reading, Writing, and Re-Writing the Prostitute Body*. Bell argues that modern Western culture has codified the prostitute's status as the "other's other." Looking to Baudelaire

and Walter Benjamin for a record of the prostitute's installation as an "allegory of modernity," Bell finds that

> the modern prostitute is a new anthropological figure. She manifests the end of aura. . . . Eros is subjugated by Thanatos; the prostitute body is written as the death body, the putrefied body, the profane body. At the same time, however, a process that Benjamin calls "spleen" operates in an insistent unconscious mapping of the lost past onto the prostitute body. Spleen is a "mental process in which the preserved image of the originally lost object is projected onto other objects so as to repeat . . . the experience of the lost other via a fantasy image." The modern prostitute body acts as a hieroglyph providing a trace to the sublime body, promising a connection with the sacred which can, however, be maintained only for a fleeting moment.[5]

Zeuxis's five models likewise function as traces of a "sublime body, promising a connection with the sacred." Once fragmented and reassembled, the models betoken access to an (inherently impossible) ideal. Of course, the association between artists' models and prostitutes has a long history in Western culture.[6] And Zeuxis Selecting Models thematizes this long-standing conjunction. The tendency for representations of Zeuxis Selecting Models to resemble brothel scenes comes, then, as no surprise. Any collection of partially clothed women put on display in order that a man might choose among them is highly suggestive of sexual commerce. Augmenting the formal similarities between Zeuxis Selecting Models and a john's visit to a bordello is their shared connection to the uncanny. Thus, the conflation of Zeuxis Selecting Models with an episode in a brothel becomes almost inevitable.

Kauffman's interpretive restraint gives way in other eighteenth-century portrayals of the scene, the most noted being the version painted by François-André Vincent (1746–1816) (Figure 24). First exhibited at the Salon of 1789, the painting received less notice than it might have if shown in another year.[7] Political events of the summer of 1789 diverted the attention of most Parisians away from their customary leisure activities. Recognizing this, reviewers tried to rally interest in a cultural event that had clearly lost its drawing power:

> The arts have been neglected for some months in favor of political events. Though art cannot generate the same interest as the momentous revolutions we are witnessing, it nevertheless

seems to me that this newspaper cannot entirely ignore the exhibition of paintings.[8]

Another critic begins his account of the Salon of that year with a politically engaged exhortation to viewers:

> In the midst of the events by which France is again troubled, poetry remains silent; literature and the arts have been, so to speak, forgotten; all minds incline generally toward the nation's pressing interests. . . . Your patriotism, citizens, has revealed itself; today, the arts are calling you back.[9]

Though Vincent's painting may have received less critical attention because of the unfolding Revolution, the theme of Zeuxis Selecting Models acquired a decidedly republican flavor in a pair of pen-and-ink drawings produced by

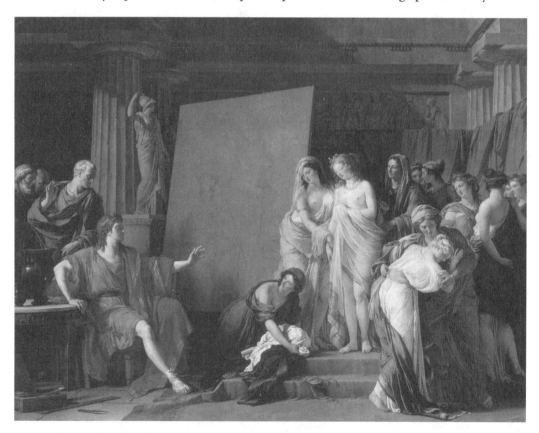

Figure 24. François-André Vincent, *Zeuxis Choosing the Most Beautiful Women from Crotone as His Models* (oil on canvas, 1789, Louvre Museum, Paris). Photograph courtesy of Réunion des Musées Nationaux / Art Resource, New York.

Joseph-Marie Vien (1716–1809). While Vien's drawings show an obvious af-
finity to Vincent's painting, they invest the narrative with an overtly politi-
cal content absent from the younger artist's version. Vien uses the uncanny
impulses of the Zeuxis myth to negotiate the excesses of the Revolution
and, especially, the Terror.

Though Vien never committed the subject to canvas, he embarked on
an extended dialogue with the Zeuxis myth in 1795. In this year, he pro-
duced several drawings exploring different moments of the narrative. These
include two finished pen-and-ink drawings, *Zeuxis Selecting His Models*
(Figure 25) and *Nicomachus Admiring Zeuxis's Painting* (Figure 26).[10] Both
drawings date to 1795, a year of no small significance for an artist close-
ly associated with the Royal Academy and culture of the ancien régime.
Informed by personal as well as political circumstances, Vien's depictions
of Zeuxis explore the problems and possibilities of art making in post-
revolutionary France.

The Revolution threatened Vien's career as well as his life. Promoted to
premier peintre du roi (first painter to the king) just two months before the
storming of the Bastille, Vien found himself dangerously linked to the mon-
archy. The execution of his architectural counterpart left him uncertain of
his fate:

> At the height of the Revolution, when I learned that the first
> architect to the king had paid for his position at court with
> his head, I said to myself: It is quite possible that the first
> painter—regardless of his age or service to the arts—would
> receive the same treatment as the architect.[11]

With the protection of his former student and close friend, Jacques-Louis
David, Vien avoided the fate of his colleague. He then entered the period he
called his "retirement": Vien ceased to exhibit at the Salon after 1793 (at the
age of seventy-six), though he continued to work and cultivate new patrons
throughout the 1790s.[12]

Compositionally, Vien's Zeuxis drawings are unquestionably indebted to
Vincent's painting. Like Vincent, Vien places Zeuxis, his entourage, and the
models inside a Juno temple. Zeuxis's unfinished canvas rests on an easel near
the center of the composition, its surface presented at an oblique angle.[13] A
group of agitated, variously clothed or draped models gather on one side of
the temple. Placed opposite are Zeuxis, a group of male onlookers, and one
or two antique sculptures. Despite these similarities, important differences
exist between Vien's and Vincent's treatment of the theme. These emerge

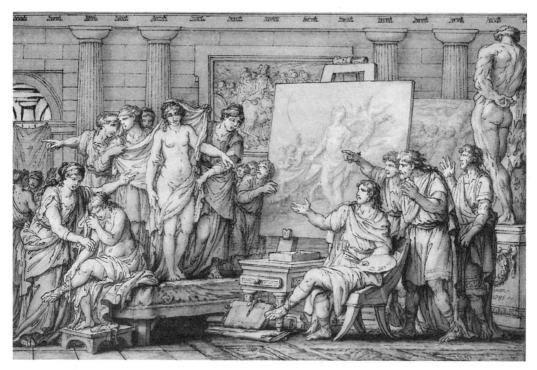

Figure 25. Joseph-Marie Vien, *Zeuxis Selecting His Models* (pen-and-ink and wash, 1795, British Museum, London). Photograph copyright Trustees of the British Museum.

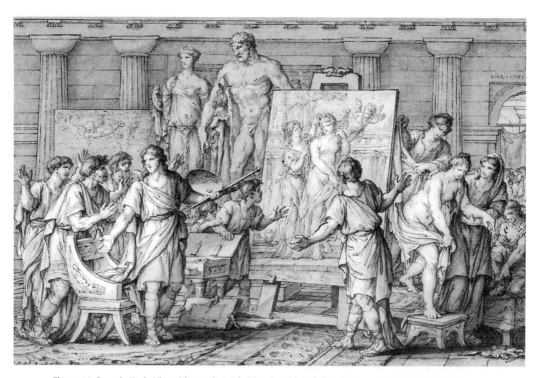

Figure 26. Joseph-Marie Vien, *Nicomachus Admiring Zeuxis's Painting* (pen-and-ink and wash, 1795, British Museum, London). Photograph copyright Trustees of the British Museum.

most clearly through a comparison of the artists' renditions of the central story, *Zeuxis Selecting Models.*

The most obvious difference involves the artists' treatment of the setting. Vien dramatically reconfigures the temple interior.[14] On the rear wall of the sanctuary, where Vincent presents a processional frieze with female attendants before seated gods and a goddess,[15] Vien depicts a battle scene. Vien's relief shows foot soldiers bearing shields and lances behind mounted warriors with plumed helmets and military cloaks. The relief recalls, formally and iconographically, battle scenes popularly represented on Roman sarcophagi. Vien likewise replaces Vincent's statue of Athena with the Farnese Hercules (Figure 27). The artist would have been familiar with the Farnese Hercules and antique sarcophagi from his years in Rome first as

Figure 27. Hendrick Goltzius, *Farnese Hercules* (engraving, ca. 1592, Harvard University Art Museums, Cambridge, Mass.). Courtesy of the Fogg Art Museum, Harvard University Art Museums; gift of William Gray from the Collection of Francis Calley Gray.

a student (1744–50) and then as director of the French Academy School (1775–81). In addition to announcing his classical erudition, Vien's changes endow the scene with a pointed subtext. The significance of this secondary narrative depends, however, upon the viewer's understanding of the relationship between Hera and Hercules as well as the postrevolutionary role of the ancient hero.

Ironically named for the goddess Hera, Hercules issued from the union of Zeus and the mortal Alcmene. Hera's consequent jealousy provoked her to torment Hercules almost from the moment of his birth. Her cruelest act was to afflict him with a violent madness, causing him to murder his family. This vengeful turn inadvertently enabled Hercules to achieve immortality. By completing the twelve labors assigned to him as atonement for deaths of his wife and children, Hercules was granted divinity.

Vien's introduction of Hercules and the battle relief into the temple transforms the meaning of the space. Because Hera is conventionally associated with brides and mothers, representations of temples dedicated to her tend toward feminine decorative themes. While Vincent alludes to this tradition with his processional relief and statue of Athena, Vien overturns it. His temple instead enshrines Hercules and martial glory. Hercules's association with the golden apples of the Hesperides draws an oblique connection between Zeuxis Selecting Models and the Judgment of Paris.[16] In this way, Helen's uncanny presence is hinted at. Furthermore, the presence of Hercules within Hera's temple evokes their difficult association and celebrates the hero's victory over feminine jealousy and caprice. This important shift in iconography links Vien's drawing to contemporary political events.

By 1793, Hercules had come to replace "Marianne" as the official symbol of the new French Republic.[17] Featured on the seal of state and Republican coins as well as on a variety of revolutionary ephemera, Hercules offered a reassuring image of patriarchal authority in a period of social disorientation and political anxiety. The tendency to associate the violent excesses of the Revolution—especially the Reign of Terror—with women's political organizations resulted in a concatenation of femininity with social instability and bloodlust in the popular imagination.[18] Hera, like the phantasmic *tricoteuses de Robespierre* and *furies de guillotine*, represented an elemental, irrational femininity that threatened social order.[19] Hercules signified a powerful, rational, resolute—and above all masculine—corrective.

Vien would certainly have been aware of the ancient hero's newly forged alliance with the Republic. Hercules was commonplace in Republican imagery by 1795, and Vien followed political developments with wary interest.[20] As already mentioned, Vien's friendship with Jacques-Louis David, a promi-

nent Jacobin, may have prevented his execution in the early stages of the Revolution. David's arrest and imprisonment immediately after the coup of Thermidor (in July 1794) and again in the spring of 1795 would have only sharpened Vien's awareness of the political ramifications of artistic practice. This concern manifests itself in his *Zeuxis Selecting His Models.* The studio appears as a battleground. Overwrought models collapse in exhaustion; agitated figures point excitedly. Emotional excess is matched by a superfluity of signification. The confusing exchange of deictic gestures fragments the composition: One woman points to the draped portal; another points to the nearly nude model posing on the dais; a spectator points toward the group of models; a mounted soldier in the battle relief points toward some unseen goal. Promising resolution, these gestures only confound the viewer. It is left to the artist to resolve these contradictory signs, to distill beauty from chaos. With Hercules as his muse, Zeuxis sits calmly with his legs crossed. Success is assured. The presence of the finished painting of Helen—a detail unique to Vien's representation of the scene—confirms the inevitable victory of the artist.

By presenting Hercules as Zeuxis's muse, Vien implicitly recognizes Republican authority over representation. To dispel any doubt about this, the artist signs his name across the pedestal supporting the statue. This gesture completes a circuit of identification among Vien, Zeuxis, and Hercules/ La République and transforms the image from an exercise in academic erudition to an allegorical self-portrait.[21] In this way, Vien neatly fuses aesthetic theory with social identity. Recent monographs on postrevolutionary French artists have demonstrated the political stakes of self-portraiture in the decade after 1789.[22] The self and its representation were inextricably joined and incalculably transformed after the Revolution and the Terror. Vien, as his uneasy reminiscences attest, understood the precarious relationships between public and private, professional and personal identities. By embedding his artistic identity—along with his political anxiety—in an allegory about representation, Vien finds a means to safely negotiate shifting aesthetic and social pressures. As an allegorical self-portrait, Vien's *Zeuxis Selecting His Models* announces his allegiance to Republican ideals while diffusing his anxiety about the relationship between art and the state.

Because Vincent completed his version of Zeuxis Selecting Models before the onset of the Revolution, it does not bear the political meaning given the subject by Vien. Instead, Vincent's rendition remains steeped in the academic conventions of the ancien régime. By 1789, Vincent had established himself as one of the most promising of the young academicians, poised to assume a position as a full professor at the academy and as one of France's

most celebrated history painters. His choice of Zeuxis Selecting Models as the subject of one of his submissions to the 1789 Salon should be understood as a public declaration of his ambitions. Surely anticipating the inevitable comparisons between himself and the famous Greek painter, Vincent's choice of subject was a bold one. His gambit paid off in one published piece on the Salon. The versified review of Vincent's painting by "Un prisonnier de la Bastille" declares

> That this painting delights my eyes!
> Beautiful bodies! Happy harmony!
> It is a masterpiece of genius,
> Ah! who will not be envious!
> At the metempsychosis, in France.
> Who would not believe, in seeing it?
> Zeuxis, under the name of Vincent,
> Shows off the excellence of his art.[23]

But the lighthearted tone of this encomium—as well as the author's instruction that it be sung to the tune of an air from the recent comic opera *Renaud d'Ast*—diminishes its critical import. Most reviewers were more circumspect. While it was clear that "when M. Vincent chose such a subject, he set for himself a most difficult task,"[24] faults were consistently found in the artist's handling of color and proportion. The most consistent criticisms, however, revolve around expression, or the emotions displayed by the characters involved.

Like the accomplished academician he was, Vincent pursued the scene's "pregnant moment."[25] And this, he determined, comes as Zeuxis finds the last feature needed to complete his depiction of Helen.[26] Zeuxis's unfinished canvas, which dominates the center of the painting, displays the outline of a female figure. Clearly, the Greek painter seeks only finishing touches. And he has discovered a source for these features. On the platform to the right of the unfinished canvas stand two models, one bathed in a rosy light and wearing only a sheer veil. Zeuxis steadies himself before this sight, leaning on the edge of the marble-topped table to his right. His left arm, with hand held out in a gesture of surprise, extends toward the inspiring model. A male observer standing behind the artist echoes this gesture, emphasizing the excitement of the discovery. The other models—gathered opposite the painter—appear alternately resigned, agitated, and even distressed; whether because of the embarrassment of being passed over or owing to the shame of displaying themselves before strangers remains unclear.

Vincent's contemporaries also puzzled over the precise meaning of these expressions. Reviews of the 1789 Salon mention the models' awkward displays of modesty and their curiously submissive deportment. The commentary published by the comte de Mende-Maupus concludes that the painting "is excellent despite complaints about the ruddy tone of his female figures and the sluggishness of the ones who have already undressed."[27] Another reviewer observes "that the pose of the young lady who turns her back is not done to good effect" and asks, "Was this pose required to convey a modesty that shrinks from the gaze, a modesty that refuses to serve as a model?"[28] Even Zeuxis's apparent pleasure at discovering a particularly beautiful feature raises some critical concern. The reviewer for the *Journal de Paris,* for instance, observes that an artist of Zeuxis's stature should exhibit greater philosophic composure in the face of such beauty.

> Zeuxis's countenance is a bit strange. . . . he seems to have an
> expression of pleasure rather than the attitude of a sublime
> artist who reflects on the choice and combination of elements
> needed to form the perfect beauty he proposes to create.[29]

These reviews endow a polysemic quality to the painting. Expressions and gestures raise concern as they incite multiple readings. Specifically, there appears to be slippage around the representation of Zeuxis's desire and the limits of the models' availability. Contributing to this slippage—and, I believe, the anxiety apparent in some reviews—are the figures who accompany the models.

Ministering to the emotionally wrought women are their companions or escorts: older women who offer moral support while also showing the younger women off to their best advantage. The role of these attendants is best seen near the center of the canvas, where an older woman can be observed removing the last bit of drapery from her younger charge. In preliminary studies, Vincent has the older woman even more actively involved, lifting the veil from the model's head (Figure 28). In the final painting, the escort's actions are subtler but are also more suggestive. Hovering between matron and crone, the escort's appearance swerves dangerously toward that of a stock character well-known to eighteenth-century viewers: the procuress. Conventionalized in seventeenth-century Dutch art, the procuress can be seen in eighteenth-century works by such painters of popular genre scenes as Jean-Baptiste Greuze and William Hogarth.

The significance of the procuress in Western literature and art revolves

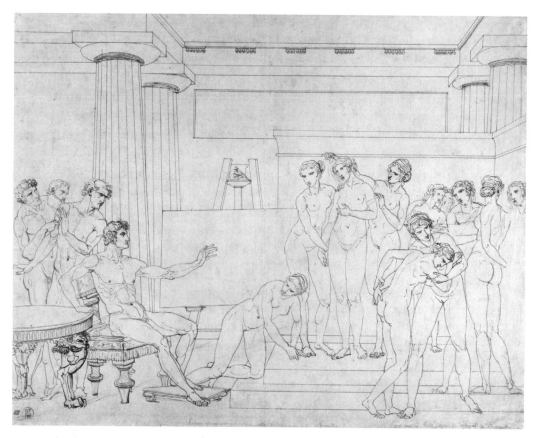

Figure 28. François-André Vincent, study for *Zeuxis Choosing the Most Beautiful Women from Crotone as His Models* (pen and black ink over graphite on tan antique-laid paper, 1788, The Horvitz Collection, Boston). Photograph courtesy of the Fogg Art Museum and the Harvard University Art Museums.

generally around her role as a go-between. As Julie A. Cassiday and Leyla Rouhi explain, the procuress is associated with

> mercenary sexuality, the world of the brothel, and financial greed. In literature the role of the go-between is given almost exclusively to older women who resemble one another remarkably, who function in strikingly similar ways, and who receive the unequivocal condemnation of those around them.[30]

Mediating the exchange of sex or love for money, the bawd demarks the (dangerously) fluid boundary between the sacred and profane. The appearance of a procuress generally signals an imminent breakdown of moral restraint. Indeed, in Western literature the procuress often possesses the

ability to perform witchcraft and to beguile young lovers with her spells. The consequences of these occult conjurings are usually social or spiritual degradation or even death. Whether serving an allegorical, moralizing, or simply titillating function, the portrayal of a procuress portends the triumph of lust and greed.[31] And the setting linked to the procuress is, of course, the brothel. The striking resemblance between Vincent's chaperons and central-casting procuresses lends an additional layer of ambivalence to the painting's subject.

With his suggestive chaperons and collection of inexplicably overwrought models in dishabille, Vincent draws a visual link between the artistic creation and erotic desire. This was not, of course, a novel parallel. The story of Pygmalion and Galatea neatly collapses the two activities. Indeed, one seventeenth-century representation of the subject seems to equate the artist's studio with a brothel by introducing a procuress to the scene (Figure 29).[32] But the overlapping between artist's studio and brothel had dangerous overtones for eighteenth-century academic painting. The temporary presence of women students in Jacques-Louis David's studio in 1787, for instance, provoked an official warning from the Directeur des bâtiments, the comte d'Angiviller, who warned, "This sort of mixture of young artists

Figure 29. Magdalena de Passe after Gerrit Honthorst, *Pygmalion and Galatea* (engraving, before 1638, Harvard University Art Museums, Cambridge, Mass.). Courtesy of the Fogg Art Museum, Harvard University Art Museums, Susan and Richard Bennett Fund.

of different sexes may well result in improprieties. . . . it is especially important to maintain propriety at the Louvre."[33] David's reply assures the *directeur* that the women "are completely separated from the studio where my male students work and have absolutely no communication with them. Their morals are beyond reproach. . . . their parents' reputations have been most honorably established."[34] As this exchange reveals, the introduction of women into an artist's studio bespoke the imminent breakdown of moral standards. The apparent ease with which such degeneration might occur indicates the fragility of the boundary between studio and brothel.

While Vincent is caught in a precarious balancing act with his *Zeuxis Choosing the Most Beautiful Women,* some of his contemporaries abandoned all caution. Nicolas Monsiau's 1797 version of the scene (Figure 30) obviously takes many formal cues from Vincent's painting.[35] Like Vincent, Monsiau (1755–1837) divides the canvas along gender lines. Zeuxis stands on the left side with a small group of male observers behind him. In his most obvious departure from Vincent's example, Monsiau shows the artist

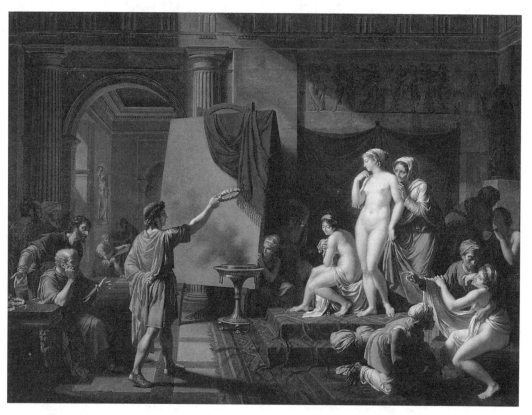

Figure 30. Nicolas Monsiau, *Zeuxis Selecting His Models* (oil on canvas, 1797, Art Gallery of Ontario. Gift from the Volunteer Committee Fund, 1988). Photograph courtesy of Art Gallery of Ontario.

awarding laurel wreaths to the chosen models. Hopeful contestants as well as apparently dejected also-rans gather on the right side of the painting. Accompanied by their wizened escorts, Monsiau's models appear to have relinquished their modesty more easily than Vincent's. Where Vincent exploits a translucent veil to "leave things open to the imagination,"[36] Monsiau dispenses entirely with the central model's drapery as well as any hint of coy modesty. No imagination is needed here. Monsiau even includes an exchange of wanton glances between a young woman half-hidden behind the unfinished canvas and a man positioned behind Zeuxis. In this way, Monsiau allows the erotic undercurrents of the subject to froth up to the surface. The transaction between Zeuxis and his canvas, like his interaction with the models, involves a libidinal as well as an aesthetic exchange.

In another deviation from Vincent's version, Monsiau adjusts the setting of the episode so that it suggests an artist's studio as much as a Juno temple.[37] Doric columns supporting a triglyph-adorned architrave, a late antique relief on the wall, a statue of Minerva, and a smoking brazier collectively seem to indicate, albeit haphazardly, a temple interior. But in another chamber visible through an incongruous arch, students can be seen busying themselves with sketching and modeling. At the same time, the suggestion of a bordello has also gained strength, as there are now at least two old procuresses, as well as a black handmaid. One old woman stands behind the model posing nude on the dais; the other urges a languid young woman seated on a stool in the right foreground to keep her attention on Zeuxis. Accompanying the latter pair is a black female servant who attends to the moony-faced model's sandals. The inclusion of a black maid here participates in a long tradition of erotic signification. Believed by Europeans to possess a more "natural" or "savage" sexuality than white women, dark-skinned (especially African) women signaled erotic abandon for eighteenth- and nineteenth-century viewers. Artists from this period often feature a subservient black woman in their works in order to emphasize another (usually white) woman's sexual availability.[38]

The ease with which Zeuxis Selecting Models might be subsumed into the broad class of brothel scenes is not a consequence of our post–Monica Lewinsky cynicism. Similar associations were drawn in the late eighteenth and the nineteenth centuries. In an undated painting by the Flemish painter Jacques-Albert Senave (1758–1823) titled Parody of Zeuxis, three insouciant modern "graces" pose before an excited Zeuxis (Figure 31). Accompanying the painter is a dog whose misshapen form suggests that he was composed using Zeuxis's famous method; only in this case the result is a bizarre, vaguely canine hybrid rather than an example of ideal beauty. Next to his

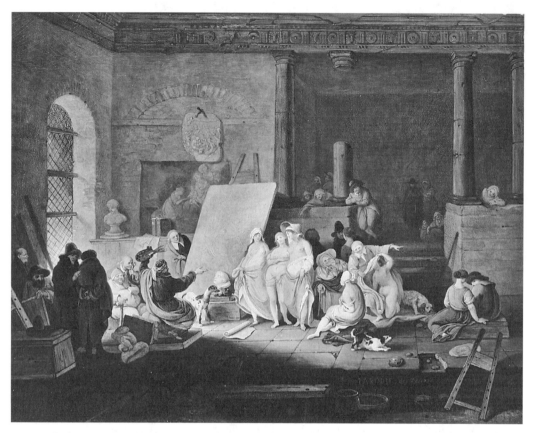

Figure 31. Jacques-Albert Senave, *Parody of Zeuxis* (oil on canvas, ca. 1800, Royal Museum of Fine Arts, Brussels, Belgium). Photograph courtesy of the Royal Museum of Fine Arts, Brussels.

saucy graces, Senave places an unmistakable procuress—complete with requisite monocle. She leers at a seated model who faces away from us in a pose suggestive of Jean-Auguste-Dominique Ingres's icon of beauty, the *Valpinçon Bather* (1808).[39]

The bordello affect of Senave's *Parody of Zeuxis* is further enhanced not only by the pair of lovers huddled furtively on the right side of the painting but also by the figures gathered in the far-left foreground. The man grasping what appears to be a framed picture recalls the shop assistant crating a painting in the left foreground of Antoine Watteau's *Gersaint's Shop Sign* of 1721 for art dealer Edmé-François Gersaint (Figure 32). And the secretive lovers function analogously to Watteau's fashionable couple entering Gersaint's gallery: They mark the boundary separating the realm of artifice and commercial pleasure from the quotidian, earthy world of the street. Even Watteau's flea-pestered dog has entered Senave's *Parody,* playfully

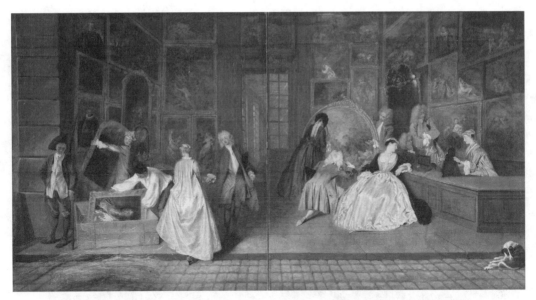

Figure 32. Antoine Watteau, *Gersaint's Shop Sign* (oil on panel, 1721, Charlottenburg Palace, Berlin). Photograph courtesy of Scala / Art Resource, New York.

seeking the attention of the surreptitious lovers. In this way, Senave humorously exposes the circuit of aesthetic-erotic-commercial traffic embedded within the Zeuxis myth.

The theme's voyeuristic potential is fully exploited by Victor-Louis Mottez (1809–97) in his oil painting *The Triumph of Painting (Zeuxis Choosing His Models)* of 1859 (Figure 33).[40] A student of Ingres, Mottez traveled and studied widely. His mature success derived both from his facility with neoclassical vocabulary and his aptitude for historic media: Mottez's most prestigious commissions were large-scale public decorations rendered in fresco. Like Vincent before him, he undoubtedly settled on the theme of Zeuxis Selecting Models as the ideal vehicle for his archaeological expertise and technical skills.[41] Mottez surely expected that exhibiting the painting at the Salon would confirm his position as an accomplished muralist as well as a skilled easel painter. But, like his predecessors, he let the theme get away from him.

Mottez coyly stages the encounter between Zeuxis and one of his models in the background of the painting, behind an elegantly embroidered curtain. The foreground of the painting is given to a group of women, some walking, some lounging, others gently comforting each other. Their varied presentation—fully clothed, partially draped, or nude—suggests that the women are models assembled for Zeuxis's review. Surrounded by ionic columns, the figures inhabit the interior of a peristyle Greek temple. In the

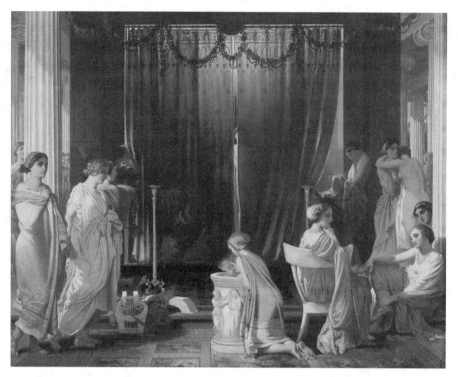

Figure 33. Victor-Louis Mottez, *The Triumph of Painting (Zeuxis Choosing His Models)* (oil on canvas, 1859, Musée Condé, Chantilly). Photograph courtesy of Réunion des Musées Nationaux / Art Resource, New York.

center of this space, a girl lights incense atop an altar, whose base is carved to show the veiled Hera as consort of Zeus. Several women, presumably the models summoned by Zeuxis, enter the temple from the left; others recline languidly on the right. Punctuating this dreamy scene are two women exhibiting strong emotion: One clings to a companion, and another covers her face with her hands, as if frightened or weeping. Just as in Vincent's and Monsiau's renditions, the precise cause of this agitation is not clear. But it endows the scene with dramatic tension: What exactly could be happening behind that curtain to reduce these women to such a state?

The curtain, in fact, is the focal point of the painting. Preventing easy visual access to the temple's *cella*, the drape serves to divide the pictorial space laterally into a foreground and a background. It also teasingly reveals just a sliver of the action taking place in the *cella*. It is here, in the temple's inner sanctum, that Zeuxis executes his painting. Part of a woman's head, breast, hip, and thigh can be seen through the center of the curtain, where its two halves part slightly. She seems to be standing on a raised platform. A powerful light source from within the *cella* casts Zeuxis's shadow onto

the curtain. His silhouette shows that he is seated, leaning eagerly toward the model. This intense encounter between Zeuxis and his model does not go unobserved. On the right, an older woman—resembling the escort/procuress in Monsiau's painting—pushes aside the drape, as if showing the scene to her young, partially clad charge. The sight of Zeuxis and his model has apparently so shocked or frightened the girl that she covers her face with her hands.

Another viewer also takes in the scene. Not nearly so brazen as the old woman, a young man stands at the left side of the curtain. He has opened it just enough to sneak a peek. Steadying himself with his left hand, his right is raised to his mouth in astonishment. This figure serves to enhance the painting's voyeuristic presentation. Like the many midcentury depictions of bathers and harem scenes, Mottez's *Triumph of Painting* presupposes a male, heterosexual viewer. Peeping around the curtain, the young man anticipates the behavior of the painting's intended audience. Not only does he enact the surreptitious gaze invited by the parted curtain, his gesture of astonishment promises a similar frisson to those who would follow his example. Clinching the voyeuristic appeal of the painting, the Peeping Tom within the painting ignores the easily accessible nude woman on the right side of the painting. Clearly, the visual pleasure depicted in this painting comes via an elicit glance at a forbidden encounter. In this way, Mottez's painting draws a clear parallel between Zeuxis Selecting Models and a primal scene.

An equally provocative encounter with the Zeuxis myth can be seen in an undated sketch (Figure 34) by the British illustrator and caricaturist Thomas Rowlandson (1756/57–1827). The inscription at the bottom of the drawing, "Apelles singling beauties from a variety of Models," indicates that the story of Zeuxis Selecting Models has here been confused and conflated with the legend of Apelles Painting the First Venus Anadyomène.[42] The characteristic pose of Venus Anadyomène (or Venus Rising from the Sea) is held by the two models at the middle of the composition. The model second from left assumes the "Venus Wringing Sea Water from her Hair" pose now familiar to many viewers thanks to Ingres's famous *Venus Anadyomène* (1848), while the model third from left holds the classic pose later captured by William Bouguereau in his similarly renowned *Birth of Venus* (1879). The half-kneeling model on the far right likewise assumes a pose suggestive of antiquity, in this case the first-century-BCE crouching Aphrodite of Rhodes as well as—in a provocative elision—the fifth-century Dying Niobid attributed to Pheidias (but known only through a Roman copy). The model furthest left suggests a bather, perhaps Diana, Venus, or Susannah.

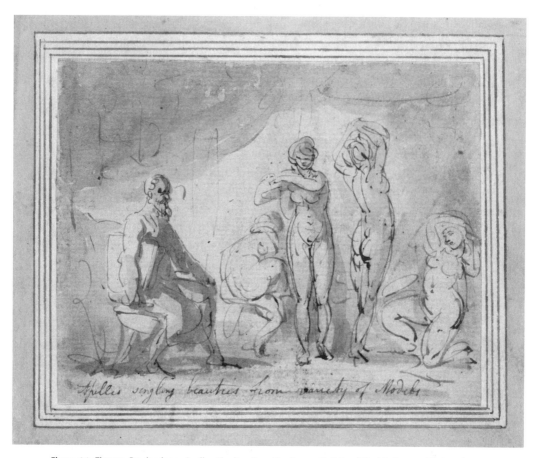

Figure 34. Thomas Rowlandson, *Apelles Singling Beauties from a Variety of Models* (pen and ink and watercolor on paper, n.d., Tate Gallery, London). Photograph courtesy of Tate Gallery, London / Art Resource, New York.

Rowlandson's quotations from these overripe archetypes commingle to produce a scene of excessive feminine sexuality. Venus, Diana, the Niobid, and Susannah: Taken together these women convey an eroticism suffused with danger and violence. Observing this superfluity is the artist seated at the left side of the drawing. He sits bolt upright and attentive. So transfixed by the scene is he, that he cannot even work: His sketchpad remains tucked under his arm and his stylus extends suggestively from his right fist. His facial expression oscillates between a smile and a grimace. Confronted by this display of femininity, sexuality, and artistic legacy, the artist hesitates as if enthralled by the uncanny scene before him.

That the scene contains erotic overtones is confirmed when it is compared with one of Rowlandson's many overtly erotic images, *Sultan's 4000 Women* (Figure 35). In this colored engraving, innumerable concubines pose

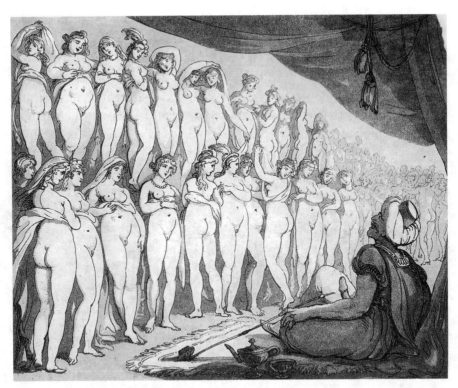

Figure 35. Thomas Rowlandson, *Sultan's 4000 Women* (colored engraving, n.d., British Museum, London). Copyright Trustees of the British Museum.

seductively before the seated—and eager—sultan. Among the positions assumed by the women are several variations on the Venus Anadyomène and Venus Wringing Her Hair attitudes. The sexual significance of these poses for Rowlandson cannot be doubted.

PAINTING IN THE PHILOSOPHICAL BROTHEL

Formal affinities between works of art from different cultures or periods can lead viewers to draw facile conclusions. Even connoisseurs and art historians occasionally succumb to this impulse. Art history—especially as practiced in the West—has long relied upon style and formal comparison as the means to determine aesthetic meaning or value. Thus, when one work strongly resembles another, art historians often seek to attribute the similarity to borrowing, influence, or appropriation. But formal correspondences can testify to other pressures as well. Like the "images" or "material of drives" generated by Kristeva's phobic patients, artistic form can make manifest a hidden, metaphorical language. Repeated themes or formal

structures deliver cultural memories, desires, and fears as much as they convey an individual artistic vision.

The striking affinities between Rowlandson's *Apelles Singling Beauties* and Picasso's *Les Demoiselles d'Avignon* (Figure 36) in no wise testify to the direct influence of one work upon the other. No evidence of conscious or deliberate borrowing exists. This is not to say that the resemblance derives from pure coincidence. Rather, the morphological correspondence between

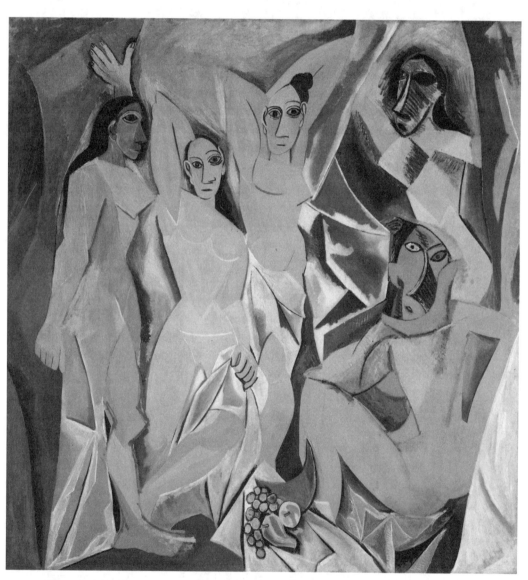

Figure 36. Pablo Picasso, *Les Demoiselles d'Avignon* (oil on canvas, 1907, Museum of Modern Art, New York). Photograph courtesy of the Museum of Modern Art, New York. Copyright 2005 Estate of Pablo Picasso / Artists Rights Society (ARS), New York.

Apelles Singling Beauties and *Les Demoiselles d'Avignon* results from their mutual engagement with the Zeuxis myth. In other words, both works confront precisely the same cultural concerns as those embedded in the legend of Zeuxis Selecting Models. The impossibility of originality, the inaccessibility of the ideal, and the failure of mimetic representation to assuage our anxieties about these shortfalls motivate the Zeuxis myth as they inform the works produced by Rowlandson and Picasso. In both cases, the artist— and the viewer—is placed *en abyme* before these women.

The Zeuxis myth illustrates cultural anxiety by registering a moment in which artistic agency—here substituting for a sense of personal wholeness and well-being—is both asserted and undermined. The assertion of artistic agency comes through Zeuxis's exemplary method. His procreative gesture of unifying disparate parts in order to give shape to the ineffable endows the artist with a divine power. Concomitantly, Zeuxis Selecting Models exposes a "lack" that undermines artistic agency. Whereas the lack revealed in Freud's primal scene is the mother's missing penis, the want confronted in Zeuxis Selecting Models is the absence of the original. In fact, the entire narrative revolves around disguising the fact of its absence. The original model (that is, Helen of Troy) is both affirmed and denied. She exists as an ideal but is supplanted as a true model by five different women. The "portrait" of Helen that Zeuxis paints, therefore, has no clear referent. The image at once signifies something and nothing. The Zeuxis myth offers a view of the uncanny.

Though not a literal depiction of Zeuxis Selecting Models, Picasso's *Demoiselles* visits the same primal scene managed by the Zeuxis narrative. Like Nicomachus struck dumb before Zeuxis's painting of Helen,[43] Picasso's contemporaries report having had a similar reaction on first seeing the *Demoiselles*. According to André Salmon, "the ugliness of the faces froze us half-converts with fear."[44] Fear of what? Not the painting's formal innovations: Salmon and the others were familiar with the radical work of the Fauves and other avant-garde artists. Nevertheless, many "artist friends began to distance themselves."[45] André Breton could speak of the painting only "mystically."[46] Some of those closest to Picasso at the time of the painting's execution remained entirely mute. Fernande Olivier, Picasso's lover, does not mention the painting in her account of life with the artist, *Picasso et ses amis* (1933). Guillaume Apollinaire never comments on it in his extensive writings on art. The painting, like a gorgon, seems to have rendered many early viewers dumbstruck. Perhaps this explains Picasso's decision to keep the painting sequestered in his studio, often hidden behind a drape, until 1912. Only when the painting joined the collection of the Museum of Modern Art (MoMA) in 1939 did talk become easier. MoMA offered

precisely the clinical environment necessary to deal safely with the paint-
ing. Once contained within antiseptic, neutral walls, the painting could be
understood in relation to other known and quantifiable categories such as
cubism, abstraction, or Negro art.[47]

The peculiar reaction of Picasso's friends and colleagues to the *Demoiselles*
suggests something other than the shock of radical artistic innovation.
Scholars have offered a variety of explanations for the painting's disquiet-
ing compositional and thematic properties.[48] Formal analyses tend to attri-
bute these qualities alternately to the painting's insult to Western pictorial
conventions or to the work's possibly unfinished state. Explications based
on style suppose the unsettling character of the work reflects its transition-
al status; neither wholly symbolist, primitivist, or cubist, the *Demoiselles*
provokes a disorienting viewing experience. Most accounts of the anxiety
encoded in the *Demoiselles,* however, depend upon biographical mate-
rial.[49] The artist's relationships with his friends or his lover, as well as his
supposed preoccupation with venereal disease, are cited as sources for the
painting's confrontational theme or violent handling. But the painting's ca-
pacity to disturb viewers nearly a century after its production invites pursuit
of a source more durable and affecting than the evanescent proclivities of a
young Spanish artist living in France at the turn of the twentieth century.

Central to the painting's meaning is its subject. That the *Demoiselles* de-
picts five prostitutes in a brothel goes undisputed.[50] Preliminary studies for
the painting clearly show the interior of a bordello and its staff of prosti-
tutes, as well as a couple of johns. The various titles given to the painting
since its completion confirm this setting. Referred to as *Le bordel d'Avignon,*
Les filles d'Avignon, or *Les demoiselles d'Avignon,* the painting would seem
to describe a specific establishment. But efforts to confirm this have proven
futile.[51] Instead, the scene seems to represent a *type* of place rather than a
specific site. This conclusion is given credence by one of the painting's earli-
est titles, *The Philosophical Brothel.* According to Salmon, Picasso's friends
gave the painting this moniker in reference to the marquis de Sade's *La phi-
losophie dans le boudoir* (1795).[52]

"THE DELICIOUS NICHE"

Sade's reputation gained ground during the early years of the twentieth cen-
tury as bohemian culture sought absolute freedom in personal as well as ar-
tistic expression. And for Picasso and his friends who associated with the
symbolist poet and critic Apollinaire, Sade undoubtedly held even greater
influence. Apollinaire's intense admiration for Sade made the libertine a

subject not only for bohemian worship but also for serious study.[53] Picasso's interest in Sade is also well attested. So the reference to Sade by *la bande Picasso* in relation to the painting is not surprising. But it does prompt a question: Why link the painting to *Philosophie dans le boudoir,* in particular? Any number of Sade's texts could summon the eroticism or even the degradation suggested by a bordello scene. The answer to this lies in the text itself as well as in the irony in the substitution of "brothel" for "bedroom" in the painting's nickname.

Structured as a series of seven dialogues, *Philosophie dans le boudoir* relates the fictional education/debauchment of the chaste fifteen-year-old Eugénie de Mistival by her friend, Madame de Saint-Ange. Saint-Ange enlists the assistance of her brother (with whom she has long enjoyed an incestuous relationship) and the philosophical libertine Monsieur Dolmancé. Together, they succeed not only in seducing the girl but in transforming her into a libertine of the most perverse order. The transformation takes place during a single afternoon. During this time, Eugénie metamorphoses from a modest virgin to a cruel wanton whose greatest pleasure comes in sexually and physically abusing her virtuous mother. The increasingly violent sexual encounters pursued by Eugénie and her tutors are framed by discussions of religion, government, parenting, education, and marriage as well as a lengthy excursus on republicanism. Sade even includes a discourse on population control that presages Thomas Malthus's 1798 *Essay on the Principle of Population.*[54] A consequence as much as a commentary upon the Enlightenment, *Philosophie dans le boudoir* takes to extreme lengths the ideas of natural law, free will, and the supremacy of reason endorsed by the philosophes.[55]

The educated, opinionated, and supremely debauched Dolmancé serves as Sade's alter ego. He possesses, as Madame Saint-Ange explains to Eugénie, "just that degree of philosophic understanding we require for your enlightenment."[56] Dolmancé also reveals something of an artistic bent, arranging the group into a series of sexual "tableaux." In one of the first tableaux enacted before Domancé, Saint-Ange instructs her young charge to recline on a couch in a niche surrounded by mirrors. The girl inquires of her tutor:

EUGENIE: Oh, dear God! the delicious niche! But why all these mirrors?

SAINT-ANGE: By repeating our attitudes and postures in a thousand different ways, they infinitely multiply those same pleasures for the persons seated upon this ottoman. Thus everything is visible, no part of the body can remain hidden: everything must be seen.[57]

Like the *Demoiselles, Philosophie dans le boudoir* pursues enlightenment via the destruction of previous beliefs. Picasso, too, shows us "the delicious niche" with its shattered surface simultaneously exposing and distorting the truth. Picasso's prostitutes assume poses redolent of sexual availability as well as Western artistic conventions. Mimicking—and simultaneously mocking— the Venus Anadyomène, the crouching Aphrodite of Rhodes, and the reclining odalisque, the *Demoiselles* invites the same unblinking pursuit of enlightenment pursued by Sade's characters.[58] But the excess of visibility is, in both *Philosophie dans le boudoir* and *Les Demoiselles d'Avignon*, at once seductive and repulsive. "Beautiful asses" provide, in *Philosophie dans le boudoir*, sexual pleasure as well as flatus. Similarly, Picasso's prostitutes push aside the curtains on a scene of erotic promise commingled with jarringly misshapen bodies and deformed faces. The desire to see, to know everything, can only be satisfied by stepping into the abyss, by confronting the uncanny as well as the beautiful. As Yve-Alain Bois points out, one theme of the *Demoiselles* is "the primordial question of sexual difference."[59] Laying everything bare, the *Demoiselles* offers a view at once alluring and threatening.

Excessive visibility can be enlisted to help manage the uncanny. Linda Williams argues that male viewers seek to master the uncanny by making feminine sexuality fully visible. Williams explains that the development of modern viewing technologies (cameras, zoopraxiscopes, and motion pictures) coincides with a desire to make visible the *difference* associated with women's erotic pleasure. This parallel development crests in the "frenzy of the visible" characteristic of hard-core pornography. By "frenzy of the visible," Williams refers to filmmakers' use of various techniques to display women's sexuality and erotic pleasure. Close-ups of body parts and the exposure of genitals normally hidden by hair or by folds of flesh are among such strategies. Because knowledge promises mastery, Williams argues, total visibility betokens a heightened erotic pleasure. Ultimately these strategies serve to reassure the male viewer by fetishizing the female body, while genuine confrontation with and mastery over the uncanny remains impossible through these means. Williams explains that "the more the male investigator probes the mysteries of female sexuality to capture the single moment revealing the secret of her mechanism . . . the more he succeeds only in reproducing the woman's pleasure based on the model, and measured against the standard of his own."[60]

The reader who seeks to have the secrets of feminine sexuality revealed in Sade's "delicious niche" finds the spectacle interrupted repeatedly by Dolmancé's demands to see the women's buttocks (he confines his own performance to anal intercourse, preferably with men) or his explanations of male ejaculation. In purporting to render transparent feminine pleasure, Sade only

affirms the dominance of masculine sexuality. The text encompasses a series of Sade's own (often misogynistic) fantasies, so its focus on male sexuality is not surprising. On female pleasure, Eugénie's teachers have little to offer. In a discourse ostensibly on the need to afford women liberty from familial demands when they reach their majority, Sade simply exchanges one form of bondage for another. For example, Saint-Ange lauds "the services a young girl renders in consenting to procure the happiness of all who apply." She explains further, "Woman's destiny is to be wanton, like the bitch, the she-wolf; she must belong to all who claim her."[61] The pleasures a young woman should pursue are not her own but those of the men who desire her.

The *Demoiselles* offers less reassurance for Williams's "male investigator." The painting refuses to interrupt the viewer's contemplation of the uncanny in the way that *Philosophie dans le boudoir* does. Masculine sexuality finds no firm purchase here. And this was a deliberate gesture on Picasso's part: The final version of the painting evacuates the men present in some of his preparatory drawings for the painting. In several preliminary sketches, two men appear in the brothel (Figure 37). One sits at a table in the center

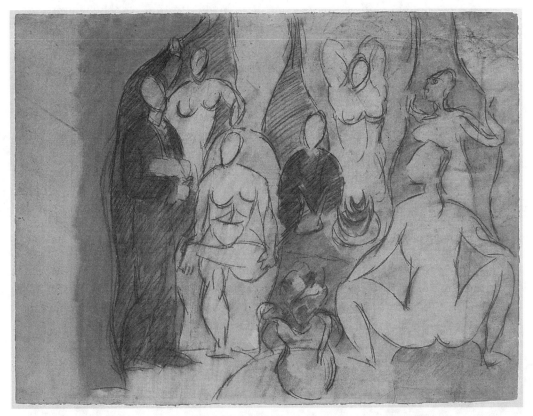

Figure 37. Pablo Picasso, *Composition Study for "Les Demoiselles d'Avignon"* (graphite and pastel on paper, 1907, Kunstmuseum Basel, Kupferstichkabinett). Photograph courtesy of Kunstmuseum Basel.

of the room, and another enters the scene from the left. Studies for the man at the left show him alternately holding a book or a skull (Figures 38 and 39). These attributes have led to the identification of the figure as a medical student. He could just as easily be reckoned an art student with his sketch-book and a skull. Indeed, William Rubin suggests that the figure functions as an "alter ego" for the artist. The figure's relationship to earlier veiled self-portraits, such as the Harlequin at the left of the *Family of Saltimbanques* (1905), have been invoked in support of such an interpretation. Picasso himself referred to one sketch for the student (Figure 40) as a "self-portrait." Even Picasso's dog "Fricka" appears happily greeting the student in some sketches (for example, Figure 39). But the artist/student is soon removed from the scene, leaving the "sailor" as the only male figure in subsequent sketches. The sailor, too, has been identified with Picasso.[62] The cool reserve of the seated man—who busies himself with rolling a cigarette—contrasts with the vigorous display surrounding him. An impassive observer, the sailor maintains his emotional distance as he takes in the scene much as would Baudelaire's "Painter of Modern Life." With the sailor's departure, the scene no longer offers a reassuring or controlling male substitute for the viewer. Only a trace of male mastery—in the form of the prostitute who has taken the place of the artist/student and who now pushes aside the curtain to reveal the scene—remains, rendering its erasure all the more palpable.

Picasso's oblique presence in these studies opens an important interpretive fissure. As home to a group of five nude women as well as at least one veiled self-portrait of the artist, the setting oscillates between bordello and studio. Even the central still life recalls a standard studio prop. Similarly, the drapery pushed aside by two of the women and clutched coyly by a third is more likely to be found in an artist's studio than in the salon of a brothel. As already discussed, the slippage between atelier and bordello participates in long-standing assumptions regarding artistic creation as related to procreation. A central motif of the Zeuxis myth, the fusion of sexual and aesthetic impulses similarly motivates Picasso's conception of the *Demoiselles.*

In reference to the final version of the *Demoiselles,* Leo Steinberg states that "the observer's presence, any man's presence, is understood without any man being painted in."[63] I agree with this assertion. The implied male presence rests, of course, outside the painting in the position occupied by the viewer. We stand with the student, with the sailor, with Rowlandson's petrified artist, and with Picasso. And finally we realize that we are seeing what Zeuxis saw: five nudes whose intense physical presence, whose shocking reality, mocks and defeats the artist's quest for the ideal. From this vantage, it is easy to understand why academic painters largely avoided the theme. It was no accident that Picasso painted the *Demoiselles* on a specially

Figure 38. Pablo Picasso, *Study for the Medical Student,* Carnet 9, f. 37v (graphite on beige paper, 1907, Picasso Museum, Paris). Photograph courtesy of Réunion des Musées Nationaux / Art Resource, New York.

Figure 39. Pablo Picasso, *Study for the Medical Student, Man in Profile, Arms Raised, Holding a Skull,* Carnet 9, f. 18r (graphite on beige paper, March–July 1907, Picasso Museum, Paris). Photograph courtesy of Réunion des Musées Nationaux / Art Resource, New York.

Figure 40. Pablo Picasso, *Self-Portrait* (ink on paper, 1906, Santa Barbara Museum of Art, Santa Barbara; gift of Margaret P. Mallory). Photograph courtesy of the Santa Barbara Museum of Art.

prepared and stretched, Salon-size canvas. His theme was an intensely academic and classical one.

In his discussion of the *Demoiselles,* Yve-Alain Bois observes that "the frightful warning stare of the demoiselles seems to figuratively declare the exclusion of the spectator. Doesn't their shattering gaze rid us of any desire to enter into the picture's space?"[64] Indeed it does. With the *Demoiselles,* Picasso shows *how to paint like Zeuxis* by placing himself—and the viewer—in the position of Zeuxis. With this gesture, the primal scene of mimetic representation is finally confronted. The consequence is both the destruction of painting and its rebirth.

Zeuxis in the Operating Room: Orlan's Carnal Art

Carnal Art is self-portraiture in the classical sense but made by means of today's technology. It swings between defiguration and refiguration. Its inscription into the flesh is due to the new possibilities inherent to our age. The body has become a "modified ready-made," no longer seen as the ideal it once represented.

— ORLAN, *CARNAL ART MANIFESTO*

A RECENT—AND RADICAL—CRITIQUE of the Zeuxis myth occurs in the work of the contemporary French performance artist Orlan.[1] Her project, *The Reincarnation of St. Orlan* (1990–93), enacts bodily the legend of Zeuxis Selecting Models. Central to *The Reincarnation of St. Orlan* are the nine surgical procedures through which Orlan modified her facial features (Figure 41) to resemble those of five women depicted in post-Renaissance Western paintings.[2] The operations are conceived and executed as performances: Orlan remains awake and conversant, relying on local anesthesia to minimize discomfort.[3] Her audience observes via closed-circuit television or satellite broadcast. During these surgery-performances, she reads aloud from psychoanalytic texts, converses with her surgeon or assistants, and sometimes responds to viewers' questions faxed to her in the operating room.[4]

Before realizing her surgical transformation, Orlan experimented on a computer using morphing software to determine which characteristics she would assume. This technology enabled her to view her face with new features taken from scanned images. Like Zeuxis, Orlan ultimately settled on parts from five different women: the forehead of Leonardo's Mona Lisa, the nose of François Gerard's Psyche, the chin of Sandro Botticelli's Venus, the

Figure 41. Orlan, "Omnipresence" (color photograph, 1993, Sandra Gering Gallery, New York). Courtesy of Sandra Gering Gallery, New York. Copyright 2005 Artists Rights Society (ARS), New York / ADAGP, Paris.

eyes of an anonymous sixteenth-century School of Fontainebleau Diana, and the lips of Gustave Moreau's Europa (Figures 42–46).[5] Thus selecting from canonical images of femininity, Orlan bodily enacts the Zeuxis myth.[6]

Orlan claims that her work is an expression of her feminism as well as an extension of conceptual art practices begun in the 1950s and 1960s. As an advocate of women's liberation, Orlan denounces cultural expectations that encourage women to undergo painful and costly procedures to change their appearance. She concedes that men, too, sometimes find themselves subject to oppressive standards for physical appearance, but this phenomenon is comparatively rare. In the West, definitions of femininity remain inextricably bound to physical form. Orlan explains in a 1988 interview that "the whole gist of my work is directed at these incredible pressures on the woman's body."[7] In a subsequent interview, Orlan clarifies that the source of these "pressures," or social forces, is patriarchy: "One thing is sure: it is

Figure 42. Leonardo da Vinci, *Mona Lisa* (oil on panel, 1503–4, Louvre Museum, Paris). Photograph courtesy of Réunion des Musées Nationaux / Art Resource, New York.

Figure 43. François Gerard, *Cupid and Psyche* (oil on canvas, 1798, Louvre Museum, Paris). Photograph courtesy of Réunion des Musées Nationaux / Art Resource, New York.

Figure 44. Sandro Botticelli, *Birth of Venus* (tempera on panel, 1482, Uffizi Gallery, Florence). Photograph courtesy Scala / Art Resource.

Figure 45. Anonymous, *Diana the Huntress* (oil on canvas, mid-sixteenth century, Louvre Museum, Paris). Photograph courtesy of Réunion des Musées Nationaux / Art Resource, New York.

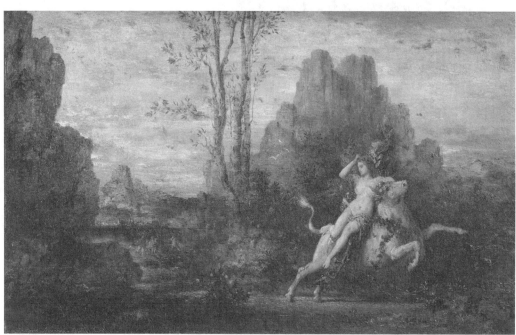

Figure 46. Gustave Moreau, *Rape of Europa* (oil on canvas, 1868, Musée d'Orsay, Paris). Photograph courtesy of Réunion des Musées Nationaux / Art Resource, New York.

through cosmetic surgery that men can exert their power over women the most."[8] The power made manifest on the operating table comes from a variety of sources. Culturally, Orlan finds men largely (though not exclusively) responsible for propagating unattainable or extreme expectations for women's physical appearance. Socially, men still dominate Western political and economic institutions. Laws that govern access to medical treatment and business practices that favor youthful-looking and attractive employees contribute to women's oppression via plastic surgery. Finally, a profound gender imbalance obtains in the operating room itself. Almost all plastic surgeons are men; most of their clients are women.[9]

This is not to say that Orlan is opposed to women undergoing elective plastic surgery. She believes that cosmetic surgery offers a valid means to reclaim or reshape one's identity. Because of physical changes wrought by trauma, disease, or simply age, individuals can find themselves feeling disoriented or alienated from their own faces. Orlan explains,

> Very often, people, once they've reached seventy, wind up with
> a face they don't recognize as theirs any longer. There is a loss
> of identity because they no longer recognize themselves. They
> are alien to themselves. And I think that, in this case, when it
> is too difficult to feel "other," there is cosmetic surgery.[10]

The emancipatory potential of changing one's appearance motivates, in part, *The Reincarnation of St. Orlan*. Among the texts Orlan reads at the start of her surgery-performances is an excerpt from *La robe* by Lacanian psychoanalyst Eugénie Lemoine-Luccioni. The passage Orlan points to as particularly germane to her project reads,

> The skin is deceptive. . . . in life one only has one's skin. . . .
> there is an error in human relations because one is never
> what one has. . . . I have an angel's skin, but I am a jackal . . . a
> crocodile's skin but I am a puppy, a black skin but I am white,
> a woman's skin but I am a man; I never have the skin of what
> I am. There is no exception to the rule because I am never
> what I have.[11]

For Orlan, this passage reveals the uncomfortable disjuncture between interior and exterior, between how we see ourselves and how we are seen by others. This breach can be mended, Orlan theorizes, through recourse to plastic surgery or other techniques that will alter one's appearance.

In addition to avowing a feminist intent to *The Reincarnation of St. Orlan,* she holds that the project is an extension of avant-garde art practices of the mid-twentieth century. Orlan has, in fact, been engaged in producing and showing conceptual art since the 1960s.[12] The tendency of journalists and even some critics to treat her *Reincarnation of St. Orlan* project as a newsworthy event instead of as an artistic enterprise rankles. "My message gets completely bastardized by the popular press."[13] Even some ostensibly scholarly essays on her work begin with statements like "Orlan is a French performance artist whose work on beauty elicits shock and disgust."[14] In light of this, Orlan's occasionally pleading emphasis on the art-historical relevance of her work is understandable. Like most conceptual art of the 1960s, *The Reincarnation of St. Orlan* challenges traditional categories of "art," "medium," and "technique" as it critiques art's role as commodity. Orlan contends that "there's no difference in my process today than . . . the process I was following in the '60s."[15] Even then, her body played a fundamental role in her art. But Orlan distinguishes her earlier body art projects from *The Reincarnation of St. Orlan,* which she describes as "carnal art."

Carnal art, according to Orlan's *Carnal Art Manifesto,* differs from body art with regard to its embrace of new technologies to redefine "self-portraiture."[16] In body art, the artist's primary medium is herself, the form and energy generated by her corporeality. The relationship between body art and self-portraiture is a vexed one. And body artists differ on the potential or relevance of self-portraiture in their work. Because Orlan's project addresses precisely the limits of physical and psychic identity, her carnal art necessarily engages the category of self-portraiture.[17] But she further distinguishes carnal art from much body art in another crucial—and perhaps unexpected—way. Orlan explains that "contrary to Body Art . . . Carnal Art does not long for pain, does not seek pain as a source of purification, does not conceive it as a redemption."[18] Pain, for Orlan, is "anachronistic and ridiculous." The privileging of pain as an elevating experience in the West, she claims, is a perverse legacy of Christianity.[19] Her frequent invocation of sainthood underscores her critique of the Christian valorization of pain; her references to religious personages also situate her work vis-à-vis art history. The prevalence of Christian imagery in Western art provides one basis for art-historical intervention. In this way, St. Orlan petitions for canonization, at least within the history of art. Orlan's invocation of sainthood also modernizes the notion of religious martyrdom. St. Orlan's mortification of the flesh promises social and psychic rather than spiritual emancipation. Her pronouncement that "it is no longer plastic surgery, but revelation" illustrates the collision between political and religious ideologies that she explores in her work.[20]

The Reincarnation of St. Orlan has generated a great deal of (often stimulating, occasionally bombastic) commentary. Many writers express concern if not outright disgust over her project. Increasingly, though, Orlan's work elicits serious scholarly consideration. But this attention comes disproportionately from women.[21] Obviously, her work strikes a chord resonant with issues of gender and feminine identity. Despite this stepped-up attention, neither critics nor scholars have offered a sustained analysis of Orlan's seizure of the Zeuxian method. Consequently, the usefulness of her work for theorizing authorship, for critiquing mimesis, and for understanding earlier representations of the Zeuxis myth remains unexploited. Any understanding of Orlan's work in relation to the history of Western art must take seriously her engagement with Zeuxis Selecting Models. This is not to say that the obvious parallels between her method and that of Zeuxis have gone unremarked. Beata Ermacora, for instance, cites the legend in a 1994 essay on the artist. After briefly recounting the legend, Ermacora rightly observes that "this procedure traditionally relates to the image of woman from the man's point of view." She then adds that this strategy "confers on the artist a creative and thus god-like status." Although Ermacora is a bit sweeping here, she acknowledges that "Orlan takes it up from the woman's viewpoint."[22] But what does it mean to assume the role of a female Zeuxis?

Orlan's intervention in Zeuxis Selecting Models recalls the painting of *Zeuxis Selecting Models for His painting of Helen of Troy* by Angelica Kauffman discussed earlier (Figure 14). Kauffman's depiction includes a self-portrait costumed as the personification of Painting, Imitation, and Invention. Standing next to Zeuxis's unfinished canvas and grasping his brushes, Kauffman's allegorical self-portrait asserts her own creative agency. Like Kauffman, Orlan renegotiates the myth's gendered division of creative labor by assuming a dual role. She presents herself simultaneously as Zeuxis, the active creator, and as Helen, the objectified ideal. And, in a gesture akin to Kauffman's, Orlan accomplishes this through the use of veiled self-portraiture. Both artists expand the conventions of self-portraiture. Self-portraits normally assert a presence that is at once active and passive, someone who is looking while being looked at. But ultimately, conventional self-portraits confirm the authority of the artist by assuring the viewer of the artist's control over the image. Kauffman and Orlan complicate this viewing structure by blurring further the distinction between artist and model.

By offering veiled self-portraits, both artists defer the moment at which their creative agency is recognized. This delay momentarily confounds a viewer who is accustomed to receiving a clear indication of the work's status

as a self-portrait. Indeed, this confusion lasts long enough to raise doubts about the stability of the categories of "artist" and "model."[23] Kauffman and Orlan insert themselves—disguised but still recognizable—into a narrative that would seem to preclude their authority. In Kauffman's case, she enters a narrative in which art making is necessarily associated with a male artist. Once recognized by the viewer, though, Kauffman's self-representation drastically undermines the conventional meaning and consequence of the theme she portrays. Likewise, Orlan participates in and disrupts an ingrained sociocultural narrative by confounding the roles of creator/created, doctor/patient. Who *makes* Orlan? Is the surgeon an artist? Or an indispensable studio assistant?[24] Orlan's body is her art, but her body also generates her art. Where does Orlan the artist end and Orlan the work of art begin? Of course, such questions defy definitive answers. But the status of her work as self-portrait is undoubtable. She is, as Ermacora states, transforming "her appearance with the aim of arriving at a new, clear identity of the Self." Orlan is "working on her self-portrait."[25] Both Kauffman's painting and Orlan's body test the limits of representation as well as of identity. The question "Who am I?" cannot be separated in either case from the question "Who is the artist?"

Orlan's use of the veiled self-portrait predates the surgery-performances of *The Reincarnation of St. Orlan*. From 1974 to 1984, Orlan explored her new identity as St. Orlan. Many of the performances, installations, and "relics," such as photographs, she produced during this time feature the artist swathed in drapery suggestive of nuns' habits. Thus dramatically costumed, Orlan theatricalized her new persona in a way suggestive of the seventeenth-century representations of saints. A 1983 photograph, "St. Orlan as a Baroque White Virgin," exemplifies Orlan's strategy (Figure 47). And that strategy is strongly reminiscent of Kauffman's. Here, Orlan represents herself as a quasi-allegorical figure, at once announcing and disavowing a desire to challenge the conventions of representation. Orlan claims artistic agency in this work through self-fashioning and self-representation while mitigating the transgressive nature of this act by depicting herself in a familiar and comforting feminine role. She appears to conform to conventions of feminine purity, sanctity, and obedience. At the same time, however, her direct reference to Baroque representations of female saints such as Gian Lorenzo Bernini's well-known *St. Theresa in Ecstasy* (1645–52) allows her self-portrait to convey the self-sufficient eroticism embodied in some seventeenth-century scenes of ecstatic religious experience. In this way, Orlan acknowledges conventions of femininity while pointing out possibilities for self-expression, spiritual fulfillment, and physical pleasure

Figure 47. Orlan, "St. Orlan as a Baroque White Virgin" (photograph, 1983, Sandra Gering Gallery, New York). Courtesy of Sandra Gering Gallery, New York. Copyright 2005 Artists Rights Society (ARS), New York / ADAGP, Paris.

available within the limits established by such conventions. Not surprisingly, Orlan's work of this period provoked little in the way of public censure. Her critique—like that of Kauffman in her *Zeuxis Selecting Models*—oscillates between self-portrait and allegory, asserting agency as it reasserts cultural norms. Not until she took up *The Reincarnation of St. Orlan* and its overt critique of the Zeuxis myth did her self-portraits assume a horrifying quality. Only then did her image begin to evoke dread.

The Reincarnation of St. Orlan bears an obvious kinship with the Zeuxian narrative explored by Mary Shelley. Allusions to *Frankenstein* percolate throughout Orlan's carnal art. Orlan—like Shelley's Victor Frankenstein—challenges nature's vagaries. "Life is a recoverable aesthetic phenomenon," Orlan explains, "and I am at the strongest points of the confrontation.

We no longer need to accept the body God and genetics have given us."[26] Orlan's declaration echoes that of Frankenstein, who proclaims, "I became myself capable of bestowing life upon lifeless matter." Frankenstein achieves this years after his juvenile pining for the "glory [that] would attend the discovery, if I could banish disease from the human frame, and render man invulnerable to any but a violent death!"[27] In chapter 5, I asserted that Shelley put into play two competing models of artistic invention in *Frankenstein:* the Zeuxian *bricoleur* and the Promethean creator. These two models are likewise conjured by Orlan.

For Orlan, the Zeuxian (or mimetic) model is exemplified by the working of DNA. Like Zeuxis, DNA retains and bestows features or physical attributes. The "copy" DNA produces can be exact (as in the case of cloning) or a composite (as in sexual reproduction or genetic engineering). Orlan's selection of features from representations of Diana, Europa, Psyche, Venus, and the Mona Lisa obviously reenacts Zeuxis's strategy for painting an image of Helen. But Orlan's project differs importantly insofar as her models are "chosen not because of [the] beauty that they are supposed to represent but for their histories."[28] DNA, Orlan asserts, is the "direct rival [of] . . . artists of representation."[29] It generates not an ideal but, rather, a composite based on biological imperatives. Orlan's "struggle" is to assert history as well as her artistic authority in the face of rival, ahistorical artists: "Nature, DNA, and God."[30] As a twentieth-century Zeuxis, Orlan asserts a new definition of the artist as well as new sites for artistic creativity.

The Reincarnation of St. Orlan draws an explicit comparison between the artist's studio and the operating room.[31] Shelley offers a similar analogy in her characterization of Frankenstein as a Zeuxian artist. Such mapping of the surgical theater or laboratory onto the artist's studio implies their shared purpose as sites of creativity and work as well as of success and failure. It also suggests that they function equally as spaces of trauma. Orlan explains, "As a plastic artist I wanted to intervene in the surgical aesthetic, which is cold and stereotyped, and to confront it with others: the decor is transformed, the surgical team and my team wear clothing conceived by established fashion designers, by myself, or by young, up-and-coming stylists."[32] Orlan's theatricalization of the operating room through the use of props, costumes, and recitations echoes Hollywood's treatment of Frankenstein's laboratory as a carnivalesque chamber of horrors (Figure 48).[33]

Orlan's surgery-performances highlight their kinship to Hollywood horror movies by both exposing and disguising the trauma by a fetishistic means. According to Freud, fetishism is a consequence of an unresolved castration complex. Triggered by a young boy's unwitting discovery that his

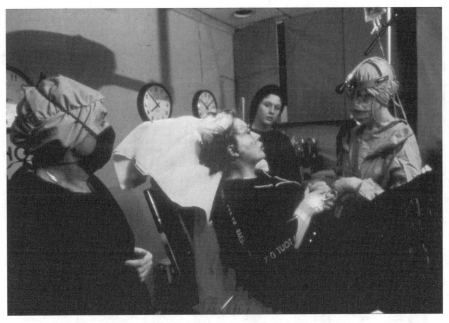

Figure 48. View of an Orlan performance in the surgical theater. Photograph courtesy of Sandra Gering Gallery, New York. Copyright 2005 Artists Rights Society (ARS), New York / ADAGP, Paris.

mother's genitals are unlike his own—that she lacks a penis—the castration complex describes the latent anxiety provoked by this sight. While the castration complex is triggered by the sight of female genitalia, the resulting anxiety is assuaged through a reenactment of the moment of discovery, usually through the vehicle of a fetish. Freud describes the typical fetish as "some part of the body (such as the foot or the hair) . . . or even some bodily defect." Thus, through the comforting vehicle of the fetish, the moment of originary trauma is revisited, and the scene is unconsciously reenacted under controlled and reassuring circumstances.

Karl Marx conceived of a different sort of fetish, one that answered the need of capitalism. For Marx, fetishism describes the process through which an object is transformed into a commodity. The fetishized object bears no sign of its production; its value is determined through its participation in a circuit of exchange. In other words, for Marx the fetish signifies currency as opposed to its own production. Mass-produced, flawless, and attractively packaged, the fetish masks its own manufacture, its own history. The commodity-as-fetish described by Marx subverts expectations of authenticity or originality. Orlan's exploration of fetishism draws upon both Freudian and Marxist models.

Photographs and video recordings of the often grisly procedures Orlan

undergoes furnish fetishes through which her performances might be psychically reenacted or authenticated. Such documentation is a crucial part of her project: Orlan means for viewers to watch the procedure-performance. This is not always a comfortable experience. Psychoanalytic critic and commentator on Orlan's art, Parveen Adams, provides a description of one of the videos that both registers and explains the viewer's involvement. Adams writes, "As the knife cuts she goes on talking. . . . The surgeon cuts for ten minutes, producing a number of flaps. . . . the ear begins to come away from the face." At this point, Adams's account shifts to reveal the sensations she herself experiences as she watches:

> The body of suffering is produced in the spectator, if not in
> the patient. Orlan demands that the yellow sheets under her
> be lifted and displayed. We see a bloody patch which drips. . . .
> There is still more. An injection in the neck and a small tube
> inserted into her face to separate the skin from the flesh. . . .
> Finally it seems that [the surgeon] can't go on and we are spared
> any more.

Adams concludes, "The dominant effect of the video on at least this viewer is horror."[34] Similarly, Sharon Waxman, reporting on Orlan's series of surgery-performances for the *Washington Post*, writes, "Still, it is hard for an observer to get over that first, instinctive reaction to Orlan's work, which is, of course, nausea. . . . you don't really want to look too closely, but then, of course, you end up staring in a sort of horror."[35] And this is precisely the sensation Orlan seeks to provoke. The photos she exhibits reveal the gore and violence that is part of most "routine" cosmetic procedures such as face-lifts.

The encounter Adams and Waxman describe is an uncanny one. Orlan makes this explicit in her own description of the procedure:

> It is here on the operating table that castration occurs, not
> in the act of cutting, not in the drama of the knife, not in
> the barely suppressed frenzy of it all, but in the space which
> is opened up. . . . Something flies off; this something is the
> security of the relation between the inside and the outside.
> It ceases to exist.[36]

But Orlan is neither a masochist nor a sadist. She relies on local anesthetic during the procedures and other analgesics for postoperative pain.[37] And she apologizes to her audience for the visual trauma to which she subjects

them. "I am sorry to make you suffer," she says, before reassuring the viewer that she does not experience great discomfort during the procedure. For Orlan, suffering only comes "when I look at the images." She explains, "Only a few kinds of images force you to shut your eyes: death, suffering, the opening of the body, some aspects of pornography for some people, and for others, giving birth."[38] These are, of course, triggers of the uncanny.

To assuage the viewer's horror, Orlan provides the mechanisms through which the uncanny experience might be safely sublimated. The surgery-performances come with ready-made fetishes.[39] Haute couture, rituals involving the recitation of special texts, and Orlan's theatrical performance nudge the performance from scene of trauma to reassuring spectacle.[40] It is perhaps not surprising that so many Hollywood interpretations of *Frankenstein* are suffused with a camp aesthetic. By appealing to extreme artifice as well as exaggerated characters, the campification of *Frankenstein* both preserves and disguises the horror of the narrative. As James Whale's treatments of *Frankenstein* in particular show, camp is a cultural response to the uncanny. These films render manageable the physical and erotic trauma embedded in Shelley's novel.

Orlan also produces literal fetishes through which her surgery-performance can be recalled from the security of a gallery, museum, or even one's home. "Reliquaries" containing samples of tissue, blood, and fat removed from her body are available for purchase. Plexiglas cases contain the small samples, preserved for display (Figure 49). In addition, some of the instruments or clothing used during procedures are also offered for sale. Fragments of the "true cross" are here supplanted by a scalpel; shreds of the Virgin's mantle are replaced by Dr. Marjorie Cramer's surgical smock (Figure 50). Such relics recall the artist's earlier self-representation as St. Orlan while pointing to her engagement with Freudian as well as Marxist notions of the fetish. Positioning herself as fetishist and fetish, Orlan at once claims and rejects the mastery promised by both Freud and Marx. In this way, Orlan, like Shelley and Kauffman, adopts a position vis-à-vis the Zeuxis myth that is unavailable to men.

Orlan's most direct reference to *Frankenstein* remains her "Self-Portrait with a Bride of Frankenstein Wig," a photograph taken in 1990 following the third operation (Figure 51). Here, Orlan refers generally to the story of Frankenstein and specifically to Whale's 1935 film *The Bride of Frankenstein*. The artist wears the Bride's distinctive coiffure, and the photograph resembles publicity shots of the film's star, Elsa Lanchester (Figure 52). Despite the film's opening credits, which announce that the movie was "suggested by the original story by Mary Shelley," *The Bride of Frankenstein* undermines

Figure 49. Photograph of an Orlan "reliquary" containing some of her tissue. Courtesy of Sandra Gering Gallery, New York. Copyright 2005 Artists Rights Society (ARS), New York / ADAGP, Paris.

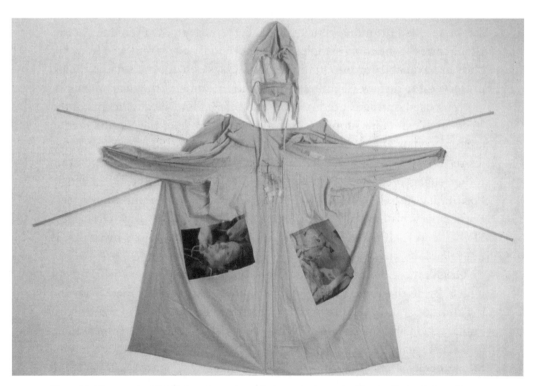

Figure 50. Photograph of Dr. Marjorie Cramer's surgical smock. Courtesy of Sandra Gering Gallery, New York. Copyright 2005 Artists Rights Society (ARS), New York / ADAGP, Paris.

Figure 51. Orlan, "Self-Portrait with a Bride of Frankenstein Wig" (photograph, 1990, Sandra Gering Gallery, New York). Courtesy of Sandra Gering Gallery, New York. Copyright 2005 Artists Rights Society (ARS), New York / ADAGP, Paris.

Figure 52. Elsa Lanchester, publicity photograph for *The Bride of Frankenstein*, 1935. Copyright Universal Studios.

one of the most daring and potentially transgressive elements of the novel. The film reasserts precisely the Zeuxian model that Shelley had called into question. Specifically, the film reinstates the Zeuxian gender roles subverted by Shelley, that is, man as creator, woman as created. Unlike Shelley's Victor Frankenstein, who could not or would not give life to the female form he had cobbled together, the film's scientist successfully reanimates a female being. She is a creature intended to mollify the monster's loneliness and violent hatred of humanity. But the uncanniness of the Zeuxis myth persists in the film, if latently: The resulting Bride—like Helen—inspires a love that can be consummated only through death. The Bride's rejection of the monster's love provokes him to destroy both himself and the object of his desire.

Orlan's assumption of the Bride's identity points to the obvious connections between her work and the Frankenstein legend. At the same time, the photograph documents her dual role as artist and image, subject and object, self and other, creator and destroyer. These traditionally polar positions collide in Orlan's work, producing an unstable icon of femininity. At once reassuring in its mimicry of Hollywood glamour shots or glossy advertisements and threatening in its evocation of monstrosity, violence, and death, the figure in "Self-Portrait with a Bride of Frankenstein Wig" vacillates between two subject positions: phallic mother and castrated and therefore threatening other.

Orlan's use of masquerade to perform the Zeuxis myth resembles the strategies of her female predecessors, Angelica Kauffman and Mary Shelley. All three women alternate among the roles of Zeuxis, his model, and the ideal he seeks to create. Their performances of the myth reveal Zeuxis Selecting Models to be a powerful vehicle for the assertion of feminine artistic agency as well as for critiquing the repressive habits of patriarchy. In this way, women artists' treatments of the myth differ importantly from those of their male contemporaries. This difference derives, I believe, from differences in their responses to the fetishistic character of the myth.

In *Female Fetishism*, Lorraine Gamman and Merja Makinen attempt to forge a theory of fetishism that responds to women's experience and behavior. Unsatisfied with Freudian and Lacanian theories—which fix fetishism within a phallocentric model, concerned only with the consequences of men's castration anxiety—Gamman and Makinen seek to conceptualize a female fetishist. They reject the idea that female fetishism is simply a form of penis envy, expressing itself by mimicking behavior used by men. Instead, they insist that the quantity and character of documented instances of female fetishism point to a trigger other than (or in addition to) castration anxiety:

If women are allowed to fetishize, then the castration com-
plex cannot be the only explanation—something else must be
occurring as well, or instead. In trying to conceptualize this
"something else," a new and positive construction of female
sexuality must come into play.[41]

One possibility is derived from the work of Hélène Cixous. Briefly,
Cixous argues on behalf of a female subjectivity based on abundance as
opposed to lack. Rejecting conventional psychoanalytic thinking that at-
tributes to women a sense of inferiority that presents itself as penis envy,
Cixous counters that women's possession of the womb and the capacity to
bear children endows them with a psyche based on abundance. What is
more, a woman's ability to create and then separate from a child precludes
the urge to dominate or compensate. As Gamman and Makinen explain,
Cixous's "woman, not having experienced castration anxiety, has not so
fully undergone the rupture from this state [of union between mother and
child], and the Imaginary plenitude is therefore more available to her."[42]
Cixous's model of female subjectivity suggests that a fetishistic scene such
as Zeuxis Selecting Models would not, presumably, trigger fear in a female
viewer or artist. Taken further, the exploration of fetishism by a woman
might even be understood as an expression of power as opposed to anxiety.

Another alternative offered by Gamman and Makinen is that fetishism
is a response to separation anxiety, something experienced by both men
and women. Proceeding from the assertion "that fetishism is a highly crea-
tive compromise which, through its doing-and-undoing oscillation, enables
the subject to cope with unconscious menace," the authors insist that there
is no reason to link the phenomenon to a trauma experienced only by men.
Unlike castration anxiety—which Freud and Lacan traced to the phallic
stage—separation anxiety develops earlier, during the oral or "pre-phallic"
stage. The infant's awareness that he or she is distinct and separable from
the mother sows fears of loss. If fetishism is a result of separation anxiety, it
would be a coping strategy available equally to men and women.[43]

Whether a trigger for anxiety or empowerment, the fetishism inherent
in Zeuxis Selecting Models points to the existence of an underlying cultur-
al memory, what I have been calling a cultural primal scene. Like any pri-
mal scene, this one raises doubts about the nature and extent of existence.
Zeuxis Selecting Models puts two, inherently antithetical, propositions into
play: (1) There exists an ideal, and (2) the form of the ideal cannot be seen,
imagined, or invented, and thus the ideal cannot be confirmed phenome-
nologically. The juxtaposition of these two propositions is contradictory,

confusing, and potentially distressing. The existence of the ideal—of spiritual transcendence—is under threat. So the Zeuxis narrative works to bury this threat deep within cultural memory. The gathering of models, the selection of their best features, their fragmentation and recombination: All of this distracts the viewer from any disquieting questions raised by classical mimesis. Instead of a threat, classical mimesis masquerades as a vehicle for aesthetic—and ontological—triumph. Orlan's surgery-performances disrupt this psychic pattern of repression and reassurance, exposing the primal scene encoded by the Zeuxis myth. Orlan forces the West's anxiety about classical mimesis out of the cultural psyche and into the body politic. And it is there, among the organizing principles and social institutions that give shape to "the West," that the origins and consequences of the Zeuxis myth can, finally, be discerned.

Conclusion
Zeuxis Selecting Models and the Cultural Unconscious

What first attracts our interest . . . is his name. One may well ask:
Where does it come from? What does it mean?

SIGMUND FREUD, *MOSES AND MONOTHEISM*

Painting, and imitation generally, produces a work that is far from
the truth; it consorts with a part of ourselves which is far from
intelligence and is its companion and friend for no healthy or true
purpose.

PLATO, *REPUBLIC*

WHETHER A GREEK ARTIST NAMED ZEUXIS actually lived during the fourth
century BCE is a question this study does not seek to answer. Instead, I am
interested in the extent to which the legend of Zeuxis Selecting Models can
be deciphered, its mythic structure exposed, and its significance for the his-
tory of Western art explored. Previous chapters traced the theme's uncanny
character to a cultural primal scene, a collective confrontation with (and
repression of) an ontological threat, the threat posed by mimetic represen-
tation itself. Here I take a different tack, seeking finally to plumb the cul-
tural conditions that gave rise to the Zeuxis myth.

Zeuxis Selecting Models presents more than an episode in the career
of an ancient artist. It sustains an unconscious history of Western art. By
unconscious history, I mean a narrative organized by hidden fears and
desires.[1] Such unacknowledged motives cause the unconscious history to

behave like a dream in which memory is intertwined with fantasy. Whereas conventional history presents protagonists with stable identities taking part in events with fixed chronologies and locales, unconscious history bedazzles us with its allusive yet changeable details. Is Zeuxis painting Helen or Juno? Is he in Croton or Agrigentum? Who is Zeuxis? What are the fears and desires motivating this history of art?

To consider these questions, I will once more draw on Freud's psychoanalytic approach. In his final book, *Moses and Monotheism,* Freud applies his interpretive method to a cultural artifact instead of an individual. The Hebrew Bible proves as adept at sublimation as any of Freud's human patients. His analysis asserts the Egyptian origins of both Moses and the monotheistic religion his laws prescribed. What's more, Freud discerns in the Pentateuch traces of Moses's assassination by his querulous followers. Though repressed, Freud argues, these details of Jewish history survive in the cultural unconscious, revealing themselves through customs and beliefs. Once Freud puts his unconscious history of Jewish origins into conversation with the history shaped by tradition and convention, a richly suggestive and complex concept of Jewish identity emerges.[2] The path charted in *Moses and Monotheism* points the way to a similarly nuanced understanding of Zeuxis and Western culture.[3]

Freud's analysis starts by querying Moses's name, the most transparent link to his Egyptian origins. Zeuxis's name promises similar clarity. In Greek, *zeuxis*[4] denotes "a method of yoking" or "bridging." Like its English analog, the term can be used literally or metaphorically. Thus, one of Hera's bynames is "Zeuxidia"[5] in reference to her role as the goddess of marriage. So neatly does Zeuxis's name describe his mimetic method—yoking together or combining the features of different models—that one cannot help wondering whether it was an epithet bestowed by contemporary admirers or later commentators.[6] Or perhaps it is a descriptive name of the sort frequently given to mythical characters. Whether an epithet or a characterization, the name suits not only the aesthetic but also the metaphysical chasm facing the artist. Through his strategy, Zeuxis sought to yoke the real with the ideal, to create a bridge from the human to the divine. The supernatural reach of this gesture is also suggested by his name through its phonic kinship to "Zeus."

The name Zeuxis, then, summons both partners in the most powerful and terrible of the divine unions: Zeus and Hera Zeuxidia. The artist's association with the latter is further conveyed by the tradition that he was born in Heraclea.[7] Such divine associations signal the artist's creative power as well as his capacity to overreach and cause harm. To be *of* Hera and Zeus

suggests a kinship with their offspring, Ares and Hephaestus.[8] These are dangerous siblings. The latter, in particular, bears a strong fraternal resemblance to Zeuxis. An artisan whose skill could confound even the gods, Hephaestus stands as a divine brother to Zeuxis. This relationship is as cautionary as it is celebratory. Not surprisingly, many stories about Zeuxis offer object lessons in the consequences of divine pretensions.

Zeuxis wore his hubris in the form of a luxurious cloak that sported his name embroidered in gold thread along the border. His famous painting of grapes fooled a bird into pecking at them, but this trifling with the bounds between nature and artifice only brought him humiliation when Parrhasius bested his effort.[9] But the strongest warning against emulating his divine counterpart is the legend of his death. Like Hephaestus, Zeuxis sought to provoke laughter through his craft. While this helped Hephaestus elevate himself among the gods, the strategy proved fatal to Zeuxis. The comic effect of his final painting—a depiction of an old woman—so amused the artist that he began to laugh at her as if she were alive and jesting with him. Unable to stop laughing, Zeuxis suffocated and died before his own painting.[10]

These stories about Zeuxis warn against claiming kinship or comparison with the gods. It is the same mythic rebuke suffered by Ariadne, Marsyas, and Niobe. Why would such a lesson against hubris be associated with a Greek painter of the early fourth century BCE? There are two places we might look for an answer. The first is fourth-century Greece, the time and place Zeuxis is purported to have lived; the second is Rome during the transition from republic to empire, the culture that produced the earliest recorded accounts of Zeuxis Selecting Models.

Art historians since Winckelmann have tended to view the fourth century BCE as a period of refined classicism. According to this tradition, principles laid out in the fifth century yielded their fullest expression in the fourth with works by artists like Apelles and Praxiteles. Yet the fourth century also gave rise to intense and lasting challenges to the role of the mimetic arts in society. What does it mean for Zeuxis to come from a culture that produced both the Aphrodite of Knidos and Plato's theory of forms? Can it be a coincidence that Zeuxis's mimetic approach to rendering ideal form is precisely the mode of representation censured in Plato's *Republic*?

Plato warns that the mimetic arts hold the capacity to corrupt social mores and political behavior. He even suggests that some individuals might be fooled by mimesis into mistaking representation for reality, deception for truth. The worst consequence of this possibility would be the extinction of the ideal. It is not by chance that Plato's exploration of the efficacy of mimesis

takes place in book 10 of his *Republic,* the dialogue in which Socrates affirms the existence of the divine. Socrates's critique of mimesis paves the way for his assertion that individuals possess a kind of immortality via the soul.[11]

A similar logical turn is attributed to Socrates by Xenophon in book 3 of his *Memorabilia.* Here, Socrates speaks directly with artisans. First, he visits the painter Parrhasius—Zeuxis's legendary rival—and asks whether he brings "together from many what is most beautiful in each," and thus makes "whole bodies appear beautiful, since it is not easy to chance upon a single human being all of whose parts are blameless." Parrhasius affirms that he works this way. Socrates then wonders whether the painter can use this method to convey the most important quality of an individual, "the soul's character." Parrhasius dismisses this as impossible: "How could a thing be imitated, Socrates, which . . . is altogether unseen?" Satisfied, Socrates moves on to the workshop of the sculptor Cleiton. There, he reframes his question: "How do you work into your statues what especially draws the souls of human beings through their sense of sight, namely, the appearance of being alive?" Cleiton hesitates, so Socrates provides an answer: "Is it by likening what you make to the forms of living beings that you make your statues appear more lifelike?" Cleiton agrees, leading Socrates to conclude that "the sculptor must make likenesses of the passions of the soul by means of the form."[12] The impossibility of Cleiton's ambition is made clear. Any aspiration to make sculptures appear lifelike is doomed to fail because life is defined wholly by embodiment of a soul, something art cannot possess.

But it is with Pistias the armorer that the lesson is driven home. Pistias claims that his breastplates are superior to others' because of their perfect proportions. Socrates points out that customers come in countless sizes and shapes, so a perfectly proportioned breastplate may be conceivable but was not forgeable. Pistias responds that each breastplate is fitted to an individual. "'You are saying, in my opinion,' said Socrates, 'that a thing is well proportioned not in itself, but with regard to the one using it."[13] Again, Socrates makes clear that the artisan's only access to an ideal is via real—and inherently imperfect—models. The soul remains beyond the scope of visual or material confirmation.

Whereas Xenophon gives instances of the insufficiency of mimetic art, Plato lays out its metaphysical consequences. In the *Republic,* he points to two main concerns. The first proceeds from the assertion that mimesis imitates that which it is not, thus producing inherently false and deceptive forms. The second, and more important, holds that if poetic descriptions (or paintings, sculptures, and breastplates) are allowed to masquerade as examples of perfect form, they will soon supplant the ideal. Such a loss of

the ideal, Plato warns, forecloses contemplation of a divine nature toward which humans instinctively strive. In other words, the primary catalyst for human betterment would be eliminated. This is Plato's main justification for excluding imitators, or *mimos,* from his ideal state.

In *The Forbidden Image,* Alain Besançon shows that Plato's fourth-century observations mark the beginning of the West's suspicion of mimetic imagery, a distrust that occasionally erupts into iconoclasm.[14] Iconoclasm is the social, material manifestation of iconophobia, whereas the story of Zeuxis Selecting Models is its psychic residue. Zeuxis Selecting Models, like iconoclasm, exercises cultural anxiety about mimetic imagery, only the Zeuxis myth confines its work to the West's cultural unconscious.

Visual representations of Zeuxis Selecting Models began to expose the story's link to the cultural unconscious during the eighteenth century as the modern psyche and its attendant awareness of the uncanny developed. The eighteenth century also witnessed the aesthetic apogee of classical mimesis. This coincidence created a perfect setting for the uncanny character of Zeuxis Selecting Models to make itself felt. In chapter 6, I traced the eruption of the uncanny in visual representations of the scene produced from the late eighteenth through the early twentieth centuries. Picasso's *Les Demoiselles d'Avignon,* I argued, marks the end of this period of heightened anxiety as it announces the suppression of classical mimesis by modern artists. During the first quarter of the twentieth century, avant-garde artists largely abandoned classical mimesis. Though Zeuxian mimesis held little aesthetic relevance for high modernism, the strategy did not disappear from the cultural unconscious.

The advent of digital technology has pressed classical mimesis once again into our cultural consciousness. Promising easy perfection, even a kind of transcendence, digital media provide a new ideal: the virtual. Virtual renderings of perfection are not, of course, manifestations of the divine. But virtual ideals *are visible.* Sense organs can apprehend the virtual ideal, leading to the impression that perfection *is* realizable, attainable. Digital media heighten the threat that Plato attributed to artifice as virtual images increasingly masquerade as the ideal. Orlan's carnal art, discussed in chapter 7, forces us to consider whether our collective cultural gaze is shifting toward this virtual model.

The Reincarnation of St. Orlan began with morphing software. With the aid of digital technology, Orlan created a template for her surgeons to follow. Then she remade herself in the image of a virtual ideal.[15] A postmodern act of *imitatio Christi,* Orlan's self-discipline confirms the truth of flesh rather than that of the spirit. She embodies the worst of Plato's *mimos.*

Read against Platonic fears regarding mimetic representation, Zeuxis Selecting Models becomes a history of art bound to a metaphysical struggle. In light of this reading, the history of Western art might be conceived as a protracted Platonic dialogue. Taking shape as a dialectic between antithetical impulses, the history of Western art becomes a history of attempts to reconcile faith with empiricism. But this is not the only cultural memory borne by Zeuxis Selecting Models.

Though identified as Greek, the Zeuxis who painted Helen of Troy must also be reckoned Roman. The earliest extant records of the story of Zeuxis Selecting Models come to us from the Latin authors Cicero and Pliny the Elder. On the surface, their references to the story may simply seem to be examples of admiration for Greek accomplishments, a sentiment expressed often in Roman texts. A closer reading, however, reveals something more. Both authors were writing during the time of Rome's transition from republic to empire. Cicero authored his version of the tale around 84 BCE; Pliny wrote his just over a century later. Though Rome had institutionalized its imperial aims by Pliny's lifetime, it shared with its republican past a preoccupation with geographic and cultural expansion. The legend of Zeuxis Selecting Models bears witness to these political ambitions.

As discussed in chapter 2, the accounts produced by Cicero and Pliny present many similarities but also some striking differences. Among the latter is the setting of the story. Cicero has Zeuxis working in Croton; Pliny places him in Agrigentum. I suggested in chapter 2 that the provincial character of these towns conveyed an uncanny quality. Now I would like to shift attention from the towns' provincial locales to their shared history as colonies. Both Croton and Agrigentum were colonized first by the Greeks, then by the Romans early in the second century BCE after the Second Punic War. On the one hand, their status as colonies signals economic growth and prosperity. Indeed, the authors take pains to note the wealth of these particular towns.[16] On the other hand, Croton and Agrigentum signify cultural difference and violent revolt: Both played significant roles in the rebellion against Rome during the wars with Carthage.

Croton's insurrection was striking not only because it was a Roman ally when it sided with Carthage but also because the town served as Hannibal's last stronghold on the Italian peninsula. As the staging ground for the enemy's final assault, Croton was uncomfortably close to the literal and symbolic center of Rome. Agrigentum carried even more complicated associations with the Punic Wars. Agrigentum was a tributary of Rome when Carthage seized control of the town and began establishing fortified

camps around it. Greek residents of the region maintained distinct settlements, confident that the Roman army would continue its practice of sparing those not allied with Rome's enemies.[17] But the battle for Agrigentum (261–60 BCE) marked the end of this custom. The Romans now adhered to a strict definition of "foreigner," refusing to differentiate between Greek and Carthaginian settlements. Most of the Greek residents of the region were killed or enslaved. This change in policy signaled a narrowing of the Roman concept of identity. Identity now reflected only political exigencies, not ethnic or cultural histories.

By the time Cicero and Pliny recorded their versions of the story of Zeuxis Selecting Models, Croton and Agrigentum were firmly contained within Roman borders. But the difficult prelude to their colonization would probably have been familiar to these two educated writers. Even if not consciously registered by either author, the fraught histories of these colonies would have endowed them with the necessary psychic buoyancy to emerge as suitable sites for Zeuxis's feat. Rome's continuing efforts at colonization in Europe, Asia, and North Africa made the challenges of maintaining an empire familiar to Cicero, Pliny, and their informed contemporaries. A persistent concern during this period involved the need to establish a shared "Roman" identity among all imperial subjects.[18] Without such a unifying notion of what it meant to be Roman, the empire could not survive.

As colonies, then, Croton and Agrigentum offer suggestive settings for the story of Zeuxis Selecting Models. Zeuxis's attempt to create an ideal whole from disparate parts is itself an act of colonization, or empire building. The notion of an aggregate that surpasses its components is not only an aesthetic and metaphysical fantasy but a political one as well. As Ray Laurence's account of Roman perceptions of ethnic diversity on the Italian peninsula explains, the process of "Romanization" supported a "unified conception of Italy" in just this way during the first century BCE:

> Unification of the disparate elements should be seen as the creation of a new "imagined community," Italy, with which all the disparate local histories and geographies could be unified. *Tota Italia* was part of the complex ideology that unified Rome and Italy politically. In many ways, the imagined community is not a description of the relationship, but a vehicle for achieving and stabilising that relationship politically. . . . In this light, we may view the concept of *tota Italia* . . . as a method of Romanisation that stressed the distinctness of the Italian peoples but united them politically with Rome at the center.[19]

Not restricted to the Italian peninsula, Romanization was pursued to one extent or another throughout the empire.

As a political myth, Zeuxis Selecting Models represents the desire for empire while disguising both the violence of its creation and the impossibility of its complete realization. Zeuxis's Helen, then, personifies the ideal citizen of the empire insofar as she embodies a harmonious union of diverse constituents. Read metaphorically in light of its sublimated ancient associations, Zeuxis Selecting Models becomes a metaphor for empire itself.

With this in mind, the history of visual representations of Zeuxis Selecting Models takes on new import. As explained above, a pattern of uncanny slippage begins to reveal itself in visual portrayals of the scene in the late eighteenth century. Could these uncanny moments be a response to cultural anxiety about the rise in colonial interests at the time? From the late eighteenth century to the twentieth, visual depictions of the subject grew increasingly redolent of a harem scene, with Zeuxis assuming the role of sultan or pasha before a collection of sexually available odalisques (see chapter 6). The theme easily moves from a vehicle for aesthetic contemplation to one of Orientalist fantasy. Especially responsive to the Orientalist imagination, Zeuxis stands in for the colonizing power, choosing from the cultures of the world those it will divide and reassemble into a glorious empire.

This Orientalist interpretation of Zeuxis Selecting Models reaches its zenith—not surprisingly—in mid-nineteenth-century French and British portrayals of the scene. The French painter Mottez, for instance, endows Zeuxis's models with a variety of skin tones and features, a hint of ethnic and racial diversity not apparent in earlier depictions of the subject (Figure 33). In this way, Mottez suggests the colonial bases for the amalgam that Zeuxis fashions behind a tantalizingly parted curtain.

In Britain, the Orientalist painter Edwin Long adopts the theme of Zeuxis Selecting Models in order to recast his breakthrough success, *The Price of Beauty: Babylonian Marriage Market* (Figure 53). Here, in the painting that made him a favorite of the Victorian exhibition-going public, Long draws his subject of an Assyrian bride auction from Herodotus, thus veiling the voyeuristic scene under the legitimating cover of antiquity. But he also musters enough archaeological and anthropological details to overcome whatever historical distance viewers may have had to surmount, inviting them to revel in the general depravity of Oriental cultures.[20] Long's painting fixes the viewer alongside the women awaiting sale. They are lined up according to their physical appeal. Assyrian custom, according to Herodotus, required that the prettiest be sold first. The hefty purses earned by the beautiful

would supply the dowries needed by the less attractive. Not surprisingly, the women leading the way to the dais exhibit features consistent with Victorian ideals of beauty: fair skin, aquiline noses, sharp chins, small mouths. The woman being presented on the stage in fact possesses the fairest skin and even blonde hair. Further from the head of the line, faces become rounder, noses flatter, mouths larger, and skin, hair, and eyes darker.[21]

Figure 53. Edwin Longsden Long, *The Price of Beauty: Babylonian Marriage Market* (oil on canvas, 1875, Picture Collection, Royal Holloway, University of London, London). Photograph courtesy of Royal Holloway, University of London.

Long redeploys Orientalist elements from *Babylonian Marriage Market* in his interpretation of Zeuxis Selecting Models, *The Search for Beauty* (Figure 54). A group of partially draped women offer themselves for apprais-al. The exotic flavor is heightened by the presence of a muscular black man whose role as attendant evokes the eunuch so prevalent in Orientalist harem scenes.[22] Though the Victorian ideal prevails among the gathered models, Long subtly signals ethnic diversity by intermingling blonde and red-haired models with brunettes. He also includes darker-skinned women, as illustrat-ed by the pair seated on the bench at the right side of the canvas. The pale arm of one woman reaches across the shoulders of her darker companion, presenting a subtle but readily apparent contrast. Long drives home that this is an embrace of the exotic by cushioning the bench with a leopard skin—a stock Orientalist prop. To the right of this couple stands a woman who bears

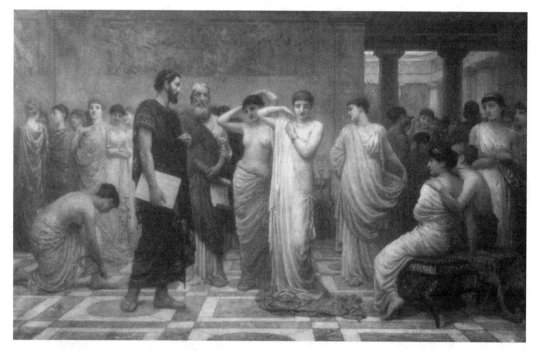

Figure 54. Edwin Longsden Long, *The Search for Beauty* (oil on canvas, 1885, private collection). Photograph copyright Christie's Images, Inc., 2006.

a strong resemblance to Long's personifications of Jamaica, Cyprus, and Egypt, produced two years later as part of his *Daughters of the Empire* series of paintings (Figure 55).[23]

Several of the would-be models presented in Long's *Search for Beauty* recall famous antique sculptures: One bends to fasten her sandal, mirroring the classical Greek relief of Nike from the Acropolis; another assumes the pose of the Venus Anadyomène; yet another adjusts her chiton in imitation of one of the bronze Dancers of Herculaneum. Long also forges a link between past and present with the model standing to the left of the seated pair; she is posed in the attitude of John Singer Sargent's infamous *Madame X*, exhibited in Paris the previous year. *The Search for Beauty*, and its companion *The Chosen Five* (Figure 56), give visual form to the imperial ambitions of late-Victorian Britain. Drawing together East and West, past and present, Zeuxis proclaims the triumph of empire. Here, as always, the Zeuxis myth both reveals and disguises the violence underlying its act of creation. In the case of British Orientalism as practiced by Long, the Zeuxis myth unconsciously acknowledges and suppresses troubling cultural memories such as the Indian Mutiny.

Figure 55. Edwin Longsden Long, *Jamaica* (oil on canvas, 1886, private collection). Photograph copyright Christie's Images, Inc., 2006.

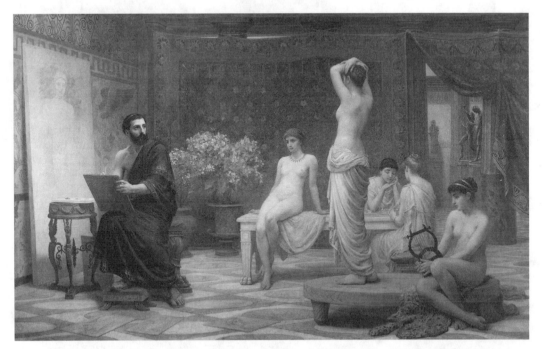

Figure 56. Edwin Longsden Long, *The Chosen Five* (oil on canvas, 1885, Russell-Cotes Art Gallery, Bournemouth). Photograph courtesy of Russell-Cotes Art Gallery, Bournemouth.

By the early twentieth century, the imperial efficacy of *Zeuxis Selecting Models* had begun to diminish. In France, for instance, imperial ambitions were tempered by public ambivalence. Art historian Patricia Leighton has argued convincingly that the bloody Dahomean Wars of 1890 and 1892 and the well-publicized abuses by colonial authorities in the French Congo at the turn of the century sparked conflicting public responses. From leftists and anarchists arose a call for the end of colonialism; from nationalists and conservatives came a demand for a more vigorous imperialism. Picasso's *Demoiselles*, Leighton explains, expresses this ambivalence. Just as the painting exercises the racism prevalent in France at the time, it also finds in African culture a means for aesthetic and social progress. As Leighton observes,

> Picasso simultaneously condemns the colonial policies that brought [African] masks to Europe, yet embraces the very stereotypes that would see African culture as a recuperative cure to degeneration "at home" rather than abroad. . . . [Picasso] operated in and against a colonialist world, addressing himself to audiences equally immersed in the assumptions and animating questions of the days.[24]

In this way, Picasso's reprise of *Zeuxis Selecting Models* signals the crisis facing imperialist powers in Europe, a crisis that would first erupt in the carnage of World War I and then continue to hemorrhage during the ensuing slow collapse of colonial rule.

This process of French decolonization took place, interestingly, during Orlan's lifetime. Her graphic enactment of—and bodily resistance to[25]— Zeuxian mimesis can also be read in relation to the prolonged and often-violent struggles of France's colonies for independence throughout the mid-twentieth century. Although her work is typically interpreted largely in relation to gender, as a feminist intervention into patriarchal constructs of feminine beauty and identity, Orlan's art also engages issues of colonization, race, and ethnicity.

Following her Zeuxian carnal art project, Orlan embarked on a series of digitally produced "hybrid" self-portraits in which she overlays her surgically modified face onto sculptures and masks taken from Mesoamerican and African cultures (Figure 57). These images have been alternately dismissed as a racist mockery and commended as a carnivalesque critique of feminine social norms. Even more obvious—but so far unremarked—is Orlan's decision to fuse her (French) identity with that of peoples subsumed by France's imperial ambitions. Her hybrid self-portraits cite Mayan, Amarna, and Fang

artworks—a clear evocation of cultures indigenous to the regions colonized by France. Seen in this light, Orlan's Zeuxian performance emerges as part of a larger exploration of the impulse toward empire in which she serves as colonizer *and* colonized. A kind of twenty-first-century Marianne, Orlan personifies the postcolonial French Republic. Scarred and distorted but no longer disguising the fantasies or the consequences of imperialism, Orlan's body evades designation as either "self" or "other."

At the same time as Orlan's critical engagement with Zeuxian mimesis attained its final corporeal form, the theme reasserted its role as a metaphor for imperial triumph in the United States. In 1993, *Time* published a special

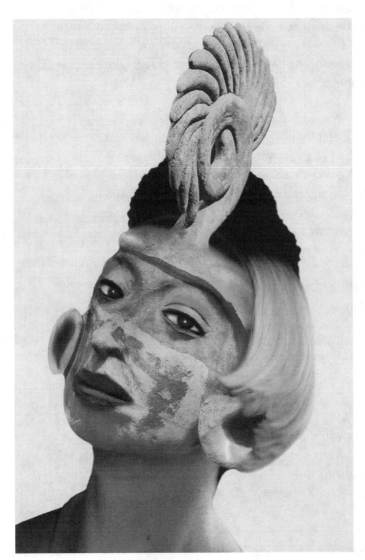

Figure 57. Orlan, "African Self-Hybridation: Fang Initiation Group Mask, Gabon, with Face of Euro-Saint-Etienne Woman" (digital photograph on color photographic paper, 1998, collection of the artist). Artists' Rights Society/ARS.

issue of its weekly magazine devoted to immigration and its effects on U.S. culture. Though not explicitly addressed to imperialism, *Time*'s discussion of forced as well as voluntary immigration to the United States cannot be separated from the nation's uninterrupted subscription to imperialist policies. As historian Amy Kaplan explains, "Not only about foreign diplomacy or international relations, imperialism is also about consolidating domestic cultures and negotiating intranational relations."[26] And this is precisely the imperialist legacy presented (celebrated?) in this issue of *Time* magazine, though nowhere more strikingly than on its cover.

Smiling from the front of *Time*'s special issue is a brown-haired, hazel-eyed young woman with gentle, even features (Figure 58). "Take a good look at this woman," the caption instructs, "She was created by a computer from a mix of several races. What you see is a remarkable preview of . . . the New Face of America." The editor of the issue, James R. Gaines, explains the process that produced the image he calls "our new Eve":

> The woman on the cover of this special issue of *Time* does not exist—except metaphysically. Her beguiling if mysterious visage is the product of a computer process called morphing. . . . When the editors were looking for a way to dramatize the impact of interethnic marriage, which has increased dramatically in the U.S. during the latest wave of immigration, they turned to morphing to create the kind of offspring that might result from seven men and seven women of various ethnic and racial backgrounds. The task fell to Time imaging specialist Kin Wah Lam, who went to work on computerized photos of fourteen models selected by Time's assistant picture editor Jay Colton. . . . A combination of . . . racial and ethnic features . . . she is 15 percent Anglo-Saxon, 17.5 percent Middle Eastern, 17.5 percent African, 7.5 percent Asian, 35 percent Southern European and 7.5 percent Hispanic.[27]

Like the Helen of Zeuxis, *Time*'s new Eve promises political as well as metaphysical wholeness while masking anxiety. Her strangely vacant expression betrays no emotion, no consciousness, really. She regards the viewer with a fixed stare and frozen half smile that refuse to coalesce into a readable personality. David Roediger comments on the disjuncture embodied by *Time*'s beatific new Eve in *Colored White: Transcending the Racial Past.* Behind her placid countenance, Roediger observes, the articles contained within the special issue were brimming with "doubts, troubling facts,

Figure 58. "The New Eve," in "The New Face of America: How Immigrants Are Shaping the World's First Multicultural Society," ed. James R. Gaines, special issue, *Time*, Fall 1993, cover. TIME Magazine copyright 2006, Time Inc., New York.

and even gloom." Roediger also hints at the trauma embedded within both the image of the new Eve and the colonialist fantasy that produced it: "Time's special issue does offer a short, rosy, and inaccurate history of immigration, but that history is written in such a distorted way as to leave no scars and set no limits."[28] Yet the scars are always there, hidden perhaps, but always threatening to reveal themselves. This, of course, is the problem with Zeuxian mimesis, as well as with the social system it serves.[29]

These, finally, are the unconscious histories recorded by Zeuxis Selecting Models. Embedded in the myth are the histories of a culture that developed in response to a colonizing instinct, a drive to pursue social unity through political, economic, or military dominance. Tied to this impulse for cultural preservation through imperialism is a craving for metaphysical assurances. Neither desire, of course, can be wholly satisfied. Unwilling to acknowledge its political or spiritual limits, the West has generated two histories: one conscious and heroic, the other unconscious and craven. The Zeuxis myth moves between these two histories, interweaving imagination and experience, substituting faith for fear.

In the end, it is doubt that propels and sustains the cultural life of the Zeuxis myth. Played out as a fantasy of confidence and triumph, cultural uncertainty has been disguised as a supreme artistic achievement. Thus, Zeuxis Selecting Models endures after two millennia, still promising imperial successes and spiritual transcendence. The history of Western art preserved by the Zeuxis myth, then, is not a history of materials or styles or patrons. Such histories are concerned with the appearance of culture, with its conscious character and beliefs. This unconscious history instead taps into the West's unspoken fears and aspirations. Here we find the history of a culture's political and spiritual hubris: the history of the West's irrepressible urge to see—and to seize—what is too beautiful to picture.

Notes

INTRODUCTION

1. Honoré de Balzac, *The Unknown Masterpiece* (1831), trans. Richard Howard (New York: New York Review Books, 2001), 25–26.

2. Ibid., 39–40.

3. Hans Belting, *The Invisible Masterpiece*, trans. Helen Atkins (Chicago: University of Chicago Press, 2001), 126. Originally published as *Das unsichtbare Meisterwerk: Die modernen Mythen der Kunst* (Munich: C. H. Beck, 1998).

4. Belting, *The Invisible Masterpiece*, 126.

5. Balzac, *The Unknown Masterpiece*, 26.

6. Among the few sustained considerations of Zeuxis Selecting Models is Renate Schlüter's *Zeuxis und Prometheus: Die Uberwendung des Nachahmungskonzeptes in der Ästhetik der Frühromantik* (Frankfurt am Main: Lang, 1995).

7. Honoré de Balzac, *Sarrasine* (1830), appendix 1 in *S/Z*, by Roland Barthes, trans. Richard Miller (New York: Hill and Wang, 1974; originally published Paris: Editions du Seuil, 1970), 237–38, 238. Balzac summons the legend of Pygmalion to illustrate Sarrasine's emotion at seeing La Zambinella for the first time: "With his eyes, Sarrasine devoured Pygmalion's statue, come down from its pedestal" (239). But it is in the legend of Zeuxis Selecting Models that I find a closer psychic and aesthetic analog.

8. Balzac, *Sarrasine*, 238.

9. Ibid., 250, 252.

10. Ibid., 253.

11. Barthes, *S/Z*, 112. Barthes discusses the fetishistic quality of Balzac's description of La Zambinella in *S/Z*, 111–15.

12. An important exception is Alain Besançon's *The Forbidden Image: An Intellectual History of Iconoclasm*, trans. Jane Marie Todd (Chicago: University of Chicago Press, 2000). Originally published as *L'image interdit: Une histoire intellectuelle de l'iconoclasme* (Paris: Fayard, 1997); citations are to the English translation.

13. Many scholars of visual culture have fruitfully deployed Freudian and other psychoanalytic approaches in their study of art. Among the most influential for my own thinking are Lynda Nead, Kaja Silverman, and Marina Warner. Their respective books—*The Female Nude: Art, Obscenity, and Sexuality* (London:

Routledge, 1990); *Male Subjectivity at the Margins* (New York and London: Routledge, 1992); and *Monuments and Maidens* (London: Weidenfeld and Nicolson, 1985)—introduced me to the application of psychoanalysis to feminist interpretations of artworks.

14. Pierre Macherey proposes a similar notion of the cultural unconscious as an expression of ideology in *A Theory of Literary Production*, trans. Geoffrey Wall (London: Routledge and Kegan Paul, 1978). Originally published as *Pour une théorie de la production littéraire* (Paris: Maspero, 1966). Slavoj Zizek likewise draws on Marxist, Freudian, and Lacanian theory to elucidate a notion of a cultural unconscious. See, for instance, his *The Sublime Object of Ideology* (London: Verso, 1989).

15. Freud introduced the primal scene in "The Paths to Symptom-Formation," lecture 23 in *Introductory Lectures on Psycho-Analysis* (1917), vol. 16 of *The Standard Edition of the Complete Psychological Works of Sigmund Freud*, 24 vols. (London: Hogarth Press, 1966–74), and gave a clinical account of its consequences in his case history of the "Wolf Man" in "From the History of an Infantile Neurosis" (1918), in *The Standard Edition*, 17:7–122.

16. Freud, "The Paths to Symptom-Formation," 369.

17. I use the masculine pronoun here deliberately since Freud's account here is limited to the psychic development of boys.

18. Freud emphasizes feminine lack in lecture 20, "The Sexual Life of Human Beings," where he briefly discusses female subject formation: "As regards little girls, we can say of them that they feel greatly at a disadvantage owing to their lack of a big, visible penis, that they envy boys for possessing one and that, in the main for this reason, they develop a wish to be a man—a wish that reemerges later on, in any neurosis that may arise if they meet with a mishap in playing a feminine part. In her childhood, moreover, a girl's clitoris takes on the role of a penis entirely: it is characterized by a special excitability and is the area in which auto-erotic satisfaction is obtained. The process of a girl's becoming a woman depends very much on the clitoris passing on this sensitivity to the vaginal orifice in good time and completely. In cases of what is known as sexual anaesthesia in women the clitoris has obstinately retained its sensitivity" (*Introductory Lectures on Psycho-Analysis*, 318).

19. See, for instance, Julia Kristeva, *Powers of Horror: An Essay on Abjection*, trans. Leon S. Roudiez (New York: Columbia University Press, 1982). Originally published as *Pouvoirs de l'horreur: Essai sur l'abjection* (Paris: Editions du Seuil, 1980); citations are to the English translation.

20. Ned Lukacher, *Primal Scenes: Literature, Philosophy, Psychoanalysis* (Ithaca, N.Y.: Cornell University Press, 1986), 24–25.

21. Ibid., 24.

22. Francette Pacteau's *Symptom of Beauty* (London: Reaktion; Cambridge, Mass.: Harvard University Press, 1994) pursues precisely the line of inquiry I commend here. Pacteau's analysis of feminine creative agency is astutely grounded in aesthetic history. Excellent examples of feminist art history that combines social history with intellectual history in order to understand early modern women's art

practice are Ann Bermingham, *Learning to Draw: Studies in the Cultural History of a Polite and Useful Art* (New Haven, Conn.: Paul Mellon Centre for Studies in British Art, by Yale University Press, 2000), and Mary Sheriff, *The Exceptional Woman: Elisabeth Vigée-Lebrun and the Cultural Politics of Art* (Chicago: University of Chicago Press, 1996).

23. For a list of extant visual depictions of the subject, see chapter 4, note 26.

1. ART HISTORY AS MYTH

1. Previous scholars have examined the mythical underpinnings of modern notions of the artist, most notably Ernst Kris and Otto Kurz, *Legend, Myth, and Magic in the Image of the Artist: A Historical Experiment* (New Haven, Conn.: Yale University Press, 1979). Originally published as *Die Legende vom Künstler: Ein geschichtlicher Versuch* (Vienna: Krystall, 1934); citations are to the English translation. My project, though in many ways indebted to this work, departs from its example: I am primarily interested in the mythic impulses underlying the methods and assumptions of art history as a narrative practice.

2. For the most complete account of the legend and significance of Veronica's Veil, see Ewa Kuryluk, *Veronica and Her Cloth: History, Symbolism, and Structure of a "True" Image* (Cambridge, Mass., and Oxford: Blackwell, 1991). On Luke's painting of the Virgin, see D. Klein, *St. Lukas als Maler der Maria: Ikonographie der Lukas-Madonna* (Berlin: Oskar Schloss, 1933).

3. "Other Appendixes to the Acts of Pilate," from *The Apocryphal New Testament,* trans. Montagu Rhodes James (Oxford: Oxford University Press, 1924), 157–58.

4. Both legends probably gained popularity during the iconoclastic controversies, as iconophiles sought scriptural or other holy precedent for the production and veneration of religious imagery. Cyril A. Mango, comp., *The Art of the Byzantine Empire, 312–1453: Sources and Documents* (Englewood Cliffs, N.J.: Prentice-Hall, 1972), 40.

5. In this way, both tales also testify to the history and benefit of venerating relics other than the bodies of martyrs, a practice always somewhat controversial in the Western church. As the thirteenth-century Golden Legend has it, Pope Gregory the Great overcame a plague in Rome: "And because the mortality ceased not, he ordained a procession, in the which he did do bear an image of our Lady, which, as is said, St. Luke the Evangelist made, which was a good painter, he had carved it and painted after the likeness of the glorious Virgin Mary.

"And anon the mortality ceased, and the air became pure and clear, and about the image was heard a voice of angels." "The Plague Ends," in *The "Golden Legend" or "Lives Of The Saints,"* compiled by Jacobus de Voragine, 1275; trans. William Caxton, 1483; from the Temple Classics edited by F. S. Ellis; http://www.aug.edu/augusta/iconography/goldenLegend/gregory.IE.htm.

6. Ovid never names the statue created by Pygmalion, but she has come to be called Galatea by convention, perhaps due to the proximity of the story of Pygmalion to that of Galatea in book 10 of *Metamorphoses.*

7. On the history and reception of the story, see Essaka Joshua, *Pygmalion and Galatea: The History of a Narrative in English Literature* (Aldershot, U.K.; Burlington, Vt.; Singapore; and Sydney, Australia: Ashgate, 2001).

8. Ovid [Publius Ovidius Naso], *Metamorphoses,* trans. Frank Justus Miller (Cambridge, Mass.: Harvard University Press, 1939; orig. 1916), 83, lines 247–49. Pages, for facing English translation, listed first; lines given for Latin.

9. Ibid., 83, line 268; 85, lines 274–76; 85, lines 280–89. Interestingly, in his 1770 opera based on the tale, *Pygmalion,* Jean-Jacques Rousseau removes Venus from the narrative, giving all agency to Pygmalion, who animates his statue by dint of his will and touch. See Mary Sheriff, "Passionate Spectators: On Enthusiasm, Nymphomania, and the Imagined Tableau," *Huntington Library Quarterly* 60 (1998): 65.

10. Viktor Stoichita's *A Short History of the Shadow* (London: Reaktion, 1997) offers an intriguing account of the theoretical import of the legend of the Corinthian Maid. On the significance of legend for eighteenth- and nineteenth-century European artists and theorists, see Robert Rosenblum, "The Origin of Painting: A Problem in the Iconography of Romantic Classicism," *Art Bulletin* 39 (December 1957): 279–90, and Ann Bermingham, "The Origin of Painting and the Ends of Art: Wright of Derby's Corinthian Maid," in *Painting and the Politics of Culture: New Essays on British Art, 1700–1850,* ed. John Barrell, 135–65 (Oxford and New York: Oxford University Press, 1992). Bermingham also touches on the theme in *Learning to Draw.*

11. Pliny the Elder, *Natural History,* trans. H. Harris Rackham (Cambridge, Mass.: Harvard University Press; London: William Heinemann, 1952), 370–73, §§ 151–52. All citations from Pliny's *Natural History* are from book 35, cited by page and section number.

12. Athenagoras's account in his *Legatio* is an exception. He essentially represents Pliny's narrative: "Images were not in use before the invention of moulding, painting, and sculpture. Then came Saurius of Samos, Crato of Sicyon, Cleanthes of Corinth, and the Corinthian maid. Tracing out shadows was discovered by Saurius, who drew the outline of a horse standing in the sun. Painting was discovered by Crato, who couloured in the outlines of the shadows of a man and woman on a whitened tablet. Relief modelling was discovered by the Corinthian maid: she fell in love with someone and traced the outline of his shadow on the wall as he slept; then her father, a potter, delighted with so precise a likeness, made a relief of the outline and filled it with clay." Athenagoras, *Legatio,* trans. William R. Schoedel (Oxford: Clarendon Press, 1972), 17.3.

13. Marcus Fabius Quintilianus, *Institutio oratoria* (London: Heinemann; New York: Putnam's Sons, 1922), 77–79, book 10, §§ 6–7.

14. "Campaspe" is the name used in most modern references to the subject, though the names "Pancaspe" and "Pankaspe" are also used. Aelian refers to her as "Pancaste."

15. See Herbert Sussman, *Victorian Masculinities: Manhood and Masculine Poetics in Early Victorian Literature and Art* (Cambridge and New York: Cambridge University Press, 1995), esp. chap. 3, "Artistic Manhood: The Pre-Raphaelite

Brotherhood," 111–72; Griselda Pollock and Deborah Cherry, "Woman as Sign in Pre-Raphaelite Literature: The Representation of Elizabeth Siddall," in *Vision and Difference,* ed. Griselda Pollock, 91–114 (London and New York: Routledge, 1988); and Barbara Munson Goff, "Artists and Models: Rossetti's Images of Women" (Ph.D. diss., Rutgers University, 1976). See also Rainer Crone, ed., *Rodin: Eros and Creativity* (New York: Prestel, 1997); Karen Kleinfelder, *The Artist, His Model, Her Image, His Gaze: Picasso's Pursuit of the Model* (Chicago: University of Chicago Press, 1993). A popular recounting of artist-model legends appears in Muriel Segal, *Dolly on the Dais* (London: Gentry Books, 1972). For dramatic interpretation of the erotic underpinnings of the artist-model relationship, see Murray Schisgal, *The Artist and the Model,* in *The Best American Short Plays, 1994–1995,* ed. Howard Stein and Glenn Young, 184–93 (New York and London: Applause, 1995). Angela Rosenthal discusses Kauffman's *Alexander and Apelles* and its quotation of Raphael's *La Fornarina* in *Angelika Kauffmann: Bildnismalerei im 18. Jahrhundert* (Berlin: Reimer, 1996), 203–7.

16. See Kris and Kurz, *Legend, Myth, and Magic in the Image of the Artist,* 117; Catherine Soussloff, *The Absolute Artist: The Historiography of a Concept* (Minneapolis: University of Minnesota Press, 1997), 49; and Laurie Schneider Adams, *The Methodologies of Art* (New York: HarperCollins, 1996), 109–15.

17. Pliny, *Natural History,* 325, §§ 86–87.

18. Painters who represented the episode include Francesco Primaticcio, Salvator Rosa, Nicolas Vleughels, Jacques-Louis David, and Angelica Kauffman. The sculptor Etienne-Maurice Falconet produced a version in marble. Musical representations of the story include the ballet *Alexander chez Campaspe* (1808), with music by C.-S. Catel and choreography by Pierre Gabriel Gardel; *Apelles et Campaspe, ou La générosité d'Alexander* (1776), a ballet-pantomime choreographed by Jean-Georges Noverre with music by Jean Joseph Rodolphe; and the one-act opera *Apelle et Campaspe* (1798), libretto by C.-A. Demoustier. See Paul Spencer-Longhurst, *"Apelles Painting Campaspe* by Jacques-Louis David," *Apollo* 135 (March 1992): 160 n. 21.

19. Vleughels accomplishes this mitigation by including Alexander's companion Hephaestion in the scene. In this way, Alexander's erotic desire is managed by Hephaestion, rendering the surrender of Campaspe less a sexual loss than a material one.

20. Göran Sörbom, *Mimesis and Art: Studies in the Origin and Early Development of an Aesthetic Vocabulary* (Stockholm: Svenska Bokförlaget, 1966), 23–40; quotation on 24. Sörbom's study remains the most thorough account of the term's significance in ancient Greek aesthetics.

21. Xenophon, *Memorabilia,* book 3, chap. 10, trans. Amy L. Bonnette (Ithaca, N.Y.: Cornell University Press, 1994), 97.

22. Sörbom, *Mimesis and Art,* 99.

23. Ibid., 96.

24. This idea is not terribly different from Charles Baudelaire's characterization of the mnemonic in art in *The Painter of Modern Life* (*Le peintre de la vie moderne,* 1863).

25. Μιμησασθαι.

26. Μιμητικη.

27. Plato, *The Republic*, trans. Tom Griffith (Cambridge: Cambridge University Press, 2000), 317, book 10.598b–c.

28. Sörbom, *Mimesis and Art*, 99.

29. In other texts, Plato is less condemnatory toward the imitative arts.

30. Pliny records this tale in *Natural History*, 323–25, §§ 84–85.

31. Terryl L. Givens, "Aristotle's Critique of Mimesis: The Romantic Prelude," *Comparative Literature Studies* 28 (1991): 121–36.

32. Aristotle, *Poetics*, 1448b, quoted in Givens, "Aristotle's Critique of Mimesis," 130.

33. Μιμησις.

34. Aristotle, *Poetics*, trans. Kenneth Telford (Lanham, Md.: University Press of America, 1985; orig. 1961), 5, § 1448a.25. By "objects" is meant subject matter.

35. Aristotle, *Poetics*, trans. Stephen Halliwell (Cambridge, Mass.: Harvard University Press, 1995), § 1454b.10.

36. Aristotle, *Poetics*, 1460b.30, translation in Givens, "Aristotle's Critique of Mimesis," 131.

37. Gunter Gebauer and Christoph Wulf offer a useful analysis of Aristotle's concept of mimesis in *Mimesis: Culture, Art, Society*, trans. Don Reneau (Berkeley and Los Angeles: University of California Press, 1995), 53–59. Originally published as *Mimesis: Kultur, Kunst, Gesellschaft* (Reinbek bei Hamburg: Rowohlt, 1992); citations are to the English translation. Gebauer and Wulf's analysis accords with my assertion that Aristotle's notion of mimesis involves both copying and idealizing. As they put it, Aristotle's mimesis "does not imply the mere copying of the externalities of nature and the portrayal of individual features. Art and poetry aim much more at 'beautifying' and 'improving' individual features, at a universalization. Mimesis is thus copying and changing in one" (54).

38. These stories include the Contest between Zeuxis and Parrhassius, Apelles and Alexander's Horse, and Apelles and the Cobbler.

39. See Besançon, *The Forbidden Image*, and Ja's Elsner, "Between Mimesis and Divine Power: Visuality in the Greco-Roman World," in *Visuality Before and Beyond the Renaissance: Seeing as Others Saw*, ed. Robert S. Nelson, 45–69 (Cambridge, New York, Melbourne, and Madrid: Cambridge University Press, 2000).

40. The idea of a twofold process of imitation that depended upon copying and then improving upon visible forms was, however, sustained in theological as well as political discourse. See "Mimesis as Imitatio," chap. 6 in Gebauer and Wulf, *Mimesis*, 64–75. Gebauer and Wulf attribute to the medieval notion of mimesis an understanding of its twofold process: "It is possible to conclude as follows regarding relations among art, nature, and mimesis in the medieval period. . . . Art, in imitating the essence of nature, does more than lend phenomenal form to a surface; imitation therefore means more than simple replication of externality by artistic means; this 'more' implies the individual freedom to create something new that has no model existing in nature. Here individual human being is conceived in the image of God as creator and artist" (68–69). Evidence for this understanding of mimesis does not, however, manifest itself in depictions of the

story of Zeuxis Selecting Models, the consummate illustration of this definition of mimesis.

41. Marjorie A. Berlincourt, "The Relationship of Some Fourteenth Century Commentaries on Valerius Maximus," *Mediaeval Studies* 34 (1972): 361–87.

42. Ibid., 362. On the enduring popularity of Valerius through the Middle Ages, see also Victor Hugo Paltsits, *A Renaissance Illuminated Manuscript of Valerius Maximus from the Library of the Aragonese Kings of Naples* (New York: New York Public Library, 1929).

43. Valerius has Zeuxis deliver these lines from Homer. Valerius Maximus, *Nine Books of Memorable Doings and Sayings (Factorum et dictorum memorabilium libri ix)* (CE 31), trans. D. R. Shackleton Bailey (Cambridge, Mass., and London: Harvard University Press, 2000), book 3.7.ext.3.

44. It should be noted that most medieval copies of Pliny's work were fragments of the lengthy classical source. Among the best medieval sources—especially for the later books, including book 35—is a ninth-century version produced in the palace scriptorium of Louis the Pious. Another ninth-century example that includes book 35 exists in Leiden and was possibly produced at Murbach. Medieval copies of Cicero's *De inventione* fared better. See L. D. Reynolds, ed., *Texts and Transmission: A Survey of Latin Classics* (Oxford: Clarendon Press, 1983), 307–16; 98–100.

45. Cicero's manual on argument, *De inventione,* was referred to as his *Rhetoric* during the Middle Ages and after. The titles are used interchangeably here. This manuscript of *De inventione,* MS 590 in the Musée Condé, Chantilly, is discussed by Jaroslav Folda in *Crusader Manuscript Illumination at Saint-Jean d'Acre, 1275–1291* (Princeton, N.J.: Princeton University Press, 1976).

46. Cicero, *Rhetoric,* Ghent MS 10, fol. 69v, Universiteitsbibliotheck Gent, Ghent, Belgium.

47. Guillaume de Lorris and Jean de Meun, *The Romance of the Rose,* trans. Charles Dahlberg (Hanover, N.H., and London: University Press of New England, 1983), lines 16,165–16,199.

48. Apparently, the painter of the miniature took the mention of models to refer to a modello, that is, a preliminary study modeled in clay or wax made prior to final sculpture.

49. Geoffrey Chaucer, "The Physician's Tale," in *Canterbury Tales,* ed. Norman Francis Blake, 427–35, York Medieval Texts (London: Arnold, 1980), 427, lines 1–16.

50. The scope of Chaucer's fourteenth-century audience remains a point of debate among scholars; some estimates limit readers to a relatively small number of courtiers and scholars, while others expand the readership to include the "middle classes" of the cities as well as rural gentry. On these debates, see Michael J. Bennett, "The Court of Richard II and the Promotion of Literature," in *Chaucer's England: Literature in Historical Context,* ed. Barbara A. Hanawalt, 3–20 (Minneapolis: University of Minnesota Press, 1992); Paul Strohm, "Chaucer's Fifteenth-Century Audience and the Narrowing of the 'Chaucer Tradition,'" *Studies in the Age of Chaucer* 4 (1982): 3–32; and Peter R. Cross, "Aspects of Cultural Diffusion in Medieval England," *Past and Present* 108 (1985): 35–79.

2. THE ZEUXIS MYTH

1. I refer to Cicero's text by the title popularly used in the early modern period, the *Rhetoric*. Marcus Tullius Cicero, *De inventione*, trans. H. M. Hubbell (Cambridge, Mass.: Harvard University Press, 1952), 168–69; Pliny, *Natural History*, 308–9, § 64. Valerius Maximus also records the legend of Zeuxis Selecting Models in his *Memorable Deeds and Sayings*, book 3.7.ext.3. Valerius's version is based upon Cicero.

2. "Quandam."

3. "'Horum,' inquiunt illi, 'sorores sunt apud nos virgines. Quare qua sint illae dignitate potes ex his suspicari.'"

4. "Ille autem quinque delegit; quarum nomina multi poëtae memoriae prodiderunt quod eius essent iudicio probatae qui pulcritudinis habere verissimum debuisset."

5. Lucian employs a similar trope in his "Essays in Portraiture" ("Imagines"), in *The Works of Lucian*, trans. A. M. Harmon (Cambridge, Mass., and London: Harvard University Press, 1953; orig. 1925). After calling to mind the most famously beautiful works of art, Lycinus explains to Polystratus, "Come now, out of them all I shall make a combination as best I can, and shall display to you a single portrait-statue that comprises whatever is most exquisite in each. . . . Nothing hard about it, Polystratus, if from now on we give Master Eloquence a free hand with those statues and allow him to adapt, combine, and unite them as harmoniously as he can, retaining at the same time that compostive effect and the variety" (265–67, §§ 5–6).

6. Quintilian, who mentions Zeuxis—but not the legend about his selection of models—in *Institutionis oratoriae libri duodecim*, instead dates his career to the time of the Peloponnesian War (431–404 BCE).

7. "Ut Agragantinis facturus tabulam, quam in templo Iunonis Laciniae publice dicarent" (Pliny, *Natural History*, 308–9, § 64).

8. Even Pliny's brief account of Zeuxis mentions his enormous wealth—as well as his later practice of giving away paintings "saying that it was impossible for them to be sold at any price adequate to their value" (Pliny, *Natural History*, 309, § 62.)

9. Agrigentum resumed a position of wealth and political importance during the late Roman Republic and early Roman Empire. I will return to the question of the legend's setting in the conclusion.

10. Later in book 35 of *Natural History*, Pliny mentions that "there is at Rome a Helena by Zeuxis in the Porticoes of Philippus" (310–11, § 66). Other classical and modern authors treat these interchangeably.

11. "Inspexerit virgines eorum nudas et quinque elegerit, ut quod in quaque laudatissimum esset pictura redderet" (Pliny, *Natural History*, 308–9 § 64).

12. William G. Doty, *Mythology: The Study of Myths and Rituals*, 2nd ed. (Tuscaloosa and London: University of Alabama Press, 2000). This volume offers a useful overview of the various disciplines and strategies engaged in interpreting myth over the past century.

13. These are akin to what Noam Chomsky would later term the "deep" and "surface" structures of his transformational grammar.

14. I will take up the formal structure of the myth again in the conclusion.

15. This would change in Renaissance and later adaptations of the story, in which Apelles occasionally assumes Zeuxis's role.

16. Sigmund Freud, "The Uncanny," trans. James Strachey, in *The Standard Edition*, 17:217–52. First published as "Das Unheimliche" in *Imago* 5, nos. 5–6 (1919): 297–324.

17. In this and the following chapters, I will use the English term "uncanny" as equivalent to the German *"unheimlich."*

18. Freud, "The Uncanny," 237. Scholars have raised the possibility that Freud's essay is itself a form of uncanny narrative. See, for example, Robin Lydenberg, "Freud's Uncanny Narratives," *PMLA* 112 (October 1997): 1072–1086. Lydenberg points out that Freud does not subject his own uncanny narrative to the same scrutiny he gives others. She finds in the various elisions and moments of rhetorical excess evidence that "The Uncanny" is a symptom of Freud's own neurotic concerns about death. Like Lydenberg's reading of Freud, my analysis of the Zeuxis legend takes "into account both the stabilizing structures and destabilizing literariness of narrative, which emerges as a hybrid of convention and innovation, law and transgression, logic and nonsense, conscious and unconscious effects" (1072).

19. Freud used the phrase "geschminkte Frauen," literally, "made-up women."

20. "Italienischen Kleinstadt," which translates literally as "small" or "provincial Italian town." Freud's reference to Italy invites a consideration of this passage in relation to the broader role of Italy in the German cultural imagination. See Gretchen L. Hachmeister, *Italy in the German Literary Imagination* (Rochester, N.Y.: Camden House, 2002).

21. Freud, "The Uncanny," 249, 244, 245, 245.

22. Ibid., 249, 240.

23. Ibid., 238.

24. Importantly, many of these triggers of the uncanny can also serve as fetishes. Of course, in order to function successfully as a fetish, such objects must be controlled by the individual. Thus, only when one is caught unawares can the uncanny trigger provoke a response; the fetishist, on the other hand, is master of the object, which he deploys at will.

25. "Sköne Oke—Sköne Oke!" E. T. A. Hoffmann, "The Sandman," in *Selected Writings of E. T. A. Hoffmann*, ed. and trans. Leonard J. Kent and Elizabeth C. Knight, 137–67 (Chicago and London: University of Chicago Press, 1969), 139, 167.

26. Freud, "The Uncanny," 231.

27. The significance of sight for Freud's essay—though unremarked by Freud—is discussed by Jane Marie Todd, "The Veiled Woman in Freud's 'Das Unheimliche,'" *Signs* 11, no. 3 (1986): 519–28, and Phillip McCaffrey, "Freud's Uncanny Woman," in *Reading Freud's Reading*, ed. Sander L. Gilman, Jutta Birmele, Jay Geller, and Valerie D. Greenberg, 91–108 (New York and London: New York University Press, 1994).

28. Freud, "The Uncanny," 240. Strachey points out that Freud refers to the phenomenon as the "bösen Blick," or "evil look."

29. Freud, "The Uncanny," 244.

30. Pliny, *Natural History*, 308–11, §§ 65–66.

31. Pliny records a similar incident involving Apelles: "There is, or was, a picture of a horse by him, painted in a competition, by which he carried his appeal for judgment from mankind to the dumb quadrupeds; for perceiving that his rivals were getting the better of him by intrigue, he had some horses brought and showed them their pictures one by one; and the horses only began to neigh when they saw the horse painted by Apelles; and this always happened subsequently, showing it to be a sound test of artistic skill" (*Natural History*, 331, §§ 95–96). A similar story is told of Giotto, who deceived Giovanni Cimabue by painting a fly on the face of a figure not yet completed by the older artist. When Cimabue resumed working on the painting, he tried to brush away the fly before realizing the trick that had been played on him.

32. Pliny, *Natural History*, 310–11, § 66.

33. Besançon, *The Forbidden Image*, 14.

34. Cited in ibid., 29.

35. Cited in ibid., 29.

36. Besançon, *The Forbidden Image*, 31.

37. The most recent variation on the tale of Zeuxis's grapes is the passage of the 1996 Child Pornography Prevention Act by the U.S. Congress. This act subjects computer-generated representations of children engaged in sexual behavior to the same criminal penalties applied to photos and videotapes documenting the sexual exploitation of actual children. The U.S. Supreme Court ruled portions of this law unconstitutional in April 2002, though much of the law was revived as the Child Pornography and Obscenity Prevention Act of 2003. For more on this legislation and its attempt to redraw the bounds between representation and reality, see my "The New Iconoclasm," *Art Journal* (Spring 2005): 20–31.

38. Doctor Faustus greets the spirit of Helen with this epithet the night of his death and final damnation. Helen bears the same dual significance in Christopher Marlowe's play: She appears to offer Faustus a final pleasure before dying, but her kiss removes his soul:

> FAUSTUS: Was this the face that launch'd a thousand ships,
> And burnt the topless towers of Ilium?—
> Sweet Helen, make me immortal with a kiss.—
> Her lips suck forth my soul: see where it flies!—
> Come, Helen, come, give me my soul again.
> Here will I dwell, for heaven is in these lips,
> And all is dross that is not Helena. (5.1.107–13)

39. Paul Friedrich, *The Meaning of Aphrodite* (Chicago: University of Chicago Press, 1978).

40. See on this point Paul Friedrich, "Sanity and the Myth of Honor: The Problem of Achilles," *Ethos*, 5 (1977): 281–305.

41. Friedrich, *Meaning of Aphrodite*, 134–35.

42. Ibid., 15. And see "... me, who am a nasty bitch evil-intriguing" *The Iliad of Homer*, trans. Richard Lattimore (Chicago: University of Chicago Press, 1951), book 6, line 344.

43. Norman Austin has argued that Helen's status as sign supersedes all her other narrative or historical roles. See his *Helen of Troy and Her Shameless Phantom* (Ithaca, N.Y.: Cornell University Press, 1994).

44. Euripides, *The Women of Troy*, in *The War Plays: "Iphigenia at Aulis," "The Women of Troy," "Helen,"* trans. Don Taylor, 79–131 (London: Methuen Drama, 1990), 112.

45. Euripides, *Helen*, in *The War Plays*, 138.

46. Ibid., 147.

47. Ibid., 160.

48. Austin, *Helen of Troy and Her Shameless Phantom*, 16, 12, 13.

49. Otto Rank, *The Double: A Psychoaonalytic Study*, trans. Harry Tucker Jr. (Chapel Hill: University of North Carolina Press, 1971). Originally published as *Der Doppelgänger: Eine psychoanalytische Studie* (Leipzig: Internationaler Psycho-analystischer, 1925).

50. Freud, "The Uncanny," 234–35.

51. Gorgias, *Encomium of Helen*, trans. D. M. MacDowell (London: Bristol Classical Press, 1982), 10.

52. Ibid., 24–27.

53. Johann Wolfgang von Goethe, *Faust*, part 2, trans. Martin Greenberg (New Haven, Conn.: Yale University Press, 1998), lines 1624–28. I cite the German from *Faust Der Tragödie zweiter Teil* (Stuttgart: Ernst Klett, 1981):

MEPHISTOPHELES: Um sie kein ort, noch weniger eine Zeit;
Von ihnen sprechen is Verlegenheit.
Die Mütter sind es!
FAUST: Mütter!
MEPHISTOPHELES: Schaudert's dich?
FAUST: Die Mütter! Mütter!—'s klingt so wunderlich! (6214-19)

54. Goethe, *Faust*, line 1680. "Den Müttern! Trifft's mich immer wie ein Schlag!" (Goethe, *Faust Der Tragödie*, line 6265).

55. Goethe, *Faust*, lines 1682–90.

MEPHISTOPHELES: Bist du beschränkt, daß neues Wort dich stört?
Willst du hören, was du schon gehört?

	Dich störe nicht, wie es auch weiter klinge,
	Schon längst gewohnt der wunderbarsten Dinge.
FAUST:	Doch im Erstarren such' ich nicht mein Heil,
	Das Schaudern ist der Menschheit bestes Teil;
	Wie auch die Welt ihm das Gefühl verteure,
	Ergriffen, fühlt er tief das Ungeheure. (6267-74)

Note that although *Ungeheure* is translated here as "great, immense," the word designates the monstrous, dreadful, or terrible. It evokes an idea akin to *unheimlich*. My thanks to Laura Barlament for pointing out this relationship.

56. Goethe, *Faust*, lines 1911–13. "Hab' ich noch Augen? Zeigt sich tief im Sinn / Der Schönheit Quelle reichlichstens ergossen? / Mein Schreckensgang bringt seligsten Gewinn" (Goethe, *Faust Der Tragödie*, lines 6487–89).

57. Goethe, *Faust*, lines 4405–6. "Doch sagt man, du erschienst ein doppelhaft Gebild, / In Ilios gesehen und in Ägypten auch" (Goethe, *Faust Der Tragödie*, lines 8872–73).

58. Strabo, *Geographika*, 8.3.12, cited in J. J. Pollitt, *The Art of Ancient Greece: Sources and Documents* (Cambridge and New York: Cambridge University Press, 1990), 124. Athenaeus, *Deipnosophists*, 8.346B–C, cited in Pollitt, *The Art of Ancient Greece*, 124. Pausanias, *Guide to Greece*, cited in Pollitt, *The Art of Ancient Greece*, 127–42.

59. Pliny, *Natural History*, 276–79, § 24; 278–79, § 26.

60. Ibid., 267–69, § 11.

61. Lattimore, *The Iliad of Homer*, book 3, line 121; book 1, line 55. Helen and Hera share the epithet "of the white arms" with others, including Andromache.

62. On the prevalence of "white arms" as a designation of beauty in other cultures, including Celtic and Hindu, see Enrico Campinile, "Ein Element der weiblichen Schönheit in der keltischen Kultur," *Zeitschrift für celtische Philologie* 46 (1994): 36–38.

63. Samuel Butler, trans., Louise R. Loomis, ed., *The Iliad of Homer* (New York: Walter J. Black, 1942), 74.

64. Aelian, *Historical Miscellany*, ed. and trans. Nigel Guy Wilson. (Cambridge, Mass.: Harvard University Press, 1997), Book 14, section 47, page 487.

65. "Quod quoniam nobis quoque voluntatis accidit ut artem dicendi perscriberemus, non unum aliquod prosposuimus exemplum cuius omnes partes, quocumque essent in genere, exprimendae nobis necessarie viderentur" (Cicero, *De inventione*, 168–69).

66. Book 35 of Pliny's *Natural History* begins, "We have now practically indicated the nature of metals, in which wealth consists, and of the substances related to them, connecting the facts in such a way as to indicate at the same time the enormous topic of medicine and the mysteries of the manufactories and the fastidious subtlety of the processes of carving and modelling and dyeing. There remain the various kinds of earth and of stones, forming an even more exten-

sive series, each of which has been treated in many whole volumes, especially by Greeks. For our part in these topics we shall adhere to the brevity suitable to our plan, yet omitting nothing that is necessary or follows a law of Nature. And first we shall say what remains to be said about painting" (260–61 §§ 1, 2).

3. MYTH AND MIMESIS IN THE RENAISSANCE

1. Northern aesthetic theorists and art historians did not revive artistic mimesis as quickly as their southern counterparts. Consequently, the story of Zeuxis Selecting Models is pushed aside by writers like Karel van Mander in favor of the story of the Contest between Zeuxis and Parrhasius, in which intense naturalism is emphasized over artistic mimesis. Van Mander's only reference to the legend of Zeuxis Selecting Models comes in connection with his mention of a now-lost painting of the theme by Octavio van Veen (a drawing possibly associated with this lost painting was sold at Sotheby's in 1974—thanks to Carl van de Velde for informing me of this drawing). On van Mander's reticence on Zeuxis Selecting Models, see Walter S. Melion, *Shaping the Netherlandish Canon: Karel van Mander's Schilder-Boeck* (Chicago and London: University of Chicago Press, 1991).

2. Martin Kemp, "From 'Mimesis' to 'Fantasia': The Quattrocento Vocabulary of Creation, Inspiration, and Genius in the Visual Arts," *Viator* 8 (1977): 347.

3. Leonardo da Vinci, Windsor MS 19045, ca. 1510, quoted in Kemp, "From 'Mimesis' to 'Fantasia,'" 378.

4. For more detailed analyses of the significance of mimesis for Renaissance art, see Roland LeMollé, *Georges Vasari et le vocabulaire de la critique d'art dans "Les Vite"* (Grenoble: Université Stendhal, 1988), esp. chap. 6, "Imitazione: Du mot au concept," and Paola Barocchi, ed., *Scritti d'arte del Cinquecento* (Turin: G. Einaudi, 1971), esp. the excerpts collected in the section "L'imitazione."

5. Of course, Alberti and Vasari's views on mimetic representation deliver only a narrow slice of the Renaissance aesthetic debates. Various positions were taken up by aestheticians and critics, making it impossible to argue on behalf of a single, coherent Renaissance attitude toward Zeuxian mimesis. For example, Alberti unhesitatingly endorses the example of Zeuxis, while Vasari's writings show an ambivalence regarding the use of a single model as opposed to the multiple models exemplified by Zeuxian mimesis. Pietro Bembo, on the other hand, strongly advocated the use of a single model. Vincenzo Danti revives a Platonic view by valorizing the single model taken from nature, though he admits that the material from which nature is made often cannot retain the perfection of nature's form, so artists must strive to represent nature as God intended it to be, that is, perfect. See Barocchi, *Scritti d'arte del Cinquecento,* for selections by Bembo and Danti.

6. Leon Battista Alberti, *On Painting,* trans. John R. Spencer, rev. ed. (New Haven, Conn., and London: Yale University Press, 1966; orig. 1956), 43.

7. Ibid., 92–93.

8. Ibid., 93.

9. Alberti, like Cicero, places the scene in Croton rather than Pliny's Agrigentum.

10. Alberti, *On Painting*, 93.

11. There is a drawing of the subject attributed to Perino del Vaga in the Worcester Art Museum collection. I have found no evidence that this sketch is related to a finished work. David Acton notes, "The drawing is laid down on an eighteenth-century mount, which is inscribed with the present attribution. It seems to me that the drawing is sixteenth century, and perhaps Florentine rather than Roman, closer to someone like Naldini than Perino" (e-mail message to author, April 22, 1999). Andor Pigler, in *Barockthemen*, 3 vols. (Budapest: Akadémiai Kiadó, 1974), 2:442, identifies a drawing by Primaticcio as a possible representation of Zeuxis Selecting Models, but after examining a reproduction of the drawing (which shows a seated man in antique garb holding a tablet and stylus with a pair of antique sculptures behind him), I do not think there is enough to designate it as a Zeuxis Selecting Models. Raffaello Borghini mentions a representation of Zeuxis executed in his Florence house by Alessandro Fei (Alessandro del Barbiere) in *Il Riposo*, 3 vols. (Milan: Società Tipografica de Classici Italiani, 1807), 3:219.

12. On this cycle, see Roberto Guerrini, "Les représentations d'artistes dans la peinture italienne à la Renaissance: Sources et modèles antiques," trans. from Italian by Lorenzo Pericolo and Francis Moulinat, in *Les "vies" d'artistes: Actes du colloque international organisé par le Service Culturel du Musée du Louvre, les 1er et 2me octobre 1993*, ed. Mattias Waschek, 57–80 (Paris: Ecole nationale supérieure des Beaux-Arts, Musée du Louvre, 1993). See also Alessandro Angelini, "Il Beccafumi e la volta dipinta della camera di casa Venturi: L'artista e I suoi Committenti," *Bullettino Senese di Storia Patria* 96 (1989): 371–83. Gustavus Medicus kindly shared with me his knowledge of Beccafumi's treatment of the Zeuxis theme.

13. Pascale Dubus, *Domenico Beccafumi*, trans. Michael Taylor (Paris: Vilo; Biro, 1999), 156.

14. "Zeuxis, not relying on art, believed that he could produce a true image if he regarded judiciously the beauty of the chosen maidens" (translation Erin Niedringhaus). Text of inscription taken from Guerrini, "Les représentations d'artistes dans la peinture italienne à la Renaissance," 61.

15. Giorgio Vasari, *Lives of the Painters, Sculptors, and Architects*, trans. Gaston du C. de Vere, 3 vols. (New York: Knopf, 1996).

16. Cited in Robert Williams, *Art, Theory, and Culture in Sixteenth-Century Italy: From Techne to Metatechne* (Cambridge and New York: Cambridge University Press, 1997), 43.

17. Vasari, *Lives of the Painters, Sculptors, and Architects*, 1:743.

18. Quoted in Giovanni Bellori, "Idea," trans. G. Donahue, reprinted in *Art History and Its Methods*, ed. Eric Fenie (New York: Phaidon, 1995), 65.

19. Williams, *Art, Theory, and Culture in Sixteenth-Century Italy*, 83. The resurrection of artistic mimesis during the Renaissance took place alongside the revival of ancient principles of rhetoric. Williams analyzes the links between Re-

naissance aesthetics and ancient rhetoric, as does Kemp in "From 'Mimesis' to 'Fantasia,'" 347–98.

20. Fredrika H. Jacobs argues that it is Apelles rather than Zeuxis who receives Vasari's highest praise. Fredrika H. Jacobs, "Vasari's Vision of the History of Painting: Frescoes in the Casa Vasari, Florence," *Art Bulletin* 66 (September 1984): 399–416.

21. Illustrated in Patricia Lee Rubin, *Giorgio Vasari: Art and History* (New Haven, Conn.: Yale University Press, 1995), 240. On Vasari's depiction of Zeuxis Selecting Models, see Guerrini, "Les représentations d'artistes dans la peinture italienne," 57–80.

22. On this cycle, see Liana Cheney, *The Paintings of the Casa Vasari: Outstanding Dissertations in the Fine Arts* (New York: Garland, 1985), and Liana de Girolami Cheney, "Giorgio Vasari's Visual Interpretation of Ancient Lost Paintings," *Visual Resources* 16 (2000): 229–58. There is some disagreement among scholars about which room the Zeuxis adorns. According to Cheney, it is the Sala della Fortuna; Patricia Rubin sites it in the Sala del Trionfo della Virtù (*Giorgio Vasari*, 240, caption to Figure 86); Annamaria Ippolito, *soprintendenza* of artworks and culture for Arezzo, assures me that the painting adorns the Sala del Camino.

23. Vasari, *Lives of the Painters, Sculptors, and Architects,* 2:1045–46.

24. Cheney, *The Paintings of the Casa Vasari,* 185.

25. Ibid., 186. Cheney argues that Vasari's deployment of the Diana of Ephesus depends upon the rich medieval/Renaissance iconographic sources such as Vincenzo Cartari, whom she quotes as describing the Diana of Ephesus as follows: "Dea della Natura tutta piena de poppe, per mostrare, che l'universo piglia nutrimento dalla virtu occulta della medesima" (Goddess of Nature full of breasts, in order to show that the universe draws nourishment from her hidden virtue—trans. Leslie Richardson). Vincenzo Cartari, *Imagini delli dei de gl'antichi,* ed. with forward by W. Koschatzky (Graz, Austria: Akademische Druck- u. Verlagsanstalt, 1963), 65. Of course, the Diana of Ephesus exceeds her bounds as a straightforward personification of nature, signifying excessive, inexhaustible, and indeed uncanny fecundity. In the following chapters, I will return to this juxtaposition in an effort to explain the significance of the Zeuxis myth.

26. Cited in Jacobs, "Vasari's Vision of the History of Painting," 401–2. Jacobs dates this cycle to 1569–73.

27. Ibid., 402.

28. Elizabeth McGrath also raises this possibility in "The Painted Decoration of Rubens's House," *Journal of the Warburg and Courtauld Institutes* 61 (1978): 268.

29. McGrath writes that Rubens designed these scenes between 1618 and 1621 (ibid., 247). According to Karel van Mander, Rubens's teacher Otto van Veen (1556–1629) attempted a similar pictorial history of art. See Karel van Mander, *The Lives of the Illustrious Netherlandish and German Painters, from the First Edition of the Schilder-boeck,* trans. Hessel Miedema (Doornspijk: Davaco, 1994), 438.

30. Jacobs, "Vasari's Vision of the History of Painting," 415.

31. Cited in McGrath, "The Painted Decoration of Rubens's House," 245.

32. *Los quatro libros des cortesano,* trans. Juan Boscán (Barcelona: Pedro Montpezat, 1534); *Le covrtisan,* trans. Jacques Colin (Lyon: de Harsy, 1537); *The covrtyer of Covnt Baldessar Castilio diuided into foure bookes. Very necessary and profitatable for yonge Gentilmen and Gentilwomen abiding in Court, Palaice or Place,* trans. Thomas Hoby (London: Wyllyam Seres, 1561); *Il cortegiano,* trans. Bernardino Marliani and Antonio Ciccarelli (Venice: Basa, 1584); *De volkmaeckte hovelinck,* trans. Lambert van den Bos (Amsterdam: Wolfganck, 1662); *Der vollkommene Hofmann und Hof-Dame,* anonymous translator (I.C.L.L.I.) (Frankfurt am Main: Schäffern, 1684).

33. Known as the paragone, the debate about which medium was superior—painting or sculpture—arose frequently in early modern aesthetic treatises. In *The Courtier,* trans. George Bull (London and New York: Penguin, 1976), the paragone is taken up by Count Lodovico Canossa and the sculptor Giovan Cristoforo Romano. Cesare Gonzaga has been listening, then chimes in with his own opinion.

34. Castiglione, *The Courtier,* 102.

35. Ibid.

36. Simon de Hesdin and Nicolas de Gonesse, trans., *Cy commencent les rubrices du liure Valerius Maximus* (Belgium, 1476). An Italian version ascribed to Diogenes Laertius is largely a free adaptation and translation of Gualterus Burlaeus's *De vita et moribus philosophorum* (ca. 1440), with additions from Valerius Maximus and Aulus Gellius: *Incomincia el libro dela vita de philosophi et delle loro elegantissime sententie* (Venice: Bernardinus Celerius, 1480); Heinrich von Muegeln [Mügleyn?], *Valeri[u]s Maxim[u]s von die Geschicht d[er] Röme[r]* (Augsburg: Anthonio Sorg, 1488); *Valerio Maximo traducido de la versión francesa de Simon de Hedin por Hugo de Urries* (Zaragoza: Pablo Hurus, 1495). The Dutch would not appear until the seventeenth century: *Conradium Mirkinium Valerii Maximi des alder-vermaertsten ende wel-sprekensten historischrpvers Negen Boecken: Van ghedenck-weerdighe, loflicke woorden . . .* (Rotterdam: Jan Leendertsz., 1614). Pliny, *Storia Naturale,* trans. Cristoforo Landino (Venice: Nicolaus Jenson, 1476). Pliny, *Bücher und Schrifften von Natur, Art, und Eygenschafft aller Creaturen, oder, Geschöpffe Gottes,* trans. Sigfried Feyerabend (Frankfurt am Main: Jost Amman, 1565); Pliny, *L'histoire du monde collationnée & corrigée sur plusieurs vieux exemplaires latins, & enrichie d'annotations en marge, servans à la conference & declaration des anciens & modernes noms des villes, regions, simples, & autres termes obscurs comprins enicelle,* trans. Antoine du Pinet (Lyon: Claude Senneton, 1562).

37. Thomas Fuller, quoted in Charles Whibley, *Literary Portraits* (London: Constable, 1904), 156, and in Paul Turner, "Introduction," in *The History of the World, Commonly Called the Natural History of C. Plinius Secundus or Pliny,* trans. Philemon Holland (New York, Toronto, London: McGraw-Hill, 1962), 10. Holland's translation was originally published as C. Plinius Secundus, *The Historie of the World. Commonly called the Natural Historie,* trans. Philemon Holland (London: Adam Islip, 1601).

38. Whibley, *Literary Portraits,* 159.

39. Ibid., 156. Turner makes the same claim in "Introduction," 11.

40. Turner, "Introduction," 12–16.

41. C. Plinius Secundus, *The Historie of the World*, 1601 edition, 534. There are numerous extant copies of the 1601 edition, and the book was reprinted in 1634 and 1635, indicating wide circulation among educated readers.

42. William Shakespeare, *The Winter's Tale*, in *The Riverside Shakespeare* (Boston: Houghton Mifflin, 1974) 4.4.87–97; references are to act, scene, and lines.

43. See J. H. P. Pafford, "Appendix I," in *The Winter's Tale*, Arden Edition of the Works of William Shakespeare (London: Methuen; Cambridge, Mass.: Harvard University Press, 1963), 169–70.

44. *The Winter's Tale*, Riverside edition, 4.4.99–106.

45. This comparison is discussed at greater length in chapter 4. Frank Kermode addresses the relationship of this theme to social issues in his introduction to *The Tempest*, in *The Riverside Shakespeare*, rev. 5th ed. (Cambridge, Mass.: Harvard University Press, 1954), xxxv.

46. *The Winter's Tale*, Riverside edition, 5.1.13–16.

47. William Shakespeare, *As You Like It*, in *The Riverside Shakespeare* (Boston: Houghton Mifflin, 1974), 3.2.145–52. Shakespeare cites Zeuxian mimesis in *Cymbeline*, in *The Riverside Shakespeare* (Boston: Houghton Mifflin, 1974), as well:

> CLOTEN: . . . From every one
> The best she hath, and she, of all compounded,
> Outsells them all. . . . (3.5.72–74)

Likewise, Philip Sidney evokes Zeuxian mimesis in his *Arcadia:* "She is her selfe, of best things the collection." Sir Philip Sidney, *The Countesse of Pembrokes Arcadia*, ed. Albert Feuillerat (Cambridge: Cambridge University Press, 1922), 128.

4. ZEUXIS IN THE ACADEMY

1. For a description of a sixteenth-century Florentine academic curriculum, see K.-E. Barzman, "The Florentine Accademia del Disegno: Liberal Education and the Renaissance Artist," in *Academies of Art between Renaissance and Romanticism*, ed. Anton W. A. Boschloo et al., 14–32 ('S-Gravenhage: SDU Uitgeverij, 1989).

2. For more complete treatments of the history of art academies, see Nicolas Pevsner, *Academies of Art* (Cambridge: Cambridge University Press, 1940), and Boschloo et al., *Academies of Art between Renaissance and Romanticism.* On the French Royal Academy, see Alain Mérot, ed., *Les conférences de l'Académie royale de peinture et de sculpture au XVIIe siècle* (Paris: Ecole nationale supérieure des Beaux-Arts, 1996), and June Hargrove, ed., *The French Academy: Classicism and Its Antagonists* (Newark: University of Delaware Press; London: Associated University Presses, 1990).

3. Pliny states, "Some writers erroneously place Zeuxis in the 89th Olympiad, when Demophilus of Himera and Neseus of Thasos must have been his contemporaries, as of one of them, it is uncertain which, he was a pupil" (Pliny, *Natural History*, 307, § 61.

4. This line comes from a poem about Zeuxis attributed by Pliny to the painter Apollodorous (Pliny, *Natural History*, 307, § 62).

5. Lucian also cites this work in his discussion of unsophisticated audiences who only praise originality when they should observe a work's fine execution, expression, and so on as well. "Zeuxis or Antiochus," in *Lucian*, trans. K. Kilburn, 8 vols. (Cambridge, Mass.: Harvard University Press, 1959), 6:154–69.

6. Pliny, *Natural History*, 311, § 66; 309, § 62.

7. Some academies, including the French Royal Academy, refused membership to artists too closely associated with commerce. For instance, the founders of the French Royal Academy withheld membership from printmakers, believing them to be too much engaged in commercial activities. Along similar lines, the academy's members could not participate in art dealing, nor could they be closely related to a dealer. Such prohibitions were, of course, not unique to France.

8. Pliny, *Natural History*, 308–9, § 62.

9. Giovanni Bellori, introduction to *Lives of the Modern Painters, Sculptors, and Architects*, trans. G. Donuhe, in *A Documentary History of Art*, ed. E. G. Holt, vol. 2: *Michelangelo and the Mannerists, the Baroque, and the Eighteenth Century* (Garden City, N.Y.: Doubleday, 1958), cited in Fernie, *Art History and Its Methods*, 63.

10. See Kris and Kurz, *Legend, Myth, and Magic in the Image of the Artist*, and Soussloff, *The Absolute Artist*.

11. Bellori, cited in Fernie, *Art History and Its Methods*, 64.

12. Anne Summerscale, *Malvasia's Life of the Carracci: Commentary and Translation* (University Park: Pennsylvania State University Press, 2000), 212, n. 277.

13. Summerscale, *Malvasia's Life of the Carracci*, 212.

14. Ludovico Carracci, quoted in ibid., 74.

15. Summerscale, *Malvasia's Life of the Carracci*, 75.

16. Giambattista Marino, "Painting: The First Discourse on the Holy Shroud, Part One," trans. Linda Nemerow, in "The Concept of 'Ut Pictura Poesis' in Giambattista Marino's *Galeria* and the *Dicerie sacre* with a Translation of 'La Pittura' and 'La Musica'" (Ph.D. diss., Indiana University, 1980), 36.

17. Though Sandrart also cites Valerius; see *Teutsche Academie* (Nuremberg, 1675–79), 19.

18. The lower half of the page is given to an illustration of the Contest between Zeuxis and Parrhasius.

19. Derrida interprets this division as a kind of aesthetic blindness. See Jacques Derrida, *Memoirs of the Blind: The Self-Portrait and Other Ruins*, trans. Pascale-Anna Brault and Michael Naas (Chicago: University of Chicago Press, 1993). Originally published as *Mémoires d'aveugle: L'autoportrait et autres ruines* (Paris: Réunion des Musées nationaux, 1990).

20. Viktoria Schmidt-Linsenhoff, "Dibutadis: Die weibliche Kindheit der

Zeichenkunst," *Kritische Berichte* 24 (1996): 7–20, quotation on page 8; "Sandrart illustrierte mit der Radierung seine Vorrede zum II. Teil der Teutschen Akademie, die das kompilatorische Standardwerk des europäischen Akademismus ist, mit dem sich sein Autor als 'Praeceptor Germaniae' und 'Teutscher Apelles' zum Propagandisten des Akademie-Gedankens in Deutschland nach dem dreissigjährigen Krieg machte."

21. Schmidt-Linsenhoff, "Dibutadis," 13; "Mit der Illustration zu der Legende der 'korinthischen Jungfrau' markiert Sandrart die Zäsur zwischen einer mythischen Ur- oder Naturgeschichte der Kunst und ihrer Zivilisationsgeschichte, die in der männlichen Genealogie der grossen Meister begründet ist."

22. Schmidt-Linsenhoff, "Dibutadis," 16. See also Peter Königfeld, *Der Maler Johann Heiss, 1640–1704* (Weißenhorn: Anton H. Konrad, 2001), 302. The paintings are now in the collection of the Stuttgart Staatsgalerie.

23. Roger de Piles, *L'arte de peinture de Charles-Alphonse du Fresnoy, traduit en français, avec remarques nécessaires et très amples* (Paris: Nicolas L'Anglois, 1668). This work was appended to his later *L'abrégé de la vie des peintres* (Paris: Chez François Muguet, 1699) and translated anonymously into English as *The Art of Painting, and the Lives of the Painters: Containing a compleat treatise of painting, designing, and the use of prints: With reflections on the works of the most celebrated painters, and of the several schools of Europe, as well ancient as modern: Being the newest, and most perfect work of the kind extant* (London: Nutt, 1706), 12. Please note that I have modernized spelling in my transcriptions of this text.

24. De Piles, *The Art of Painting and the Lives of the Painters*, 80.

25. De Piles addresses the importance of copying for students in book 1 of *The Art of Painting and the Lives of Painters.*

26. The extant examples include Ludovico David, *Apelles Painting the Graces (la Scuola del nudo)* (fresco, 1667–86, Palazzo Albrizzi, Venice) (Figure 16); Johann Heiss, *Artist's Studio with Five Female Nudes* (oil on canvas, 1687, Stattsgalerie, Stuttgart) (Figure 13); after Francesco Solimena, *Zeuxis Painting Venus* (oil, 1690, Musée des Beaux-Arts, Dijon); Angelica Kauffman, *Zeuxis Selecting Models for His Painting of Helen of Troy* (oil on canvas, ca. 1780–82, Brown University Library, Providence, R.I.) (Figure 14); François-André Vincent, *Zeuxis Choosing the Most Beautiful Women from Crotone as His Models* (oil on canvas, 1789, Louvre Museum, Paris) (Figure 24); a reduced copy produced by Vincent of his 1789 painting (1791, private collection); Jacques-Albert Senave, *Parody of Zeuxis* (oil on canvas, ca. 1800, Royal Museum of Fine Arts, Brussels) (Figure 31); Nicolas Monsiau, *Zeuxis Selecting His Models* (oil on canvas, 1797, Art Gallery of Ontario) (Figure 30); Victor-Louis Mottez, *The Triumph of Painting (Zeuxis Choosing His Models)* (oil on canvas, 1859, Musée Condé, Chantilly) (Figure 33); Edwin Longsden Long, *The Search for Beauty* (oil on canvas, 1885, private collection) (Figure 54); Edwin Longsden Long, *The Chosen Five* (oil on canvas, 1885, Russell-Cotes Art Gallery, Bournemouth) (Figure 56).

Andor Pigler cites a version by Otto van Veen (Karel van Mander attributes to van Veen a Zeuxis "who paints five women from life, that is very outstandingly well made"; see van Mander, *The Lives of the Illustrious Netherlandish and German*

Painters, 1:438). A grisaille drawing (155 × 201 mm) possibly related to this painting was sold at Sotheby's London in a June 26, 1974, sale, lot 149. Pigler also refers to versions by Peter Paul Rubens and Heinrich Friedrich Füger.

27. Studies by François-André Vincent for his 1789 painting can be found at the Fogg Art Museum in Cambridge, Massachusetts (see Figure 28) and the Musée Atget in Montpellier, which has three in its collection. Joseph-Marie Vien produced two finished drawings of the subject, both now at the British Museum (see Figures 25 and 26). Thomas Rowlandson's interesting sketch, *Apelles Singling Beauties from a Variety of Models,* can be found in the Tate Gallery (Figure 34). Among the prints to offer an original interpretation of the subject are Joachim von Sandrart's engraving (ca. 1675) for his *Teutsche Academie* (Figure 11). Reproductive engravings include Jacob Harrewijn's 1692 engraving of Rubens's frescoes adorning his house in Antwerp (Figure 10); Brion de la Tour's engraving after Nicolas Monsiau; Joseph Goupy's, after Francesco Solimena; and Joseph Eissner's after a (lost?) painting by Friedrich Heinrich Füger. See Pigler, *Barockthemen,* 2:442.

28. Winckelmann's discussions of Zeuxis suggest that he consulted Sandrart as well as ancient sources. His version of Zeuxis Selecting Models veers from these sources: From Cicero he takes the location (Croton), but he fixes on Juno as the subject of Zeuxis's painting. J. J. Winckelmann, "Aus Geschichte der Kunst des Altertums" (1763–64), in *Winckelmanns Werke in einem Band* (Berlin and Weimar: Aufbau, 1982), 186. All English translations come from Johann Joachim Winckelmann, *History of Ancient Art,* trans. G. Henry Lodge, 4 vols. (New York: Frederick Ungar, 1968; orig. Boston: James Monroe, 1849). For the quotation in the text here, see 1:188.

29. Winckelmann, *History of Ancient Art*, 1:204.

30. Ibid., 1:205. "Es fällte Bernini ein sehr ungegründetes Urteil, wenn er die Wahl der schönsten Teile, welche Zeuxis an fünf Schönheiten zu Kroton machte, da er eine Juno daselbst zu malen hatte, für ungereimt und für erdichtet ansah, weil er sich einbildete, ein bestimmtes Teil oder Glied reime sich zu keinem andern Körper, als dem es eign ist. Andere haben keine als individuelle Schönheiten denken können, und ihr Lehrsatz ist: Die alten Statuen sind schön, weil sie der schönen Nature ähnlich sind, und die Natur wird allezeit schön sein, wenn sie den schönen Statuen ählich ist. Der vordere Satz ist wahr, aber nicht einzeln, sondern gesammelt, der zweite Satz aber ist falsch, denn es ist schwer, ja fast unmöglich, ein Gewächs zu finden, wie der vatikanische Apollo ist" (Winckelmann, "Aus Geschichte der Kunst des Altertums," 200–1).

31. Winckelmann, *History of Ancient Art*, 1:205.

32. Ibid., 1:204.

33. This quotation comes from Nicolas Venette, *The Mysteries of Conjugal Love Reveal'd* (London, 1707) cited in Paul-Gabriel Boucé, "Some Sexual Beliefs and Myths in Eighteenth-Century Britain," in *Sexuality in Eighteenth-Century Britain,* ed. Paul-Gabriel Boucé, 28–46 (Manchester, U.K.: Manchester University Press, 1982), 41. Venette also authored works on horticulture, including *L'art de tailler les arbres fruitiers* (1683). Venette's sex manual enjoyed a wide audience among European readers. Translations from French into English, German, Dutch,

Italian, and Spanish were published as late as the nineteenth century. Such ideas, therefore, no doubt held currency even among those who did not have firsthand knowledge of the text. Interestingly, the same advice is given to women in similarly horticultural terms in *Aristotle's Compleat Masterpiece* (1684), another enduringly popular text produced ostensibly for doctors and newlyweds. The volume's pseudo-Aristotelian author instructs women wishing to conceive to refrain from frequent sexual intercourse. Using prostitutes as evidence that conception rarely takes place among women who "use the act of coition too often," the author reminds the reader that "the grass seldom grows in a path that is commonly trodden in." *Aristotle's Compleat Masterpiece* (Philadelphia: Jarnett G. Bossy, 1798; orig. London, ca. 1684), 20.

34. *Middlesex Journal, or Chronicle of Liberty,* Tuesday, May 2–Thursday, May 4, 1775, 2, cited in Rosenthal, *Angelika Kauffmann,* 51.

35. Quoted in Clara Pinto-Correia, *The Ovary of Eve: Egg and Sperm and Preformation* (Chicago: University of Chicago Press, 1997), 154.

36. Thomas Laqueur, *Making Sex: Body and Gender from the Greeks to Freud* (Cambridge, Mass.: Harvard University Press, 1990), 42.

37. Cited in Laqueur, *Making Sex,* 35.

38. Winckelmann, *History of Ancient Art,* 1:204.

39. Anton Raphael Mengs, "Reflections upon Beauty and Taste in Painting," in *The Works of Anthony Raphael Mengs,* trans. José Nicolás de Azara (1762; rpt. London: R. Faulder, 1796), 19. The bee's role as an erotic metaphor has a long history. Ancient Chinese poets invoked the metaphor, as did Roger Hammerstein in his libretto for *The King and I:* "A woman must be like a blossom, with honey for just one man. A man must be like a honey bee, and gather all he can. To fly from blossom to blossom, the honey bee must be free. But blossom must not ever fly, from bee to bee to bee!" Quoted in Michael Pollan, *The Botany of Desire* (New York: Random House, 2001), 73, 76.

40. Mengs, "Reflections upon Beauty and Taste in Painting," 18.

41. On the tendency of Western culture to ascribe masculine characteristics to positive or innovative trends in art while dismissing outmoded or unfashionable aesthetic tendencies as feminine, see Norma Broude, *Impressionism: A Feminist Reading* (New York: Rizzoli, 1991), 178.

42. Richardson cites the Contest between Zeuxis and Parrhasius in "An Essay on the Whole Art of Criticism as It Relates to Painting," in *Two Discourses* (Menston, U.K.: Scolar facsimile, 1972; orig. London, 1719), 41. He gives the legend as an example of the "silly stories" contained in studies of lives and works of great artists.

43. Jonathan Richardson, *Essay on the Theory of Painting,* 2nd ed. (Menston, U.K.: Scolar, 1971; orig. 1725), 7. I have modernized spelling in quotations from this work.

44. Ibid., 11.

45. Jonathan Richardson, "A Discourse on the Dignity, Certainty, Pleasure and Advantage, of the Science of a Connoisseur" (1719) in *Two Discourses,* 12–13.

46. Ibid., 17.

47. Sir Joshua Reynolds, *Discourses on Art*, ed. Robert R. Wark (New Haven, Conn.: Yale University Press, 1975), 103.

48. Ibid., 99.

49. Ibid.

50. Ibid., 99–100.

51. See Angus McClaren, *Reproductive Rituals: The Perception of Fertility in England from the Sixteenth Century to the Nineteenth Century* (New York: Methuen, 1984), 22–26, for an account of eighteenth-century English theories of conception and reproduction.

52. *Aristotle's Compleat Masterpiece*, 19.

53. Quoted in Pinto-Correia, *The Ovary of Eve*, 109.

54. *Aristotle's Compleat Masterpiece*, 28.

55. Ibid., 48–51. For a discussion of the influence of the mother's imagination on her fetus in eighteenth-century literature, see McClaren, *Reproductive Rituals*, 49–50.

56. Pinto-Correia, *The Ovary of Eve*, 157–59.

57. Donatien-Alphonse-François de Sade, *Philosophy in the Bedroom*, in *The Marquis de Sade: "Justine," "Philosophy in the Bedroom," and Other Writings*, comp. and trans. Richard Seaver and Austryn Wainhouse, 177–367 (New York: Grove Press, 1965).

58. Reynolds, *Discourses on Art*, 44.

59. Schmidt-Linsenhoff, in "Dibutadis," argues that Zeuxis provides an exemplar of masculine artistic creativity in Sandrart's *Teutsche Academie* in contrast to the feminine example provided by Dibutadis.

5. WOMEN ARTISTS AND THE ZEUXIS MYTH

1. The history of feminist contributions to art history is best summarized in Thalia Gouma-Peterson and Patricia Mathews, "The Feminist Critique of Art History," *Art Bulletin* 69 (September 1987): 326–57.

2. Ann Bermingham proceeds from a similar premise in her essay "The Origin of Painting and the Ends of Art."

3. An excellent analysis of her career and work will be found in Rosenthal, *Angelika Kauffmann*. Other good sources on Kauffman's life and oeuvre are Wendy Wassyng Roworth, ed., *Angelica Kauffman: A Continental Artist in Georgian England* (London: Reaktion, 1992); Waltraud Meierhofer, *Angelika Kauffmann* (Hamburg: Rowohlt Taschenbuch, 1997); Victoria Manners and G. C. William, *Angelica Kauffman, R.A.* (London: John Lane, 1924); and Frances Gerard, *Angelica Kauffman: A Biography* (New York: Macmillan, 1893; orig. London: Ward and Downey, 1892).

4. That she studied after live models is speculated but not attested.

5. They were introduced by Brownlow Cecil, 9th Earl of Exeter; see Roworth, *Angelica Kauffman*, 37. Richard Wendorf offers trenchant insight into their relationship in *The Elements of Life: Biography and Portrait Painting in Stuart and Georgian England* (Oxford: Clarendon Press, 1990).

6. Kauffman was one of only two women founding members. The other was still-life painter Mary Moser.

7. Gerard, *Angelica Kauffman*, 367, 369, and 393. Gerard describes Bowles as the work's original owner in her appendix listing Kauffman's paintings; J. Corbett, Esq., appears as the painting's owner at the time of Gerard's writing. In the appendix section "Pictures and Designs Engraved by Bartolozzi," *Zeuxis Composing His Picture of Juno* includes the following note: "From the original painted for George Bowles" (393). No documentation to support her assertion is offered, however.

8. Whether Kauffman and Bowles met in person or began corresponding at this time is uncertain. See Manners and William, *Angelica Kauffman, R.A.*, 58.

9. Kauffman, her father, and Zucchi arrived in Venice on October 4, 1781, and departed for Rome in April 1782. Roworth, *Angelica Kauffman*, "Chronology," 191. The circumstances of Kauffman's July 1781 wedding are discussed by Manners and William, *Angelica Kauffman, R.A.*, 50.

10. Roworth, *Angelica Kauffman*, 12–13, and Wendy Wassyng Roworth, "Angelica Kauffman's 'Memorandum of Paintings,'" *Burlington Magazine* 126 (1984): 627–30. According to Roworth, the memorandum was kept by Kauffman's husband until his death in 1798. Manners and William, in *Angelica Kauffman, R.A.*, provide a translation of the "Memorandum of Paintings," which they believe was recorded by Kauffman.

11. Manners asserts that the "Memorandum" is particularly unreliable for the years 1781 and 1782. See Manners and William, *Angelica Kauffman, R.A.*, 58.

12. Francesco Bartolozzi, *Zeuxis Composing the Picture of Juno* (engraving, brown ink, 1785, Calabi 1355 IV). An Italian painter and printmaker active in England from 1764 until 1802, Bartolozzi began reproducing Kauffman's paintings in 1778. The first of these was the stipple engraving *Zoraida, the Beautiful Moor* (1778). See David Alexander, "Kauffman and the Print Market in Eighteenth-Century England," in Roworth, *Angelica Kauffman*, 162, 186.

13. Manners and William, *Angelica Kauffman, R.A.*, 56–58.

14. Rosenthal suggests on the basis of style that the painting dates to the late 1770s. See Rosenthal, *Angelika Kauffmann*, 40, and Rosenthal, "Angelica Kauffman Ma(s)king Claims," *Art History* 15 (1992): 49. Rosenthal argues on behalf of a stylistic affinity between Zeuxis and *The Return of Telemachus*, which Kauffman painted circa 1775. But there is no significant breach in her style during the late 1770s and the first years of the 1780s.

15. Other versions known to have existed at this time include Beccafumi's fresco of circa 1519 in Siena's Palazzo Bindi-Sergardi; Vasari's two versions of circa 1548 and circa 1569–1573, both in fresco, in his Arezzo and Florence houses; Rubens's circa 1610–1620 fresco on the exterior wall of his Antwerp house; Sandrart's illustration of the scene included in his *Teutsche Academie* (1675); Heiss's 1687 painting for the Augsburg Academy; and Solimena's 1690 painting. I have been unable to determine the eighteenth-century condition or locations of the versions by Agostino Carracci, Otto van Veen, and Alessandro Fei listed in Pigler, *Barockthemen*, 2:442.

16. The painting dates to 1667–86, the years David worked in Venice. See Carlo Donzelli and Giuseppe Maria Pilo, *I Pittori del Seicento Veneto* (Florence: R. Sandron, 1967), 151–52. Kauffman visited Venice in mid-1765 and may have seen David's fresco then. See Roworth, *Angelica Kauffman*, "Chronology," 190.

17. David ran an academy in Venice for a time, but he held that painting and imagination were more important than drawing or *disegno*. Curiously, his *Apelles Painting the Graces* seems to recommend quite the opposite. On David's aesthetic theories, see N. Turner, "An Attack on the Accademia di S. Luca: Ludovico David's *L'Amore dell'arte*," *British Museum Yearbook* 1 (1976): 157–86.

18. This work accords with Bellori's theories of beauty and the ideal. See chapter 4.

19. I am not suggesting that David's painting introduced her to the subject. Certainly, her association with the leading artists and theorists of the day ensure her familiarity with the famous anecdote. Rather, I believe that David's painting called the subject to mind, inviting her to offer her own—quite different—interpretation of the episode. Kauffman seems to have been particularly interested in representations of artists and processes of creativity during the late 1770s and early 1780s. Numerous allegorical representations of design, composition, invention, and imitation date from the late 1770s and early 1780s. Among these are *Allegory of Imitation* of 1780, a rendition of *Leonardo da Vinci Expiring in the Arms of Francis I* in 1781, and, two years later, for Bowles, a painting of Alexander and Apelles. During this time, she also produced a number of self-portraits in which she figures as a painter or as an allegorical representation of the arts.

20. Rosenthal notes the resemblance between the seated figures in Kauffman's and David's works in *Angelika Kauffmann,* 46, but does not attribute to Kauffman a direct citation (possibly because Rosenthal believes the painting dates to the 1770s). Rosenthal further notes that the original source for this figure, who appears in eighteenth-century works by Pompeo Batoni and Thomas Gainsborough, among others, is a Roman copy of a Greek Nymph in the Vatican collection. Another citation of the seated figure occurs in Claude Lorrain's *Judgment of Paris,* 1645–46.

21. In this way, David's and Kauffman's renditions differ from earlier versions by Beccafumi, Vasari, Sandrart, and Solimena, in which the models pose more or less uniformly. Vasari offers some variety among his models' poses, but he does not juxtapose seated and standing positions or frontal and rear views. The seventeenth-century academic painter Heiss places the models in a variety of poses suggestive of antiquity.

The active poses of Kauffman's models challenge somewhat Rosenthal's assertion that the Zeuxis participates in an economy of viewing akin to that of *The Judgment of Paris.* Rosenthal points to Heinrich Füger's interpretation of Zeuxis Selecting Models as evidence for a similar conflation in Kauffman's painting. In Füger's version (which I know only through the engraved reproduction of the painting by Joseph Eisner at the Albertina), the five models obviously echo representations of the Three Graces, a convention common to representations of the Judgment of Paris. Kauffman, however, does not employ this visual trope.

22. Her quotation of the antique Venus Kallipygos then in Naples adds further credence to this possibility. I discuss Kauffman's citation of this sculpture in the following paragraphs.

23. On this painting, see Rosenthal, *Angelika Kauffmann*, 203–8.

24. Winckelmann writes of "the story of the selection of the most beautiful parts, made by Zeuxis from five beautiful women of Crotona, on being employed to paint a Juno there" (Winckelmann, *History of Ancient Art*, 2:205). " . . . wenn er die Wahl der schönsten Teile, welche Zeuxis an fünf Schönheiten zu Kroton machte, da er eine Juno daselbst zu malen hatte" (Winckelmann, *Winckelmanns Werke in einem Band*, 200). But later, in his *History of Ancient Art*, Winckelmann discusses "the Helen of Zeuxis" (221). Pliny also refers to a painting of Helen in a section of his account of the artist that stands apart from his recitation of the legend of Zeuxis Selecting Models. Aelian mentions a painting of Helen by Zeuxis intensely admired by the artist Nicomachus. This is the image that provoked Nicomachus to respond to a viewer who asks what makes the painting so great: "You wouldn't have asked me if you had my eyes." Aelian, *Historical Miscellany*, book 14.47, trans. G. P. Goold (Cambridge, Mass.: Harvard University Press, 1997), 486–87. Whether this is the Helen that Zeuxis created using five models or, rather, another Helen is not certain. None of the classical sources clarifies whether Zeuxis was known for two different representations of Helen or a single painting.

25. This corresponds thematically with David's version, in which Zeuxis has cast aside his palette and brushes in order to draw what he sees directly on the canvas. Rosenthal interprets this gesture as a signal that the artist has abandoned his intellectual engagement with the model and has instead succumbed to an erotic impulse and the desire to touch her. Rosenthal, *Angelika Kauffmann*, 50–52.

26. Fritz Saxl and Rudolf Wittkower make this observation in *British Art and the Mediterranean* (London and New York: Oxford University Press, 1948), 82–83. They note of Kauffman's painting that "the picture illustrates the old theme of the Greek artist Zeuxis composing an ideal figure of Helen of Troy from a number of separate models. But though Angelica Kauffmann used classic originals as models for her figures, the treatment is sweet and rather insipid, lacking true understanding of the classic spirit. The elegant character of her work appealed to Robert Adam, who frequently used her as a decorator of his interiors" (82).

27. In addition to her visit from June to November 1782, Kauffman resided in Naples from July 1763 until early 1764.

28. Cesare Ripa's *Iconologia* was first published in Italian in 1593 and went through many reprintings in several languages.

29. Winckelmann advocates its use by contemporary artists in his *Reflections on the Painting and Sculpture of the Greeks*, trans. Henry Fuseli (London, 1765). Originally published as *Gedanken über die Naehahmung der griecheschen Werke in der Mahlerey und Bildhauer-Kunst* (Dresden, 1755). See Ann Hope, "Cesare Ripa's *Iconologia* and the Neoclassical Movement," *Apollo* 86, supplement (October 1967): 2, n. 6.

30. Hope, "Cesare Ripa's *Iconologia* and the Neoclassical Movement," 1–4.

31. *Iconologia, or Moral Emblems, by Cesar Ripa,* trans. P. Tempest (London: Benjamin Motte, 1709), 63.

32. Cesare Ripa, *Iconologia* (New York and London: Garland, 1976), 429. "Donna bella, con capelli neri, & grossi, sparsi, & ritorti in diverse maniere, con le ciglia inarcare, che mostrino pensieri fantastichi, si cuopra la bocca, con una fascia ligata dietro à gl'orecchi, con una ca tena d'oro al collo, dalla quale penda una maschera, & habbia scritto nel la fronte, imitatio" (429). Translated by George Richardson: "Painting . . . is characterized by the figure of a fine woman, with a diadem on her head, and dressed in changing coloured garments, to denote the excellency and pleasing variety of this art. She has a golden chain about her neck, from which hangs a mask, with the motto *imitatio.*" George Richardson, *Iconology, or A Collection of Emblematical Figures* (London: G. Scott, 1779), 73.

33. Suggesting, appropriately, Ripa's description of Invention: a young woman with a she-bear and cub at her feet.

34. Rosenthal makes this last observation in "Angelica Kauffman Ma(s)king Claims," 53.

35. Modern palettes only came into use during the fifteenth century with the popularization of oil paints. Eighteenth-century artists were certainly aware of this, as evidenced by a print (based loosely on a painting of the subject produced in 1797 by Nicolas Monsiau, though the print bears the inscription "Apelles choisissant ses Modèles parmi les plus belles filles de la Grèce") by Brion de la Tour as well as by an early eighteenth-century engraving after Solimena's 1690 painting by Goupy. In both prints, Zeuxis uses dishes or pots to hold his colors rather than a palette. An impression of the Goupy print is in the Albertina.

36. Kauffman is known to have consulted this edition extensively. See Hope, "Cesare Ripa's *Iconologia* and the Neoclassical Movement," 1–4. Zucchi is among the subscribers listed between the title page and the dedication. I consulted the Garland facsimile edition of 1979 as well as a UMI photocopy of the original: Richardson, *Iconology, or A Collection of Emblematical Figures.* Ripa gives to Invention "a cuff" on one arm, though both arms should remain naked to signify "continuous action."

37. Albert Boime, *Art in the Age of Revolution, 1750–1800* (Chicago: University of Chicago Press, 1987), 114. Rosenthal builds importantly upon this observation in *Angelika Kauffmann,* 42–55. Rosenthal discusses the figure not in terms of an allegorical image but, rather, as a "Historien-Selbstporträt" (43).

38. Zucchi notes in the "Memorandum" that her *Self-Portrait in the Character of Painting Embraced by Poetry* was a gift for Bowles "because the figure representing Painting is the portrait of herself Angelica Kauffman" (quoted in Manners and William, *Angelica Kauffman, R.A.,* 59). This observation lends credence to the supposition that Bowles appreciated Kauffman's penchant for allegorical self-portraits and may have sought another, such as her *Zeuxis Selecting Models* (Manners and William, *Angelica Kauffman, R.A.,* 143). Among Kauffman's allegorical self-portraits are *Self-Portrait in the Character of Painting Embraced by Poetry* (oil on canvas, 1782, Kenwood House, London); *Self-Portrait Hesitating between Music and Painting* (oil on canvas, 1791, Nostell Priory, West Yorkshire)

(Figure 19); *Self-Portrait as Painting* (oil on canvas, ca. 1770s, location unknown); *Self-Portrait as Painting* (drawing, 1771, Paul Mellon Collection, New Haven, Conn.); *Self-Portrait as Hope* (oil on canvas, 1765, Academy of St. Luke, Rome); *Self-Portrait as Flora* (oil on canvas, ca. 1770s, Belvoir Castle), illustrated in Manners and William, *Angelica Kauffman, R.A.*, frontispiece and between 8 and 9. On Kauffman's self-portraits, see Rosenthal, "Künstlerische Selbstinszenierung," chap. 8 in *Angelika Kauffmann*, 303–55.

39. Rosenthal discusses Kauffman's pursuit of authority in this painting in "Angelica Kauffman Ma(s)king Claims," esp. 49–55.

40. "Die Ansprüche, die in dem Bild formuliert werden, nehmen nun durch Kauffmanns Einschreibung in die Geschichte eine neue Dimension an. Indem sie sich als aktive Künstlerin vor ihre Leinwand stellt, hat sie nicht nur Zeuxis eines seiner Modelle vorenthalten, sondern ihm gleichzeitig durch die In-Besitz-Nahme der Malinstrumente auch den Status als Maler entzogen. Zeuxis erscheint nun nich mehr als Künstler, sondern vielmehr als ein Werkstattgehilfe Kauffmans" (Rosenthal, *Angelika Kauffmann*, 42–43; English translation in the text by Cristina Tarpo).

41. "Indem Kauffmanns 'Zeuxis' die vor ihm stehende Frauengestalt nicht mit dem Auge, sondern durch den Tastsinn zu erfassen sucht, wird hier noch ein weiterer Mythos in Erinnerung gerufen. Man wird an den griechischen Bildhauer Pygmalion erinnert, der sich in eine von ihm geschaffene idealisierte Frauenstatue verliebt. Man möchte fast meinen, daß Kauffmanns Bildnis der in helles Licht getauchten Schönheit mit ihrer marmorweißen Haut und Gewandung erst jetzt—auf 'Pygmalions' Flehen—von Aphrodite Leben eingehaucht bekommt" (Rosenthal, *Angelika Kauffmann*, 49; English translation in the text by Cristina Tarpo).

42. Joan Riviere, "Womanliness as Masquerade" (1929), in *Formations of Fantasy*, ed. Victor Burgin, James Donald, and Cora Kaplan (New York: Methuen, 1986), 35–44. Rosenthal deploys Riviere's theory in *Angelika Kauffmann*, but not in relation to the Zeuxis. Instead, she takes recourse to the idea of a female masquerade in her chapter "The Inner Orient," which addresses Kauffman's representations of female models and sitters.

43. Riviere cites business, academic, and scientific careers as those that are traditionally masculine. This masquerade of femininity is not unique to what Riviere terms "homosexual" women or women with an unresolved Oedipal complex: "Both the 'normal' woman and the homosexual desire the father's penis and rebel against frustration (or castration); but one of the differences between them lies in the difference in the degree of sadism and of the power of dealing both with it and with the anxiety it gives rise to in the two types of women" ("Womanliness as Masquerade," 44).

44. Ibid., 38.

45. She appears as Painting in *Self-Portrait as Painting* (stipple engraving, 1781) and *Painting Embraced by Poetry* (oil painting, 1782, Kenwood, U.K.). Roworth argues that Kauffman's *Self-Portrait* in the Uffizi "shows her seated in Imitation's pose" (*Angelica Kauffman*, 72).

46. Observing the close association between femininity and allegory, Mary Garrard has argued that such a strategy for self-representation is only available to women artists. "Artemisia Gentileschi's Self-Portrait as the Allegory of Painting," *Art Bulletin* 62 (March 1980): 97–112. Kauffman was well aware of the consequences of stepping outside the codes of behavior imposed upon women of her social location. Intimations of sexual impropriety—motivated by her gender and her friendships with powerful men—plagued her throughout her career. Her mortification at learning she had been duped into marrying a con man named Brandt when she thought she had wed a nobleman made her even more cautious in later life.

47. Sandrart (Figure 11), Solimena, and Vien (Figures 25 and 26) succumb to this temptation, with awkward results.

48. Beccafumi, Vasari, and Heiss follow this strategy (see Figures 5, 8, and 13), as does the Victorian painter Edwin Long (Figure 56). A drawing of Zeuxis Selecting Models attributed to Perino del Vaga in the Worcester Art Museum also shows the artist sketching on a tablet.

49. I discuss this painting and contemporary critics' responses at length in chapter 6.

50. In a later drawing for an unrealized rendition of Apelles, Vincent takes recourse to another strategy: The legendary artist's canvas remains draped.

51. Contemporary critics commented on this confusion. See chapter 6.

52. Orientalist painter Victor-Louis Mottez further occults and fetishizes the subject by hiding Zeuxis and his painting and model behind a sheer drape, through which the viewer can just barely discern the scene (Figure 33). I address this painting in chapter 6 and again in the conclusion.

53. Marcia Ian, *Remembering the Phallic Mother: Psychoanalysis, Modernism, and the Fetish* (Ithaca, N.Y.: Cornell University Press, 1993), 7.

54. See Algernon Graves, *The Royal Academy of Arts: A Complete Dictionary of Contributors and Their Work from Its Foundation in 1769 to 1904* (London: Henry Graves and C. and George Bell and Sons, 1906), 299–301.

55. The painting is not mentioned in Graves, *The Royal Academy of Arts.*

56. Even today the painting remains "closeted" in a storeroom in the John Carter Brown Library at Brown University, where it hangs.

57. Wendy Steiner comments briefly on the Zeuxian character of Frankenstein's creation in *Venus in Exile: The Rejection of Beauty in Twentieth-Century Art* (New York: Free Press, 2001), 7.

58. Miranda Seymour indicates that Mary Shelley's stepsister, Claire (a.k.a. Jane or Clare) Clairmont also participated in the contest. Seymour, *Mary Shelley* (New York: Grove Press, 2000), 156–57. Seymour explains Shelley's failure to mention that Claire had likewise not immediately embarked on a story as "tactful" rather than as evidence that Claire was not participating in the game.

59. Shelley, "Introduction" (to the 1831 edition), *Frankenstein,* ed. Johanna M. Smith, Case Studies in Contemporary Criticism (Boston: Bedford Books/St. Martin's Press, 1992), 22.

60. Ibid., 20. She expressed similar feelings in an 1838 journal entry: "I was

nursed and fed with a love of glory. To be something great and good was the precept given me by my Father: Shelley reiterated it." *Mary Shelley's Journal*, ed. Frederick L. Jones (Norman: University of Oklahoma Press, 1947), 204–6, cited in Mary Poovey, *The Proper Lady and the Woman Writer: Ideology as Style in the Works of Mary Wollstonecraft, Mary Shelley, and Jane Austen* (Chicago and London: University of Chicago Press, 1984), 114. Poovey discusses Shelley's purposeful pursuit of literary reputation on pages 119–22.

61. Joshua Reynolds, *Discourse II*, in *Discourses on Art*, 27.

62. See Charles A. Cramer, "Alexander Cozens's *New Method:* The Blot and General Nature," *Art Bulletin* 79 (March 1997): 112–29.

63. Quoted in ibid., 115.

64. John Ruskin, *Modern Painters*, 5 vols. (New York: Merrill and Baker, n.d.), 2:212, 1.2.6.3 § 23.

65. Though her early education remains somewhat veiled, her direct familiarity with artists and poets and their ideas is attested. Her father received visits from Wordsworth, Thomas Lawrence, and James Northcote among luminaries from the world of British arts and letters. See Emily W. Sunstein, *Mary Shelley: Romance and Reality* (Baltimore, Md.: The Johns Hopkins University Press, 1991), 40–41.

66. Henry Richter, *Daylight: A Recent Discovery in the Art of Painting; With Hints on the Philosophy of the Fine Arts, and on That of the Human Mind, as First Dissected by Emmanuel Kant, in Art in Theory* (London: Blackwell, 2000; orig. London 1817), 1105.

67. On Mary Shelley's pursuit of intellectual authority, see Zachary Leader, "Parenting Frankenstein," chap. 4 in *Revision and Romantic Authorship* (Oxford: Clarendon Press, 1996), 167–205.

68. Mary Poovey discusses Mary Shelley's ambivalence about the capacity for genius in her sex in "'My Hideous Progeny': The Lady and the Monster," chap. 4 in *The Proper Lady and the Woman Writer*, 114–42.

69. Quoted in Sunstein, *Mary Shelley*, 231.

70. Sunstein, *Mary Shelley*, 231.

71. In the 1818 edition, this section appeared as the first of three volumes. Later editions run them together as a single volume. My page numbers refer to the 1992 edition edited by Johanna M. Smith.

72. Of course, it's the Fiend's voice as recalled by Frankenstein and recorded by Walton. On Shelley's construct of a narrator in *Frankenstein*, see Marion Carol Zwickel, "Narratological Reading Emphasizing the Narrator/Narratee Relationships in Mary Shelley's *Frankenstein*, Charles Robert Maturin's *Melmoth the Wanderer*, and J. Sheridan Le Fanu's *Carmilla*" (Ph.D. diss., West Virginia University, 1995). In the original 1818 version, this transition takes place with the third chapter of volume 2.

73. See Schlüter, *Zeuxis und Prometheus*, 31–54 and 55–74.

74. Shelley, *Frankenstein*, 37, 175.

75. Ibid., 42.

76. Shelley, "Introduction," 23. Poovey discusses Shelley's use of artistic

metaphors (though toward a different end than that pursued here) in *The Proper Lady and the Woman Writer,* 138–42.

77. Shelley, *Frankenstein,* 55, 57, 58.

78. Ibid., 58.

79. Ibid.

80. Ibid., 91.

81. Ibid., 101. When Frankenstein sees the Fiend, "breathless horror and disgust [fills his] heart" (58). The Fiend perceives vision as the medium for love as well. Coming upon Justine asleep in the barn, he leans over her and whispers, "Awake, fairest, thy lover is near—he who would give his life but to obtain one look of affection from thine eyes" (124).

82. Ibid., 117. So the Fiend resolves to travel only at night, "when I was secured from the view of man" (121).

83. Ibid., 123, 127, 181, 181.

84. Pliny, *Natural History,* 309, § 64.

85. Shelley, *Frankenstein,* 56.

86. Ibid., 127, 141.

87. Ibid., 140.

88. This corresponds roughly to volume 2 of the original 1818 edition.

89. "Accursed creator!" (Shelley, *Frankenstein,* 113). "I remembered Adam's supplication to his Creator. But where was mine? He had abandoned me; and, in the bitterness of my heart, I cursed him" (114). The Fiend addresses Frankenstein as "Cursed, cursed creator!" (117) and "my creator" (125).

90. Shelley, *Frankenstein,* 125.

91. Ibid., 93.

92. Ibid., 102.

93. Ibid., 87–88.

94. See, for instance, Alan Bewell, "An Issue of Monstrous Desire: Frankenstein and Obstetrics," *Yale Journal of Criticism* 2, no. 1 (Fall 1988): 105–28; Robert Kiely, *The Romantic Novel in England* (Cambridge, Mass.: Harvard University Press, 1972), 155–73; and Ellen Moers, "Female Gothic," in *Literary Women* (Oxford: Oxford University Press, 1985), 90–110.

95. Shelley, "Introduction," 23.

96. Mary Poovey discusses the unreliability of strongly biographical interpretations of Shelley's writing in *The Proper Lady and the Woman Writer,* 117.

97. Shelley, "Introduction," 22.

98. Shelley's theory of artistic creativity accords interestingly with later ideas such as Hans Sedlmeyer's *Kunstwollen,* a metaphysical theory for the evolution of style.

99. Shelley, "Introduction," 22.

100. Letter dated February 19, 1828. *The Letters of Mary Wollstonecraft Shelley,* ed. Betty T. Bennett, 3 vols. (Baltimore, Md.: The Johns Hopkins University Press, 1980), 2:27.

101. Poovey, "'My Hideous Progeny.'"

102. On the liberatory potential of fetishism for women, see Lorraine Gam-

man and Merja Makinen, *Female Fetishism* (New York: New York University Press, 1995).

6. PAINTING IN THE PHILOSOPHICAL BROTHEL

1. Terry Castle, *The Female Thermometer: Eighteenth-Century Culture and the Invention of the Uncanny* (New York and Oxford: Oxford University Press, 1995), 8–9.

2. Kristeva, *Powers of Horror,* 37.

3. Ibid., 59.

4. Angela Rosenthal describes the painting as "an image with erotic overtones," but I believe that in comparison with other representations of Zeuxis Selecting Models, Kauffman's work appears almost puritanical. Rosenthal's critique of Bettina Baumgärtel's interpretation of the painting includes the admonition that the theme of Zeuxis Selecting Models elicits intellectual engagement because it "demands election and not delight." Rosenthal cites Raphael's invocation of the legend as support for this claim. But as we have seen, the theme frequently lapsed from its high-minded purpose. See Rosenthal, "Angelica Kauffman Ma(s)king Claims," 38–59.

5. Shannon Bell, *Reading, Writing, and Re-Writing the Prostitute Body* (Bloomington and Indianapolis: Indiana University Press, 1994), 44. She here cites Angelika Rauch, "The *Trauerspiel* of the Prostituted Body, or Woman as Allegory of Modernity," *Cultural Critique* (Fall 1988): 81.

6. See Frances Borzello, *The Artist's Model* (London: Junction Books, 1982).

7. The painting was reportedly shown again at the Salon of 1799, but is not listed in the *livret* for that year, *Explication des ouvrages de peinture et dessins, sculpture, architecture, et gravure, Des artistes vivans, exposés au Muséum central des arts, d'après l'arrêté du Ministre de l'Intérieur, le 2er. fructidor, an VII de la République française* (Paris: Imprimerie des Sciences et Arts, 1799).

8. "Quoique les arts soient négligés depuis quelques mois pour les matières politiques et qu'ils ne puissent exciter le même intéret que les grandes révolutions dont nous sommes témoins, il me semble pourtant qu'un journal comme le votre ne peut passer sous silence l'exposition des tableaux." Joseph Joubert, "Lettre aux auteurs du Journal sur les tableaux exposés au Louvre en 1789," *Le modérateur,* October 13, 1789: 451. Translations are mine unless otherwise noted.

9. "Au milieu des mouvements dont la France est encore agitée, la poesie est restée muette; la littérature et les arts ont été, pour ainsi dire, oubliés; tous les esprits se sont vus entraînés par une pente générale vers les grands intérêts de la nation. . . . Votre patriotisme, citoyens, s'est manifesté; aujourd'hui les arts vous rappellent." *Observations critiques sur les tableaux du Sallon de l'année 1789: IIIe suite du discours sur la peinture* (Paris: Chez le Marchands de Nouveautés, 1789), 1.

10. Vien's depiction *Nicomachus Admiring Zeuxis's Painting* suggests that he relied upon the description of Zeuxis provided in L. M. Caudon's *Nouveau dictionnaire historique* (Amsterdam: Marc-Michel Rey, 1766) (several editions of this work appeared during the last half of the eighteenth century, some from Parisian

publishers). Winckelmann also mentions Nicomachus's reaction to Zeuxis's painting in *History of Ancient Art:* "Compare with the criticism [of Zeuxis levied by Aristotle] the reply made by Nicomachus, also a celebrated painter, to some one who was finding fault with the Helen of Zeuxis: 'Take my eyes and she will seem to you a goddess'" (4:221). Neither Cicero nor Pliny mentions this episode. A preliminary study for Nicomachus is in the collection of the Musée des Beaux-Arts, Bézier. See Thomas Gaehtgens and Jacques Lugand, *Joseph-Marie Vien: Peintre du Roi* (Paris: Arthena, 1988).

11. "Dans le moment le plus fort de la Révolution, lorsque je venais d'apprendre que le premier architecte du Roi avait payé la place qu'il avait à la Cour par la perte de sa tête, je me dis à moi-même: Il serait fort possible que le premier peintre, sans qu'on eut égard à son age, ni aux services qu'il peut avoir rendus aux Arts, fut traité de même que l'architecte." Joseph-Marie Vien, "Les mémoires," reproduced in Gaehtgens and Lugand, *Joseph-Marie Vien,* 317. Vien finished his memoirs in 1804 at the age of eighty-eight.

12. Vien, "Les mémoires," 318. James Wyatt numbered among these new clients. A British architect famous for his neoclassical and Gothic inventions as well as his indolence, Wyatt probably purchased the Zeuxis drawings from the artist. "Ensuite j'ai fait vingt autres dessins (sur) les vicissitudes de la guerre, depuis le départ d'une armée jusqu'aux réjouissances publiques. Ces deux suites, ainsi que deux autres dessins sur différens sujets, m'ont été achetés par l'architecte de M. de Becfort, anglais" ("Les mémoires," 318). Wyatt worked for William Beckford from 1796 to 1813. Gaehtgens and Lugand surmise that the Zeuxis drawings were among the "autres dessins" (other drawings) sold to Wyatt.

13. Vien's composition differs from other versions of the scene by showing Zeuxis at work on a nearly finished painting. While the presence of a finished canvas satisfies the narrative requirements of *Nicomachus Admiring Zeuxis's Painting,* the scene of *Zeuxis Selecting His Models* would seem to demand an unfinished painting. In fact, Vien's contemporaries usually depicted Zeuxis with an unfinished painting. Vincent's version, for example, shows Zeuxis before a canvas marked only by an indistinct underdrawing. Kauffman, like most artists who depicted the subject, refrained from representing any part of Zeuxis's legendary painting. Whether Vien's departure from this convention resulted from presumptuousness or from compositional or iconographical necessity remains, at present, unclear.

14. Vien's composition is a mirror image of Vincent's. There is no record of a print after Vincent's painting, so the reversal must have been Vien's doing.

15. Vincent seems to have modeled this relief on the culminating scene of the so-called Panathenaic Procession at the Parthenon.

16. Thanks to Timothy A. Riggs for drawing this connection to my attention. Angela Rosenthal discusses the connection between Zeuxis Selecting Models and the Judgment of Paris in *Angelika Kauffmann.*

17. See Lynn Hunt, *Politics, Culture, and Class in the French Revolution* (Berkeley and Los Angeles: University of California Press, 1984); Hunt, "The Political Psychology of Revolutionary Caricatures," in *French Caricature and the*

French Revolution, 1789–1799 (Los Angeles: Grunwald Center for the Graphic Arts, 1988), 33–40; and Ewa Lajer-Burcharth, *Necklines: The Art of Jacques-Louis David after the Terror* (New Haven, Conn.: Yale University Press, 1999), 20–32.

18. See Joan B. Landes, *Women and the Public Sphere in the Age of the French Revolution* (Ithaca, N.Y.: Cornell University Press, 1988), esp. chap. 4, "Women and Revolution."

19. See Lajer-Burcharth, *Necklines*, 163–74. The association between Hera and dangerous femininity had a precedent in French official imagery: Rubens's Marie d'Medici cycle at the Luxembourg Palace established a visual link between the unpopular queen—popularly remembered as a usurper—and the jealous goddess.

20. Vien's memoirs record his concern with political developments and his attempts to keep himself safely occupied: "Fermement résolu à attendre l'événement quel qu'il fut, j'éloignai de moi toute pensée inquiétante et je cherchai dans les occupations de mon Art un adoucissement à mes malheurs" (Steadfastly resolved to await the event—whatever it may be—I put aside my worries and sought comfort in my art) ("Les mémoires," 317).

21. Vien's deployment of the allegorical potential of Zeuxis Selecting Models was not unprecedented. Angelica Kauffman, in her painting of the subject from the late 1770s, capitalizes on the theme's possibilities for allegory and self-representation by including herself in the composition as the personification of Painting or Invention or Imitation. (See chapter 5.)

22. I refer here to Mary Sheriff, "The Portrait of the Artist," in *The Exceptional Woman*, 180–220, and to the first chapter of Lajer-Burcharth's *Necklines*, 8–70.

23. *Pensées d'un prisonnier de la Bastille sur les tableaux exposés au Sallon du Louvre en 1789* (Paris, 1789), 8–9.

> Que ce tableau flatte mes yeux!
> Les beaux corps! l'heureuse harmonie!
> C'est un chef-d'oeuvre du génie,
> Ah! qui n'en serait envieux!
> A la métempsicose, en France.
> Qui ne croirait, en le voyant?
> Zeuxis, sous le nom de Vincent
> De son art montre l'excellence!

24. *Observations critiques sur les tableaux du Sallon de l'année 1789*, 16. "Lorsque M. Vincent a fait choix d'un tel sujet, il s'est imposé une tâche bien difficile à remplir."

25. The concept of the "pregnant moment" was developed by the dramatist, critic, and aesthetician Gotthold Ephraim Lessing and adopted by academic painters.

26. The painting was exhibited at the 1789 Salon with the title *Zeuxis choisissant pour modèles les plus belles filles de Crotone*, suggesting that Vincent relied

upon Cicero as his source. This means that he understood Zeuxis's painting to represent Helen.

27. Comte de Mende-Maupas, *Remarques sur les ouvrages exposées au Salon par le C.D.M.M. de plusieurs académies* (Paris: Knapen Fils, 1789), 8–9. ". . . est excellent, malgré les raproches du ton rougeâtre qu'ont ses femmes, et l'engourdissement de celle qui est déjà déshabillée."

28. *Observations critiques sur les tableaux du Sallon de l'année 1789*, 17. ". . . que l'attitude de la jeune fille qui tourne le dos n'est pas d'un bon effet. Cette position étoit-elle nécessaire pour exprimer la pudeur qui veut se dérober aux regards, et se refuse à servir de modèle?"

29. "Examen du Salon de l'année 1789," *Journal de Paris*, 1789: 1188. "On trouve l'attitude de Zeuxis un peu oiseuse; . . . on craint qu'il n'ait plutôt l'expression du plaisir, que celle d'un Artiste sublime, qui doit réfléchir sur la combination et la choix des parties qui lui sont necessaires pour former le beau tout qu'il se propose d'executer."

30. Julie A. Cassiday and Leyla Rouhi, "From Nevskii Prospekt to Zoia's Apartment: Trials of the Russian Procuress," *Russian Review* 58 (July 1999): 413–31.

31. In some cases, the procuress even brings destruction to herself and the lovers she unites, as in the fifteenth-century Spanish play *Celestina*.

32. Attributed to Magdalena de Passe after Gerrit Honthorst, *Pygmalion and Galatea* (engraving, before 1638, Harvard University Art Museums, Cambridge, Mass.). My thanks go to Marjorie B. Cohn for bringing this print to my attention.

33. Quoted in Susan Waller, *Women Artists in the Modern Era: A Documentary History* (Metuchen, N.J.: Scarecrow Press, 1991), 31. The women were actually students of Elisabeth Vigée-Lebrun, who studied with David only while Lebrun's studio was being refurbished.

34. Quoted in ibid., 31.

35. This painting was exhibited at the Salon of 1798 (Year 6) and appears as catalog number 311 in the *Explication des ouvrages de peinture, et dessins, sculpture, architecture et gravure, exposés au Muséum central des arts d'après l'arrêté du Ministre de l'Intérieur, le 2er thermidor, an VI de la République française* (Paris: Imprimerie des Sciences et Arts, 1798), 53.

36. *Observations critiques sur les tableaux du Sallon de l'année 1789*, 17. ". . . laisser un champ libre à l'imagination."

37. That Monsiau intended the setting to be understood as a Juno temple is suggested by the description of the painting in the *Explications des ouvrages* accompanying the 1798 Salon: "Ce peintre célèbre parmi les Grecs, ayant une Hélène à représenter pour les Agrigentins, et qu'ils voulaient consacrer dans le temple de Junon, cette nation lui envoya, par les plus notables de la ville, ses plus belles filles pour lui servir de modèles. Zeuxis en choisit cinq, à qui il distribua des couronnes comme prix de la beauté. En réunissant les graces particulières a chacune, il espérait atteindre à la plus grande perfection." (This painter, celebrated among the Greeks, painted a Helen for the citizens of Agrigentum, which they wanted to consecrate to the temple of Juno. The leading citizens conveyed to him [Zeuxis] the most beautiful girls to serve as models. Zeuxis selected five,

to whom he distributed wreaths as prizes. In combining the particular graces of each, he hoped to achieve the greatest perfection.) (*Explication des ouvrages de peinture, et dessins, sculpture, architecture, et gravure*, 53.)

38. See David Dabydeen, *Hogarth's Blacks: Images of Blacks in Eighteenth-Century English Art* (Mundelstrup, Denmark: Dangaroo Press, 1985), 97; Gen Doy, *Out of Africa: Orientalism, "Race," and the Female Body* (London: Sage, 1996); and Paul Gilroy, *Picturing Blackness in British Art, 1700s–1990s* (London: Tate Gallery, 1995).

39. The affinity between these two figures may point to a post-1808 date for Senave's painting.

40. Two versions of the painting exist, one in the Musée Condé in Chantilly, the other in the collection of the Musée des Beaux-Arts in Lille. An autograph copy is in the Museum of Art and History in Roubaix. The Chantilly version was the one shown at the Salon of 1859. Reviewers were not kind. Zacharie Astruc lamented the inaccuracies and stiffness of the scene. Zacharie Astruc, *Les quatorze stations de la Salon de 1859 suivies d'un récit douloureux* (Paris: Poulet-Malassis et de Broise, 1859). Likewise, Ernest Chesneau complained that the figures were so badly handled as to resemble the crude puppets used in street theater. Ernest Chesneau, *Libre étude sur l'art contemporain* (Paris: Imprimerie centrale de Napoléon Chaix, 1859).

41. Chesneau describes the subject as "the most beautiful subject for a painter, a magnificent occasion for studies of the nude" (le plus sujet pour un peintre, une magnifique occasion de faire des études de nu). Chesneau, *Libre étude*, cited in Nicole Garnier-Pelle, *Chantilly Musée Condé: Peintures de XIXe et XXe siècles* (Paris: Réunion des Musées Nationaux, 1997), 287.

42. According to Pliny, *Natural History*, 325, § 87, Apelles based his Venus on the figure of his lover, Pancaspe (sometimes Campaspe). While many eighteenth-century sources kept the stories of Zeuxis Selecting Models and Apelles Painting the First Venus Anadyomène separate (such as Roger de Piles's 1699 *L'Abrégé de la vie des peintres*), earlier authorities did not. Vasari, for instance, confuses them, as does Carlo Cesare Malvasia in his description of Agostino Carracci's "Apelles painting his famous Venus with three naked women as his models" (Summerscale, *Malvasia's Life of the Carracci*, 568).

43. Neither Cicero nor Pliny mentions this episode but it does appear in Aelian, *Historical Miscellany*, book 14.47. Eighteenth-century sources include Caudon's *Nouveau dictionnaire historique*. See also note 11 above on Winckelmann's mention of Nicomachus's reaction to Zeuxis's painting.

44. Quoted in William Rubin, "The Genesis of *Les Demoiselles d'Avignon*," in William Rubin, Hélène Seckel, and Judith Cousins, *Les Demoiselles d'Avignon* (New York: Museum of Modern Art, 1994), 21. This essay strongly shaped my own thinking on this painting.

45. Rubin, "The Genesis of *Les Demoiselles d'Avignon*," 21.

46. "I cannot speak other than mystically [about this picture]. . . . the *Demoiselles d'Avignon* defies analysis, and the laws of its vast composition are in no way formulatable. For me, it is pure symbol, like the Chaldean bull, an intense

projection of that modernity of which we catch a sense only in bits and pieces" (Breton to Jacques Doucet, 1924 letter, quoted in Rubin, "The Genesis of *Les Demoiselles d'Avignon*," 126, n. 83).

47. According to associate museum archivist Michelle Harvey, the original wall color inside MoMA was described as "beige," "natural," and "ecru" by contemporary viewers. By the middle of the twentieth century, the art-historical fashion for categorizing works according to a taxonomy based on style was in full bloom. The *Demoiselles*, interestingly, was used by different scholars to exemplify a variety of stylistic movements.

48. An overview of these interpretations can be found in Francis Frascina, "Realism and Ideology: An Introduction to Semiotics and Cubism," in *Primitivism, Cubism, Abstraction: The Early Twentieth Century*, ed. Charles Harrison, 104–34 (New Haven, Conn.: Yale University Press in association with the Open University Press, 1993).

49. Leo Steinberg resists this reductivism, and my analysis of Picasso's *Demoiselles* is deeply indebted to his "The Philosophical Brothel," pts. 1 and 2, first published in *ArtNews* 71 (September, 1972): 20–29; (October 1972): 38–47; a revised and slightly expanded version of this essay appeared in *October* 44 (Spring 1988): 7–74.

50. Though this crucial fact is undisputed, it went unmentioned by Kahnweiler in his first commentary on the painting, "Der Kubismus," *Der Weissen Blätter* 3, no. 9 (September 23, 1916): 209–22. See Rubin, "The Genesis of *Les Demoiselles d'Avignon*," 21.

51. Rubin devotes an entire section of his essay to the problem of the painting's early titles; see "The Genesis of *Les Demoiselles d'Avignon*," 17–19.

52. Ibid., 17–18. Rubin believes that the title was "proposed by Apollinaire, revised by [Max] Jacob, and adopted by Salmon."

53. See Laurence Campa, "Apollinaire et Sade," *Cahiers de l'Association internationale des études françaises* 47 (May 1995): 391–404, and Jean Raymond, "L'Imitation de Sade," *Europe: Revue littéraire mensuelle* (1972): 88–105. Apollinaire edited a collection of Sade's works and some unpublished letters: *L'oeuvre: "Zoloé," "Justine," "Juliette," "La philosophie dans le boudoir," "Les crimes de l'amour," "Aline et Valcour": Pages choisies, comprenant des morceaux inédits et des lettres publiées pour la première fois, tirées des Archives de la Comédie-Française* (Paris: Bibliotheque de Curieux, 1909).

54. *The Marquis de Sade: "Justine," "Philosophy in the Bedroom," and Other Writings*, 215–17.

55. The influence of Rousseau is particularly evident in *Philosophie dans le boudoir*.

56. Sade, *Philosophy in the Bedroom*, 197.

57. Ibid., 202–3. The French is from *La philosophie dans le boudoir*, at the Web site "Œuvres du Marquis de Sade," http://desade.free.fr/philo/philo.htm:

EUGÉNIE: O Dieu! la délicieuse niche! Mais pourquoi toutes ces glaces?

MME DE SAINT-ANGE: C'est pour que, répétant les attitudes en mille sens divers, elles multiplient à l'infini les mêmes jouissances aux yeux de ceux qui les goûtent sur cette ottomane. Aucune des parties de l'un ou l'autre corps ne peut être cachée par ce moyen: il faut que tout soit en vue.

58. Leo Steinberg makes a compelling case that the figure with her arm raised and bent is constructed as a reclining odalisque that has been rotated into a vertical position. Steinberg, "The Philosophical Brothel," pt. 1, 23–24.

59. Yve-Alain Bois, "Painting as Trauma," *Art in America* (June 1988): 136. Hal Foster also considers the *Demoiselles* in relation to psychic trauma, as symptomatic of a primal scene. See his "Primitive Scenes," chap. 1 in *Prosthetic Gods* (Cambridge, Mass.: MIT Press, 2004), 1–52.

60. Linda Williams, *Hard Core: Power, Pleasure, and the "Frenzy of the Visible"* (Berkeley and Los Angeles: University of California Press, 1989), 53.

61. Sade, *Philosophy in the Bedroom*, 219.

62. Rubin, "The Genesis of *Les Demoiselles d'Avignon*," 45–56, 49, 59, 60–61.

63. Leo Steinberg, "The Algerian Women and Picasso at Large," in *Other Criteria: Confrontations with Twentieth-Century Art* (London, Oxford, and New York: Oxford University Press, 1972), 173.

64. Bois, "Painting as Trauma," 137.

7. ZEUXIS IN THE OPERATING ROOM

1. Orlan was born in 1947. The best sources for information on her career are C. Jill O'Bryan, *Carnal Art: Orlan's Refacing* (Minneapolis: University of Minnesota Press, 2005); Parveen Adams, *Orlan: This Is My Body—This Is My Software* (London: Black Dog, 2002); Peg Zeglin Brand, "Bound to Beauty: An Interview with Orlan," in *Beauty Matters,* ed. Peg Zeglin Brand, 289–313 (Bloomington and Indianapolis: Indiana University Press, 2000); Michelle Hirschhorn, "Orlan: Artist in the Post-Human Age of Mechanical Reincarnation; Body as Ready (to Be Re-)Made," in *Generations and Geographies in the Visual Arts: Feminist Readings,* ed. Griselda Pollock, 110–34 (London and New York: Routledge, 1996); Barbara Rose, "Is It Art? Orlan and the Transgressive Act," *Art in America* 81 (February 1993): 82–87, 125; Parveen Adams, "Operation Orlan," in *The Emptiness of the Image: Psychoanalysis and Sexual Difference* (London and New York: Routledge, 1996). Melissa Pearl Friedling offers an excellent analysis in "Psychoanalysis and the Performance of Plastic Surgery," in *Recovering Women: Feminisms and the Representation of Addiction* (Boulder, Colo.: Westview Press, 2000), 115–53.

2. The first operation, *Art Charnel*, took place on July 21, 1990 (Paris; surgeon, Dr. Chérif Kamel Zaar; costume designer, Charlotte Caldeburg); the second, *Opération dite de la licorne*, on July 25, 1990 (Paris; Zaar; text by Julia Kristeva); the third on September 11, 1990 (Paris; Zaar); the fourth, *Opération réussie*, on

December 8, 1990 (Paris; surgeon, Dr. Bernard Cormette de Saint-Cyr; designer, Paco Rabanne; text by Eugénie Lemoine-Luccioni, *La robe*); the fifth, *The Cloak of Harlequin*, on July 6, 1991 (Ivry-sur-Seine; Cormette de Saint-Cyr; designer, Franck Sorbier); the sixth in February 1993 (Liège; text by Antonin Artaud, *To Have Done with the Judgment of God*); the seventh, *Omnipresence*, on November 21, 1993 (New York; surgeon, Dr. Marjorie Cramer; text by Eugénie Lemoine-Luccioni, *La robe*; designer, Issey Miyake; this performance was underwritten by the CBS television show *20/20*); the eighth on December 8, 1993 (New York; Cramer), the ninth on December 14, 1993 (New York; Cramer). Descriptions were made available at Orlan's now-discontinued Web site www.cicv .fr/creation_artistique/online/orlan/ (accessed April 4, 2002) and also appear in O'Bryan, *Carnal Art*, 14–16.

3. According to Orlan's surgeon Marjorie Cramer, the use of local anesthesia is not unusual for facial cosmetic surgery (Marjorie Cramer, interview by the author, October 26, 1998). Some commentators on Orlan's performances have mistakenly reported that she relies on an epidural block.

4. The seventh operation was broadcast live via closed-circuit television to viewers in the Sandra Gering Gallery, New York; the Centre Georges Pompidou, Paris; the McLuhan Center, Toronto; the Multi-Media Center, Banff, and other sites that participated in the interactive transmission. Orlan read and answered questions faxed to her during the procedure, which lasted more than five hours. Orlan, *Net Magazine*, www.baskerville.it/NegMag/G_Orlan.html (accessed Tuesday, September 29, 1998; the *Net Magazine* project is now closed). She begins all her surgery-performances by reading a particular passage from Eugénie Lemoine-Luccioni's *La robe: Essai psychanalytique sur le vêtement* (Paris: Seuil, 1983).

5. She has not yet modified her nose.

6. Orlan denies that she deliberately sought beautiful models for her project, saying instead that she selected each woman for the ideas she signifies. "At the inception of this performance, I constructed my self-portrait by mixing, hybridizing, with the help of a computer, representations of goddesses of Greek mythology: chosen not because of beauty that they are supposed to represent . . . but for their histories" *(Net Magazine)*. Of course, that explanation does not accommodate her use of the *Mona Lisa*. The representations she chose are all closely associated with the West's canon of feminine beauty. Brand, "Bound to Beauty," 304; Hirschhorn, "Orlan," 111.

7. Orlan, "Beauty and the I of the Beholder," interview by Robert Enright, *Border Crossings* 17, no. 2 (May 1998): 44.

8. Orlan, in Brand, "Bound to Beauty," 296.

9. Cramer, Orlan's surgeon for the seventh, eighth, and ninth procedures, claims that 2 percent of American plastic surgeons are women, whereas 70–80 percent of plastic-surgery patients are female. Cramer has long been an advocate for women in the field of plastic surgery (Cramer, interview). According to the American Society of Plastic Surgeons survey of cosmetic surgery for 2000, 86 percent of cosmetic procedures were performed on women, and 14 percent on men. American Society of Plastic Surgeons, www.plasticsurgery.org/mediactr/ gender1.pdf (accessed April 3, 2002; Web page now discontinued).

10. Orlan, in Brand, "Bound to Beauty," 297. Orlan has also issued the un-qualified statement that "my work is not against cosmetic surgery, but against the standards of beauty, against the dictates of a dominant ideology that im-press themselves more and more on feminine flesh . . . and masculine flesh" *(Net Magazine).*

11. Lemoine-Luccioni, *La robe.*

12. Her official biography cites 1964 as the year of her first performances, *Les marches au ralenti, Le geuloir,* and *Femme sur le trottoir.* Orlan, www.cicv.fr/creation_artistique/online/orlan/exibitions/expo_list.html (accessed April 4, 2002), now "Biography" on www.orlan.net (accessed May 23, 2006). See also Beata Ermacora, "Orlan," *European Photography* 15 (Fall 1994): 15.

13. Orlan, "Beauty and the I of the Beholder," 45.

14. Brand, "Bound to Beauty," 289.

15. Orlan, "Beauty and the I of the Beholder," 44.

16. The undated *Carnal Art Manifesto* appeared in French and English ver-sions on Orlan's now-discontinued Web site, www.cicv.fr/creation_artistique/online/orlan/ (accessed April 4, 2002). The English version of the manifesto also appears in Orlan, "Beauty and the I of the Beholder," 46.

17. Nor does her embrace of technology break completely with other mani-festations of body or performance art. Laurie Anderson and Matthew Barney are two prominent examples of artists who privilege the role of technology in their work. Similarly, self-portraiture via digital and other new media is not unique to Orlan's carnal art.

18. Orlan, "Beauty and the I of the Beholder," 46.

19. On the cultural significance of pain, see Elaine Scarry, *The Body in Pain* (New York and Oxford: Oxford University Press, 1985).

20. Orlan, quoted in Linda Weintraub, "Self-Sanctification," chap. 8 in *Art on the Edge* (Litchfield, Conn.: Art Insights, 1996), 77–83, quotation on 79.

21. Among the women to have published on Orlan at the time of this writing: Parveen Adams, Rachel Armstrong, Tanya Augsburg, Peg Zeglin Brand, Robyn Bretano, Whitney Chadwick, Kelly Coyne, Beata Ermacora, Margalit Fox, Melissa Pearl Friedling, Olivia Georgia, Michelle Hirschhorn, Kate Ince, Amelia Jones, Linda Kauffman, Rosie Millard, Jill O'Bryan, Barbara Rose, Roberta Smith, and Sharon Waxman. Men include Robert Enright, Mike Featherstone, Hilton Kramer, Michel Moos, Timothy Murray, and Robert A. Sobieszek.

22. Ermacora, "Orlan," 16.

23. Mary Shelley pursued a similar strategy, though in her case it is a literary self-portrait rather than a pictorial one. See the discussion of Shelley's *Franken-stein* in chapter 5.

24. When asked this question, Orlan's surgeon Cramer disavowed any claim to artistic agency in her work with Orlan. She ascribes total creative, and hence artis-tic, control to Orlan. Interestingly, though, Cramer had long sculpted as a hobby.

25. Ermacora, "Orlan," 16.

26. Orlan, quoted in Weintraub, "Self-Sanctification," 79.

27. Shelley, *Frankenstein,* 45.

28. *Net Magazine.*

29. Ibid., In this way, recent legislative attempts to prevent human cloning in the United States could be understood as another form of iconoclasm. The realization of representations or perfect copies promised by cloning threatens to destabilize our category of the real as well as that of the ideal or divine creator.

30. Ibid.

31. Orlan acknowledges this: "The operating room becomes my studio from which I am conscious of producing images, making a film, a video, photos, and objects that will later be exhibited" (ibid.).

32. Ibid. She mentions her work with Paco Rabanne, Franck Sorbier, Issey Miyake, and Lan Vu.

33. Orlan discusses the carnivalesque in *Net Magazine.*

34. Adams, "Operation Orlan," 143.

35. Sharon Waxman, "Art by the Slice: France's Orlan Performs in the Surgical Theater," *Washington Post,* May 2, 1993, G5; cited in Friedling, "Psychoanalysis and the Performance of Plastic Surgery," 135.

36. Orlan, in Brand, "Bound to Beauty," 293.

37. "Hurray for the morphine!" she writes in the *Carnal Art Manifesto.*

38. Orlan, quoted in Weintraub, "Self-Sanctification," 82.

39. Orlan's participation in and critique of the mimetic tradition as it is embodied by the Zeuxis myth can best be explored, I believe, through recourse to theories of the fetish. This approach is warranted, I think, not only by Orlan's frequent evocation of psychoanalytic texts but by her undisguised fascination with the fetishistic drama embedded within the Zeuxis myth. As film theorists Laura Mulvey and Kaja Silverman, among others, have demonstrated, theories of the fetish can facilitate cultural analysis insofar as both Freudian and Marxist approaches treat the fetish as a symptom, a representation of ideology, whether individual or social.

40. According to her surgeon, during the seventh operation, Orlan appeared to swoon. Fearing that this was a result of the anesthetic, Cramer became concerned. Cramer's evaluation of the artist's vital signs and of her responses to questions assured the surgeon that Orlan's behavior was a calculated part of her performance (Cramer, interview).

41. Gamman and Makinen, *Female Fetishism,* 105.

42. Ibid., 106.

43. This theory of fetishism as a consequence of separation rather than castration anxiety derives from the work of W. H. Gillespie, Robert C. Bak, D. W. Winnicott, Melitta Sperling, Phyllis Greenacre, and Masud Khan. See Gamman and Makinen, *Female Fetishism,* 110–16.

CONCLUSION

1. The possibility that a culture may possess an unconscious capable of exercising influence on the development and reception of certain literary themes is interestingly explored by Macherey in *A Theory of Literary Production.* Zizek also proposes the possibility of a cultural unconscious, which might be tapped

using Freudian, Lacanian, and Marxist modes of inquiry. See his *Sublime Object of Ideology.*

2. Edward Said describes this as a "contrapuntal" effect. See his *Freud and the Non-European* (London: Verso, 2003), 24–30.

3. The relevance of *Moses and Monotheism* to the present study was pointed out by reviewer Jill Casid, whose direction on this point and many others I gratefully acknowledge. Freud's argument in *Moses and Monotheism* can be summarized briefly. Freud finds in the Pentateuch evidence that the historical Moses was an Egyptian, probably a high official in the court of Akhenaton (Amenhotep IV), the pharaoh who demanded adherence to a single god. According to Freud's analysis, Moses flees Egypt after the death of the pharaoh during the consequent suppression of the monotheistic religion, to which he remains faithful. An experienced administrator and persuasive leader, Moses adopts the similarly dispossessed and restless Hebrews as his new community. Together, they leave Egypt during the civil upheaval following Akhenaton's death. Moses insists that the Hebrews conform to his monotheistic religion; their occasional lapses into their former polytheistic practices are punished harshly. Moses is as intolerant of their old gods as he is devoted to their survival: qualities that the Hebrews would ultimately ascribe to their god. The Hebrews eventually find Moses's demands too much to bear and murder him. A few generations later, a new leader rises among the Jews to reinstate the laws and customs introduced by Moses. In the Hebrew Bible, the identity of this postexilic leader is elided comfortably with that of the original Moses, repressing the trauma of the latter's murder. Thus, the authors of the Hebrew Bible sublimated—but could not erase—these essential experiences, experiences that nevertheless continue to inflect Jewish perceptions of their cultural identity.

4. Ζεῦξις.

5. Ζευξίδια.

6. In Plato's *Protagoras* (380 BCE), Socrates refers to a young painter from Heraclea named Zeuxippus. Nothing more than his recent arrival in Athens is mentioned. This artist has been identified with Zeuxis by some scholars. If he is the historical Zeuxis, the shortened form of the name would function along the lines of the epithet I describe.

7. Precisely which Heraclea is not made clear by ancient sources.

8. Some legends hold that their offspring also include the minor goddesses Hebe and Eileithya.

9. Zeuxis was reminded of his human fallibility when Parrhasius painted an illusionistic curtain that Zeuxis attempted to push aside. I discuss their legendary contest at greater length in chapter 2.

10. The tradition that Zeuxis laughed himself to death is recorded in François Rabelais, *Gargantua and Pantagruel* (1548), book 4, chap. 17.

11. Plato, *Republic*, trans. G. M. A. Grube (Indianapolis: Hackett, 1974), §§ 607–8.

12. Xenophon, *Memorabilia*, 97–99, book 3, chap. 10. Interestingly, the method associated with Zeuxis in later antiquity is here linked to Parrhasius.

13. Ibid., 100, book 3, chap. 10.

14. Besançon, *The Forbidden Image*.

15. C. Jill O'Bryan, in her discussion of Jacqueline Rose's analysis of Orlan's carnal art, points out that the artist is not seeking to "'represent an ideal.'" O'Bryan explains that "Orlan's experiment does pertain to a gap between nature and the ideal as portrayed in art, identity, and communication between ontology and the materiality of the human body, but within this technological experiment Orlan interrogates the realm of the ideal rather than attempting to achieve an ideal physique." I agree with O'Bryan's assertion; it is this contested, contingent notion of the ideal that Orlan summons through her surgery-performances. See O'Bryan, *Carnal Art*, 19.

16. Cicero writes, "The citizens of Croton . . . had abundant wealth and were numbered among the most prosperous in Italy" (*De inventione*, 167); Pliny indicates that the expense of Zeuxis's commission was supported by the public.

17. Greeks in particular enjoyed a special status vis-à-vis Romans: They were not Roman, nor were they classed among "foreigners."

18. Thomas N. Habinek, *The Politics of Latin Literature: Writing, Identity, and Empire in Ancient Rome* (Princeton, N.J.: Princeton University Press, 1998); Erich S. Gruen, *Culture and National Identity in Republican Rome* (Ithaca, N.Y.: Cornell University Press, 1992); Ray Laurence and Joanne Berry, eds., *Cultural Identity in the Roman Empire* (London and New York: Routledge, 1998); Janet Huskinson, ed., *Experiencing Rome: Culture, Identity, and Power in the Roman Empire* (London and New York: Routledge, with Open University Press, 2000).

19. Ray Laurence, "Territory, Ethnonyms, and Geography: The Construction of Identity in Roman Italy," in Laurence and Berry, *Cultural Identity in the Roman Empire*, 95–110, quotation on 109.

20. Mary Cowling mentions Ruskin's suggestion that the Anthropological Society purchase Long's *Babylonian Marriage Market* because of its seemingly accurate depiction of "racial types." Cowling, *The Artist as Anthropologist: The Representation of Type and Character in Victorian England* (Cambridge: Cambridge University Press, 1989), 233.

21. The belief that a racial or ethnic "type" could be discerned or isolated visually was widespread during the nineteenth century. See, for instance, Shawn Michelle Smith, *American Archives: Gender, Race, and Class in Visual Culture* (Princeton, N.J.: Princeton University Press, 1999); Lucy Hartley, *Physiognomy and the Meaning of Expression in Nineteenth-Century Culture* (Cambridge and New York: Cambridge University Press, 2005); Curtis L. Perry, *Apes and Angels: The Irishman in Victorian Caricature* (Washington, D.C.: Smithsonian Institution Press, 1971).

22. Ruth Bernard Yeazell, *Harems of the Mind: Passages of Western Art and Literature* (New Haven, Conn.: Yale University Press, 2000), and Wendy Leeks, "Ingres Other-wise," *Oxford Art Journal* 9, no. 1 (1986): 29–37.

23. On this series, see Mark Bills, *Edwin Longsden Long, R.A.* (London: Cygnus Arts; Madison and Teaneck, N.J.: Fairleigh Dickinson University Press,

1998), 155–62, and *Daughters of Our Empire: A Series of Pictures by Edwin Long, R.A.* (London: Agnew and Sons Gallery, 1887).

24. Patricia Leighton, "Colonialism, l'art nègre, and *Les Demoiselles d'Avignon*," in *Picasso's "Les Demoiselles d'Avignon*," ed. Christopher Green, 77–103 (Cambridge: Cambridge University Press, 2001), 96.

25. Shortly after the ninth operation, according to surgeon Marjorie Cramer, Orlan developed an infection as her body rejected one of the cheek implants inserted into her forehead. The implant had to be removed, leaving Orlan's forehead asymmetrical for a time (Cramer, interview, October 26, 1998).

26. Amy Kaplan, "'Left Alone with America': The Absence of Empire in the Study of American Culture," in *Cultures of United States Imperialism*, ed. Amy Kaplan and Donald E. Pease, 3–21 (Durham, N.C., and London: Duke University Press, 1993), 14.

27. James R. Gaines, "The New Face of America: How Immigrants Are Shaping the World's First Multicultural Society," ed. James R. Gaines, special issue, *Time*, Fall 1993, cover, 2.

28. David Roediger, *Colored White: Transcending the Racial Past* (Berkeley and Los Angeles: University of California Press, 2002), 3, 7.

29. Shawn Michelle Smith delivers a fascinating reading of this image in *American Archives*, 222–25. Among other things, Smith connects the *Time* image to the composite photographs produced by Francis Galton in the late nineteenth century. In these photos, Galton would combine images of several individuals to achieve a universal racial, ethnic, social, or medical "type." While not precisely the Zeuxian quest for an ideal, Galton's method bears a strong kinship in its pursuit of a generalized image. On Galton, see additionally Smith, *American Archives*, 89–93.

Index